Praise for

How to...
MAKE LOVE
LIKE A PORN ST★R
A CAUTIONARY TALE

"[Jameson] put the star in porn star." *—Rolling Stone*

"In this book, Jameson gets you rooting for her.... a real person comes through in its pages.... Lively, hellacious, entertaining, sharp, feisty, and touching enough to earn Jameson the right to wear the 'Heart Breaker' tattoo on her right butt cheek." *—Salon.com*

"Fascinating." *—Entertainment Weekly*

"Jenna Jameson the author deserves accolades. She is tireless.... for aspiring performers, it's a gold mine." *—New York Times Book Review*

"Wow!" *—Esquire*

"Jenna Jameson is the biggest adult film star in the world.... She's a legend in her own time." *—Playboy*

"As you'd expect, it's chock full of oh-my-God tidbits." *—Newsweek*

"Racy." *—Star*

"With its wit ... its celebrity dish ... and its frank, one-fisted prose style ... the queen of porn's autobiography is destined to become a lowbrow classic. Remarkably appealing and honest." *—Publishers Weekly*

"A gratifying read." *—Maxim*

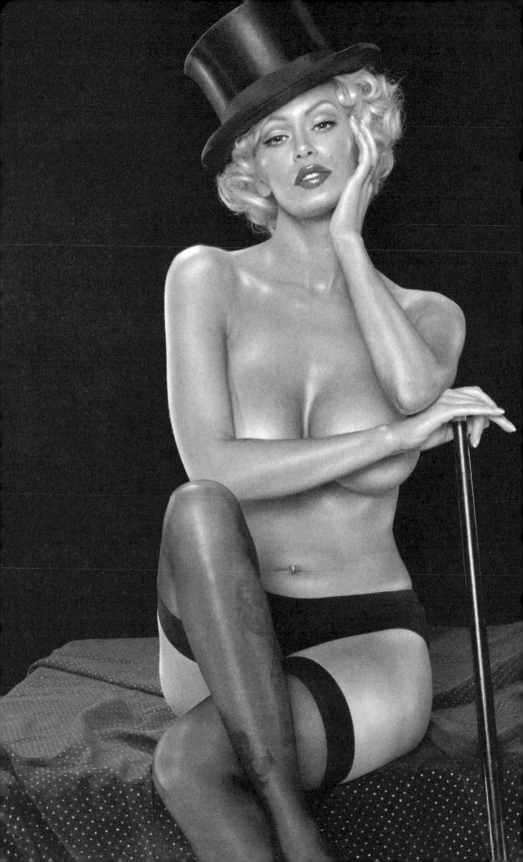

How to...
MAKE LOVE
LIKE A PORN ST★R

A CAUTIONARY TALE

JENNA JAMESON

with *Neil Strauss*

*it*books

AN IMPRINT OF HARPERCOLLINS PUBLISHERS

*it***books**

All epigraphs are from the sonnets of William Shakespeare:
Book I: Sonnet #1; Book II: Sonnet #5; Book III: Sonnet #12; Book IV: Sonnet #23;
Book V: Sonnet #31; Book VI: Sonnet #48.

PHOTOGRAPHY CREDITS

Text photographs on pages 28, 32, 37, 40, 45, 123, 129, 141, 163, 174–175, 210, 214, 228, 234, 258, 266, 270, 290, 294, 298, 313, 314, 319, 322, 327, 330, 336, 343, 346, 352, 362, 366, 370, 427, 430, 438, 443, 452, 456, 474, 486, 512, 534, 538, 544, 550, 556, 558 (left), 561, 562, and 568 courtesy of ClubJenna; pages ii, iii, vi, vii, viii, x, 4, 88, 186, 306, 378, 416, and 494 by William Hawkes; pages 59, 95, 107, 114, 116, 119, and 275 courtesy of www.vivthomas.com; pages 18, 19, 63, 98, 103, 104, 113, 180, 281, 335, 339, and 365 by Suze Randall; pages 54, 120, 124, 142, 168, 246, 414, and 482 by "Dirty Bob" Krotts; pages 73, 340, and 388 by Brad Willis, courtesy of Wicked Pictures®; pages 76 and 282 by Michael Williams; page 90 by Stephen Hicks; pages 158 and 243 courtesy of Vivid; page 100 courtesy of *High Society*; page 220 courtesy of Digital Sin; page 358 by Tony Jennarazzi. All other photographs courtesy of the author. First insert photographs on page 5 (top and bottom) by Suze Randall; page 5 (middle) courtesy of www.vivthomas.com; page 6 (top) courtesy of *High Society*; page 8 by William Hawkes, courtesy of Vivid; all other photographs courtesy of the author. Second insert photographs by William Hawkes. Third insert photographs on pages 1–7 by William Hawkes; page 8 courtesy of ClubJenna. Fourth insert photographs by William Hawkes.

Wardrobe for Hawkes' photographs by Electric Ladyland.

A hardcover edition of this book was published in 2004 by HarperCollins Publishers.

HOW TO MAKE LOVE LIKE A PORN STAR.

FIRST IT BOOKS PAPERBACK EDITION PUBLISHED 2010.

Designed by Richard Ljoenes / Kris Tobiassen
Illustrations by Bernard Chang

Library of Congress Cataloging-in-Publication Data

Jameson, Jenna.
 How to make love like a porn star: a cautionary tale / Jenna Jameson with Neil Strauss—1st ed.
 p. cm.
 ISBN 0-06-053909-7 (alk. paper)
 1. Jameson, Jenna. 2. Motion picture actors and actresses—United States—Biography.
 3. Erotic films. I. Strauss, Neil. II. Title.
PN2287.J295A3 2004
791.4302'8'092—dc22

2004046776

ISBN 978-0-06-053910-8 (pbk.)

10 11 12 13 14 15 16 17 WCF 10 09 08 07 06 05 04 03 02 01

to my mother,
Judith Hunt

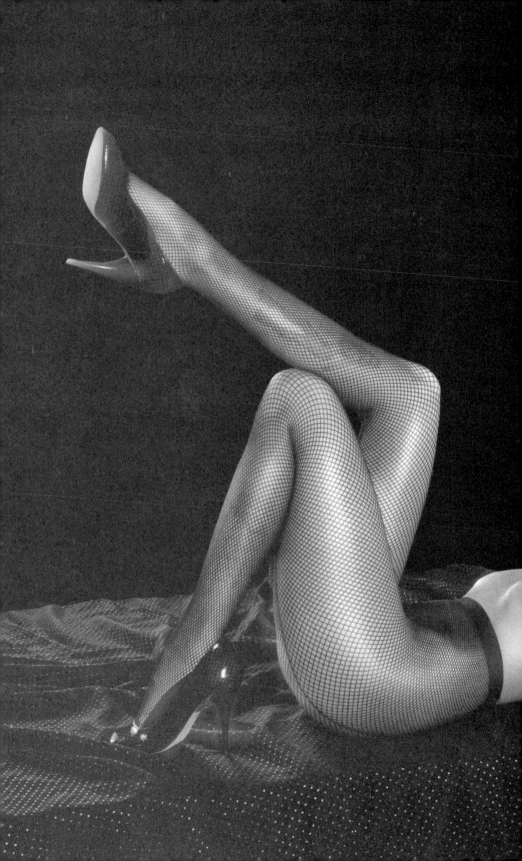

Remember,

Ginger Rogers did everything Fred Astaire did, but she did it backwards and in high heels.

—FAITH WHITTLESEY

FOR TWO DECADES I LOOKED MEN IN THE EYE AND
DENIED EVERYTHING. AND THEN FOR YEARS, IN PRIVATE,
I WRESTLED WITH MYSELF. THE TRUTH WON.

THE FOLLOWING, THEN, IS A TRUE STORY.

★ ★ ★

IT IS MORE NAKED THAN I HAVE EVER ALLOWED MYSELF TO
BE SEEN. NEITHER MY FATHER NOR MY HUSBAND HAVE
BEEN PRIVY TO THESE EXPERIENCES; THEY HAVE BEEN A
BURDEN AND A BLESSING FOR ME TO CARRY ALONE.

Until now.

Only some names and identifying features of individuals have been changed
in order to preserve their anonymity and protect their innocence. In addition,
some characters are composites, and one movie title has been changed.

IT IS A SHOCKING TALE,
BUT IT IS ALSO ONE OF HOPE AND BEAUTY.

.

XXX XXX

QUEEN OF PORN

CONTENTS

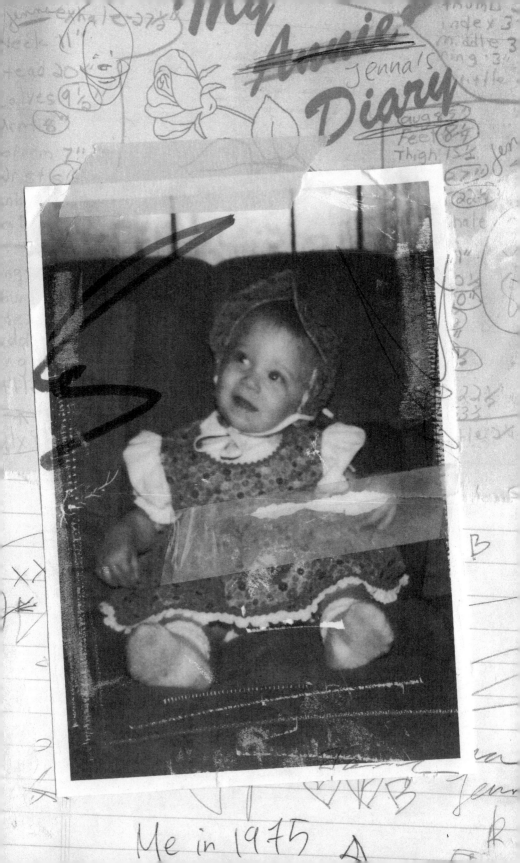

Me in 1975

PROLOGUE

She was young, beautiful, and damned. Her name was Vanessa. And she was dead.

Vanessa was thin, tan, and graceful, with perfect boobs, a broad muscular back, and wire-straight blond hair cut in bangs that grazed her eyebrows. When she walked into the Crazy Horse Too for her first day of work, she instantly attracted customer and stripper alike. Some people are beautiful, others are sexy, but Vanessa was both. Add to this intelligence and a wicked sense of humor, and she was a goddess, at least to my seventeen-year-old mind. No man could resist emptying his wallet for her.

A born hustler with a love of the game, she taught me everything I needed to know about working guys. She had to: she was my only friend.

What was most striking about Vanessa were her eyes: big saucers of blue that sparkled with life. But beneath the surface was a deep reservoir of sadness. I knew that terrible things must have happened—and it made me feel close to her, because we had that in common.

I never asked Vanessa about her personal life, though. I knew better. But as Vanessa and I danced together, month after month, cracks began to appear in her perfect facade. She started to drink more heavily and would burst into fits of sobbing or curse out customers for no reason. On Christmas Eve, I decided to take Vanessa out to forget about her problems.

I took the night off work, picked up her friend Sharon, and we drank

until Vanessa called and said she was ready. We drove to her house in Sharon's Corvette. As we pulled up outside, we could hear Christmas music blaring from inside. Usually Vanessa listened to Guns N' Roses.

> *Deck the halls with boughs of holly*
> *Fa la la la la, la la la la*
> *'Tis the season to be jolly*
> *Fa la la la la, la la la la*

"Great," I thought. "Vanessa's in a good mood tonight."

As we stepped out of the car, Vanessa's terrier, Frou Frou, ran toward us, barking. I knocked on the chipped yellow front door. There was no answer. The music was way too loud. We tried to push open the door, but it was locked. We went around to the back, with Frou Frou bounding after us, her barking loud and urgent. That door was locked too. Fortunately the kitchen window next to it was open a few inches. I reached around, turned the door handle from the inside, and pushed it open. As we climbed the stairs to Vanessa's bedroom, the music became almost deafening. I couldn't understand why she had it on so loud.

> *See the blazing Yule before us*
> *Fa la la la la, la la la la*
> *Strike the harp and join the chorus*
> *Fa la la la la, la la la la*

Light streamed out of Vanessa's room, but there was no one there. Her clothes for the night were laid out on the bed, and I could hear water running in the bathroom. I followed the sound, and there she was: topless, with those perfect breasts, and her face made up like a goddess. She was always gorgeous, and her makeup accentuated her natural beauty without ever seeming too caked on.

> *Follow me in merry measure*
> *Fa la la la la, la la la la*

But everything was wrong. White foam dripped from her lower lip, cov-

ering her chin in lather. Her skin was discolored by heart-shaped bruises, which ran up her arms to her shoulders. I couldn't see her neck, because there was a rope around it. She was hanging from the door of her shower.

While I tell of Yuletide treasure
Fa la la la la, la la la la

As Sharon screamed and ran out of the bathroom, I grabbed Vanessa around the hips and hoisted her up a few inches to take the pressure off her neck. I hoped that somehow we had arrived in time and could save her. As her head lifted off the rope, I heard one last puff of air escape from her lungs.

"Get a knife from the kitchen!" I yelled to Sharon. We needed to cut her down.

"What?" she screamed over the music.

"Get me a fucking knife!"

As I waited for Sharon, I noticed something strange: Vanessa's feet. When I let go, they still touched the ground. There was no way she could have done this to herself. My father was a cop, and he always told me about suicides: girls rarely hang themselves. And when they do, they aren't half-naked. And then there was that full face of makeup, just staring at me, mouth open, tongue out. Why would a girl ever want to be found like this? The Vanessa I know would have taken pills. In fact, she *had* pills.

Though the police deemed the matter a suicide, something wasn't right. This had to be the work of a man. And I knew just who that man was. He was probably the most vile human being I had ever encountered.

They called him Preacher.

Fast away the old year passes
Fa la la la la, la la la la

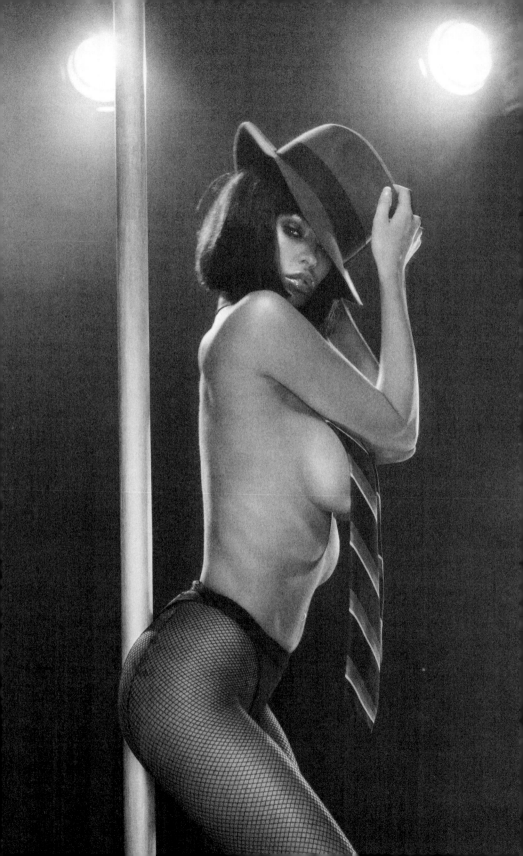

JENNA JAMESON

XXX

Book

I

..............

QUEEN OF PORN

THE WORLD'S FRESH ORNAMENT

*"Thou that art now the world's fresh ornament,
And only herald to the gaudy spring."*

★

Chapter ONE

There comes a moment in every life when a choice must be made between right and wrong, between good and evil, between light and darkness. These decisions are made in an instant, but with repercussions that last a lifetime. My troubles began the day I chose the darkness—the day I chose Jack.

Men tend to be power-driven. They measure their lives by their accomplishments. Women are more relationship-driven. They tend to define episodes of their lives by the men they are with. That is, until they learn better. Jack was my learning lesson.

At age sixteen, I finally grew the breasts and pubic hair I had been praying for since sixth grade. It was as if they just appeared overnight. And suddenly I transformed from a homely wallflower to a full-bodied woman who turned heads. It was every father's nightmare.

"Oh my God, you are your mother," my father said to me one morning, shaking his head in disbelief. "You look just like your mother."

As I became comfortable with my breasts, my closet changed too. The stonewashed jeans became tighter; the *Flashdance* shirts became see-through; the black-and-white-spotted cowboy boots gave way to high-heeled black go-go boots; the T-shirts now stopped at the midriff; and the boxer shorts were no longer something to sleep in. I wore them out of the house, rolled up my thighs as high as possible. I didn't have any female friends who were intelligent, so there was no one to tell me that I looked like a hoochie mama. That is, a hoochie mama with braces.

Opposite: Me at 15.

When I walked down the Vegas strip, I loved watching men gasp and turn their heads, especially when they were walking arm-in-arm with their wives. I loved the attention. But whenever anyone tried to talk to me, I freaked out. I didn't know how to interact. I couldn't even look them in the eye. If somebody complimented me or asked a question, I had no idea how to respond. I would just say that I had to go to the bathroom and escape as soon as I could.

One of my favorite outfits was a tight red cut-off top, Daisy Duke jeans, and black boots with ridiculous chains wrapped around the bottom. I was trying to look like Bobbie Brown from Warrant's "Cherry Pie" video. When I left the house like that to go to a Little Caesar concert, my dad didn't even raise an eyebrow. I was always secretly jealous of my friends, who had to change in the car because their fathers didn't want their baby girls leaving the house dressed like a slut. Since I was four, my father had been letting me run wild in the streets, but the freedom had come with a price: security.

My friend Jennifer was still in her sweatpants and sweatshirt when I jumped into her car. As she changed, I drove to the show, which was the finale to a weekend-long biker rally called the Laughlin River Run. We had to look hot: We were both in love with the lead singer of Little Caesar and wanted him to notice us.

He didn't.

But the show blew my mind, almost as much as the audience did. We were surrounded by chrome, ink, and facial hair. Everyone we met opened their beer coolers to us, offered us rides on the back of their bikes, and unsuccessfully tried to talk us into smoking their foul crank.

Afterward, some bikers invited us to an after-party at The Rabbit Hole, the most respected tattoo parlor in north Las Vegas. There were Hell's Angels, Satan's Disciples, and Outlaws, not to mention the guys from Little Caesar. And for some reason, I wasn't scared, though I probably should have been. I didn't talk much, as usual. I just watched, and noticed how all these psychotic guys called their girlfriends "old ladies"

and treated them like farm animals. I promised myself that I would never allow a man to take me for granted like that. Sadly, that promise didn't last very long.

After the festivities, I came home and told my brother, "I want to get a tattoo."

"Are you sure?" he asked.

"Absolutely," I told him.

So the following Saturday, he drove me back to The Rabbit Hole with his girlfriend, Megan—a mousy, heavyset twenty-year-old brunette who for some reason looked up to me, even though I knew nothing about life or how to move through it. As soon as we walked in, I saw a big sign over the counter: MUST BE 18 OR OVER. I ignored it and pulled my lips taut over my teeth, so that my braces wouldn't show.

A door behind the counter opened and out walked a slim, well-pierced, five-foot-ten-inch man with a ghostly pale complexion, spiky chestnut hair, and a Satanic-looking goatee. Sleeves of tattoos, mostly of Chinese characters and tribal patterns, ran up his arms and spiraled around his neck. He looked like trouble. I recognized him from the party because I'd met him and his girlfriend there.

"What do you want?" he asked me.

I looked up at the wall and saw two little overlapping red hearts. I bent forward over the counter, trying to show my breasts, hoping that if I worked it a little he wouldn't question my age. "I want to get those hearts done," I told him as coquettishly as I could manage with my lips curled over my teeth.

"Where?" he asked.

I needed to put it someplace where my father couldn't see it. I'm not sure whether I was scared that he would react to it or, even worse, that he wouldn't. "On my butt cheek?" I replied nervously.

"No problem," he said. "Follow me."

I was awestruck: I didn't expect it to be that easy. My brother's unoriginal girlfriend decided on the spot that she wanted to get the hearts too and followed us back.

"You are so cute," the tattoo artist said as he pulled a single-tipped needle out of the autoclave. "How old are you?"

"Eighteen," I lied.

His name was Jack and he was twenty-five. He hit on me throughout the whole affair. I was so shy, and nervous about being tattooed, that I hardly responded.

"Do you want to hang out?" he asked when he was through. "There's a cool lounge upstairs, and we can listen to some music."

"No, that's okay," I said. "I have to go home. But it was nice meeting you."

"Well, how about you give me your phone number, so we can hang out sometime?" he persisted.

I declined again. I thought of myself as a sweet, innocent, traditional girl back then. In many ways, I still think of myself that way. And a sweet girl such as myself would never hang out alone with a beautiful tattooed boy she had just met. But she wanted to. In fact, she wanted to so badly that she decided to get another tattoo.

I convinced myself that the hearts weren't enough. They were too ordinary. They conveyed nothing other than the whim of a teeny-bopper who pointed to the first girly image she saw on a tattoo-shop wall. But if the hearts had a crack through them, that would be cool. And if the word "heartbreaker" were inked over the broken hearts, that would be even cooler. And if that rock-and-roll-looking boy from the tattoo shop invited me upstairs again afterward, that would be the coolest. This time I wouldn't be caught by surprise. This time I would say yes.

Two weeks later, I returned to his shop—alone. When I walked through the glass door, his face lit up. I could tell that he had thought about me, but hadn't expected to see me again. This allowed me to rationalize that he didn't hit on every single girl who came in for a tattoo. Just some of them. This time, the experience of getting a tattoo wasn't like the last one, or any one I've had since. Every time he bent over me to apply the transfer or the ink, he'd stroke my leg or brush against my inner

thigh. If he had done it the first time I was there, I would have thought he was a creep. But this time, all I could think was, "Right on!"

After he finished, he invited me upstairs for a drink again. My plan was to say yes right away, but I hesitated. I was scared. After all, he had no idea I was only sixteen. When he finally coaxed me upstairs, we sat on the couch and talked about our lives. His was so different from mine—so dangerous, so free, and so sad.

Suddenly, out of the blue, he said, "You have beautiful boobs."

They were still growing in, and I was really proud of them.

"Why don't you show them to me?" he asked.

And like an idiot, I did. I didn't even hesitate. I put my hands under my yellow top, which stopped just below my breasts anyway, and lifted it up as I arched my back like some college girl in a spring break video.

His jaw dropped open. For the first time all night, he didn't know what to say. That lasted about three seconds.

"Is there *anything* wrong with you?" he stammered.

We'd broken the barrier: there was now officially a romantic spark between us.

On his left forearm was a row of Chinese ideograms. "Look," he said, gesturing to one of the characters and then looking at me with his soft, brown eyes. "It looks like a 'J.' I'm going to start telling everyone this is your name."

It's easy to see now that he used that line on every woman, but I fell for it and thought it was so romantic. He was working me, and it worked.

"What about your girlfriend?" I asked.

"It's taken care of," he said.

There it was: a big neon warning sign flashing right in my eyes. But I was already infatuated and oblivious. Most of the guys I had gone out with before were immature high-school brats. Jack was the exact opposite. He was strong, powerful, successful, and in control. I was searching so desperately for someone to take care of me. I wanted to feel safe and that afternoon I felt safe.

But what really got me is a trait that every girl falls for: he was emotionally closed off. And I thought I could fix him. I thought that I could break through the tough facade and find the real Jack, the sensitive man-child hiding behind all those tattoos. Precisely because he never opened up about anything emotional or sensitive, I thought he was the most emotional and sensitive man in the world. And I thought that I—and only I—could break through the walls he put up and turn him into the bad-boy lover man I'd always dreamed of. How ridiculous.

Now I know that if you're dating somebody to improve him, you're not really in a love relationship. You're just being a nurse. The simple truth, and the hardest thing most women ever learn, is that what you see is what you get.

As for Jack, it was no secret why he loved me. He wanted me in the shop all the time, and I willingly obliged, driving forty-five minutes from Mount Charleston every day to see him. He liked showing me off to his friends, who were all even older than he was, and I enjoyed that he enjoyed it. I was the new girl on the block. And I was slowly becoming completely dependent on him. However, I never spent the night there— I had a midnight curfew.

After a few weeks of dating, Jack told me that he was having a party on a boat he had rented. He said it would be good times. There would be lots of alcohol, cool girls to meet, and he would even pick me up in Mount Charleston and drive me there. I told him I could go, as long as I was home by curfew.

If I could look back on my life and change one thing, it would be saying yes to that boat trip. It was the worst mistake I have ever made—and not just because I missed my curfew. If only it had been that painless.

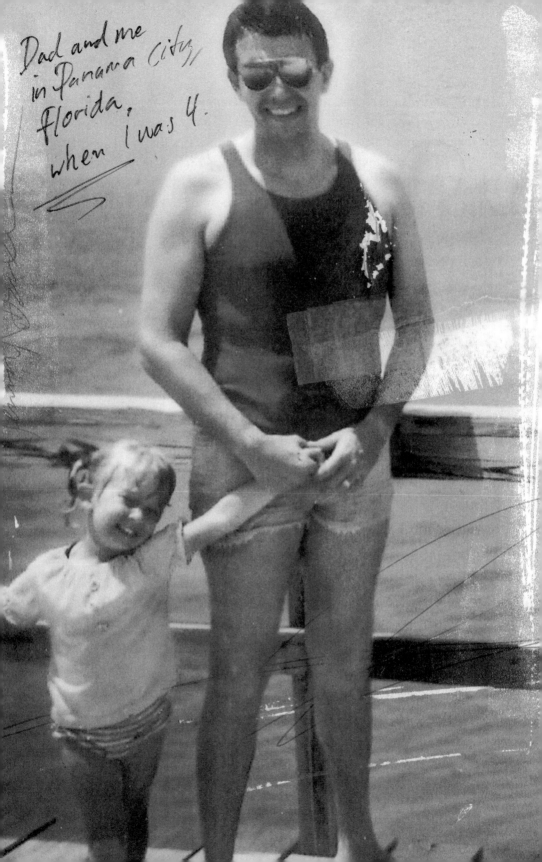

Dad and me
in Panama City,
Florida,
when I was 4.

Chapter TWO

Ⓘt was an old wooden houseboat with a large cabin and the words "The Ark" stenciled on the back. Every kind of biker tattoo artist in Las Vegas and his old lady were on board.

Jack and I climbed onto the boat together. Waiting to greet us at the top of the gangplank was an older man with leathery skin and a high forehead with strands of greasy black hair running down his shoulders. His head looked like the kind of stained-wood souvenir you buy from a Native American gift store and put in your bedroom, but then remove because you're too scared to sleep with it staring at you all night. His arms were strong but had seen better days, and the tattoos were faded and hanging in wrinkled flaps of skin, like a tie-dye shirt left in the sun too long. He smiled as we boarded, revealing a bottom row of teeth blackened from chewing tobacco.

"Hello, Jenna," he said in a thick German accent. He knew my name. "I'm Preacher."

I reached my hand out to shake his and he clasped it in both of his hands, squeezing a little too tightly. Typically, this would be a gesture of sincerity and fondness. But it felt malicious, like he was trying to trap and possess me. I pulled away and walked with Jack to the cabin below deck so that we could dump our stuff onto a bed.

"I was raised by Preacher," Jack explained, "since the day I was born."

Jack's mother had gotten knocked up by a trucker and died during

childbirth, so he had been sent to live with his uncle, Preacher, who was running with a right-wing German biker gang at the time.

The boat pushed off, and Preacher steered it to a small sand beach on the other side of Lake Mead. I was enjoying the chance to relax with Jack and meet some of his friends outside the shop. We all swam, laid out in the sun, and drank beer. I was never entirely comfortable, because everyone was so much older than me, but I was at least more relaxed than I had ever been around Jack and his friends.

As the sun set, the guys fired up a barbecue. I went back to the boat to use the bathroom. I climbed down the stairs to the head of the ship. Where the cabin came to a point in the head, there were two beds on either side and, in front of them, a small door leading to a bathroom and a sink. I never made it to the door.

As I walked toward it, something grabbed my shoulders from behind, pulled me backward, and threw me to the ground. It was Preacher. He jumped on top of me, as fast as a raptor, and straddled my stomach. He lay down over me, pressing his chest against my face so that I couldn't scream. It was all happening too quickly for me to comprehend what was going on.

He shimmied downward along my body and, as soon as his chest slipped below my face, he slapped his hand over my mouth. People always say that if anyone tries to rob or rape you, you're supposed to stay still and comply, so that you don't get hurt. But I was my father's daughter, and I fought him tooth and nail.

He pulled his shorts down and stroked himself a few times, until he was hard. I wanted to kick that thing with all my strength, but his legs were pinning mine down. My arms, however, were free. When I tore at his hair, his mouth twisted into an expression of pure hate and he spit in my face. Then he grabbed both of my wrists with one hand and held them over my head. I screamed at the top of my lungs.

"Shut up and stay still, you fucking whore," he snarled.

He pressed his waist against my hips, keeping them steady while, with his other hand, he pulled my bikini bottom out of the way and thrust inside me. If it hurt, I didn't feel it. I just flailed away twice as hard,

until my arms broke loose and I started hitting him in the face and scratching whatever piece of flesh my hands landed on.

As we struggled, he kept slipping out and cursing. Every time he started to get it in, I would summon the strength to knock him off me until, finally, he just stood up and pulled up his shorts.

I looked up, and the first thing I saw was his eyes. They weren't beady, they weren't glowing, they weren't like anything I had seen before. They were like the eyes of a wolf that has just torn apart a dog and is still in attack mode.

He pointed a finger straight down at me. "Don't you say a fucking word or you're dead," he scowled. "Nobody believes a whore anyway." He spat on the floor, then turned around and walked upstairs.

It was only then that I began to comprehend what had happened. I sat up, wrapped my arms around my knees, put my head between my legs, and started crying. My whole body was shaking. It wasn't just the trauma of the rape but the realization that I was all alone. I was stranded with a bunch of strangers. There was no one to save me, or just tell me I'd get home okay. Except maybe Jack.

I walked into the bathroom to try to compose myself, so that I could brave the walk across the boat and to the beach to find him. But I couldn't stop crying. I just stared at myself in the mirror and cried. As I washed myself—my hands, my legs, everywhere he had touched—I couldn't stop trembling.

I wiped the snot off my upper lip, splashed water on my face, and took in a lungful of air as I prepared to climb the stairs. The first person I saw at the top was Preacher. He was laughing, sitting on a bench outside the cabin joking around with a few of the tattoo artists, as if nothing had happened.

Only Matt, who worked at the tattoo shop with Jack, looked up at me as I made my way to the back of the boat, clutching the metal railing. His eyes widened a little and his smile faded as he looked at me, as if he knew that I had just become Preacher's latest victim.

I jumped off the back of the boat to the beach and found Jack. I needed

to pull myself together. I wanted my father, I wanted to go home, I wanted somebody to help me or fucking do something. I was out in the middle of nowhere and the only way home was on that motherfucker's boat.

As I told Jack what had happened between sobs, he didn't say anything. He didn't hug me; he didn't even look me in the eyes. He just sat there—emotionless, useless. It was too much for me to handle. My body felt cold, like I had a fever, and all I wanted to do was go home, curl up in bed, and cry to my father. I was only sixteen. I still had braces and Barbie dolls.

"I want to go home," I cried.

"Okay," Jack said. "We're going to take you home."

He walked with me to the boat, and talked to his uncle.

"She says she needs to go home," Jack told him.

Preacher didn't even blink. "We can't," he responded. "The boat is broken."

I ran off the boat and back onto the beach. I so desperately wanted to escape, but I knew that I couldn't get very far. It was the middle of summer, about 105 degrees on the lake, and around me were just desert and mountains. So I had my choice: either run away and hope that someone would find me, or wait.

I waited. A girl with long brown hair, a dancer I had seen hanging around the tattoo shop, walked past me. She stopped, turned around, looked at me—my puffy eyes, running nose, shaking body—and said, "He raped you, didn't he?"

I didn't say anything.

"You aren't the first one and you're not going to be the last," she said.

I still didn't say anything. I wanted to ask whether he had done the same thing to her, but I couldn't get the words out. She stood there for a moment, looking at me with a mixture of pity and disgust, then turned and walked away.

When the sun sank, Jack came out and told me that the boat would be fixed in the morning, so I should come inside and sleep. I refused to shut my eyes anywhere near that monster. So I slept in a sleeping bag on

the beach. Jack crawled in and held me as I shook and sobbed for hours. All night, he didn't utter a word. All I could think was that Preacher had done this before, that Jack knew he had, that maybe Jack had even offered me up to him. I thought about it all night, until I just shut down. I realized that I couldn't trust Jack or anyone.

Conveniently, when we awoke the boat was running again. To this day, I have no idea if the boat was really broken or if Preacher just wanted to give me a night to calm down before sending me back into the real world. If I had gone home right away, I definitely would have told my dad and the police, because I was so shaken.

When we returned to the harbor, I asked Jack to take me home. We rode in silence. Every now and then he reached over and petted me. I couldn't wait to get out of that car.

As Jack drove up the hill to my house, I had him drop me off half a mile away, so that my dad wouldn't know I was with him. It was 8 A.M., eight hours past my curfew. I walked the rest of the way uphill, trying to figure out what to say to my father. I was a wreck compared to the girl who had left the house the day before.

I reached the front door, put my key in the lock, and turned the knob, hoping my father was away on patrol. But there he was, sitting on the living-room couch, just waiting in silence.

I so badly wanted to please my dad all the time. I never liked to get into trouble. My brother was so much worse than I was, but I was always getting punished instead. I was the good girl, and I was constantly trying to prove it to my dad.

"Where have you been?" he finally asked, very calm and cool. Having been a lieutenant in Vietnam and a police officer in Las Vegas, my father's nerves had long since stopped responding to adrenaline. The more upsetting or dangerous a situation was, the cooler he became. He had never, in sixteen years, even yelled at me.

I scanned my brain for excuses. "I lost track of time," I said. "The boat broke down, and then we got lost on the way home."

"That's it," he said. His voice was actually starting to rise, the skin

around the creases in his face reddened. "I am not going to put up with this from you anymore. This is bullshit."

I was taken aback by his reaction. I felt all the anger—and more than that, disappointment—that I had kept hidden from him for so many years well up inside me and explode. Since my mother had died of cancer when I was three, my older brother Tony and I had been left to raise ourselves while my father tried to deal with his grief. He never really got over it. Instead, he buried himself in his work and different women, leaving Tony and me to raise ourselves. Despite everything, I loved him so much that I'd stay awake until after midnight sometimes waiting for him to come home. I never felt safe until I heard the door slam and the rustle of his uniform as he removed it.

As a teenager, I learned to enjoy his absence, because it spared me the growing pains that my friends were experiencing as they rebelled against their parents' strictness. There were times when I longed for someone to talk about my problems with—or just to hug me when I was upset and help me feel grounded in this confusing world—but I knew that person wasn't my dad. The problem wasn't that he didn't care about me; it was that he didn't know how to show it. If I told him about boys who were pressuring me to have sex, he would sooner snap a guy's neck than tell me about the birds and the bees. When I brought home a poem I had written about how lonely I was and how much I loved him—a thinly disguised plea for help—his eyes filled with tears, but he never talked with me about it or even attempted to deal with the problem. Eventually I stopped trying to reach out to him.

So he had no right to get angry now just because I was late coming home, especially after what I had been through. I needed him, more than ever before, to be there for me, to understand. And what did he choose to say instead? "I'm done." He had never even started. I realized that I was truly on my own, that no one understood, that there was nowhere to turn.

"Fuck you, Dad!" I yelled. I'd never talked to him like this in my life. "What do you mean 'anymore'? You've put up with it your whole life, you asshole. I'm a grown woman and I can do what I fucking want.

Mom wouldn't have treated me like this!" I couldn't believe the things that were coming out of my mouth.

My dad was stunned. He slumped back on the couch. "I am not going to deal with this," he said. "I should put you in a foster home. I'm not going to have you in my house."

When he said that, all the emotion flooded out of my body and I went cold. I didn't say another word. I couldn't say another word. I walked upstairs and collapsed onto my bed. I slept all day and all night. I was physically, emotionally, mentally exhausted.

When I woke up the next morning, I went to the kitchen and brought a handful of Glad garbage bags up to my room. I threw all my shoes, clothes, makeup, dolls, and schoolbooks into them. I was used to packing by now. Our family had moved at least a dozen times. But this would be the first time I was moving alone.

Never had I been more sure about anything in my life: I was running away from home, never to return. And when I made a promise to myself, I kept it.

So where did I run away to? There was only one place I could go to: Jack's house.

Chapter Three
THE 10 COMMANDMENTS

PART

1

..........

I don't mind heavy guys, skinny guys, short guys, tall guys, little boys, old men, trust-fund babies, chronically unemployed slackers, convenience-store clerks, rat-catchers, drug addicts, or rock stars (who fit into most of the above categories anyway). I like all kinds. But that doesn't mean that I'll let all kinds into my bed.

Ultimately, the deciding factor is the lack of a "dealbreaker." I can have a perfect dinner with the hottest guy, but if he opens his mouth and smells like dead fish, the date's over. That is a dealbreaker. For most girls, dirt underneath a guy's fingernails is a dealbreaker because nobody wants that filth left up their insides after a night of passion. There are many dealbreakers, and in one crucial moment any one of them can end a relationship before it's even begun.

Below are ten dealbreakers, all of which I have experienced. Consider this a not-to-do list:

I. THOU SHALT NOT drive a Porsche and then take me back to your studio apartment in Valencia.

II. THOU SHALT NOT speak any of the following lines:

 a. "I'll just put the head in."
 b. "So does this mean I'm not getting any?"
 c. "We don't have to use a condom; I've never had a problem before."
 d. "What do you mean you don't want to cuddle?"
 e. "My friends will never believe this."
 f. "I can put all those guys you've worked with to shame."
 g. "I ran out of money. Where's your purse?"
 h. "These sex toys are basically new."
 i. "We have to be quiet. My mother's sleeping."
 j. "Your tits feel almost as good as my sister's."
 k. "I swear the camera is not on."
 l. "Well, my ex-girlfriend used to do it."
 m. "If it's the police, tell them I'm not home."
 n. "It's not contagious anymore."
 o. Any question from Book VI, Chapter 4.

III. THOU SHALT NOT keep your dead pets preserved in Saran Wrap in the freezer.

IV. **THOU SHALT NOT** ask me to quit smoking, drinking, taking pills, or watching reality TV shows.

V. **THOU SHALT NOT** have any of the following items in your house:
 a. A face tanner
 b. A douche bag in the shower.
 c. Tubes of Preparation H in the medicine cabinet.
 d. Meals prepared by your mother in the refrigerator, each in a Tupperware container labeled for a different day of the week.
 e. Posters in the bedroom of Traci Lords, Ron Jeremy, Bill O'Reilly, or any other porn star who has written a book that can possibly compete with mine.
 f. Dirty laundry that has been folded and stacked in neat piles.
 g. Makeup from an ex-girlfriend of more than six months, especially if her last name was James.
 h. More fur coats than I have.

VI. **THOU SHALT NOT** be able to take a bigger dildo than I can.

VII. **THOU SHALT NOT** have a tan line in the shape of a thong.

VIII. **THOU SHALT NOT** pass gas in front of me, pick your nose and flick the boogers, cry on the first date, or, most egregiously, put your hand down your pants, check your smell, and then lean over to kiss me with your face reeking of ass.

IX. **THOU SHALT NOT** pretend like it slipped. (I refer here to back-door guys who try to put it in your butt every other stroke.)

X. **THOU MAY** leave the toilet seat up. But thou shalt not leave the toilet seat down and pee on it.

Commandments that my husband, Jay, has broken:
II, IV, V, VIII, and X.

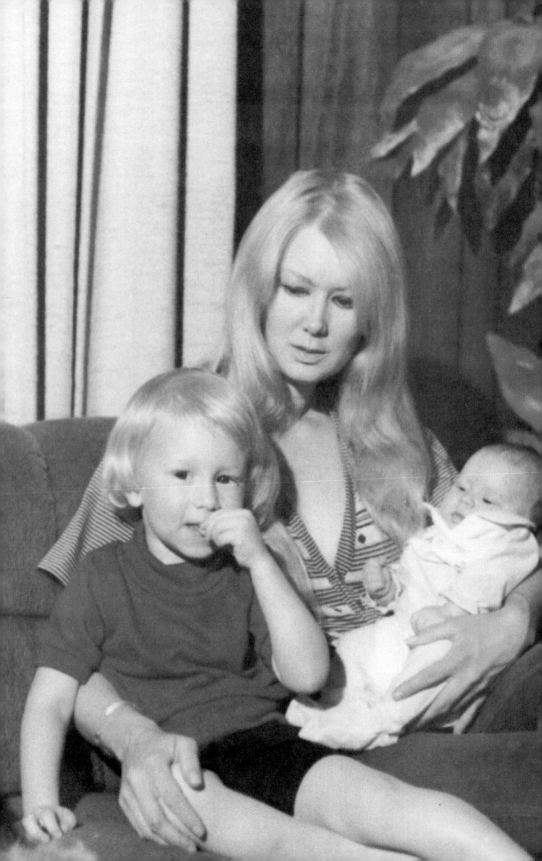

Chapter FOUR

My father never told me much about my mother. I think it was his way of trying to protect me from being traumatized by her loss. He figured the less I knew about her, the less I had to miss. But his silence had the opposite effect: the less I knew about her, the more I thought about her.

My only memories of my mother were of her being sick, and of being kept away from her room because she had no hair. Apart from photos, I can't remember what she looked like; but I remember what she sounded like. As I lay in my bed at night, I could hear her screaming in pain from her room.

The night she died exists only in snippets in my head. The house was dark, and my father was outside. I remember seeing the ambulance lights, and sitting in the darkness in my brother's room. He was very quiet. He knew what was going on. I didn't, but I was crying for some reason. I knew something was wrong. After that night, I refused to sleep alone or in the dark. Every night, I crept into my brother's room, flipped on the lights, and crawled into bed with him. After that, I just remember my father being sad—extremely sad. The parade of women he dated never seemed to fill the void in him, or in me.

One of the few things my father told me about my mother when I grew older was that she had worked as a Vegas showgirl. He was in the audience at one of her shows, and had fallen in love with her as soon as he set eyes on her. In the few pictures I have of my mom, she looks so beautiful, fragile, and sophisticated—like a swinging London model.

Opposite: My mom, me, and Tony.

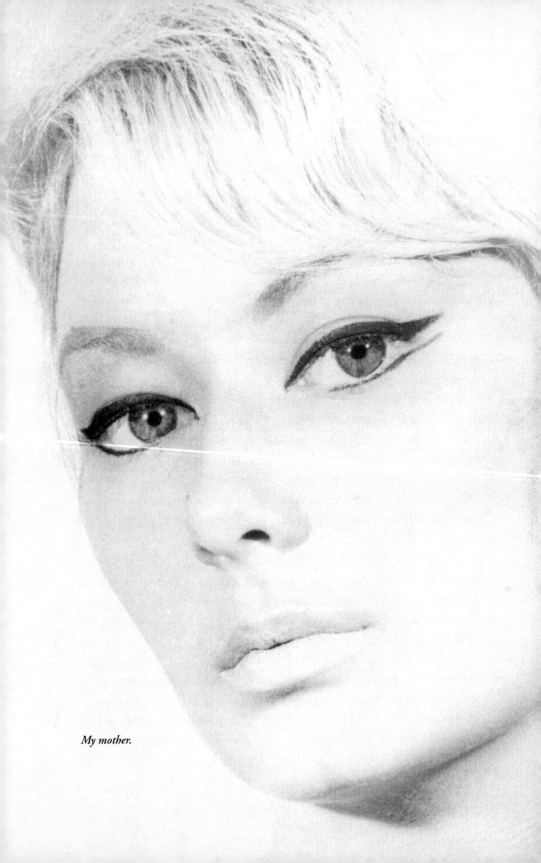

My mother.

When I moved in with Jack, it was summer and I needed a job, especially since I no longer had anyone to support me. So I decided that I would follow in my mother's footsteps and become a showgirl. After all, it was in my blood.

There was only one genetic problem: I was five feet six inches, three inches shorter than the required height for most of the hotel and theater shows. I looked like a colt. I was a tall girl—with long, thin legs and arms and a slender waist—trapped in the body of a small girl.

But once I set my mind on a goal back then, the only thing that could stop me was death or Jack. The first place I went to was the most prestigious show in Vegas, the Folies Bergères at the Tropicana, where my mother had been one of the principal dancers in the fifties. I had this fantasy that someone would remember my mother and recognize me as her daughter. I even decided to call myself Jenna Hunt, using my mother's maiden name.

But the first thing they did at the Tropicana audition was measure me. And since I was nowhere near five feet nine inches, they threw me out. It didn't even cross my mind that there was probably no one left from when my mother danced nearly three decades ago.

I went to the Lido Show at the Stardust, Jubilee! at Bally's, and the Casino de Paris at the Dunes. And every one rejected me—I was too young, too short, too inexperienced. Yet I kept going back, trying place after place.

The easiest audition was an open call at Vegas World, in the Stratosphere Hotel. At the other revues, if I passed the first cut (which was rarely), they asked me to strut, walk, bow, kick, and dance tap, ballet, and jazz. But at Vegas World, all they wanted was three eight-counts of ballet, just to see my posture and turns.

Though I was painfully shy and antisocial in real life, when I got onstage, I transformed. I had learned how to perform when I put myself through pageants in junior high. The personality and attitude I repressed with everyone exploded out of me onstage. Something inside of me just turned on. I made eye contact with the interviewers, moved with a sen-

sual grace I never knew I possessed, and sashayed around the stage like a natural. I had been taking dance classes since I was four, everything from ballet to clogging, and I knew just what to do: I even iced my nipples to make them stand out. The hardest part was to look like I was enjoying myself without smiling and unveiling my braces.

The next day, I stopped by to find out how I did, and they said I was hired. I had wanted to be a principal dancer like my mother, but they put me in the chorus, which was fine. I was still a Vegas showgirl! As for my height problems, they said that they were going to put lifts in my shoes, give me a big headdress, and place me upstage so that I appeared taller. It was the best news I'd had in years. My dreams were coming true, and I was making my mom proud. Of course, that only lasted for two months.

My costume was yellow with big plumes and a headdress that weighed fifteen pounds. I wore a rhinestone bra—which would come off halfway through the show to reveal sparkled tassels over my nipples—a G-string, stockings, and jazz shoes with lifts. I remember looking in the mirror with all my stage makeup on—including four sets of fake eyelashes—and thinking, "Wow, I truly am my mother's daughter!"

I was not only the youngest but also the quietest girl in the show. The rest of the girls called me "mouse" and, when they saw my braces, told me I should be playing house with my schoolmates instead.

I could tolerate having no friends there and being constantly ordered around by the women, but the schedule was brutal: eight hours of rehearsal a day and then two shows a night. It was a lot of work, and the money was terrible. As for the glamour I had always imagined when my father told me about palling around with Frank Sinatra Jr. and Wayne Newton in the old days, there was none.

Besides, Jack knew a way I could make much more money.

Chapter FIVE

Life at Jack's was fun at first. There were parties every night, and during the day I hung out at the tattoo shop whenever Preacher, whose biker club met there, wasn't around. I don't know if I forgave Jack for what happened, but I put it out of my mind. It was my only choice.

Most of the girls who hung out with Jack's tattoo and biker friends worked at a strip club called Crazy Horse Too. When I left my job as a showgirl after two months, Jack suggested I join them. It made sense. After all, it was just like being a showgirl, except without the pasties over the nipples and with a lot more money. Besides, stripping is what the girlfriends of tattoo artists did. And, as pathetic as it was, that was how I defined myself at the time. I was no longer a daughter, a sister, a student, or a girl with any identity of her own whatsoever. I was just Jack's girlfriend. That's how I usually introduced myself. Pathetic.

The Crazy Horse Too was the best strip club in Vegas at the time, a flashing neon oasis in an industrial wasteland underneath the freeway. When I first walked inside, even though it was 4 P.M., the club was so dark that I couldn't see a thing.

I just stood in the doorway, waiting for my pupils to dilate, until I could make out two long stages on either side of a bar and a pool table. That's all there was to the place, besides round booths along the walls with tables that had stripper poles thrust through their centers. It was my first time in a strip club.

A little old lady stood at a nearby display case, selling memorabilia. She seemed as if she'd been there since the beginning of time (and, in fact, she's still there today). Around the club were about twenty girls, most of them gorgeous, with bodies ten times as firm and breasts that much larger than mine.

I suddenly felt a pair of eyes on me. A small, tan, well-dressed Italian man with salt-and-pepper hair stood nearby. He was clearly in charge. Like an Italian mobster, he carried his power wordlessly. It simply emanated from his being.

"Are you the manager?" I asked.

"What do you want?" His tone was impatient and patronizing.

"Do you have any jobs available?" The mouse was out now, squeaking at yet another authority figure. I hoped he'd at least give me a chance to show him what the mouse could transform into.

He took one look at my face, said, "Come back when you've got those off," and walked away. Fuck, I'd forgotten to cover my braces with my upper lip.

I was tired of hearing the same shit from everyone: Come back when you've lost the braces, come back when you're older, come back when you're taller, come back when you're Korean. When was I finally going to get a chance to participate in life?

I returned to Jack's house. He wasn't there, of course. I turned up the shower as hot as I could stand and peeled off my clothes. I stepped inside and just marinated. It's funny, but as soon as you stop thinking—or trying to think—all of your best ideas come to you. When you don't focus on a problem, your subconscious will solve it for you. And that's what happened.

About ten minutes into my soaking, I had an epiphany. I leaped out of the shower, ran dripping to the hallway closet, and took a needle-nose pliers and wire cutters out of Jack's toolbox. I rushed back to the bathroom, rubbed a clear circle into the fog on the mirror, and began snipping the wire holding my braces together. Then I popped each metal link away from my teeth, one by one. I screamed, I swore, I doubled over in pain. But I got most of those fuckers off. The only problem was that I

couldn't pry four of the metal braces off my back teeth—they were larger than the other ones and had hooks for the rubber bands—but it didn't matter since no one could see them anyway. Then I chipped and cleaned the dried cement out of my teeth, and smiled. It was an adult smile.

The next afternoon, I went back to the Crazy Horse in a tube top that was far too small for my breasts and a pair of teeny white terry-cloth shorts. I walked right up to the Italian guy who had sent me away and smiled.

"They're gone," I said. "The braces are gone."

"You've got to be kidding," he said, in genuine shock, a rare thing for a guy who looked like he had seen everything. "You got your braces off?"

"I pulled them off myself," I told him.

He threw his head back and let out a long, guttural laugh. I just watched him, hoping this meant that he would let me audition for him. "How old are you?"

"I'm seventeen." My voice failed me here, and it came out like a squeak.

"Sorry you had to go through all that, girl," he said. "You aren't old enough to work here."

I wasn't ready to hear no. In fact, I never liked that word. "Listen," I told him, giving him my best I'm-as-serious-as-your-life stare. "I will make you a lot of money. I'm very good, and I know how to do this."

Actually, I had no idea how. But I knew that if I set my mind to it, I could figure it out. I've never believed in using words like "can't" or "don't know." Instead, I'll just pretend like I can. Otherwise, I'd never get the chance to try anything.

He lowered his head and scanned my body.

"Okay, then. Go in the back and get dressed."

"What do you mean?" I stammered.

"Go in the back and get dressed," he said, either impatient or pretending to be. "You are going onstage."

Suddenly, it hit me. I was going to have to follow through. There would be no audition, no rehearsal, no preparation. I was going to strip for a hundred guys.

"I'm Vinnie," he said. "What name do you use?"

I told him the name I had always used in my imagination for my fantasy self: "Jennasis."

"Like 'In the beginning'?" he asked.

"Exactly."

He called over a handsome Italian man and told him, "Gino, take her in the back and give her a locker. She's going on next."

As we walked back, Gino asked me what songs I wanted to dance to. I chose "Fire" by Jimi Hendrix and "Black" by Pearl Jam.

The locker room was immense, brightly lit, and full of women in various stages of undress. There were redheads, blondes, brunettes, even shaved heads and mohawks; there were leopard-print bikinis, satin nighties, denim cutoffs, and strapless evening dresses; there were old women, young women, and just plain tired-looking women. And every one of them turned to stare at me when I walked in. I represented money leaving their pockets.

They looked so jaded and hardened. I didn't see a friendly face among them. There was no way I could survive here. These girls would eat me alive. They had cases of makeup, racks of costumes, and tons of experience. I hadn't even brought anything to wear onstage. I scanned the faces—most of which were not a pretty sight under bright fluorescent lights—and found one that seemed friendly. She was a blond girl just a little bigger than me. I asked her if I could borrow something to wear onstage, and she gave me a light-blue bikini and a pair of black high-heeled shoes. I felt so uncomfortable that I snuck into a bathroom stall to change.

As I did so, I heard an announcement on the loudspeakers: "Next on stage," came the voice of the DJ, "is a girl I know you're all going to love. She's new, she's young, she's blond—she's Jennasis!"

I slammed my feet into my shoes and ran across the locker room. About halfway to the door, in front of all the other girls, I caught my heel on a fold in the carpet and hit the ground, bruising my bony knees. I could feel all the other girls laughing at me, even if they weren't.

The opening chords of "Fire" rang through the locker room. I was so woefully unprepared to do this in front of a bunch of leering guys. I had always imagined how sexy I would be stripping, and what a turn-on it would be teasing all the guys, but all I was conscious of at that moment was the sweat forming in my underarms and actually dripping onto the stage. My body was out of control: my knees were knocking compulsively like chattering teeth.

I realized, a tad too late, that I didn't know any stripper moves. Fortunately, I found a friend onstage: the metal pole. For some reason, I couldn't let go of it. I just held on to the pole and stared at the stage, too scared to make eye contact with anyone in the audience. The shoes were

My first bikini contest, at age 17.

too big for me, and it felt like I was going to fall on my face again at any moment. I was sure that everyone was making fun of me.

Fortunately I had my dance lessons, preteen pageants, and chorus lines to fall back on, and my body sputtered to life and started moving by itself while my mind twisted into nervous knots. When the song finally ended, I heard applause and whistles. "Fire" was a good choice: it pumped up the crowd. Then, of course, "Black" started, and it was perhaps the most depressing song the men had heard all night.

I was so naïve that I didn't even stop to gather the dollar bills that were left for me when the song ended. As I left the stage, I realized that people were actually applauding. And when I sat in a booth in the back corner, hoping not to be seen, I could see the interest in the eyes of the men around me. They wanted me.

When it was my turn to dance again an hour later, I was ready. Nobody cared what I danced like, I realized, because I was that little blond teenage girl that they fantasized about while they were in bed next to their wives.

I walked onstage as if I owned it, like I was at a dance competition, and ran through one of my old pageant routines. I worked the men like I had worked the old pageant judges, looking directly into their eyes as if to say that this dance was for them. I was in control—of myself, and the men around me. And I loved it: I loved the attention and the confidence it gave me. Even though I had no idea how to hustle guys for lap dances, I was the new girl, and they all wanted me.

By my last dance of the night, men were crowding around the stage and throwing money at me. It was then that I knew not only could I make it as a stripper, but I could get each and every one of those other girls back for laughing at me.

The one thousand dollars I made that night didn't hurt either.

Chapter SIX

Initially, I was too shy to talk to men or even the other strippers at the club. My mouse nickname stuck, because that's how I moved around the club when I was offstage. Men had to come to me if they wanted to talk or get a dance.

On my second week at work, I was walking toward an empty table in the corner so I could be by myself for a moment when, suddenly, someone slammed into my shoulder. It was so hard and malicious that I stumbled into a nearby chair, knocking it to the ground. I turned around and saw an older Latin American woman with a well-gelled explosion of hair dyed the color of rust. She had a huge tattoo of a roaring tiger standing on its hind legs, its claws pointing menacingly out of her backflesh. I knew just who this was: Opal.

Opal was Preacher's live-in girlfriend. And, although I should have felt sorry for anyone married to that sociopath, I soon learned that Opal was cut from the same cloth as Preacher. I never talked to her and knew little about her, but aging is a great truth-teller and the person she was on the inside was already beginning to seep through to the outside. A diminished trailer park beauty queen, her flesh was soft, but less than a millimeter beneath it was cold, uninviting steel. She used to live with Preacher and his wife, Sadie, as their girl toy. But she eventually manipulated her way into Preacher's heart and ran Sadie away.

Jack had never told me she worked at the club, and I was pissed. Knowing that Opal would be there every night made going to work each

day that much more of a challenge. Even though she knew exactly who I was, she refused to make eye contact or talk with me, except perhaps for flashing a smile when she walked off with her thirty-fifth customer of the night. Her silence was worse than overt hostility, because it made me feel subhuman, especially since she controlled all the other strippers like an underworld queen.

A strip club has its own caste system in the locker room: the amount of private space a girl has, the closer she is to the bathroom, the more lights she has in her changing area all denote her rank. The top girls don't even have to go onstage because they are so busy giving private dances. Opal was one of the highest-ranking girls there; I, of course, started at the bottom.

Most girls there just wanted to make a few hundred bucks a night and go home. They didn't really care about their work. And, outside of the club, it was just a great big joke to Jack that he had turned me into a stripper. But because I am such a competitive person, in my mind, stripping was a serious challenge. I cared about the job. It was my first taste of independence in the real world, and I wanted to be the best. I wanted the locker closest to the bathroom. Every night, I would go home and think about what I had done wrong, what I could have done better, what new idea I could try to drive a guy so crazy that he would run to the cash machine to get more money to pay me.

The Crazy Horse Too was the best high-school class I ever took. The subject was social dynamics. It was amazing how the incentive of cash made it so easy to talk to people; before, I'd had no motivation to learn to be polite or carry on a conversation with a guy. They all wanted the same thing anyway. Within weeks at the club, I began to transform from a geeky teenage girl into a money-crazed psycho. And I loved it.

It wasn't that I discovered some dormant ability to be a natural conversationalist. Instead, I learned to be an actress, because I was still not outgoing naturally. My job was simply to put up with the poor conversational skills of the customers, to seem open and caring while they talked about themselves. When my turn came to talk, I learned to lie.

Everything that came out of my mouth was complete bullshit. I could tell by looking at each person what he wanted to hear. I'd tell him I was studying to be a real-estate agent, a lifeguard, a construction worker. Anything to steer them away from what was really going on in my life.

Since most of the men were into me because I looked so young and innocent, I decided to amplify that. As my grandmother always said, "What you can't fix, you feature." So one night I put my hair up in pony-tails, wore little pink shoes, and carried a plastic Barbie purse, which fur-ther contrasted me from the hardened girls. And that was when I landed my first regular, the president of a large Vegas hotel. Rather than blather-ing about his problems, he wanted to listen to me talk. He gave me $2,000 to chat with him for two or three songs. And not only was the money great, it also helped me tip out more to Vinnie and increase my rank at the club.

Vinnie didn't yell at girls or abuse them; in fact, he rarely said a word. He just looked at you, and you *knew* to behave. He ran the place through quiet, all-pervading fear. At the end of the night, when I paid him his commission, he never smiled or spoke—no matter how much I tried to provoke him. The only words I ever heard him say in my first six months at the club were, "How much did you do tonight?"

But, as much as I feared him, I knew he was my friend, too. I could see it in his eyes. He liked my work ethic. To stand out from the other girls, I begged him to let me do a lotion show, but he said it would just mess up the stage. So, because I was such a conniving little sneak, I found other ways to differentiate myself. It was a topless club, so we had to wear bikini bottoms. But while shopping one day, I found a G-string that had just a thin strand of thread going up the back so that whenever I bent over, the boys had a full view. One night when I was in the middle of my dance, shimmying up a pole on one of the back booths, Vinnie grabbed my wrist and, eyes on fire, said, "Go change that G-string right now!" Unbeknownst to me, by law in Las Vegas the butt floss in the back of a G-string had to be at least an inch thick.

However, the next night I found a legal way around it. I wore the

smallest, whitest G-string I could and wet it before I went onstage, so that the guys still got a little hint of what was going on downstairs. Night after night, it never failed to pack pervert's row next to the stage, with guys craning their necks to get a good look. Other nights I would dance in roller skates, which was pretty dorky, but the guys showed their appreciation in dollar bills.

Just as I was beginning to grow up after a month and a half at the club, September rolled around and school began. I decided to stay at the club. I quit the cheerleading team and abandoned my few friends, determined to make it through senior year without anyone finding out what I was doing. I lived in constant fear of seeing one of my teachers walk through the door of the club. Instead, one night a group of varsity basketball players came in and, after eyeing me for a while, asked, "Aren't you Jenna Massoli?"

I was caught. "No," I told them without even hesitating. "I don't know who you're talking about."

That night, I went home early. I was so scared I'd been busted that I couldn't work. I wanted to keep my two lives separate: to be a mouse during the day and a shark at night. Fortunately, I was so good at lying to men by then that the basketball players actually believed me.

Life changed for me at the Crazy Horse the day Jack introduced me to my first friend there. One afternoon at the tattoo shop he said that his cousin had moved back to Las Vegas and would be dancing at the club. He wanted me to meet her.

She came to his house that night, and I was mesmerized. It was like seeing myself in one of those department-store mirrors that make customers look ten times better than they actually are. She was tall, blond, thin, and big-breasted. She was three years older than me. And she was all about the money. We clicked instantly.

Unlike when I first walked into the Crazy Horse, when she entered for the first time, she commanded attention and respect. She seemed so confident and sure of herself. Her life had been so difficult that she radiated strength and beauty by way of compensation. In my mind, she lit-

erally glowed. Her name was Vanessa, and she was Preacher's daughter.

On her first day, Vanessa sat me down and taught me how to move on the pole—she could grip it between her thighs and hang upside down by one leg—and what to say to the customers. "When a guy comes into a club, most girls come up to him and say, 'Do you want a dance?'" she told me. "That's the last thing you should do. Be personable. Make him like you. Talk to him. Ask about his job. Act like you are interested."

That was lesson one—the basics. Lesson two was to prearrange a deal with the waitress to put water in my shot and extra alcohol in the guy's, and then order a round of drinks as soon as I sat with him.

"Get him as drunk as possible," she said, "and rack those songs up."

If a guy said he wasn't sure if he wanted a dance, she taught me to stay and talk with him for four songs. Then, when he finally asked for a dance, I'd charge him for five songs: the four I sat there with him plus the one I actually danced. By then, he'd usually have bought me a few watered-down drinks, each of which I got a kickback for from the waitress.

Vanessa was a strip-club marketing genius, a human deposits-only cash machine. I watched every move she made when dancing and listened to every word she said to the customers. I learned what a finely detailed art stripping actually is. Everything had to be just right: the way I styled my hair, the outfit I wore, the shoes I selected, how tan I was. (She pointed out that a lot of the girls made the big mistake of being too tan.) Strippers are creating a fantasy, she said, so everything in that fantasy has to be perfect. Even though guys don't consciously notice things like shoes or nails, a chipping manicure or a beat-up pair of shoes could intrude on the illusion.

Finally, I had a confidante, mentor, and partner in crime at the club. After two months of friendship, I had soaked it all up and was as good as she was. Together, we became the perfect team, the top moneymakers in the club. When we double-teamed guys, dancing for them at the same time, every balding head in the room turned and no other girls could get a guy to buy a dance from them.

For us, these schemes weren't only about the money; they were also

for the adrenaline rush. It was a high to get the upper hand over a customer. They were dumb, they were drunk, and they deserved it. At least that's what I thought at the time. Strippers can be vicious. The mentality is that if these guys are going to victimize us, we're going to totally victimize them right back. It seemed like a fair exchange. And it was character building: I was finally learning to take control of people instead of being so passive in social situations.

⌒⌒

That year, Vanessa and I became the number-one dancers at the Crazy Horse Too. We were Vinnie's favorite girls, and we knew exactly why: We were working twelve-hour shifts. While the other girls took breaks and socialized, we hustled nonstop. We figured that the more friends we made there, the less money we'd make.

From left, Christy Lake, Nikki Tyler, Jenteal, Christy Canyon, Jill Kelly, Victoria Paris, me, and Janine Lindemulder.

While most girls were bringing home three hundred to five hundred dollars a night, a good take compared to clubs in most other cities, I made two thousand to four thousand dollars per night. Somehow, I managed to spend a large share of it on dresses, purses, and shoes.

They say that money can't buy happiness, but that is an oversimplification. It actually depends on how you earn your money. If you're juggling high-stress investments or managing scores of employees or deluged with phone calls or hiding something from the authorities, life is no fun. But if you can walk into a room, lead on a bunch of guys, and then leave with thousands of dollars in cash in your pocket and no obligation to anyone—not even an obligation to show up to work the next day—life is good. If I wanted to I would splurge on six bottles of Cristal champagne for my friends without a second thought. I wasn't concerned about

the future. My main objective was making money, and I met that objective night after night.

My only real competition was a blond girl with a huge boob job who worked just once a week. When we were both in the club at the same time, we were working so hard it was as if we both had lightning behind us. We never exchanged a single word, but there was an unspoken sense of rivalry—even hatred. If she made more money than me one night, it pissed me off so much that I would go home and scheme until I figured out a way to beat her. My only sticking point was my boobs: the girls with the boob jobs were the only ones who could make more than me, especially because they weren't as common then as they are today. Every time a guy told me I was too skinny, I interpreted it to mean that my boobs were too small.

For every inadequacy I felt that I had, however, I compensated with something else. When Vanessa wasn't around, I found that the most effective way of making money was by teasing men senseless. If customers bought just one dance, I did nothing for them. I didn't even get close to them. I just tempted them until they wanted me to touch them or rub my breasts against their chest so badly that they were willing to pay for another dance. And with each dance, I moved a little closer and touched them a little more until, in some cases, I had them paying for twelve dances and so wound up that they'd have to go home and fuck their wives silly or beat themselves off to hell and back.

For a stripper at the Crazy Horse, this was unheard of. They'd usually just grind the guys raw, but I never did that. And the guys liked me even more because I was unattainable. I'd just stay as far away as I could with my wet little G-string, nearing them only briefly to breathe in their ear or make deep eye contact, until they cried out, "Oh, for the love of God, this girl is killing me!" Some of the guys looked like they were about to explode. A few even did, and came in their pants without even being touched. I quickly realized that I didn't have to charge five dollars a dance, like the other girls did. I could get away with charging whatever I wanted: twenty dollars, fifty dollars, one hundred dollars a song.

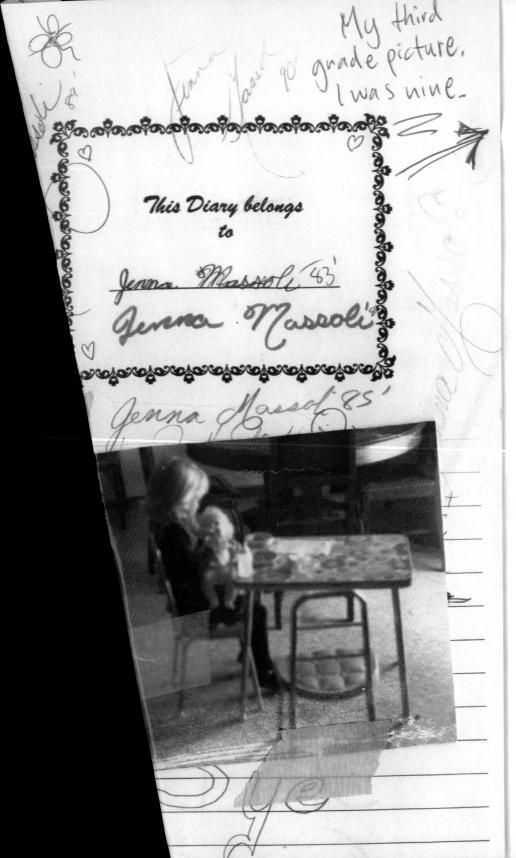

My third grade picture. I was nine.

This Diary belongs
to

Jenna Massoli '83

Jenna Massoli

Jenna Massoli '85

Soon, I had so many regulars that all I had to do each night was cater to them. One guy would give me a thousand dollars to let him brush my hair. Another would rub my feet. So I'd just sit there, get pampered, and, *boom,* earn another thousand dollars. I didn't have to dance, speak, flirt, or give these guys any part of me. One local politician liked to be dominated and, although I had such a submissive personality naturally, one night I took his beer into the bathroom, peed into it, and then made him drink it. He loved it. The next night, he tipped me with a pink slip: for a brand-new Corvette.

One afternoon, a modeling agency came to the club to shoot the girls for playing cards. They were making different sets for every club in America. They put a curtain up against the back wall and shot Vanessa and me together. When the cards came out, we were identified as the Barbie Twins, and the nickname stuck. I used to look at my dad's *Playboy* magazines when I was thirteen and dream of being one of those girls. The photos in the magazine made the girls look so beautiful and glamorous, like models of perfect femininity. The soft-focus shots of flawless faces framed by sun-streaked blond hair reminded me so much of the old modeling shots of my mom that my father kept in his dresser drawer. But the dream still seemed just as far off even though four years had passed since then and I had an actual body now. Vanessa and I talked about modeling for men's magazines all the time, but we never thought of getting an agent. We had no idea how to go about it.

Outside of the club, Vanessa was a very different person. She was quieter and more contemplative. She was so much smarter than anyone I had met before. She seemed to have everything going for her. I wasn't used to having friends who were good to me, but she was loyal and cared about my well-being. It made it much easier for me to gain confidence at the club when I knew someone always had my back. If I ever had a bad night at work, she would bring me a cupcake with a little candle on it. Or she'd tape a note to my mirror telling me, "Put on that winning smile, baby, and go out there and get them." She always put other people before herself.

Chapter 7

Dear Diary,

Wow has it been a long time. Probably because I thought I grew out of writing in my diary after what happened in Montana. I guess not. I live with Jack in my own home that we rent. He makes me feel so incredible. I really feel a lot of love for him. I wish things were different. But I can't change the way I feel. I want something more, and he refuses to give it. He hurts me so bad. But he doesn't realize why.

He says he loves me. But not in the way I want him to. He can't talk to me. I wish he'd sit me down and confide in me or just tell me what I mean to him and what he wants our plans to be. I don't think he's ready. Or maybe he just doesn't want that kind of life. I want him to take my feelings serious, but I just make him mad. I can't win.

I want to be closer to him so badly but he won't let me in. He never has time to talk with me seriously, and when I catch a moment of time with him, he acts like I'm just going through a routine. Why would I put myself and him through this if there wasn't a legitimate reason?

I just want him to make me feel like he really wants to know what I think about us. Everything is top priority (money, job, bills, friends, partying, etc.) and when it comes to telling me that he wants me in his life forever and he wants to make some sort of bond with me when

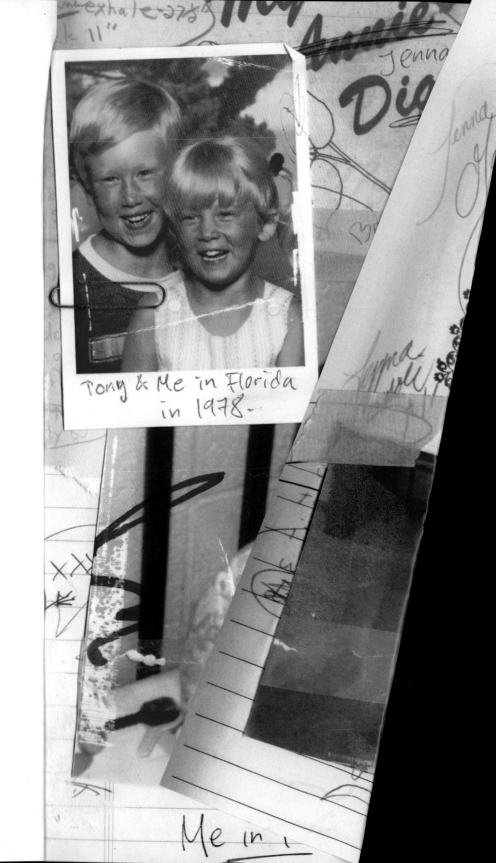

Tony & Me in Florida in 1978.

Me in

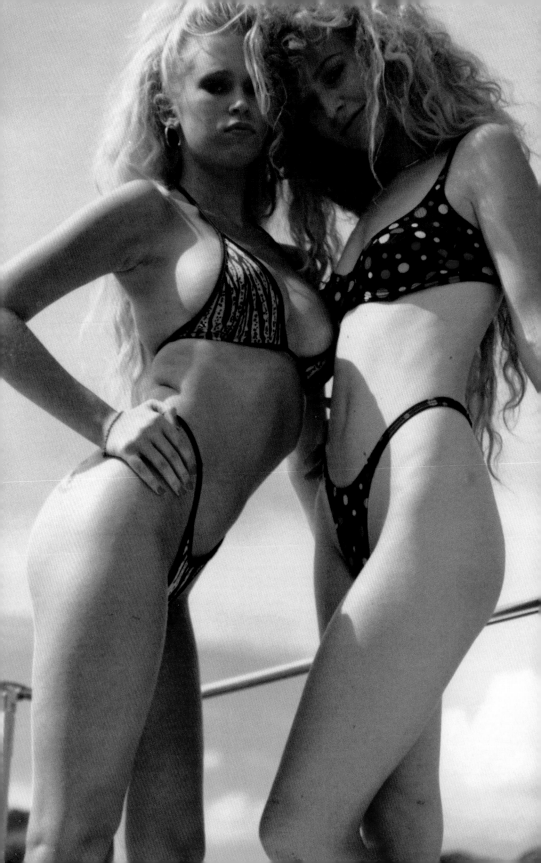

I tr

I tree

the

"
o

ther

These are some of
my earliest photo
shoots. at my
first nude one ever,
they didn't believe
my boobs were
real!

in

if

messing

My first bikini contest. I lost! ☹

All dolled up for the Wicked signing in 1995.

the classic shot, on the day Nikki Tyler and I met. ↑

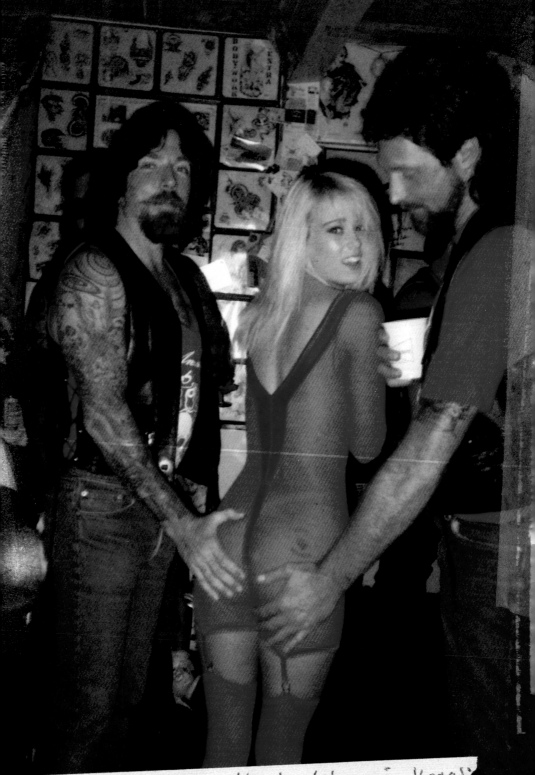

Hanging out with the bikers in Vegas.

I'm hurt, that's put on the back burner. But for all I know he doesn't really care about our relationship in that way.

I want an adult, loving, communicating, caring partnership with him. He doesn't understand this. He thinks everything's great how it is but it could be so much better. I wish this kind of talk didn't upset him. I wish he'd listen to me and know it's only because I want something I've never had before, someone for whom I come first. Someone who is sensitive enough to send me flowers for no reason or just leave a note that I'll find after he leaves for work.

Jack doesn't know much about women, so I feel bad for getting upset when he does something hurtful to me unknowingly. But maybe if he'd sit me down and talk to me about him and tell me what he wants out of all this, I could help him understand me.

I love you Jack,

Jenna

Chapter EIGHT

Once I clawed my way to the top of the club, Jack actually seemed proud of me for a moment and bragged to all his friends that I was the new top dog at the Crazy Horse Too. We celebrated one night with dinner at an Italian restaurant in the Venetian. Sitting next to him, without all his asshole biker friends around, I remembered how I'd felt the first time I saw him in the tattoo shop. Waiting for the food to come, we began making out. He placed my hand on his pants, and I felt him growing hard. I unzipped it, and began to play with it. And then, seized by some sort of mad-genius inspiration, I scooped a handful of whipped butter off a plate on the table. It softened quickly as I stroked him with it until, minutes later, we had made such a mess of his pants that we had to clean the butter and cum off with San Pellegrino water.

So our relationship got its second wind, which lasted for about a week. The problem was that in the biker crowd he hung out with, women were treated as subservient beings. And after my education at the club, I began to resent not having the permission to be myself around Jack and his friends. The only person I could even talk to was Matt, who worked at the tattoo shop with Jack and had given me that oddly understanding smile on the boat.

Eventually, I made the mistake of telling Jack that I was feeling uncomfortable and that he needed to stick up for me. I should have known that Jack would react by doing the exact opposite—treating me

even worse around his friends and leaving me alone constantly while he went on motorcycle runs to California. Of course, his behavior just made me more obsessed with him, as I kept trying to find the sensitivity that I believed he had. I was like a religious zealot. There was no evidence: my belief was based on faith alone. No man at the club could get the better of me, but Jack still could.

I hadn't talked to my dad since I'd left home. All he had to do was call and ask me to come home, and I would have. He'd been the sum total of my world since I was a little girl. But I wasn't surprised by his behavior: it was not in his character to reach out to me in any way or make an effort to talk about anything.

Before I met Jack, I was never much of a partier. I just had a few drinks. Whenever I saw him snorting various white, yellow, and pink powders, I always told myself there was no way I was putting that stuff up my nose. It wasn't that my father had raised me well. It just seemed gross and pointless—and it probably stung. Of course, that didn't stop Jack from trying to force his drug of choice on me: crystal meth. The conversation usually went like this:

Jack: Try a bump.
Me: I don't think so.
Jack: It's just like a cup of coffee.
Me: It's not my gig.
Jack: Just a little bump?
Me: I said no, Jack. Stop it.
Jack: You're missing out.

And then one day, the conversation ended like this:

Me: Okay, a little bump.

Between my experience on Lake Mead and my encounters with the men at the strip club, I had become a little more nihilistic. Jack dumped some powder on a Metallica CD case and spread it with his driver's license. The shape it formed was clearly a line, not a bump—unless a

bump was just druggie talk for a line. He handed me a rolled-up twenty-dollar bill. I bent over the black CD case and tried to snort as little as I could. To accomplish this, I took a little sniff and then messed up the tail of the line with the end of the bill, so that it looked like I had snorted it all.

Within moments, my nose was burning and my head was pounding. It hurt, and I couldn't figure out why anyone would want to sniff this nasty dust. Then I swallowed the saliva in my mouth and, slowly, the migraine transformed into euphoria. My blood surged and my heart pounded. It was as though my spirit was too excited to stay in my body and wanted to leap out and dance among the stars—or at least vacuum the whole house. For the first time since leaving home, I didn't think about the pain of being away from my father; I didn't think about Preacher; I didn't think about whether Jack liked me or not. Nothing mattered.

"Jack," I said. "Can I have another little bump?"

So I did one more bump-line. A full one. I felt invincible. A few hours later, a thought suddenly occurred. I shared it with Jack.

"How am I supposed to go to sleep?"

He just smiled at me wickedly and said, "Enjoy it."

I crawled into bed and shut my eyes. They popped back open instantly. A day and a half later, I was still awake, shaking from exhaustion and hunger, and I couldn't stop grinding my jaw. I was miserable. I pledged never to do it again.

That pledge lasted about a week. And, as an added benefit, Jack's house never looked so clean. I tried a couple sniffs before work one day because I thought it would help me hustle better, but instead I found myself layering on so much makeup and doing my hair for so long that I walked onto the stage looking like Liberace.

Once I hit the stage, I grabbed the pole and didn't let go. I just stood there dancing as my knuckles turned white and my teeth ground together so hard that sparks were practically flying out of my jaw. Note to self: work and drugs do not mix.

Around this time, Vanessa started drinking more heavily, losing her temper, and bursting inexplicably into tears. Every now and then she'd say something strange, like she didn't feel safe at home alone, and would beg me to spend the night at her house. Gradually, she began canceling plans and pulling away from me. Something bad was looming over her. And that something bad was Preacher.

Vanessa lived about five miles away from her father. Sometimes when I was at Vanessa's, Preacher would stop by drunk. I would stay upstairs, for fear of seeing him, but often I could hear them quarreling. One night, while I was downstairs doing a bump-line with Vanessa, Preacher barged into the house. When he saw me, he froze for a moment. His face contorted into a threatening scowl, then he turned and left.

After that night, Vanessa stopped talking to me. She wouldn't even return my calls. I couldn't figure out what the matter was, so I stopped by her house unannounced. When she saw me, her face blanched.

"What's gotten into you?" I asked.

"Are you fucking my dad?" She glared at me with pure hatred.

I stood there shocked for a moment. "Jesus Christ, Vanessa. What are you talking about?"

"My dad told me you were fucking him!" she said. "You are such white trash, Jenna. How could you?"

I had never planned on telling Vanessa anything, but the mind does funny things when it's put on the defensive. "You've got it wrong," I told her flatly. "Actually, he raped me."

As soon as the words left my mouth, Vanessa burst into tears and crumpled to the floor.

"It's okay," I reassured her. "I'm not going to turn him in. I won't do anything, all right?"

"That's not it," she gasped through her sobs. I looked at her and suddenly, I knew. Not only had she been through the same thing with Preacher, but she was still going through it.

"He's been raping me my whole life," she confessed and then just exploded. Tears flew out of her eyes, snot gushed from her nose, and her

wails pierced my eardrum. All the defensive walls she had put up from being victimized her whole life suddenly crumbled in front of me. He was her father; he still had control over her.

"That bastard is creeping around here again, and I don't think I can handle it," she said. "I've spent too much of my life trying to find the strength to stand up to him."

She buried her face in her knees. Her blond hair streamed over her legs. "My first memory is him coming into my room and climbing into bed with me," she said, her voice muffled. "And he never stopped. He broke into the house and climbed into the shower with me last week. It's been going on for so long I don't know what to do."

We talked for hours. Actually, she mostly talked. I just listened. She didn't need any advice; she simply needed to tell someone about all the times he would wake her in the middle of the night, trying to touch her and fuck her. Often people make the mistake of thinking that when others open up to them, they are looking for advice. But actually, they've heard the same advice hundreds of times and never acted on it. Logically, they know the advice is right, but emotionally they can't tear themselves away from their set patterns. And emotions always overpower thoughts. So I let Vanessa talk, and watched as the anger, confusion, and impotence slowly settled in her, so that she could go to sleep that night.

Worst of all, she had told Jack about it. And what did Jack do? The same thing he had done when I told him about my rape: nothing. It pissed me off so much: he loved Vanessa as much as I did. How could he not stand up for her?

"I swear to God I can't believe my family is betraying me," she said. "I just want to get my life back."

I felt so helpless listening to her. I had never gone to the police to report my rape because it would just have been my word against his; but I told Vanessa we could go together. However, she said she just wasn't ready to face the shame of everyone knowing. Before I left, she promised to confront her father and put a stop to it. I hugged her until we both couldn't cry anymore.

The next day she was dead.

What made it so hard was that I felt I hadn't been there for Vanessa. As soon as I saw her hanging from the shower, I realized that I should have stayed with her. But, strangely, I didn't cry. Even though I was freaking out on the inside, I stayed calm, just like my father would have, while Sharon returned with the knife to cut her down. My father had always described his mental state during shootouts as extremely crisp and lucid, as if everything were moving in slow motion. And that's how it was for me.

Sharon ran around like a psycho while I kept telling her, "Cut her down!"

When Sharon finally did, Vanessa came toppling down on me with a loud hissing sound, like air escaping. I thought that maybe she had just breathed, maybe I could save her. I slid out from under her and laid her on the bathroom floor. Her tongue was hanging out and there was foam all over her face. Her skin began breaking out in purple, blotchy patches before my eyes.

I wiped the foam from around her mouth with toilet paper, which kept flaking off and leaving white pieces of tissue all over her face. I tried to place her tongue in a normal position as I bent over her mouth. Sharon just stood there, with her own mouth hanging open. Over the music, I could hear Frou Frou still barking outside. She was panicking too.

"Jesus, call 911 or something!" I shouted at Sharon.

I had never actually performed CPR, but in an emergency situation, it's amazing how you just automatically know what to do. I pinched her nose and breathed into her mouth, then leaned over her chest with my full body weight and pumped it with my hands clasped over her heart. When Sharon returned, I told her to rub Vanessa's arms and legs to get her circulation going. I'm sure this all would have been very helpful if it hadn't already been far too late.

When the police and paramedics arrived, they pronounced her dead after five minutes.

"It's really strange," one of the paramedics told me. "Because she doesn't look dead."

I looked at Vanessa, and the color had returned to her skin. The purple blotches had even started to fade back to flesh. Only a pooling of blood that had settled and flattened out the skin of her back along the floor betrayed the reality of the situation. "Well," I told him, "that's because we've been rubbing her for the last ten minutes trying to get her circulation going."

"I've never seen anything like this," he said. "You two worked her blood back to the surface."

Sharon and I waited there while they called Preacher, who arrived with Jack. He told the police that she had been doing a lot of drugs lately and had lost her mind. Instantly, a light went off in my head. That motherfucker. After all Vanessa had been through, she wasn't the type of person to just give up like this. What clinched it was when Preacher told the police that he didn't want a drug test or even an autopsy.

I imagined him and Vanessa arguing, and her threatening to go to the cops. I looked at his hairy-knuckled hands and thought about how easy it must have been for him to strangle her; how cold-blooded he must have been to hang his own daughter afterward to fake a suicide. But I just stood there silently, wishing I had the guts to say something. That guy intimidated the fuck out of me.

Two days later, her mother, Sadie, flew in from Michigan for her funeral. I stood there, watching everyone weep for her, but I still couldn't bring myself to shed a tear. She had suffered for so many years, and no one had ever cared or helped in any way. And now, when it was too late to do anything, they were putting on this great show of love and remorse. It seemed so hypocritical. But, more than that, it seemed eerily familiar, and I realized that my life would probably also end with everyone caring too much too late.

I wanted to stay strong. If I lost it over Vanessa, I felt like I would unravel entirely from all the things I had never dealt with: the death of my mother, leaving my father, Preacher raping me, and my anger at Jack for doing nothing about his uncle. So I just kept everything pent up inside, like I always did. It was such a terrible end to her hard life. And

she was such a great girl inside that it didn't seem fair. At best, she was better off, because she didn't have to live in the same world as her father anymore. Since then, not a day has gone by when I haven't thought of Vanessa and the look on her face when I last saw her.

The next day, I sat in Vanessa's bedroom with her mother, going through Vanessa's possessions. There were so many little things that I wanted to keep as reminders of her friendship and beauty. But her mom, who had never been there for her before, took everything. All she left me with was a little antique sake set, which I keep in my bedroom to this day.

Afterward, I discussed Vanessa's death with some of the women around the tattoo shop, most of whom had heard stories about Preacher molesting girls.

"Somebody needs to do something about it," they kept saying.

Even though they had no idea what had happened on the boat, I felt like they were talking to me. But, after all my character-building in the strip club, after all I had learned about the world and myself, I realized that I was still a little girl. I just didn't have the strength.

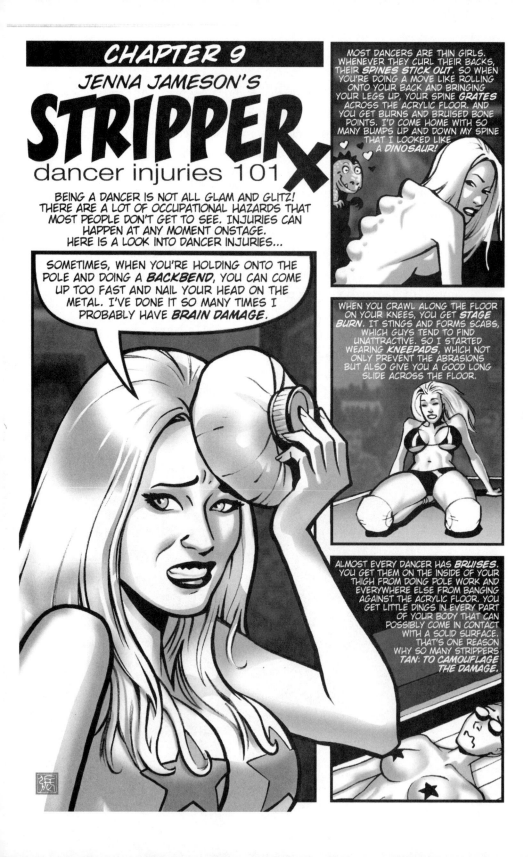

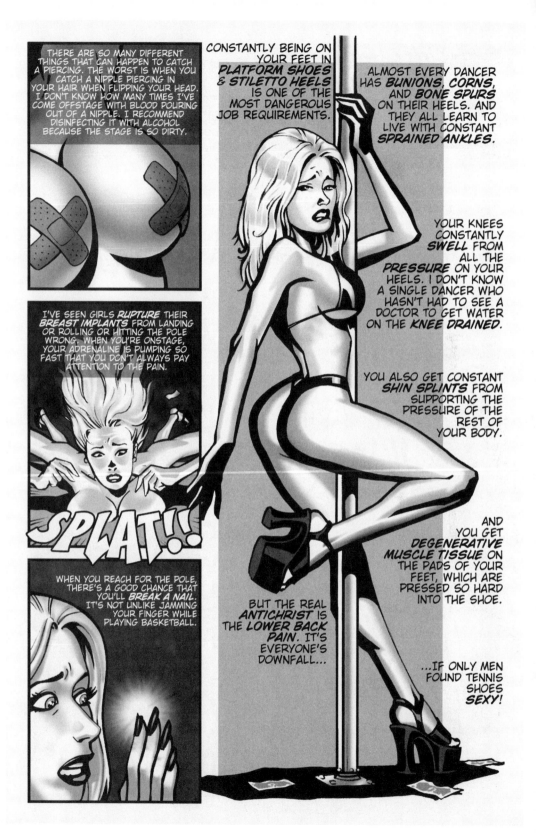

THERE ARE SO MANY DIFFERENT THINGS THAT CAN HAPPEN TO CATCH A PIERCING. THE WORST IS WHEN YOU CATCH A NIPPLE PIERCING IN YOUR HAIR WHEN FLIPPING YOUR HEAD. I DON'T KNOW HOW MANY TIMES I'VE COME OFFSTAGE WITH BLOOD POURING OUT OF A NIPPLE. I RECOMMEND DISINFECTING IT WITH ALCOHOL BECAUSE THE STAGE IS SO DIRTY.

I'VE SEEN GIRLS *RUPTURE* THEIR *BREAST IMPLANTS* FROM LANDING OR ROLLING OR HITTING THE POLE WRONG. WHEN YOU'RE ONSTAGE, YOUR ADRENALINE IS PUMPING SO FAST THAT YOU DON'T ALWAYS PAY ATTENTION TO THE PAIN.

SPLAT!!!

WHEN YOU REACH FOR THE POLE, THERE'S A GOOD CHANCE THAT YOU'LL *BREAK A NAIL.* IT'S NOT UNLIKE JAMMING YOUR FINGER WHILE PLAYING BASKETBALL.

CONSTANTLY BEING ON YOUR FEET IN *PLATFORM SHOES & STILETTO HEELS* IS ONE OF THE MOST DANGEROUS JOB REQUIREMENTS.

ALMOST EVERY DANCER HAS *BUNIONS, CORNS,* AND *BONE SPURS* ON THEIR HEELS. AND THEY ALL LEARN TO LIVE WITH CONSTANT *SPRAINED ANKLES.*

YOUR KNEES CONSTANTLY *SWELL* FROM ALL THE *PRESSURE* ON YOUR HEELS. I DON'T KNOW A SINGLE DANCER WHO HASN'T HAD TO SEE A DOCTOR TO GET WATER ON THE *KNEE DRAINED.*

YOU ALSO GET CONSTANT *SHIN SPLINTS* FROM SUPPORTING THE PRESSURE OF THE REST OF YOUR BODY.

AND YOU GET *DEGENERATIVE MUSCLE TISSUE* ON THE PADS OF YOUR FEET, WHICH ARE PRESSED SO HARD INTO THE SHOE.

BUT THE REAL *ANTICHRIST* IS THE *LOWER BACK PAIN.* IT'S EVERYONE'S DOWNFALL...

...IF ONLY MEN FOUND TENNIS SHOES *SEXY!*

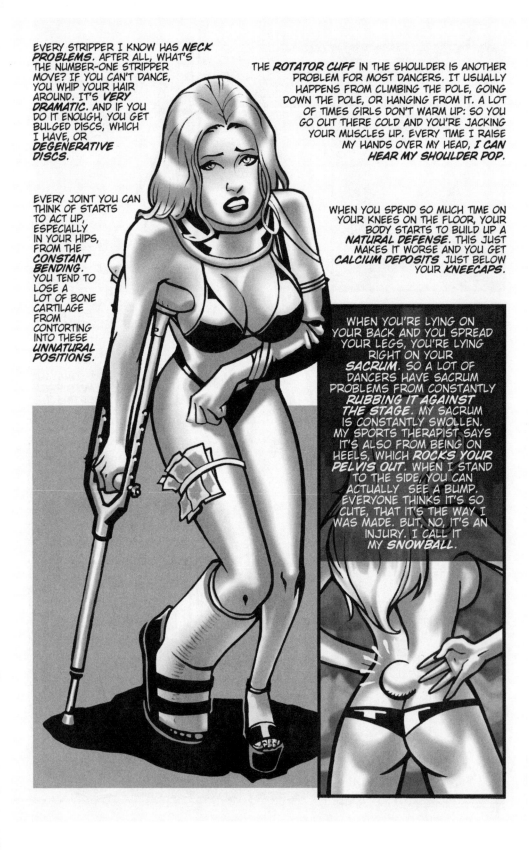

EVERY STRIPPER I KNOW HAS **NECK PROBLEMS**. AFTER ALL, WHAT'S THE NUMBER-ONE STRIPPER MOVE? IF YOU CAN'T DANCE, YOU WHIP YOUR HAIR AROUND. IT'S **VERY DRAMATIC**. AND IF YOU DO IT ENOUGH, YOU GET BULGED DISCS, WHICH I HAVE, OR **DEGENERATIVE DISCS**.

EVERY JOINT YOU CAN THINK OF STARTS TO ACT UP, ESPECIALLY IN YOUR HIPS, FROM THE **CONSTANT BENDING**. YOU TEND TO LOSE A LOT OF BONE CARTILAGE FROM CONTORTING INTO THESE **UNNATURAL POSITIONS**.

THE **ROTATOR CUFF** IN THE SHOULDER IS ANOTHER PROBLEM FOR MOST DANCERS. IT USUALLY HAPPENS FROM CLIMBING THE POLE, GOING DOWN THE POLE, OR HANGING FROM IT. A LOT OF TIMES GIRLS DON'T WARM UP: SO YOU GO OUT THERE COLD AND YOU'RE JACKING YOUR MUSCLES UP. EVERY TIME I RAISE MY HANDS OVER MY HEAD, *I CAN HEAR MY SHOULDER POP*.

WHEN YOU SPEND SO MUCH TIME ON YOUR KNEES ON THE FLOOR, YOUR BODY STARTS TO BUILD UP A **NATURAL DEFENSE**. THIS JUST MAKES IT WORSE AND YOU GET **CALCIUM DEPOSITS** JUST BELOW YOUR **KNEECAPS**.

WHEN YOU'RE LYING ON YOUR BACK AND YOU SPREAD YOUR LEGS, YOU'RE LYING RIGHT ON YOUR **SACRUM**. SO A LOT OF DANCERS HAVE SACRUM PROBLEMS FROM CONSTANTLY *RUBBING IT AGAINST THE STAGE*. MY SACRUM IS CONSTANTLY SWOLLEN. MY SPORTS THERAPIST SAYS IT'S ALSO FROM BEING ON HEELS, WHICH *ROCKS YOUR PELVIS OUT*. WHEN I STAND TO THE SIDE, YOU CAN ACTUALLY SEE A BUMP. EVERYONE THINKS IT'S SO CUTE, THAT IT'S THE WAY I WAS MADE. BUT, NO, IT'S AN INJURY. I CALL IT MY **SNOWBALL**.

OF COURSE, THERE ARE *OTHER PROBLEMS* THAT HAVE NOTHING TO DO
WITH YOUR SHOES OR DANCING:
YOU GET *SKIN PROBLEMS* FROM ALL THE *MAKEUP* YOU HAVE TO WEAR.
YOU GET *MIGRAINE HEADACHES* FROM *HANGOVERS*.

SOME OF THE CLUBS BLAST THE *MUSIC SO LOUD* THAT IT'S LIKE BEING AT A CONCERT. AND WHEN YOU'RE ONSTAGE, YOU'RE RIGHT NEXT TO THE SPEAKERS. SO A LOT OF GIRLS HAVE *HEARING PROBLEMS*. EVERY NIGHT WHEN I GO TO BED, I HAVE *RINGING IN MY EARS*.

BOOM BOOM BOOM

YOU GET *BRUISES ON THE ASS* FROM GUYS PINCHING IT.

HEY!

PINCH PINCH

HEH HEH

AND MANY GIRLS HAVE *ACUTE SCHIZOPHRENIA* FROM ALL THE *INANE CONVERSATION*, NOT TO MENTION SORE THROATS FROM SAYING, "SO, WHAT DO YOU DO?" ALL THE TIME.

ONE DAY, I'LL START A *RETIREMENT HOME FOR DANCERS*. WE CAN ALL SIT AROUND IN OUR WHEELCHAIRS, COMPLAINING ABOUT THE GOOD OLD DAYS, *SNORTING GERITOL* IN THE BATHROOM...

...AND *PINCHING* THE ASSES OF THE MALE NURSES WHENEVER THEY WALK BY.

Chapter
TEN

After the funeral, Jack finally began to put some distance between Preacher and himself. He quit the tattoo shop and decided to open one of his own, along with a rival biker club, with Matt. As for investors, they found one: me. I had saved tens of thousands of dollars from stripping. There were only so many pairs of shoes I could buy. So not only did I give him my money, but I learned to lay tile, drywall, and solder. I was in the shop every waking hour, and there were lots of them because of the meth I was doing to numb myself after Vanessa's death.

In January, we finally finished the tattoo parlor. It was set to open on February 1. That morning, we arrived at the shop and it was gone. The roof was blown off, the windows were shattered, and the tiles I had worked so hard on were dust and debris. Three fire engines and a police car were parked outside.

Someone, it seemed, had fire-bombed the shop. And Jack and I both knew who that someone was.

One of the worst things you can do in the biker community is start a competing club. Preacher had connections with organized crime, I was told, and if I wanted to live, I should stay away from anything to do with tattoo parlors and biker clubs while Jack rebuilt his.

So I buried myself in work, stripping for thirteen hours a day, making ridiculous bank. It was depressing without Vanessa there to support and distract me. Now, as soon as I walked into the club each afternoon, I could see the competition, envy, and petty hatred in the eyes of the other girls.

Opposote: My first adult convention—the Consumer Electronics Show.

People often say that the world would be so much better if it were run by women. But women have as many faults as men. Their faults are just different. So the truth is that the world would not be better if it were run by a woman, it would be better if it were run by the *right* woman. When men race or fight, they are only striving to prove their masculinity or protect their sense of pride. But women do not compartmentalize in the same way. Our actions are a reflection of our complete selves, worthiness, and deservedness. For the worst of our species, any other attractive female is seen as competition and a threat.

Thus, without Vanessa, I had no friends at the club. One afternoon, though, I noticed a girl I hadn't seen before. She was sitting on the side of a small stage in the back of the room. A single spotlight shone down on her, casting her in an angelic glow. While most of the strippers at the club wore cheesy neon-green tube tops or American-flag bikinis, she was wearing an expensive-looking black French lace bra with matching panties. A lace shawl was wrapped around her shoulders, and a soft, perfectly straight, raven-black cascade of hair fell over them; she had a tiny waist, a plump round butt, and boobs like cupcakes with beautiful little cherries on top. But what really made her stand out was her posture: so perfect, like a Japanese geisha, as if she belonged to a gentler, more refined world. When she noticed me looking at her, she didn't flash a look of hatred or territorialism like most girls in the club would. She just looked down demurely. I could not figure out what this sweet, classy girl was doing here.

By the end of the night, I had worked up the courage to talk to her. She was sitting in a booth in the corner of the club, where I joined her. "You are the most beautiful girl I have ever seen in my life," I told her.

"Tell the men that," she sighed. "Everyone wants to marry me, but no one wants a dance." She grabbed a handful of twenty-dollar bills out of her purse, and put them down on the table. I estimated that there were five of them. And at this point in my stripper days, I was very good at estimating these things.

"That's all I made tonight," she said. "And it was a good night."

I had made almost four thousand dollars from my regulars.

"With your looks, you could be one of the top girls in the club," I told her.

"That's just not me," she said. "I feel totally out of place doing this."

"Then why are you doing it?"

She was even more beautiful up close.

"I'm doing it," she said, and paused, "because it pays my bills."

I decided that it was my duty to teach her the ropes, as Vanessa had done for me. "I was just like you when I came here," I said. "I was the shyest girl you ever met. And do you know how I succeeded? Do you know the cliché, fake it until you make it? Well, it's true. If you act like the prize stripper who charges fifty dollars for a dance, eventually the guys are going to start paying you fifty dollars for a dance. And then one hundred dollars. And then two hundred dollars."

I talked to her for fifteen minutes, schooling her on the ins and outs, the dos and don'ts, the shouldn'ts that you shouldn't and the shouldn'ts that you should. "It's not real life in here. It's a game, one big game of mind fucking. If you're somewhat in tune with other people and can pick up on what they are thinking and who they are by talking to them, then you can win. You may not be a manipulative person deep inside, but in here you must manipulate. And you will learn that you can get anything you want by maneuvering correctly."

I felt proud of myself, like I was the seasoned professional dispensing wisdom and advice to a new girl who needed it. As I was talking, she suddenly reached across the table, put her hand under my chin, pulled my face into hers, and kissed me.

It wasn't a peck on the lips, or one of those fake sexy kisses that girls do with other girls to turn men on. It was a full-on tongue-exploring-mouth soul kiss. My breath quickened, and my mind raced. I was in shock. But, at the same time, I wasn't. This was why I had really come up to her. I didn't want to help her become a better stripper at all. I wanted to run my hands through her hair, feel her cheek against mine, and hold her in my arms. I had to make a split-second decision. And that decision was yes. Yes, I wanted to throw down with this girl.

She released my mouth and looked softly into my eyes. I wrapped my right hand behind her head, and she pressed her lips once more against mine. She kissed with the confidence and passion of a man. She slid her hand along my thigh, under my short white skirt, and let it rest in the waistband of my panties. I responded by sinking my fingers into the depths of the hair at the back of her neck, closing my hand into a fist, and pulling her head back. She moaned with such animal desire that I instantly let go. I couldn't believe that this demure girl had such a fierceness inside her. As it came to the surface, I could feel my panties moisten. The best sex takes place in the mind first.

"Do you want to continue this someplace more private," she whispered, her eyes moist, her breath rising in time with mine. We were in our own world now, and I wanted to stay there.

As she unlocked the door to her house, I wondered if I was doing the right thing. I'd never been with a girl before, and never thought I would be. Sure, I'd entertain Jack by making out with a girl in front of him, but this was different. This was just me and another girl, alone, one on one, for no one else's pleasure but our own.

As soon as we walked in the door, she put her hands around my neck, threw me up against the wall, and rammed her tongue down my throat. If a man had done this, I would have been terrified. But coming from her, it was such a turn-on. She lifted my shirt over my shoulders and began to lick slowly around my breasts, circling closer and closer to my nipples, as she ran her hands along the curve of my back. Her tongue and touch felt so much different than a man's. She was just as confident and strong, yet underneath was a gentle, nurturing touch that sent shivers through my body. I was hooked, and because it was a woman, the thought that I was cheating on Jack never crossed my mind.

She led me to the bedroom and pulled my skirt off. My panties were so damp that I was embarrassed. Sitting over me, she pulled off her top, unhooked her bra, and pressed herself against me. I could feel heat ema-

Opposite: The cover of my movie **Pure.**

nating from every pore of her body. It had been so long since I had felt this kind of intimacy.

She kissed me for what seemed like forever before working her way down my skin, kissing every inch. She reached my thighs, then stopped and cupped her hand over my pussy. Just feeling the sheer warmth of it—after so much teasing—made me want to explode. When she finally went down on me, I was practically crawling up the walls. She put one finger inside, working my g-spot, as she licked my clit. She looked up at me, her chin damp with my wetness, and asked whether I minded if she used a toy. I said no, imagining that she had some sort of thin red vibrator that she wanted to rub against my clit. But instead she reached under the bed and whipped out a cream-colored back massager with a long, thick handle and a top that looked like a showerhead. Involuntarily, my whole body tensed. I was petrified.

She placed a blanket over my pussy so that the vibrations wouldn't be too intense and direct, and I began to relax. Clearly, I was in the hands of a qualified professional. She turned her monstrous apparatus on, and just touched it to the blanket over my clit. My body started to twitch and shudder uncontrollably, forcing me to arch my back until it happened. I exploded, over and over again. I couldn't stop. It felt like wave after wave of color was running through me. Every time I thought it was over, my body would rock with another set of spasms and I'd dig my fingers deeper into her neck and yell every curse word in the dictionary, in addition to some I invented on the spot.

When it was over, I collapsed and started laughing, and then crying, and then laughing and crying at the same time. It was as if my body were recovering from a traumatic shock. She crawled up and hugged me, stroked my hair, and then licked the tears off my face. I had never had an orgasm that intense in my life.

We rolled around together for hours that night, alternating moments of tender caresses with hair-ripping lust. She had a full arsenal of toys under her bed—none of which I'd ever experimented with before—and seemed to know everything that was possible for one

woman to do to another. When I went down on her, she screamed so loudly and thrashed around so violently that she actually broke her bedside lamp. The neighbors must have thought she was being murdered.

When I left her house the next afternoon, I felt an emotion I'd forgotten ever having experienced. I felt loved. I was smitten with this woman, and I wanted to be with her again. She gave me a sense of security that I never had with Jack. We were so in tune emotionally that we hardly even needed to speak. I was confused. Was I gay? Was I straight? Did I love her? Did I love Jack? Or was this all just some kind of afterglow from the sexual release? So many questions were spinning through my mind. But overall I was happy. I felt safe. And in my life, that was a rare thing.

Now, if only I knew her name.

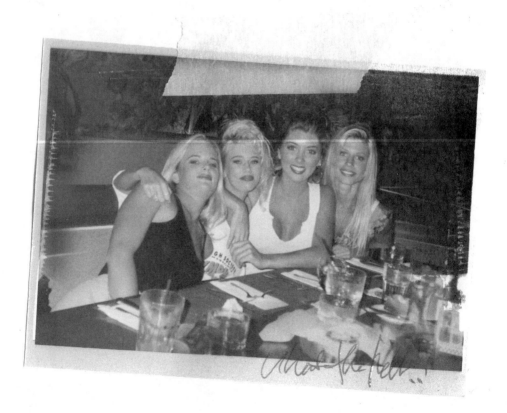

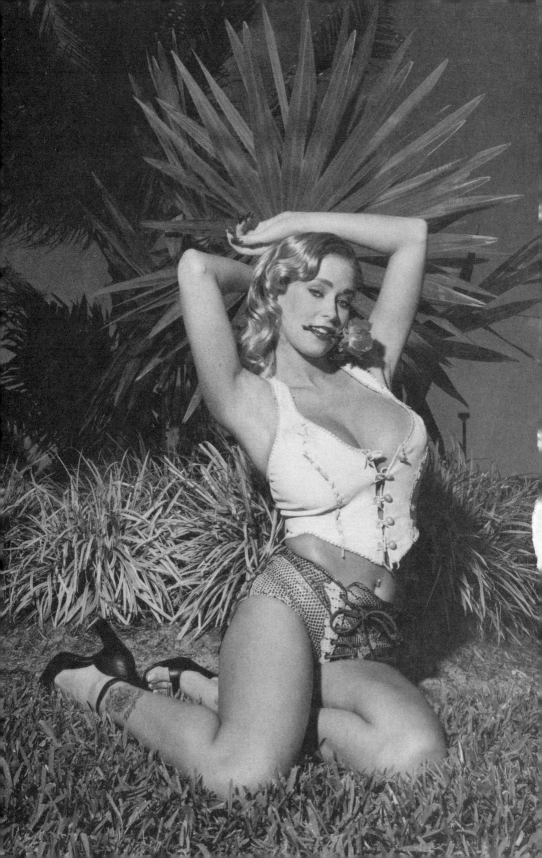

Chapter ELEVEN

I doubled back to her house and checked her mailbox. There was only a last name there: Parke. And it was unlocked. I reached in and checked one of the letters: Her name was Jennifer D. Parke. And, after that amazing night of lovemaking, Jennifer D. Parke and I were inseparable.

Every day after work, I went to her house and we talked for hours. Unlike the relationships I had been in before, the more time we spent together, the better the relationship became. She was incredibly good-hearted, and soon became equal parts lover, mother, and friend. On top of all of this, she had been a *Penthouse* Pet. I told her that I'd always wanted to be in magazines, and she promised that that she would make sure my time would come.

Though Jack had no idea what was going on—and to tell the truth, I had no idea what he was doing behind my back either—every girl at the Crazy Horse knew we were a couple. Jennifer and I would take breaks at the same time and meet each other in a bathroom stall. She was so loud that our relationship was no secret all over the club. When we walked out, we both had to reapply our makeup. If only the customers knew what was really going on behind the scenes.

Though it wasn't obvious from her appearance, Jennifer was one of the most sexual girls I had ever met. She could come fifteen times in a single session, and always wanted to eat me out when I was on my period. She called it war paint. And she loved having oral sex in public places—cabs, casinos, restaurants, amusement parks. On our off days,

we snuck into the pool at the Mirage and spread our towels in a secluded spot in the sun, where only the cabana boys could see us having sex.

A relationship with a woman is much different than with a man. There is a much stronger emotional connection between women; with a man, there is more of a power dynamic at work. Discussions between women seem less surface and shallow. But as deep as the connection between Jennifer and I became, I still couldn't shake loose Jack's psychological control over me. The more he pulled back, the more obsessed with him I became. Sometimes, when he wouldn't come home for four days, I would sit in my house and cry, unable to go to the club or even see Jennifer. He would call me when he was fifteen minutes away from home, and I'd chew him out and tell him that our relationship was over and I was moving out. Sometimes I'd even have my bags packed. But as soon as he walked in the door, I melted. And he'd be nice to me for a day or two, and then turn into a total dick. Fortunately, for a while, I had Jennifer to go to.

Though Jack didn't know about Jennifer, he was always hinting not so subtly about a threesome. There was a girl named Kirsten at work who I knew was interested in me. She was a cute brunette, but nothing special. So, mostly out of guilt over my shenanigans with Jennifer, I brought her home from work one night. The two of us had a few drinks in the kitchen with Jack, and then I led her to the bedroom. After we had been making out for half an hour, Jack jumped into bed naked. He ignored me completely and, within minutes, was fucking her. Three strokes later, he pulled out and started fucking me. But his dick had gone soft. I reached over and felt Kirsten's pussy, and there was cum all over it. The asshole had gotten so excited that he had lost it in three strokes.

It hurt me so much, because it seemed like he was so much more excited over this plain girl than me. And he had cum with her—not me. I put on my clothes, and kicked her out of the house. I was furious. I cried for two weeks straight over the fact that he had paid almost no attention whatsoever to me in bed. And I think the experience ultimately ruined me for every man thereafter, because I never again brought a girl home for a guy I was dating.

Trying to juggle the emotional and physical whirlwind my life had become, I started snorting more meth to keep me going. I'd do it with Jack because it brought us closer together; I'd do it with Jennifer because, like most strippers, she liked to party; and I'd do it by myself just to stay awake. In my head, the borders were firmly drawn: snorting it was like coffee, a social lubricant and pick-me-up; smoking it, like Jack and some of his biker friends did, was for addicts.

Then there was my brother, Tony. Before puberty, we were inseparable. Because my dad was never around, he became my protector and would beat up anyone who even looked at me funny. And he was genius smart, in a *Rain Man* way. Even though he started getting into drugs, drinking, and fighting as a teenager, he was always in control and always my best friend. No matter what he did, he was my father's pride and joy.

Tony.

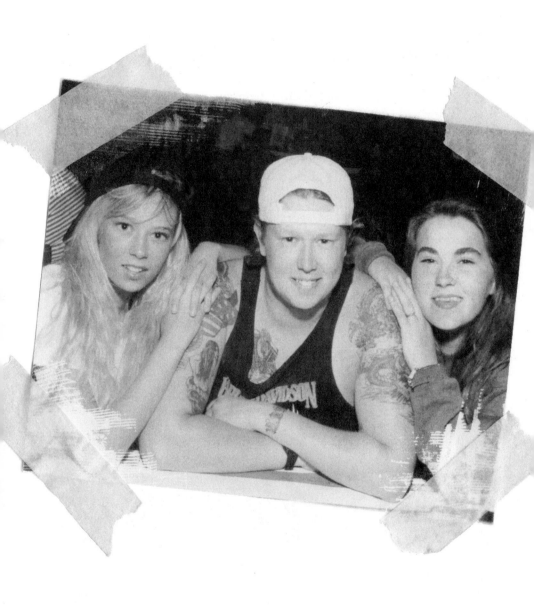

Me, Tony, and Selena.

But as we grew older, I began to resent the relationship my brother had with my father, because I wanted to be that close to my dad. The more my father said, "Why can't you be more like your brother," the more I pulled away from Tony. He was out getting high and robbing people, and getting away with it. We remained friends, but we were never as close as when our world consisted of just the two of us and our invisible father.

The rift between us grew when he met a girl named Selena, who reminded me of myself in a way, because she was a good girl caught up in a bad crowd. After he moved into her trailer, he started hanging out with her Hell's Angels friends. And their drug of choice also happened to be the stripper drug of choice: methamphetamine. First he was snorting, then he was smoking, and soon he was a full-on needle-using addict. When he came to visit Jack and me, he'd carry a doctor's bag, slam it down on the little table in our kitchen, and pull out a bag of speed. He'd turn to me and ask, "Will you help me shoot up?"

And, loving sister that I am, my answer was always the same: "Hell no."

"Then I'm just going to do it myself," he'd say, and tie off and search for a vein. It would sometimes take him five minutes to find one in his arm or leg he could still use. Jack wanted me to smoke meth and my brother wanted me to shoot it up, but I thought I'd just snort it like a good girl. I didn't want to end up like them: my brother was becoming paranoid and mean-spirited, with unpredictable mood swings and a violent temper. When he walked through the door, I never knew what to expect. Usually he'd think the cops were chasing him, and would look through the peephole all night long with his gun drawn, convinced that the police were coming to get him. At his worst, he'd swat at molecules of air as if they were attacking him.

One night, during one of Jack's two-day disappearing acts, Tony stopped by and asked for a little meth just to keep him going until his dealer called. Jack hid his drugs in the cabinet beneath the sink, crammed into the bend in a pipe. I reached underneath, grabbed a fat bag of peanut-butter meth, and gave him a scoop.

"Will you shoot me up?"

"Hell no."

I watched as he scanned his body, finally settling on a vein in his hand.

The next day, when I came back from the club, Jack had returned. And he was livid.

"What the fuck did you do with my meth?"

"What are you talking about?" I asked him.

"The big fucking bag I had under the sink!"

"I gave my brother a little scoop," I confessed. "I'm sorry. It didn't seem like much."

"You dumb bitch," he said, pushing me backward into the kitchen cabinets. "The whole fucking bag is gone. Your brother jacked you."

I cut my brother off after that. I couldn't believe he had sunk that low. I called Selena to tell her I was removing him from my life, and it turned out that he was stealing from her, too and squandering it all on injectables—coke, meth, heroin.

There was one more call I had to make. And it was to a man I hadn't spoken with in almost a year: my father. He hadn't called once since I'd moved away. And I wasn't surprised. Throughout my childhood, if there was ever a problem, he'd always act oblivious to it—and maybe he was—until I brought it up. If one of the many women passing through his life was acting psycho with Tony and me, he wouldn't do anything about it until we said something. However, once we did, he'd always take our side, with no questions asked. For all his problems, it was reassuring to know that he was—in his own strange way—in our corner if we ever really needed him. And that is why I picked up the phone, even though I was angry that I was making the first move once again. That was supposed to be a father's role, I thought.

"Hi, Dad, it's Jenna," I said.

"Hi, honey," he said. Instead of being affectionate, the word "honey" sounded cold, drained of any sentiment and feeling.

"I'm calling to talk about Tony. He needs help."

We spoke for ten minutes. And we talked only of Tony, and what

steps my father could take to try to save the life Tony was throwing away. I told my dad that I couldn't be responsible for Tony anymore, but if someone didn't do something, he was going to end up dead or in prison. The conversation wasn't at all like that of a father and a daughter, but more like that of a divorced couple discussing custody of their child.

"He's out of control," my dad said, "but I'll do what I can to rein him in, even if it means hurting him in the short term. I can't promise you that I'll be successful, but I can promise to try my best."

It hurt me so much to let go of my brother that day, because he was my last link to my family. Now all I had in the world were Jack and Jennifer.

Soon after, Jack came into the club with a friend of his named Lester, a dark-skinned, six-foot-tall biker who had just moved into town and was deep into the rockabilly scene. Lester had jet-black hair, greased and pushed back, and, just below it, a red bandanna wrapped around his head, so that just his eyes, set in perfectly tan skin, glittered mischievously underneath. His cocky smile let on that he wasn't just a bad boy, he was a player.

I usually didn't have much time for Jack when he came into the club, and he knew it. Ten minutes talking to him was two hundred fewer dollars in my purse. So when Jack and Lester came in, I didn't even greet them. I was dancing at the time for Nicolas Cage, who was a regular. A lot of celebrities came into the club, though I never seemed to recognize them. People would tell me after I was through dancing for them.

"Did you know you were just dancing for Pantera?"
"Really, those assholes were Pantera?"

"Did you know you were just dancing for Jack Nicholson?"
"Really, that old weirdo was Jack Nicholson?"

"Did you know you were just dancing for Whitesnake?"
"Really, like I give a crap."

"Did you know you were just dancing for David Lee Roth?"
"Yeah, what a letdown. I used to have wet dreams over him. But he was

rude, irritating, and babbled incoherently the whole time. And my friend Carrie just left the club with him. I've lost all respect for both of them."

Because he was a regular, Nicolas Cage was one of the few celebrities I recognized. I could usually smell him coming a mile away. He always had a funny stench, kind of like the distilled sweat of homeless people was lightly dabbed on the unshaven tangle of stubble on his neck. It mixed with the old leather smell of the beat-up jacket he always wore.

I loved dancing for him, because he was very respectful and a great listener, but I never quite knew why he bothered. No matter what I did, he never looked at me while I was dancing. So I took the opportunity to look around the club. I noticed that Jennifer was sitting with Jack and Lester. And Lester was leaning in to her, just chattering away, working her. It pissed me off, but there was nothing I could do. I was with a customer, and I wouldn't stop working for anything.

When Jennifer told me the next week that she was seeing Lester, it nearly broke my heart. I couldn't believe that she was dating a guy. And, even worse, it was one of Jack's fucking friends. I went home and cried for hours. I consoled myself, though, by thinking that it was only fair since I was carrying on a relationship with Jack. I wasn't giving all of myself to her, so it made sense that she'd find someone else to fulfill her needs as well.

Though Jennifer and I continued to see each other, I became nothing more than a distraction for when her boyfriend wasn't around. With Jennifer and my family gone, I began to cling even more to Jack. Of course, the more dependent I was, the more I irritated him. And the more I could see that I irritated him, the more insecure I became. Before long, every part of my happiness, every part of my being, was entirely dependent on him. If he was nice to me one day, I was in the best mood ever. If he was mean, my heart ached so badly I could hardly leave my bed. I'm sure the meth didn't help much either.

I really didn't enjoy going to the Crazy Horse anymore. My days consisted of working, sleeping until four in the afternoon, running errands, and then returning to work. Stripping was no longer a challenge. I was the number-one girl there, and probably could have slept onstage and

still had guys throwing money at me. And whenever I reach a point where I've succeeded and can't go any farther, I want to do something else. So every time I went to the Crazy Horse, I felt I was throwing my life away. I didn't want to end up like Opal. I was destined for better things, or at least that's what my brother used to tell me.

Life has a funny way of surprising you. When you least expect something to happen, it does. The time, for example, when you look like shit and are too tired to go out, but your friends drag you to a club anyway—that's the night you end up meeting the love of your life. And so it was that, after another fight with Jack, I was having a bad day at the Crazy Horse and my life changed.

I was wearing an armful of cheap bracelets—one-dollar rubber bands and dumb braided-string friendship bracelets; I had on a black straw cowboy hat, which I was wearing not just because it was cool back then (or at least I thought it was) but because it saved me the trouble of having to do my hair; a red tank top, like Bobbie Brown in the "Cherry Pie" video; and jeans I had cut into Daisy Dukes. I was dancing to the Eagles—only because it was smart to use music the guys there were familiar with—and working the men as usual for as much money as I could hustle. It wasn't quite as much fun without Vanessa as a partner in crime, but at least Jennifer was there for moral support.

When I finished my feature dance, Jennifer was standing at the edge of the stage next to a thin, beautiful girl with long brown hair and big natural boobs. I assumed that the woman was a new dancer, and probably competition. She was hot, and seemed bright and experienced.

"Jenna?" the long-haired woman said. I pivoted to greet her.

"My name's Julia Parton," she said.

I recognized the name. Jennifer had talked about her. She was a highly photographed nude model, and was supposedly a distant cousin to Dolly Parton.

"I hear you're interested in doing magazine work," she said.

I didn't know how to react. I just stared at her stupidly. Jennifer had been threatening to bring in a talent scout to take a look at me, but I

didn't think she'd do it without giving me advance notice.

"Well, I'm very good friends with Jennifer," she continued, "and I would really love to do a test shoot and get you into *Penthouse*."

Suddenly, the whole club seemed to fall silent. A blinding white light filled the room and a chorus of angels began to sing somewhere in the background.

I smiled beatifically, and then tripped over my tongue with enthusiasm. "When do we start? What should I wear? Do you want to call me, or should I call you?"

"I want you to start," Julia said, "tomorrow."

Suddenly, nothing seemed to matter: not Jack or Jennifer; not my brother, father, or mother; and not Preacher, Vanessa, or anyone else. My life was about to start. Finally.

"Get some rest," she said, "and I'll call you at noon and tell you where we're going to shoot."

When I returned home that night, I couldn't sleep. I sat down in the kitchen and tried to figure out what name I wanted to use. My birth name, Jenna Massoli, sounded too *Godfather;* it conjured up the visual of a fat woman cooking spaghetti while her husband comes home from a hard day spent fucking hotter, thinner women. Besides, if I used my real name, then guys would figure out where I lived and stalk me.

I could have used my stripper name, Jennasis, but it sounded too much like a sex-industry name. I didn't want to have a porno name like Cherry Rain, Candy Floss, or Jenna Lynn (for some reason, everyone picks the last name Lynn). I knew I wanted my first and last initials to be the same, and I wanted it to sound like it wasn't some made-up stage name.

I liked Jenna because I didn't know anyone else with that name. So I grabbed the phone book from underneath the kitchen sink (no longer Jack's meth hiding place of choice) and flipped to the J surnames. There was Jack (too close to home), Jacobson (too matronly), Jacoby (too lawyerlike), Jaffe (too Valley Girl), James (too common), and Jameson (too alcoholic). That was my first reaction. But as I thought about Jameson, I decided that I liked it. It was the name of a whiskey, and

whiskey was rock and roll. Jenna Jameson, alcoholic, rock and roller. Right on. The name just stuck. I suppose if I were pickier I would have kept going through the J's and ended up as Jenna Johnson or Jenna Justus or Jenna Juvenile Diabetes Foundation.

In retrospect, I'm surprised that I didn't come up with a more flamboyant name, because that would have suited my personality at the time. But a part of me must have known that the photo shoot was a new beginning, a chance to make a real career for myself. Of course, back then I thought that career was modeling.

I was wrong.

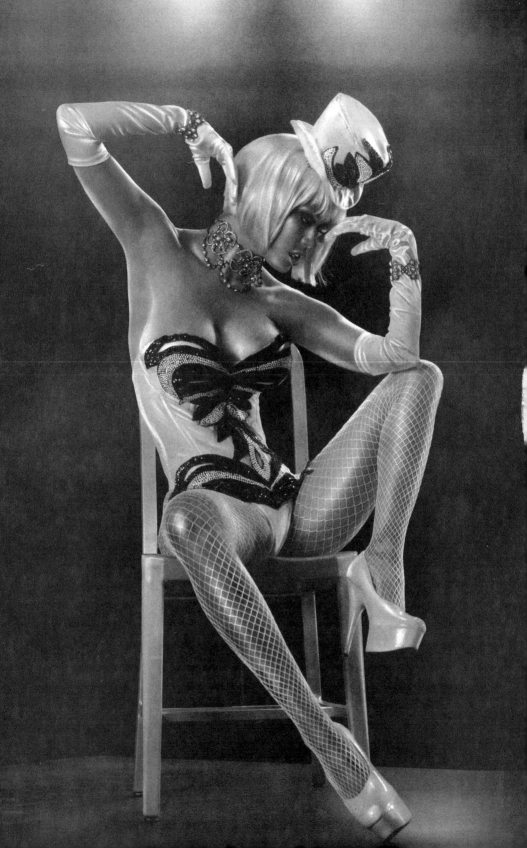

- XXX

XXX

A LIQUID PRISONER
PENT IN WALLS OF GLA

"A liquid prisoner pent in walls of glass,
beauty's effect with beauty were bereft."

★★

Chapter ONE

Amber Lynn, Ginger Lynn, Porsche Lynn, Hyapatia Lee, Heather Hunter, Nina Hartley, Asia Carrera, Teri Weigel, Savannah. Every one of them, along with some 491 other adult models and film stars, had one thing in common: they had stared, at an early age, down the lens of Suze Randall's camera. And, more than anything, I wanted to stare down that lens too.

Since I was ten, I'd been taking pictures of myself and studying them, hoping that I had what it took. I didn't want to be just any model: I wanted to be the best, the most photographed, the most known. I wanted people to say, "Oh, I know Jenna. I've seen her in hundreds of magazines." And my passport to that was Suze Randall. She had been in the business since the sixties in Britain, when she was working in a hospital and moonlighting as a model. Her goal was only to help pay the bills while her husband tried to write a book. But when the book was finished, she kept on modeling. On the side, she snapped nude photos of some of her gorgeous friends, and her work caught the eye of Hugh Hefner, who hired her to shoot for him. Supposedly, after she appeared nude in *Hustler*, Hefner fired her and, from there, she became the go-to girl for *Penthouse, Hustler,* and just about every other men's magazine on the stands. I wanted her to notice me. And that was exactly what Julia Parton promised.

"If I like the photos we take," she said at the Crazy Horse that night, "I'll make sure they end up in Suze Randall's hands."

The photo shoot wasn't actually for a specific magazine like *Penthouse*. Julia and the photographer were scouts, and made their money by sending the pictures to the major photographers in the business—Suze, Steven Hicks, Earl Miller, Clive McLean. If anyone hired me, Julia received a finder's fee. She was also a scout for *Playboy*, but I didn't feel like I was in that league. The women in *Playboy* seemed so much more mature. So I set my sights on a more appropriate goal: a magazine my father used to have around the house, like *Penthouse* or *Hustler*.

I didn't have much modeling experience. Outside of being photographed by a guy who supplied Vegas entertainment freebies with crappy pictures, my only real photo shoot—where I didn't have to pay the photographer to take my picture—was for the cover of *Easy Rider* nearly a year earlier. In the world of the tattoo shop, the cover of *Easy Rider* was a much more prestigious coup than *Penthouse, Playboy,* or *Newsweek*. So I sent the magazine some photos I'd taken with Vanessa in a makeshift studio. They were awkward poses, poorly lit, and tinted sepia-tone because for some reason we thought they'd look more professional that way.

But a month later *Easy Rider* called and said I'd gotten the cover. All I had to do was show up in a bikini at a studio in Las Vegas that Friday. I took the night off work, packed a handful of swimsuits, and arrived at 11 A.M. They did my makeup, and then put a red wig on me. As they were spritzing it with hair spray, Nikki Sixx and Tommy Lee of Mötley Crüe arrived. Instead of just me, the pictorial was going to be Nikki and Tommy on their bikes, with girls on the back.

The other girl was Bobbie Brown, but not the model-actress-groupie Bobbie Brown from the Warrant video. This was a girl who had stolen her name (and was later sued by the real Bobbie Brown). And since Tommy Lee was dating the real Bobbie Brown at the time, nobody wanted to talk to this girl. I would have felt badly for her if she hadn't been so unlikable and uptight.

I was so excited by the situation that I was willing to do anything. I whipped off my bikini and jumped onto Nikki's motorcycle, wrapping my arms around him. After the photo shoot, I was in the makeup room

taking off my wig when Nikki walked in behind me. As soon as he saw that I was blond, he was on me like a frigging wet blanket.

"Hey, what are you doing afterward?" he asked. (Rock stars never really have to learn social skills like the rest of us.)

"I have to work," I told him.

"Well, we should go out," he said.

"I'd love to, but I can't," I said. "Maybe some other time."

I couldn't believe the words that were coming out of my mouth. Since the time I was thirteen (which was actually only four years earlier), I'd been in love with Vince Neil and Nikki Sixx. I had pictures of those two guys all over my bedroom. (I was never really attracted to Tommy Lee, so naturally he was the one I ended up dating years later.)

Nikki, however, didn't want to take no for an answer. He kept backing me into a corner and asking, over and over, if I'd go out with him. Each time, I told him no, until he gave up and left the room, pissed.

When my brother took me to see their *Girls, Girls, Girls* tour when I was fourteen, I prayed so hard that Nikki would see me in the crowd and take me backstage. I kept telling my brother, "Tony, put me on your shoulders!" "Tony, Nikki just pointed at me!"

Now, three years later, here I was, alone in a room with Nikki Sixx himself, passing up the chance for a night on the town with a rock god. Was I nervous? No. Was I a good girl? Hell no. I wanted to do it so badly. But the fact is: I was on my period. And I turned him down because of that. To this day, if he remembers me at all, he still doesn't know why I rejected him. Because if I hadn't been having my period, I would have fucked him forever!

At my next real photo shoot, at Julia Parton's house in Las Vegas, I *was* Jenna Jameson. When I signed the release, it felt so good to write "Jenna Massoli, a.k.a. Jenna Jameson." It was as if a public persona was suddenly coming into being.

"You look just like Racquel Darrian," Julia said as she took my hand and led me to the bathroom to do my makeup and hair.

In my mind, I didn't look anything like Racquel Darrian. I looked

like Savannah. My dad subscribed to the Playboy Channel, and when I saw her in a movie one night, she took my breath away. I couldn't get over the fact that a woman who was so gorgeous that she seemed untouchable would ever do adult movies.

In emulation of Savannah, I wore my hair flat with bangs. And because I was used to painting my face so that it would stand out in a dark strip club, I caked on lots of makeup and black eyeliner. All this was anathema to Julia. She scrubbed me clean and redid my face with only a little makeup. Then she wet my hair, undoing hours of work, and gave me a wavier look. A statuesque redhead walked into the room. Julia introduced the woman as her "wife," and the first thing her wife said was that I could be a stunt double for Racquel Darrian.

When Julia finished my face, I walked into the bright lights of her living room, which had been made into a studio for the day. Everyone stared at me expectantly. They wanted me to start posing. I had no idea what to do, so I just stood there, uncomfortable with the style Julia had created for me and the looks I was getting from the photographer. Finally, Julia pulled me aside.

"Okay, what I need you to do," she said, "is to keep your shoulders back, kick one of your hips out, and tighten up as many muscles as you can."

Next, she put me on all fours for a butt shot and asked me to turn my head back to look at the camera. But since my head looked teeny in comparison to my ass in that position, she asked me to bend my body so that my face and my ass were the same distance from the camera and both in focus. I had no idea what she was talking about.

It was such a challenge to look sexy and relaxed while manipulating my body into the various uncomfortable contortions Julia was running me through. Even for what Julia considered the simplest pose, like looking over my shoulder with my back to the camera, I had to arch so hard that my lower back cramped. When I see those photos now, it seems obvious that the sexy pout I thought I was giving the camera was just a poorly disguised grimace of pain.

When I took off my top, Julia pulled her wife aside. They conferred

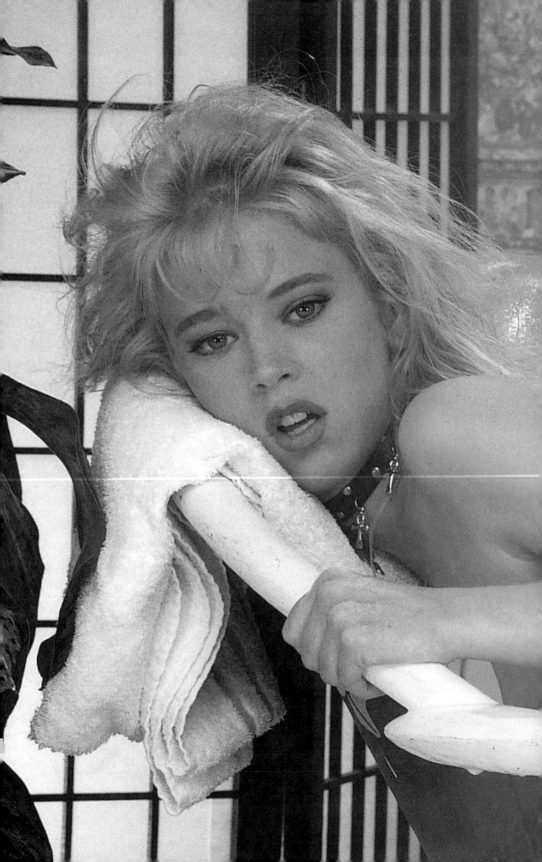

about something, and then talked to the photographer. Soon, the three of them were having an all-out argument. Finally, Julia turned to me.

"Are your boobs real?" she asked.

"Yeah, they're real."

And then, in unison, her wife and the photographer said, "No, they're not!"

"I swear they are."

"Then why is it," her wife asked, "that when you push them together, you have that little raised area of flesh right there?"

"Well, that's my rib."

I don't think they ever believed that my boobs were real. Perhaps they'd forgotten what it was like to be eighteen, firm, and perky.

After a few more shots, the photographer asked me to remove the rest of my clothes. I was used to being topless, but not bottomless. I felt so vulnerable.

Once I was naked, the photographer asked for a "standing bridesmaid."

"What the fuck is that?" I asked Julia. I had no idea what language this was. So Julia pulled me into the makeup room. She told me about the standing bridesmaid, the piledriver, the cowgirl, the reverse cowgirl, the standing cowgirl, the sidesaddle, the doggie, the dirty doggie, the scissor, the scissor mish, the sixty-nine, the standing sixty-nine, the blow job, the reverse blow job, and the wheelbarrow, most of which I fortunately didn't need to commit to memory because they required a partner.

And just when I had the necessary vocabulary mastered, the photographer wanted an "American split."

Being naked was one thing, but spreading my legs was the worst. I had no idea it would be so intimidating to sit spread-eagled under bright lights in a room full of clothed people.

They kept shouting "whiter" at me. I had no idea what they were talking about until I broke down and asked. Turned out they were saying "wider." The worst was yet to come.

"Okay," the photographer said. "Now show me pink!"

"What are you talking about?" I asked him.

"Um," he replied. "You need to spread your lips like this." He held two fingers upside down and slowly separated them.

Though I really wanted to please him, I couldn't. When given a new challenge, I usually need to go home and practice alone before attempting it in front of other people. And exposing my insides to strangers was so daunting that, instead of spreading my lips with my fingers, I kept trying to cover them up.

I was uncomfortable for so many reasons. It was my first time, the photographer was a guy, and he was so quiet that I didn't know if I was giving him what he wanted or fucking everything up. I wanted so badly for him to like me and give my photos to Suze. But the only things he'd say were, "wider," "spread it a little bit more," and "pull it up more."

They worked me for seven hours before letting me go. I swore that next time I'd show them so much pink they'd think the sun was setting.

But the second day of our shoot was even more intimidating: we set up outdoors at Red Rocks, a pile of scorched earth just west of Vegas. We didn't have permits, so we operated on the shoot-and-run principle. We scrambled up to a secluded spot, spread out a blanket, and then I peeled off my clothes and tried to remember the poses while every few seconds a stray tourist would wander over the ridge. Soon, we had a crowd, which made it impossible for me to show any more pink than I had the day before.

When I went home, I was sure that I had blown it and they never wanted to see me again. No one had prepared me for the standing bridesmaid or the American split or the hot fudge sundae with a pink cherry on top. But two days later, the phone at the apartment rang. It was Suze Randall.

Chapter
TWO

I got off the plane in L.A. at 7 A.M. the next Monday, wearing cowboy boots, rolled-up men's boxer shorts, a tiny white tank top that just barely covered my very real breasts, and a Yankees baseball cap turned backward. I'd never really had a female role model besides Vanessa and Jennifer. So I dressed with only one thing in mind: making men go "Oh, my God!" and trip over things and crash their cars and want to stab themselves in the heart.

My cab driver smelled like spoiled milk. During the whole ride to the studio, his beady eyes were fixed to the rearview mirror, scoping me out. When the creep finally arrived at the studio, a small industrial building near an overpass for the 405 Freeway, a beautiful brown-haired girl came running toward me, yelling my name in an English accent.

"I'm Emma Nixon," she said, breaking into a wide smile. "I'm your makeup artist."

As usual, whenever I'm nervous or in a new situation, I turn into the mouse. I reached into my purse to pay the cab driver, and suddenly realized that I had been so anxious about the photo shoot that I'd spaced out and left my wallet on the plane. I looked up at Emma, embarrassed, and explained what had happened.

She didn't have any cash either, so she told the cab driver that she'd write him a check.

"Well," he said, gesturing to me. "She can pay me in other ways." He probably thought I was a hooker and, in retrospect, I can hardly blame him.

Suddenly, Emma wasn't so sweet anymore. "Oh really, mother-fucker?" she told him. "We'll see about that."

She lifted the telephone handset that she had been holding and punched in the number for Yellow Taxi. Within ten minutes, he was fired and the ride was free. I couldn't believe how confident this girl was. When I was in my element at the strip club, I could lay creeps like that low. But I still hadn't gotten used to asserting myself in the real world.

Once the excitement was over, Emma sat me down in her makeup chair and examined me. "You're not making my job very easy," she said, laughing. I looked like such a hick to her.

Emma said that Suze had seen the photos Julia had sent her, and was instantly attracted by the prospect of a fresh, new blonde. As Emma went to work on my face, the other girls started arriving. They were so loud and confident, and it seemed like they were all friends with each other. It was like my first day at the Crazy Horse all over again. But the customers watching me here would be Suze and the editors and publishers of the biggest men's magazines in the country. This was it: if they didn't like me, I'd have to find another dream.

After Emma finished my face, I hardly recognized myself: I looked, for the first time in my life, like a woman. And that woman appeared sexy, confident, and sophisticated. She was Jenna Jameson. And I liked her a lot more than Jenna Massoli.

The studio basically consisted of a four-poster bed in the middle of a cold concrete room. A handful of girls were already draped seductively over the satin sheets. "Look at you," Suze said to me. "You're like a little baby buttercup."

Strewn throughout the building were photos she had taken of some of the most ravishing women in the world, and every one of them looked her best. I trusted Suze instantly. Unlike Julia Parton's photographer, who was so quiet I had no idea if I sucked or not, Suze gave me constant feedback. I learned right away how much better it is to work with a very vocal photographer. And because Suze was a woman and spoke in a charming British accent, she could get away with saying things that I would have wanted to strangle most guys for.

"Oh, you're a pussy fiend, aren't you Buttercup?" she'd yell as she coaxed me to bend over further. "You dirty little cunt! Oh, make it hotter! You know you wanna be a slut, you little cocksucker! Jolly good!" It was so hard not to laugh sometimes. But I wanted to show her pink, because she made me feel so comfortable and sexy.

To keep all of my body in focus and in the light, I had to bend and contort into all sorts of unnatural positions that were supposed to look effortless, just as I had at my shoot with Julia. But this time, I had to hold the positions much longer and wait for them to meter the light, take a

Polaroid, and check the light again before they even started shooting. I was so out of shape from my unhealthy lifestyle that my knees would suddenly start knocking during a pose or my lower back would spasm when I arched it for too long. But I knew that if I moved even an inch, they'd be pissed because they would have to remeter the light; and all the other girls, who were posing so effortlessly, would be annoyed. I really wanted to please Suze, so I was willing to hold my knees over my head for twenty minutes straight, until my spine felt like it was going to snap.

They changed my outfit fifteen times in order to get as many different magazine covers out of the session as possible. And with each photo set, I slowly learned to transmit sexuality in a new medium beyond the dark lights of the Crazy Horse Too. I wanted to work the camera as well as I did a strip-club customer.

After the shoot, Emma offered to drive me to the motel where I'd be staying. We climbed into her Porsche convertible, which made her even cooler in my eyes, and she took me to my hotel, a Burbank shithole called the Vagabond Inn. I went to the check-in desk and even though Suze had prepaid the room, they said they needed my credit card. I had no credit card and no money, so they refused to give me a key. I was only eighteen, and had never really traveled alone before. I had no idea where to go or stay in this fucked-up city.

I walked out of the hotel dragging my massive suitcase behind me and watched the passing traffic as I thought about how fucked I was. Suddenly, Emma drove up. She had come back to make sure I was okay. I must have made a pathetic first impression that morning in the cab.

"What's the matter?" she asked when she saw me standing there with tears in my eyes. "Are you okay?"

"They won't let me in the room," I bawled.

Once again, Emma rescued me and checked me into that crack motel. I didn't even mind the little bedbug bloodstains on the sheets or the roaches that scurried away every time I turned on the lights. I could hardly sleep that night. My mind was racing with excitement and adrenaline from the day, but I was worried that I'd created too much drama for

the people who could make me into a star, or—if they wanted—lay me low and chase me out of town.

The second day, Suze shot me alone and then took me to the beach, where she wanted to pose me with two other girls, a little thing named Erin and an experienced model named Shayla LaVeaux, who looked at me like she was going to devour me. We had no permits to shoot there, so Suze blocked us from the beach dwellers with big white sheets. For the shoot, she wanted us to pour oil on each other. As we were doing that, she asked Erin to pour some directly on my ding-ding. I pulled back.

"I'd rather not do that," I said. "It'll get infected."

"Fine," Suze sighed.

I was sure she'd be upset or take me off the shoot for saying that. I couldn't believe she had agreed so quickly. I'd never stood up for myself before. It felt good. I'd have to try this again sometime. Maybe I could ask for a nicer fucking motel next time.

With Nikki Tyler.

And so it began. I woke up at five every morning and got to the studio by seven for makeup. If I weren't so young, my face would have looked like hell after all the sleep deprivation. Though she is a great person and a talented photographer, Suze, I soon realized, is also a shark. Her specialty is naïve young girls—much like myself—who are so happy to have a modeling opportunity that they'll do anything. Once she sank her teeth into me, she didn't let go. She shot me until I was half dead.

The pay was three hundred dollars a day, but sometimes she'd cram three different photo shoots into a day. And I had no idea how much she was getting paid for the photos or how many magazines she was selling them to. I was only supposed to be in L.A. for two days, but she kept me for a week, shooting nonstop. For all I know, she snuck into my hotel room while I was sleeping and shot more sets. Probably the reason she liked me so much was because I was so grateful that I didn't complain once. If she wanted me to balance on one foot on a cliff, I would have done it, because I was finally living my dream.

The third day, Suze planned a big wacko shoot with ten girls at a huge mansion. As I sat in the makeup chair, I watched one hottie after another arrive—stuck-up, fucked-up, worked-up, or hard-up. They all seemed to be looking at me and wondering what a little girl was doing on a set full of women. And I was in mouse mode, stuck in my head and not talking, as usual. However, once Emma was finished with me, all the girls looked at me differently. They couldn't believe the transformation. Suddenly, I was competition.

Outside the mansion, there was an opulent fountain spitting water dozens of feet. I sat on the marble steps, talking with Emma, when a blonde with long, straight hair and the cutest little freckles walked up. "Hi, Em!" she chirped.

Then she looked at me: "What's your name?"

"Um, Jenna."

"I'm Nikki. Nikki Tyler. You must be one of Suze's new girls."

I couldn't believe a model had actually acknowledged my presence. She was so outgoing, and I was entranced by her freckles. Throughout

the different setups, such as the classic lay-all-the-girls-naked-in-a-row-on-deckchairs-and-get-a-shot-of-all-their-butts pose, she stayed at my side, gave me advice, and filled me in on gossip about the other girls. As the day wore on, thanks to Nikki's support, I started to get comfortable enough to let my personality out in the photos. My eyes sparkled, my energy intensified, and I even started suggesting poses. And the more I relaxed and expressed myself, the more Suze encouraged me with deep heartfelt praise, such as, "Yes! That's it, you dirty little thing." Because I was so flexible from dancing as a teenager, I could contort my legs and spine in ways that the other models couldn't, inspiring Suze to actually name poses after me, like the Jameson Split, for which I balanced my body on my upper back with my legs spread, my ass in the air, and my head resting on one leg.

Of course, in the excitement of the moment, I thought Nikki was being sweet to me because I was the new girl. I was too naïve to realize that she was as bisexual as the day is long and completely on the make. When we paired off together for a girl-on-girl shoot, she'd follow through by kissing me on the lips whenever the camera stopped, even though intimate contact between the models was not allowed. For some reason, it neither made me uncomfortable nor aroused. I just thought it was rad. She, on the other hand, was a psychology major, and knew just what she was doing. She wasn't getting sexual enough to send any warning signals, but not being so distant that I didn't at least entertain the idea.

I was giddy by the end of the day, because I knew I stood out from the other girls, even though they had much more experience. Life was repeating itself. I liked thrusting myself into these new worlds where I didn't fit in or know everything, especially when I ended up discovering a natural talent that surprised me.

When the photo shoot ended, Nikki switched into her mild-mannered day guise—horn-rimmed glasses, overalls, and a ponytail—and offered to drive me back to my hotel.

"So where are you staying?" she asked.

"The Vagabond Inn," I told her.

Chapter
FOUR

Nikki had a cute apartment in Sherman Oaks near Mel's diner. When we got there, she introduced me to her boyfriend, Buddy, who must have known her M.O. The three of us sat on her couch and watched television for an hour, until Buddy suddenly stood up and said, "Okay, goodnight girls!"

As soon as he left for bed, the atmosphere suddenly became tense. Nikki wanted me, and I wasn't entirely comfortable yet.

"Do you want to watch a movie?" she asked.

"Okay, sure. Cool."

She rifled through her videos, and put one in. It was a porno. A Savannah movie: *Savannah Superstar.* Her game was tight and clearly well-rehearsed.

"Are you cold?" she asked.

"Yeah, a little."

She brought me a big soft blanket from the closet, threw it over me, climbed under it, and put her arm around me. It was just like being at a horny high-school jock's house.

Her strategy was to get me so turned on that my desire outweighed my discomfort. First, she laid her hand against the side of my leg. Then, gradually, she started rubbing the side of my knee in slow, less-and-less-innocent circles. As agonizing minute after minute ticked by, she worked her way up to my outer thigh and then around to my inner thigh. She was careful not to touch my private parts, but she was also careful to

bring her hand just near enough to make them tingle with anticipation. Soon, I stopped paying attention to the movie and started paying attention to how her hand was making me feel, and that's when my libido began to overpower my brain.

Suddenly, all the tension erupted and we were all over each other. Nikki locked lips with me, and pushed me down. She straddled me and pulled off my top. Her hands and mouth were everywhere. She was much more aggressive than Jennifer had been—and much more experienced, if that was even possible, even though she was only two years older than me. All I could do was kiss her and scratch her back as she ravished every inch of my body.

We rolled off the couch and onto the floor. While she was going down on me, she reached under the couch and grabbed an immense flesh-colored dildo. She didn't like vibrators, because she was extremely sensitive and considered batteries to be cheating. But she loved dildos—the bigger, the better.

After three hours of sweaty, psychotic sex, she handed me a huge black strap-on. Evidently, she wanted me to wear it. I had never even thought about using one, but after all the pleasure she'd just given me, I could hardly deny her some reciprocation. I will never forget the feeling of putting it on: when you have a huge thing like that between your legs, something just comes over you. You turn into an animal, a monster, a maniac—in short, a man. As it stuck out of me, she rubbed lubrication over it with both hands, and my nerves began to merge with this giant piece of plastic. I could feel every sensation.

She turned around and kneeled on all fours, expectant. This was weird. I stepped behind her, with one knee on the ground, and wrapped my body over hers. My intention was just to put it in slowly, so that I didn't hurt her, but after the head went inside, something came over me. I thrust the rest of it in, and slammed her hard. I fucked her and fucked her and fucked her.

"Don't move your body back and forth," she advised me. "Rock your hips upward, like a guy. Mmm. Now move your pelvis down a little, so that it hits my G-spot."

When I complied, she went crazy. Just looking at the veins on her neck popping out, her upper back mottled red, and her face transfixed in ecstasy made my body convulse with another orgasm.

After I pulled out, we collapsed and fell asleep on the floor together with the thing still hanging from my pelvis, brushing against her leg. In the morning, she dropped me off at my next photo shoot.

I didn't want to impose on her, so I spent the rest of the week at the hotel. I saw Nikki one other time, and nothing physical happened. We just went to dinner, talked for hours, and planted the seed for a real friendship. She had gotten into nude modeling, she said, when she was looking for a way to pay the vet bills for her sick dog and happened across an ad for bikini models.

"Any time you're in L.A.," she said, "my place is your place."

Then I flew back to Jack and the hellhole in which we lived. I put the $2,100 I'd made in L.A. into my treasure chest —I had stashed about $33,000 in a box under the bed—and went back to the Crazy Horse. Though it might not seem like a lot of money after so much time stripping, there are side effects of the job: it spoils your relationships with both men and money. You see too much of both, and you lose respect for both. That is why most strippers are bisexual and why I learned to live up to the "heartbreaker" tattooed on my ass.

As for the money, it makes it hard to ever work a normal job when, instead of a paycheck, you're getting fistfuls of tax-free cash nightly. As a result, you tend to spend it almost as quickly as you get it—on clothes, nice dinners, hotel rooms, champagne, drugs, and other vices for yourself, your friends, your boyfriend, and your boyfriend's friends.

But I felt like I had saved enough money for Jack and I to move to— and nicely furnish—a place where the hot water worked, the rats and roaches were exterminated, and the wallpaper wasn't yellow and peeling. Over the next month, I looked at dozens of apartments that were listed in the newspaper, until I finally found a nice two-bedroom in a high-rise downtown. I agreed to move in and went home to my stash. I pulled out the box and dumped the bills onto the bed to count them. One dollar, two dollars, three dollars, four dollars, five dollars, six dollars, seven dollars, eight . . .

I suddenly blanched. They were all singles. What happened to the fistfuls of twenties and hundreds I'd been saving for so long? Only one person knew where I kept the money.

Chapter
FIVE

As soon as Jack came home from the tattoo shop, I confronted him. "Where the fuck's my money?" I yelled.

He couldn't even be bothered to lie. "I borrowed some," he said. "I didn't think you'd mind."

"Fuck yeah, I mind," I told him. "We need to move the fuck out of this shithole."

"I know, baby," he said. "And that's what I've been trying to do. I thought I could make you some more money at the Golden Nugget."

Jack loved to get high and gamble. I just never realized he'd been doing it with my money.

"Go to work," he said, as he chopped up a couple lines on the kitchen counter. "You'll earn it back in a week anyway."

"You asshole," I yelled, punching him in the back. He didn't give a shit about me or my money.

I swore that I'd earn back that cash and leave his ass for good. Then I bent over the kitchen table and sniffed a giant line of meth, wiping away the suddenly distant memory of L.A. and Suze Randall and Nikki Tyler. It was the first line I had done in at least half a year. And it was the line that would ultimately send me over the edge. Doing drugs for fun and recreation is a lot less harmful than doing them for an emotional reason, such as trying to forget about the fact that your own boyfriend stole your life savings.

There was something about Vegas that was poison. Every day I spent there, I slowly lost my grip on reality. Even Jennifer, my only real friend

there, was disappearing deeper into boyfriendland every day. It seemed as if the better and more exciting L.A. became, the worse I made Las Vegas for myself. I had such a drive to succeed, but somewhere even deeper there was a part of me that felt unworthy, as if I didn't deserve it. And so I punished myself constantly—with insecurity, with drugs, and with Jack. Whenever I left town, I was sure Jack was cheating on me. So when I returned, I'd inspect the apartment for clues and sometimes even follow him when he left the house. That kind of behavior was beneath me. Even though I had found a much deeper emotional connection with Jennifer and then Nikki, I was completely co-dependent on Jack—in part because I felt him pulling away and it hurt me. I hated him for that. And I loved him for it, as well.

After one of our screaming matches, I was sobbing naked in the hallway, wiping away actual foam that had formed around my mouth from ranting and raving so much. And I was suddenly seized by the desire to call my dad. I missed Tony, and wanted to make sure he was still alive. Last I'd heard, after I'd talked with my father, he'd invited Tony and his girlfriend, Selena, to live with him so he could keep an eye on them. My dad had helped start some sort of real estate business with his brother, Jim, so to further rehabilitate Tony, he had brought him in as a partner. But Tony was still so heavily into drugs that he was constantly stealing things of my dad's to sell.

When I called my dad's house, no one answered. I thought nothing of it at the time, but I kept calling. And when no one answered the next day, and the day after, and the day after that, I began to worry. After five days without hearing from them, I asked Jack to drive me to my old house to look for them.

It was the first time I'd been home since running away. When we pulled up outside, the door was unlocked and hanging open. Something was definitely wrong. The television was on. A half-empty beer bottle sat on the coffee table. And the phone was ringing.

I picked it up. As soon as I answered, the line went dead. I began to cry uncontrollably. I had no idea where my family had gone or what had

happened to them. Sure, it had never been much of a family, but it was better than not having a family at all, which seemed to be the case now. I called my grandmother, and there was no answer at her house either. All Jack could say was, "What the fuck is wrong with your dad?" The hypocrisy of the comment didn't strike me at the time.

When two weeks passed without hearing from either Dad, Tony, Selena, or Grandma, I began to worry that perhaps Tony had gotten in

trouble with some drug dealers, and they had kidnapped or killed my family in retaliation. I was a wreck.

It was then that my phone rang. I scrambled to get it. The voice on the other end was a woman's: it was Suze Randall. She had sold most of the photos from our first sessions, and wanted me to model again. I flew to L.A. for a week, and slept on Nikki's couch. It was one of the hardest weeks of my life, because away from Vegas I was powerless to do anything about my family. I pledged to contact the police when I returned home.

However, there was a message waiting for me when I got back to Vegas. "Your dad called," Jack wrote in a note in the kitchen. "He can't tell you where he is. Something happened and they all had to leave. He'll call you soon."

It was two weeks before I heard from my father again. He called from a pay phone in South Dakota. He wouldn't tell me what had happened, but he assured me that he and Tony had done nothing wrong. They had packed Selena and my poor grandmother into a truck and gone on the run. For all my dad's faults, he had always seemed to be in control of his life, but now he sounded like my brother—hunted and desperate.

After that my dad started calling every few weeks, always from a new city and with a new telephone number. After a while, I stopped bothering to write down his contact information, since it was constantly changing. I couldn't imagine what kind of trouble he and Tony had gotten themselves into.

In the meantime, I began flying back and forth to L.A., crashing with Nikki. I began a cycle of going cold turkey on the meth for photo shoots—because my small chin and blue eyes don't mask a clenched jaw and dilated pupils very well—and getting loaded when I returned to Vegas. Because I was able to stop getting high when duty called, I thought I had everything under control.

In L.A., Nikki took me to the corner newsstand every other afternoon so I could look for pictures of myself. And, slowly, they began to appear: on the cover of *Hustler*, and then *Cherry*, and then *High Society*. All three were on the stands with me on the cover at the same time. I was

the slut of the month. Of course, none of them mentioned Jenna Jameson. They called me Shelly or Daisy or Missy. And, though the editors had never spoken a word to me, they featured interviews in which I discussed how inordinately horny I was, how much I liked sex with anonymous strangers, and how I fantasized about inviting my girlfriends over for threesomes with my boyfriend. (Not surprisingly, the original photos I shot with Julia Parton never appeared anywhere: they were so bad that she couldn't even sell them.)

We were usually given a huge discount on the magazines for one simple reason: Nikki's boyfriend Buddy worked at the newsstand. They had originally met when he caught her lurking around the newsstand suspiciously, trying to work up the courage to buy her first-ever layout in a men's magazine.

Eventually I earned enough money from dancing and modeling to move. I rented a small, high-end two-bedroom apartment in a skyscraper in Las Vegas called the Crystal Towers. It was beautiful: the foyer had black-and-white checkered tile, the bedroom was immense, and the balcony overlooked an outdoor pool. I made sure to leave a forwarding number on the old phone, just in case my dad called. I was worried I was going to lose contact with him and Tony forever.

Being totally on my own wasn't something I had ever experienced— or was even ready for. So Jack moved in with me, of course.

Relationships are funny, because they are not logical. Instead of judging them by the facts, we assess them by our expectations. I still thought that Jack was going to change. Things had been going well that week: with the money he was making at the tattoo shop, he chipped in for the rent and some furniture. And now that I was starting to get a little famous in Vegas because of my modeling, he was proud to take me out on his arm. Besides, I didn't know any other guys I could sleep with, do drugs with, and throw dishes at. More than that, if we were going to continue to date, I wanted him close, so that I could keep my eye on him. I didn't trust him at all. I was still too young to know that there is no such thing as love without trust. There is only obsession and co-dependence.

Even though I made much less money modeling than stripping, I never wanted to go to the Crazy Horse anymore. I felt like I had moved beyond it and onto a new challenge. Whenever I was there, I felt lonely, empty, and often angry—so, in that respect, it was not unlike a family to me. I didn't have any friends there besides Jennifer, whom I still really loved, though she was spending more and more time with Lester. And talking to drunk guys on a nightly basis gets old fast. Every time a guy called me a whore or a bitch, it became harder to keep my mouth shut, especially when I was trying so hard to grow an adult-sized confidence. So when I told Vinnie that I was leaving, I had no regrets. I was definitely a child of the Crazy Horse—it gave me my first taste of independence and the tools I needed to survive in the real world—but I was ready for my next lesson.

Unfortunately, that lesson came a little sooner than I expected.

Chapter SIX

Until the day they bury me, a discarded pile of flesh, bones, and silicone, I will always be answering the same question. It comes at me every time I leave the house—which is less often than you might think because, believe me, it's not easy to tear myself away from the E! channel. Be it a man or a woman, a teenager or a grandparent, an attractive person or Bill O'Reilly, they all want to know: "So how did you start doing porn anyway?"

When someone asks an actor, a photographer, or a snowboard instructor how he or she got into the business, what they generally want to know is how to break in themselves. But in the case of my profession, what they generally want to know is what enables someone to make the decision to have sex with strangers on camera for a living. This is why the second question I get asked most commonly is whether I was beaten, abused, or suffered some sort of childhood trauma like a bump on the head or food poisoning.

The actual answer, which I never really realized until I started writing this book, is this:

Baby steps.

STEP ONE
Teenager wants to be a model.

REASON
Like all teenagers, she thinks she's special.

STEP TWO
Teenager starts dating a tattoo artist and biker.

REASON
He's older, badder, and allegedly wiser.

STEP THREE
Teenager becomes a stripper.

REASON
Work, money, and approval of boyfriend.

STEP FOUR
Teenager starts modeling nude.

REASON
It's just like real modeling, except with stripping added in.

STEP FIVE
Teenager starts acting in soft-core all-female adult movies.

REASON
Revenge.

I knew that Jack was cheating on me. The only problem was that I hadn't caught him yet. I staked out the tattoo shop, did drive-bys to check his whereabouts, and combed every inch of the house for telltale hairs, earring clasps, ponytail holders, and unfamiliar perfume smells. And my searches were thorough, because they were usually conducted under the influence of meth.

One night I got my chance. Jack was throwing one of his usual parties at the tattoo parlor and a tall, thick-bodied blond girl stood in the corner. Her eyes met mine and I just knew: she was the one—my rival, my enemy, my nightmare. As the night went on and the intoxication level increased, the girl kept looking at me not only like a woman sizing up her competition but also like a woman who was clearly attracted—or at least intrigued.

So when Jack went to make a beer run, I decided to befriend her. Her name was Lacey. Once I established that she knew we were dating, I set my trap.

"You know, me and my old man, we have a pretty open relationship," I told her. "I probably shouldn't tell you this, but I really get off on sharing girls with him. I love watching him fuck. So, since he told me that you guys have a little thing going on anyway, do you want to come do it with both of us?"

I wasn't sure how she'd react. I was being so direct. But her eyes lit up and she said, "We've only fucked a couple of times and, yeah, it would be fun with you."

Boom! Caught.

Now, a lesser girl would have kicked the crap out of her then and there. But I had learned the finer points of detective work from my dad. I knew that if I attacked her at the party, that would just make me look like a psycho bitch. If I waited and actually caught her in the act, however, then that would be another story.

So later in the night, I told Jack that I was attracted to Lacey and asked if we could take her home to play with. The idiot had no idea what was up and thought he could get away with fucking the other girl he was seeing right in front of me.

After the party, we brought her back to the house and all sat on the couch talking. I went to the bathroom, stayed in for a good ten minutes, and when I walked back out, Jack was still sitting on the couch. But his pants were down and she was kneeling in front of him with her top off, blowing him. I lost it. Knowing something like that is happening is one thing, but seeing it is another story altogether. My skin color must have changed from UV-lamp tan to sunstroke red. I was at the couch with her hair in my hand within a quarter second. I dragged her outside, kicked her in the stomach, and screamed, "How dare you fuck my boyfriend behind my back, you motherfucking bitch? If you ever come around here again, I'll fucking kill you." Then I slammed the door.

When I saw her clothes on the sofa, I realized that I had forgotten something. I opened the door, spit on her, and then slammed it again.

"You are out of your fucking mind," Jack yelled. He was in shock. "You're the one who invited her back here."

"You lying son of a bitch. You've been fucking that girl. She told me."

And then I broke down and started crying. "How could you do this to me?"

Jack didn't even bother explaining. He walked to the bedroom and slammed the door. I cried so hard that night I practically dehydrated.

As time passed and the wound didn't heal, I decided to get back at him and cheat, in my own way. In the biker and tattoo-artist community, the worst stigma a man can have is if his old lady is sleeping with someone else—and everyone knows it but him. And the best way for me to do that was on camera.

Chapter
SEVEN

Savannah had always been someone I looked up to. Every step I took, it felt like I was being drawn inescapably in the direction her career had gone in. So I knew that adult movies were in the future, but at the same time I wasn't necessarily ready yet. A girl really has to have her head and life together to do porn. Unfortunately, Savannah didn't. The former Shannon Wiley, after crashing her Corvette and disfiguring her face on the way home from a night of partying, shot herself in the head. She was twenty-three years old, depressed, and in debt.

When I heard the news, it seemed incomprehensible at first that such a beautiful girl would do that to herself. But then I looked at my own life: my career was on the fast track, but my family and personal life were in the shitter. It seemed like a formula for the same kind of tragic end. With such an unstable foundation, the larger an edifice of fame you build on it, the more unwieldy it becomes—until it just collapses. There were so many things I still needed to figure out for myself.

But instead I let Jack's cheating ways bring me into the business sooner than I anticipated. As I lay in bed each night, I imagined having this other life that he knew nothing about and couldn't control, a secret identity that would crush him if he discovered it.

The other temptation was money: Suze paid three hundred dollars a day. By appearing in a film, I could make anywhere from two thousand dollars to six thousand dollars for just a few hours of work. That's a lot of new purses.

Most girls get their first experience in gonzo films—in which they're taken to a crappy studio apartment in Mission Hills and penetrated in every hole possible by some abusive asshole who thinks her name is Bitch. And these girls, some of whom have the potential to become major stars in the industry, go home afterward and pledge never to do it again because it was such a terrible experience. But, unfortunately, they can't take that experience back, so they live the rest of their days in fear that their relatives, their co-workers, or their children will find out, which they inevitably do.

That could have happened to me. Fortunately, I decided to start slow. First, I experimented by doing a couple scenes for a company called Sin City in Vegas. All I had to do was basically pose for photographs in front of a moving camera instead of a still one. Since it was so easy, I decided to take the next baby step up: to soft-core, for which I didn't even have to spread and show pink. I had no problem showing my outside, but exposing my insides still seemed kind of gross. To this day, I still can't watch my own sex scenes.

The most prestigious soft-core director at that time was Andrew Blake, one of the few visionaries in the genre of titillation. He is an obsessive artist with lush Helmut Newton–inspired cinematography and beautiful girls, mostly top-of-the-line *Penthouse* Pets with natural boobs. He had also filmed with Savannah. So of course that's who I wanted to work for, despite the fact that he liked more curvy, sophisticated women. However, not one to get discouraged by slim margins of success, I told Julia Parton that I wanted to be in an Andrew Blake film. Julia had kindly allowed me to make her phone number my business line, so that Jack didn't find out what I was doing.

"I've got Andrew's number," she said. "Do you want me to call him?"

"No, that's okay," I told her. "I'll call him." By now, I knew a few things about marketing myself, especially to guys.

I phoned him the next day and said right away, "Hi, my name's Jenna Jameson. I would really really love to be in one of your films."

He didn't hang up on me.

"I know who you are," he replied. "I've seen one of your layouts."

I gave him my résumé anyway.

"I'll tell you what," he finally said. "I'm shooting in a couple of weeks with Kaylan Nicole, Celeste, and Julia Ann. Maybe that's something you would like to do?"

I was such a dreamer that I was actually disappointed. When I heard the names of all those top girls, I realized that I wouldn't be the star.

"Sure," I said. "I'm in."

"Would you be willing to do girl-girl?"

I didn't mind that. I just didn't want to be stuck having to get intimate with some drug-addled basket case. So I asked, "Can I pick the girl?"

"Who do you have in mind?"

I knew exactly who I wanted: Nikki Tyler.

"Let me look into it," he said, "and I'll call you back."

The next week, Nikki was approved and I was on the plane to L.A. once more. I had only worked with Suze before, where there was one makeup artist and you had to pick your clothes from her closet. But Andrew Blake's production was huge, with two makeup artists, a stylist, and half a dozen trailers. When I walked onto the set, everyone looked at me funny. I couldn't tell why. I climbed into the honey wagon and saw, in the front seat, a girl with black hair. She was slouched in her chair and so trashed that she couldn't even keep her head up. It was the first time I'd seen a girl in the industry who had let herself get that fucked up.

Nikki hadn't arrived yet, so I kept to myself. When it was my turn for makeup, I sat in the chair for what seemed like hours. The makeup artist was having so much trouble with me—putting on a new face, inspecting it, and then taking it off. Finally, I worked up the courage to ask him what was going on.

"Honey," he said. "Let's just say you're a challenge. And I mean that in the best possible way, sweetheart."

"I'm a big girl," I told him. "You can be blunt."

"You look like you're twelve, darling," he said. "I mean, a couple of the girls here thought someone had brought their daughter to the set."

He finally solved the problem, at least in his mind, by painting black makeup all around my eyes, so that I looked like a chicken in a Lone Ranger mask. Then he curled my hair into a twenties flapper 'do, and I was ready.

Nikki soon arrived and gushed, "Hi baby! How's my little girl?" And suddenly everything was good. I sat and wrote in my day planner as they worked on her. The ever-motherly Nikki brought a pedicure kit to the set, so since they were behind schedule—which I'd come to learn is nothing unusual—Nikki sat at my feet and gave me a pedicure. Every other person on the set looked at us like we were monkeys picking the bugs out of each other's fur.

When we broke for lunch, I made a beeline for the fruit table. As I was inspecting the bananas like a good monkey, a tall, thin, beautiful brunette walked up to me. It was Shauna Ryan, a *Penthouse* Pet and clearly the alpha female of the tribe. She looked me up and down and then sneered, "How old are you? Eleven?"

I turned and looked up at her and said, "A few decades younger than you." Then I went back to my bananas.

The strange thing about bullies is that if you take their abuse, it never ends. But once you get the balls to stand up to them, they respect you and move on to a weaker target. I never heard a bitchy word from her again. It was that easy—and that difficult.

After lunch, it was time for my scene. When I took my clothes off, Andrew Blake stepped out from behind his Bolex camera and gasped, "Wow! What a body! You have beautiful boobs!" If a guy in a strip club said that I'd think he was a creep, but coming from a director and authority figure it was the best compliment in the world. Since the scene was soft-core, we couldn't touch each other's private parts, so it was hard to really get into it. In fact, it sucked.

Andrew kept moving us to different locations. By the time we were at the fourth, in front of an artificial waterfall, Nikki and I had so much pent-up libido that our inner thighs were turning blue. For the shot, my back was to her and she was supposed to lean over me, kiss my neck, and

pretend like she was fingering me. My front was not visible from the camera's point of view, so Nikki started gently rubbing my clit as the Bolex whirred and clicked. The sound of it was so comforting and reassuring. I closed my eyes and just imagined being a twenties actress making her silent screen debut in Hollywood. Suddenly, my body began to shudder and my knees buckled. I arched my back and a soft moan escaped from my lips. I was coming.

I opened my eyes and Andrew was just sitting there, watching us with a big smile on his face. We had gotten totally lost in the moment, and I'm sure it was rare for him to capture authentic sex on a soft-core shoot. That is, if the camera was actually still rolling.

On the plane home, I was ecstatic. Moviemaking was so simple and fun. And I was sure that Andrew Blake loved me. At least, he loved my body and breasts, and we gave him a real performance. But he never called me again. I suppose his type of girl was dark-haired, shapely, and looked like she was old enough to vote. Even in interviews to this day, he says that I was meek, that nothing stood out about me, and that he didn't think I was going to make it in the business. And I have to give him points for his honesty, because almost anyone else would try to take credit for discovering someone.

It was disappointing not to hear from him, because I was so enthralled with the experience—and the end result. The scene looked beautiful, with grainy black-and-white footage of the orgasm. Seems the camera *was* still rolling.

Chapter EIGHT

Up and Cummers, volume 10

transcript 4/18/94

Jenna: Jenna Jameson　　*Kylie:* kylie ireland, her co-star

Randy: randy west, her male lead, and the director and producer of the *Up and Cummers* gonzo video series

Note to the reader: The following is Jenna Jameson's first interview, printed here for classroom study.

Randy West: Well, look what we have here today. Two cuties with nice booties.
Kylie Ireland: Hi.

Jenna waves.

Randy: Who is everybody?
Kylie: I'm Kylie.
Jenna: I'm Jenna.

Randy: Hi Kylie and Jenna. You guys sure are cute.
Kylie: Why, thank you.

Randy: Let's see. I guess I'll check you both out at the same time. Um. Kylie, raise your hand so I know which one you are.

Kylie raises hand.

Randy: That's Kylie over there. So that means Jenna must be on the right. . . . Let's find out a little bit about you. Where are you from?
Jenna: I'm from Las Vegas, Nevada.

Randy: So we're all Western folks now, huh?
Jenna: Yeah, I guess so.
Kylie: Just country girls.

Jenna *(sarcastically)*: Oh yeah.

Randy: And let's see. How old might you be?
Jenna: Well, I'm nineteen.

Randy: You're nineteen. And you have proof of it, thank god. Because you could pass for a few things. I won't say anything, but . . .
Jenna: Oh yeah, I have proof.

Randy: Yeah, I did see that beforehand. Were you a dancer too?
Jenna: Yeah, at the Crazy Horse Too in Las Vegas.

Randy: The Crazy Horse Too? I tend to go over to the Olympic Gardens a little more often.
Jenna: Oh yeah.

Randy: Did you ever dance there?

Jenna: Yeah, I was there for like one month, but it's like more of an upscale crowd.

Randy: Mm-hmm. And you'd rather have those cheap sleazy bastards, right?
Jenna: Yeah.
Kylie: They're a little more fun sometimes.
Jenna: Yeah, sometimes.

Randy: You see more of your friends there?
Jenna: Yeah, exactly.

Randy: Actually, I only went to the Crazy Horse Too one time, and it was so crowded because there was a convention there that I just left.
Jenna: Yeah, it gets really packed.

Randy: I'll have to go there on another night sometime and check it out.
Jenna: Yeah.

Randy: Um. And before you were a dancer, were you doing any other employment?
Jenna: High school.

Randy: High school?!
Kylie: That's employment. That's work.

Randy: They never paid me for that though. I guess you're kind of employed, but the fees aren't very good, are they?
Jenna: Oh, God, I'm glad it's over with.

Randy: So you got out of high school and got right into stripping, huh?
Jenna: Yeah.

Randy: And have you done any magazine work or anything?
Jenna: Mm, yeah. I've done every magazine. Except for *Playboy.*

Randy: Haven't done *Playboy*? What about, um, *Sports and Field* or *Fishing Illustrated*?
Jenna: Oh yeah. I'm into those rubber boots, you know?

Randy: Ooh, baby. Well, we'll bring you back for another time. So have you done *Penthouse* or *Hustler*?
Jenna: I've shot for *Penthouse* and it should be coming out soon. But I've done *Hustler,* and I'm shooting for them this week for a centerfold. So look for me.

Randy: I will. Don't worry about that. Um, I guess that pretty much covers it. Right now you guys look so pretty, I'm gonna shut up because I just want to see you guys get to know each other a little bit. Is that alright with you?
Jenna: Absolutely.
Kylie: It's alright with me.

Randy: Okay. Right now it's your world, and I'm just passing through. So have a good time and I'll see you later.
Jenna: Yay.
Kylie: We're free.

Phone rings.

Chapter
NINE

After the Andrew Blake movie was released, I received a call from Randy West, a roots-rock singer from New York who had moved to Los Angeles to become a star. But soon he was making a living with his surfer-hoodlum-doughboy looks instead: first as a *Playgirl* model, then as a Chippendale dancer, and, finally, starting in the mid-seventies, in adult films. After appearing in hundreds of movies, he had decided to start his own video line, *Up and Cummers,* a gonzo series which usually starred Randy having sex with different girls. The conversation went something like this:

Randy: So, are you interested in coming out to L.A. to shoot a video?
Me: Absolutely not. I only want to do high-end stuff.
Randy: The pay is three thousand dollars for one scene.
Me: What day you want me there?

I told Randy that I would only do scenes with girls, and he agreed. He told me the girl would be Kylie Ireland, a stripper and former video-store manager from Colorado who had gotten into the business the week before and had already filmed five movies. He flew me to Los Angeles and I stayed at his house in the Hollywood Hills. Unlike Andrew Blake, Randy West's entire crew consisted of himself. As for trailers and Kraft services, there were none. And, for a set, Randy just threw a blanket down on the lawn and let us go at it. I felt comfortable with Kylie

instantly. She didn't take herself too seriously, and wasn't constantly condescending to me and acting competitive like other girls.

There was no script, no lighting, no direction—it was just sex in front of a camera. From the second work started to the second we were finished, the elapsed time was an hour and a half. We kissed, ate each other out, and played with some toys he had brought. It was easy work.

Unlike Andrew Blake, Randy wanted to film me again. Right away. The moment we finished filming, he pulled me aside. The conversation went something like this:

Randy: I will pay you twice as much if you do a boy-girl shoot.
Me: I told you, I don't want to do that.
Randy: How about we do a boy-girl-girl shoot, you only work with the girl, and I still pay you twice as much?
Me: Sure. I don't see a problem with that.
Randy: Will you do a little bit of head?
Me: We'll see how it goes.

I had only worked with a guy once before, during a photo shoot with Suze a few months before. She'd called me and said she had an amazingly talented and ridiculously attractive male model she wanted to photograph me with. I wavered, so she sent me pictures of him from *Playgirl.* He was their Man of the Year. I decided that if I was going to do a boy-girl shoot, I might as well start with the best.

The next week, I went to Suze's studio, which was decorated like a bad Western set, and met Marcello. He was incredibly attractive, a cross between Antonio Banderas and the one-hit-wonder Gerardo, but he was also the most stuck-up, self-obsessed man I had ever met. He fussed over his hair more than most girls, couldn't stop gazing at himself in every reflective surface, and even brought his own face tanner. Fortunately, I didn't actually have to touch him anywhere. All I had to do was get close enough to make it seem real. He was so creepy and unlikable that I didn't work with a guy again until Randy West.

Randy, who of course volunteered to be the man in the shoot, was a decent guy. He was a little old and had the fashion sense of a homeless wrestler, but I didn't have to touch him if I didn't want to. So I figured a threesome—technically a two-and-a-halfsome—would be tolerable. Before shooting, he interviewed Kylie and me. It was the first time I had ever been interviewed. Though I would soon tire of hearing the same questions constantly, it was exciting because as I spoke, it dawned on me for the first time that this really was a professional career for me now, albeit an odd one.

During the scene, I was even inspired to help Kylie give him a blow job. I needed something to do to keep from looking stupid on camera, so I just held it in my mouth a little. But afterward, as I sat there trying to keep myself busy while watching Kylie and Randy fuck, I thought, "That doesn't look so bad."

Randy West must have either recognized my potential or wanted to fuck me really badly, because afterward, he pulled me aside again. The conversation went something like this:

Randy: How about doing a shoot with just me tomorrow?
Me: How many times do I have to tell you, I don't really want to do that.
Randy: How about I pay you two thousand dollars more?
Me: Two thousand more than today?
Randy: Yes.
Me: Is tomorrow good for you?

It wasn't just the money. The ever-increasing amounts just helped rationalize it. I was nineteen and had been in every hard-core adult magazine there was, except for maybe _Over 60 and Still Swinging_. There was nowhere else to go. Adult films seemed like the natural next step. Many of the other magazine girls at that time didn't move on to film. There were notable exceptions, though: Savannah, of course, whom I had seen in my dad's copies of _Penthouse_ and _Hustler_ before she ever appeared in films; Racquel Darrian was a top nude model; and Janine Lindemulder

was one of the most published girls in *Penthouse* before she started working for Andrew Blake. Besides, if I made it in film, then maybe the magazines would finally start calling me Jenna Jameson in my pictorials instead of Shelly and Daisy and Missy.

After my tentative threesome with Randy, I knew I could do it with him. And if, along the way, I got a couple jabs in at Jack, all the better. For the girls who get penetrated in every hole in their first film, it's physical and mental overload. The easiest way to approach anything new is to take those cautious baby steps, and Randy was teaching me how to walk one thousand dollars at a time. Of course, he denies to this day that he gave me that much money, but that's probably because other girls would expect it then, too.

The next day, Randy set up the camera in his bedroom as I put on a sexy white tennis dress. He stood behind the camera and posed me, asking me to lick my breasts and spread my legs and—something I wasn't expecting—put my fingers in my ass. I was caught off guard, but I just smiled, arched my back, reached my hand behind me, and hoped he didn't push me any further. I was so used to posing for Suze that I knew exactly how to bend my body, turn my head, and seduce the camera. While I was tentatively putting a finger up my backside, Randy climbed onto the bed with me.

He interviewed me for a while, rubbing his hand lasciviously all over my body. I wasn't sure I could go through with it, because he seemed a little bit lecherous. But the moment he shut up and stripped down, something snapped inside me and a primal part I had never been in touch with leaped out. It was like the moment I first used a strap-on with Nikki, only much more intense. I turned into a different person. Doing scenes with other girls was like dancing with another woman: There was no one to lead; it was just fluffy and tame. With a guy, there was strength, energy, intensity, and passion. It was a dance in which we wrestled for control. And as soon as I let go and abandoned myself to the moment, I won.

I wasn't ready to experience something so explosive, something in which I had absolutely no shred of self-consciousness. Neither was Randy.

When I gave him a blow job, working my mouth and my hand on his shaft with an expertise I never knew I had, he kept stopping me. From the grimace on his face, I could see that it was taking every ounce of self-control he had to keep from blowing his load and ruining the scene.

It was so much different from sex at home, because here I had the camera as an audience, and every muscle in my being was just naturally flexing, twisting, and arching to make sure our dance looked good for the lens. And knowing that I looked sexy made the sex itself better. Randy, in the meantime, seemed to have forgotten about the camera entirely. When I was on top of him, he had this expression on his face that read, "Holy shit!" And when he flipped me over, he kept whispering my name under his breath and throwing me into positions that seemed more for his benefit than the camera's. Then, about forty minutes into it, something strange happened.

As he was nearing orgasm, he suddenly stopped his jackhammer pounding and leaned over my ear.

"Can I come in you?" he asked.

I was expecting him to follow the tried-and-true formula of pulling out for a pop shot on my face or boobs. And, to tell the truth, it was the part of the scene that I was dreading the most. This was not something I had done before with Suze or in soft-core.

Instead of pulling out, however, he came deep inside me. I thought, "That's not going to look very good on film." Then he pulled out and said, "Squeeze."

I flexed my PC muscle and the cum just burst out of me, accompanied by a loud squirting sound. It would be an unglamorous but pivotal moment for the adult film business—one of the first internal pop shots.

Afterward, Randy kissed my back. It was a strangely affectionate move to make in a movie like this. Then he turned to the camera and said, "She's kind of like Randy West with a pussy and tits."

I had found my calling.

TEN

UP AND CUMMERS, VOLUME 11

TRANSCRIPT 4/19/94

Jenna: JENNA JAMESON

Randy: RANDY WEST, her co-star, and the director and producer of the *Up and Cummers* gonzo video series

Note to the reader: The following sex scene has been transcribed in its entirety, so that no scintillating detail is left to the imagination.

Jenna (*on bed with cat*): Come here, Mama.

Randy: Well, I uh obviously don't have animals in my shoots. However, we did want to bring Mama out for a cameo because she's the most famous cat in the adult film business because all my friends know her and love her. And she thinks she's people. She's been waiting to model for a long time. And you guys look so good together. Two of my favorite pussies, there's no doubt about that.

Jenna laughs uncomfortably.

Randy: All right Mama, we're going to have to say good-bye to you because we're gonna work on this blonde over here.
Jenna: Aw, she doesn't want to leave.

Randy: No she doesn't. Well, you know what we're going to do, Jen? I think I'm gonna talk you through the way we would do it for a still shoot, and show everybody at home what it's like when you're doing the still shoot and stuff, because a lot of people are curious.
Jenna: All right.

Randy: We'll do a little bit of that and we'll get you naked and we'll let you show off a little bit. And when I can't stand it anymore, I'm jumping into my bed with you.
Jenna: Okay, sure.

Randy: I want you to do some poses like you were posing for a magazine, so I'll talk you through a few things and if you come up with some ideas, you know, you can lay them on me.

Phone rings.

Randy: I'd like to see you slowly unzip that thing a little bit for me.
Jenna: All right.

Randy: Oh, good. Let me see. Get your hair out of your face. Let me see that. Put your hand on your breasts. Nice. Very nice. Yeah.

Randy: Take your right breast out. Let's see you play with it a little bit. Can you lick it?
Jenna: Oh yeah. (*Giggles*)

Randy: Let's see it. Mmmm. Oh, that's hot.

Jenna plays with her breasts.

Randy: Let me see those eyes again. Do that one more time. Let me see the eyes. If I'm shooting stills, I'd want to see the eyes now. That's the shot you'd see in your magazines, folks. Right there. Yeah. Great.

Jenna looks up at the camera.

Randy: Just put your fingers on your nipples. Just rub the tip of the nipples. Good. Good. Good.

Jenna complies.

Randy: Let's see what you got going on down here. Why don't we spin you around baby. Spin you around. Let's see some butt. Mmm. Yeah. That's it. There. That's how she'll pose. Right there. That's it. That cute little smile, nice butt. Nice baby. Now let's see you bend over. There's another shot. I'd have that in the layout, no doubt about that. Beautiful. That's beautiful, baby.

Jenna poses.

Randy: Let's see you put your hand between your legs and rub your pussy a little bit. From underneath. Yeah. That's great. Another shot for the layout right there. Beautiful.

Jenna strikes another pose.

Randy: Okay, Jenna. Do me a favor. Pull those panties over to the side for me. That's it. Arch your butt way over. Pull it back over the butt cheek. There you go. Beautiful. Yeah. Nice, baby. How's that feel?
Jenna: Mmm, good.

Randy: Okay, now I want to do one of those classic butt shots. I want you to put your hands on your cheeks. Spread 'em for me. Can you do that with two hands? Are you in a position to do that? Yeah. Yes! Oh. That's nice. That's nice. This is what the boys and girls want to see.

Jenna giggles.

Randy: Yeah. Okay, give me one big spread shot right there. A nice big one. Yeah. Oh yeah.

Jenna does as she's told.

Randy: Now can we do that with the pussy too?
Jenna: Oh yeah.

Randy: If we're shooting a magazine, I got to see some spread. Pretty pink. Yes. That's it baby. Nice. Oh yeah. Let's see that pretty pink. Mmm. Good. Can I see a finger go in that pretty pink? Mm-hmm.

A finger goes in that pretty pink.

Randy: Can you put your finger in your ass for me a little bit?
Jenna: Mm-huh. Oh . . .

Randy: There, baby. Mmm. You are getting this photographer awful horny.
Jenna: Mmm. Yeah?

Randy: Yeah. Are you getting a little horny?
Jenna: Yeah, definitely.

Randy: Do you get horny when you shoot stills?
Jenna: Yeah (*pause*). Usually.

Randy: Really?
Jenna: Yeah.

Randy: Do you ever get off when you're doing it?
Jenna: No, I'm not allowed to.

Randy: You're not allowed to?
Jenna: Unless I'm shooting a girl-girl. But not usually on my own. I usually go home and take care of myself.

Randy: Finish the job at home, yeah? But it is a turn-on to shoot, though?
Jenna: Oh, absolutely.

Randy: Yeah?
Jenna: Yeah.

Randy: Good. Is this a turn-on too?
Jenna: Yeah, in a big way. (*Giggles*)

Randy: Well, I'll tell you what. Do you mind if I join you?
Jenna: I think that that would be great.

Randy: Good. I was hoping you'd say that. I'm going to get my camera-man, and I'll be right back. You can, uh, do what you want to do and I'll be back. Keep it warm and wet for me, okay?
Jenna: No problem.

Randy: I didn't think so. (*To audience*) See, what happened is we did that first shoot with Jenna. Well, can we tell them the truth, kind of what happened? You did your first boy-girl shoot. It didn't come off quite as good as you had hoped.
Jenna: Yeah.

Randy: She got kind of nervous about doing boy-girl stuff, so when I got her together with Kylie I asked her if maybe we could do some boy-girl stuff and improve on last time.
Jenna: Yeah.

Randy: She finally said okay, we can do a little oral stuff. But we didn't really complete the deal. So I talked to her and asked her what her state of mind was now and she said it's a lot better. I said, "Good. Can we just do regular boy-girl?" She said, "Yeah," she'd like to try it. And let's see if we can put a good one on tape for her.

Jenna giggles.

Randy: So this is kind of a continuation from last time, except it's kind of like the guy who liked the razor so much he bought the company. I liked Jenna so much I brought her back to my place. So that's the story. And here we go.

Later . . .

Randy: In case you didn't notice, these are one hundred percent all-American breasts. No artificial ingredients, fillers, or colors.

Still later . . .

Randy: I could eat your pussy for months.
Jenna: I'd let you.

Randy: I've been waiting so long to be alone with you. Oh yeah.

Even more later . . .

Randy: I love a good blow job. But your hand feels so fucking good. If you do them both together, I'm dead meat. Oh man. I told you. Oh fuck. Oh baby. Come on, save that for the end.

A little bit laterer . . .

Randy: Let me ask you something: Do you have a favorite position to have sex in?
Jenna: Doggie style.

Randy: You like doggie style?
Jenna: Mm-hmm.

Randy: Do you want to start with doggie or finish with doggie?
Jenna: Finish.

Randy: Finish?
Jenna: Yeah.

Several positions later . . .

Randy: In case you can't tell, I'm crazy about you.
Jenna: Mm-hmm.

Randy: I want you to fuck my cock exactly the way your pussy likes to fuck. I'm just going to keep it nice and hard.

A good pounding later . . .

Randy: Okay baby, let's bring this one home, huh? I am dying to come in you. Do you mind if I come inside ya?
Jenna: Mmm, I'd love it.

Randy: I'd love it too. I've never done an internal cum shot yet. For you I'll make an exception. You like that? Does it feel good when a guy comes inside you?
Jenna: Oh, I love it.

Randy: Can you tell the difference?
Jenna: Oh yeah, I like to feel it.

Randy: Good.
Jenna: Yeah.

Randy: Oh God. Yeah. Oooooooooh yes. Are you gonna cum with me?
Jenna: Yes.

Randy: Yes?

Randy begins to orgasm.

Randy: Yeah! Ha ha! Ah ha. Ahh. Ha. Ah. Ha ha. Ha. Oh baby. Oh fuck. Ha. Ha. Ha. Ah. Oh baby. Huh-ahhh. Ah. Oh God. Oh God. Mmm. Yeah. Squeeze.

Gurgling sound of cum being squeezed out of Jenna.

Randy: Oh ho ho. Oh yeah. Oh fuck. Yeah. Oh look at you. Look at you. Look at that. Oh baby. You are so fucking fine.

Jenna giggles.

Randy: Oh, girlfriend. My first internal cum shot was a beauty. With a beauty. You're fucking awesome. Fucking awesome. Yeah. (*To audience*) Well guys, here's probably Jenna's first really good boy-girl scene.
Jenna: Yeah.

Randy: Does that rate on your scale?
Jenna: Absolutely.

Randy: Good. There you go. (*Picks something out of her mouth.*) A little lint. I guess it was such a good fuck, she started sucking off my bed is what happened. Got a few strands left on there, y'know. Well, I'll tell you what. Whether you like it or not, I'm bringing Jenna back for some more stuff. Okay? Keep your eyes peeled. Who knows what she's gonna do next?

Chapter ELEVEN

When *Up and Cummers #11* came out, my life changed. Everyone in the incestuous little world of adult film was suddenly buzzing about this new nineteen-year-old all-natural sexual dynamo with the face of a little girl. There was only one drawback: Jack found out.

I came home from Jennifer's apartment one night and he was sitting on the couch, just waiting, his veins practically popping out of his head. I sat down across from him, and he blew up.

"You are a fucking whore! Why would you ever do this?"

He picked up the videocassette and threw it at me. It hit the wall, leaving a black dent. He didn't have a problem with the girl-girl stuff I had done in magazines, but being with another man on camera was worse than cheating in his mind.

"You're an idiot!" he screamed. "How could I ever love a girl who would fucking do this to me?"

"Come on!" I yelled back. I was growing the confidence to stand up to him now. "How many girls have you fucked at the tattoo shop? How many? Be honest."

"Jenna, give me a break. You are a fucking psycho. There was no one besides Lacey. Give it a rest, for chrissake."

I knew that was a lie. I had inside information that there were others. And I didn't feel a shred of remorse or guilt for doing the movies behind his back. I had beaten him at his own game. I had taken revenge in a way that the whole world could see.

We yelled at each other for an hour straight, destroying dishes, CDs, a bookcase, a coffee table, and my last surviving Barbie doll, in the process. Finally, he stormed out of the house, slamming the door so hard that chips of paint flew off.

He was gone for seven days. During that time my dad called. He and Tony had finally stopped running, he promised, and settled in a town called Reading in northern California with Grandma and Selena. He had met a lady up there and married her, and he wanted to give me his new number.

One afternoon a few days later, I came home from shopping and Jack had reappeared. He was cutting up lines on the kitchen counter.

"Here, you can have the biggest one," he said.

He handed me a rolled-up dollar bill. I bent down and snorted it all. Suddenly everything was back to normal again. They say that time heals all wounds, but drugs get the job done quicker. Ever since I'd quit the strip club, I'd started spending more and more of my nights with a dollar bill up my nose. As a result, I began to lose the independence I was starting to achieve. I began to cling to him more, because now he was not only my boyfriend but also my dealer. For the first time in months, we started having sex again (perhaps because he wanted to regain his masculine pride after seeing the Randy West video). And every now and then, I'd wake up in the morning and fly to Los Angeles to do more of those movies that he didn't want me appearing in anymore.

One of the most frustrating things about the film work was that the producers never wanted to put me on box covers. They all said my breasts were too small. My boobs were certainly big enough for all the men who stared at them every time I left the house. But they weren't big by porn standards. Just like at the Crazy Horse, the girls with the monster silicone got all the attention and I had to compete with the one organ I had that was bigger, my brain.

But then I met a producer in L.A. who called himself Nappy Headon. He wanted me to star in a movie called *Sponge Cake,* and he promised to put me on the box cover. Before then, the only box cover I'd been on was *Up and Cummers,* but this was a feature.

However, I'd have to perform with a guy again. (For the box cover shoot, the photographers, Brad and Cynthia Willis, a husband-and-wife team, actually made me wear a push-up bra so that my breasts looked bigger.)

The movie was filmed in a house in Studio City. I didn't know anybody there; the rooms didn't look like they'd been cleaned for years; and, in comparison with Andrew Blake's sets, the production seemed beyond low-budget.

The plot was very original: a naïve young girl from the Midwest runs away from home to make it in Hollywood but somehow finds herself in the adult film industry and has to hide the truth from her boyfriend back home. I was the naïve young girl, and something about the story had a ring of autobiography to it. While I was waiting for my first sex scene, my co-star, a gentleman I had never met before named Arnold Biltmore, sat next to me. He had a soft, pasty body; a porous, greasy complexion; and a kindergarten haircut, parted in the middle and combed to either side.

He flashed a big shit-eating grin and said, "So, are you ready to have a good time?"

I smiled back at him, wanly.

"You know," he said. "You're a cute girl. You've got potential. Congratulate yourself."

He wrapped his sweaty arm around me. I was so obsessed with Jack that I never even thought about other guys; but even if I had been on the market, this guy still would have creeped me out.

"Look at you," he said. "You're like a lost little lamb with a cute pink belly."

I gave him no encouragement.

"Here," he said. "You look tense. Let me give you a back rub."

He started kneading my shoulders. I stiffened my body.

"I'm thinking," he continued, "of getting a tattoo of a sundial around my dick, so that whenever I get hard I can tell what time it is."

Nothing about Arnold Biltmore turned me on. And in ten minutes, I was supposed to be having sex with him.

When our scene started, he tried to kiss me. I turned my head away from the camera, so that no one could see me grimace. All girls, be they sorority girls, porn stars, or Botoxed old ladies, like rock-hard dicks that look like they're straining to wiggle free of the man they are attached to. But Arnold's dick never felt like it got all the way hard. It was stiff but mushy, like a twig that's been seaborne for several days. Prior to this movie, I'd had only good experiences. But as my head kept bumping into his stomach while I gave him head, all I could think was, "What the hell am I doing here? This is disgusting. This is not me." This was truly the underbelly of the business.

"Now slowly roll your eyes upward and linger there," the director yelled at me. He wanted one of those shots where I look up with soft, doe eyes as I'm giving head and make intimate eye contact with the camera—and, by extension, the person sitting at home watching. I slowly tilted my head back and rolled my eyes upward. And then I saw it. A bead of sweat on Arnold's forehead seemed to be glistening more than all of the other dewy particles there. It swelled and grew until it turned into a bubble, and then slowly pried itself free of his forehead. It dropped slowly, growing from my perspective to the size of a beach ball.

When it smacked me between the eyes, it flipped a switch in my head. "I'm done," I thought. "I can't do this anymore."

After the scene, I didn't talk to anybody. I went to the dressing room to gather my clothes. Kylie Ireland was in there with her manager, an obsessive, overbearing guy who was willing to be her lapdog in exchange for the opportunity to suck as much money as he could from her. We call those types of people suitcase pimps. They date industry girls, become their managers, take all their money, and often leave them broke, jobless, prematurely aged wrecks. These fine specimens can often be seen trailing behind the girls in airports, carrying all their suitcases. Porn stars constantly go for this type of guy because they think he's going to protect her, manage her, and do her drudge work for her. After a girl works in the industry for a while, that's the only thing guys seem good for—taking care of stuff.

Kylie was having trouble with her sponge. When a girl is on her period, a company can't afford to put a movie on hold and wait until she's not bleeding. So some genius came up with the idea of inserting a sea sponge against the cervix. It catches all the blood, and the camera never sees a thing.

Kylie couldn't seem to pull her sponge out, so her suitcase pimp decided to come to the rescue. He knelt in front of her and reached deep inside her. He had a very strange expression on his face, as if he actually enjoyed the responsibility. When he fished it out between his bloody fingers, he actually sniffed it. I had to get out of there. I never wanted to do another movie again.

YOU MAY HAVE SEEN HIM BEFORE, YELLING AT HIS GORGEOUS GIRLFRIEND, AND WONDERED, "WHY DOES SHE PUT UP WITH THAT?" OR "WHAT DOES HE HAVE THAT I DON'T?" THE ANSWER, MY CURIOUS FRIEND, IS A *FANNY PACK!*

THIS EXOTIC SPECIES CAN OFTEN BE SEEN IN AIRPORTS. LOOK FOR A GIRL WITH BIG BLOND HAIR WEARING A HALF TOP, NO BRA, AND PLATFORM HEELS, TALKING ON HER CELL. BEHIND HER YOU'LL FIND A MAN CARRYING 18 PINK SUITCASES, WEARING A GOLD'S GYM TANK TOP, SHORTS THAT ARE TOO TIGHT IN THE ASS, AND OF COURSE, THE *INDUSTRY STANDARD* FANNY PACK.

NOW, THE TIME HAS COME TO ASK YOURSELF: ARE YOU *PREPARED* TO MAKE THE CHANGES NECESSARY TO DATE A PORN STAR? IT WILL BE A LONG AND ARDUOUS JOURNEY, BUT THE PATH IS OPEN TO ANYONE -- LOOKS, INTELLIGENCE, FAME, AND MONEY ARE NOT NEEDED.

ALL YOU MUST DO IS FOLLOW THESE *SIMPLE STEPS:*

SUITCASE PIMP CHECKLIST

✓ FANNY PACK W/ LUBE, BABY WIPES, LIP BALM, JUICY LIP TUBES, DENTAL FLOSS, SEVEN LIGHTERS (SHE ALWAYS LOSES THEM)

✓ WARRANT OUT FOR YOUR ARREST

✓ SPIKED HAIR OR SHAVED HEAD

✓ FLASHY JEWELRY; PIERCINGS AND TATTOOS

✓ NO SMILING OR LAUGHING

✓ MEMORIZE PHRASES : 1) "WE ARE GOING TO BE FAMOUS"
 2) "SHOW MORE PINK"

✓ RESEARCH FOLLOWING SUBJECTS: 1) LATEST MAC PRODUCTS
 2) WEAVE MAINTENANCE
 3) HAIR EXTENSION REMOVAL
 4) G-STRING CLEANING
 5) GIVING GUILT TRIPS

CHOOSE ONE DRUG FROM ANY TWO OF THE FOLLOWING COLUMNS TO BECOME ADDICTED TO:

COLUMN A	COLUMN B	COLUMN C
CRYSTAL METH	HEROIN	STEROIDS
COCAINE	OXYCONTIN	
GLASS	PERCOSET	
SPEED	PCP	
CRACK		

NOW THAT YOU HAVE **TRANSFORMED YOURSELF**, YOU ARE READY TO FIND A GIRL. BUT SCHOOL IS NOT OVER. YOU MUST FOLLOW THESE RULES OR YOU WILL LOSE HER!

ALWAYS REFER TO HER MONEY AS **"OUR MONEY."** USE THE TERM **"WE"** FOR ALL BUSINESS NEGOTIATIONS. HOWEVER, ALWAYS USE THE WORD **"YOU"** WHENEVER A MISTAKE IS MADE, EVEN IF IT'S YOURS.

WE DON'T DO ANAL.

insert your picture here

HAVE A **GET-RICH-QUICK PLAN** THAT WILL NEVER WORK. HERE IS A SIMPLE FILL-IN-THE-BLANK FORMULA:

WE'RE GONNA TAKE ALL OF **OUR** MONEY AND PUT IT INTO _____. BUT FIRST WE NEED TO BUY OURSELVES A _____.

AND THEN WE HAVE TO BUY **ME** A HARLEY.

insert your picture here

WHEN SHE IS WORKING, SUPERVISE ALL CONTACT WITH MEN AND AFTERWARD, **ACCUSE HER** OF FLIRTING. IF THERE IS A MALE LEAD YOU DON'T WANT HER WORKING WITH, THIS WORKS ALL THE TIME:

PSST, I HEARD HE IS **BI**!

insert your picture here

DIRECTO

GET YOUR NAME **TATTOOED** ON HER...

NE

... BUT SOMEWHERE THAT IT WON'T **INTERFERE** WITH HER CAREER.

WHEN TALKING TO OTHER MEN, DON'T DISCUSS ANYTHING BUT **"DEALS"** AND TRYING TO MAKE ONE. MAKE SURE THAT YOU NEVER ACTUALLY **CLOSE** ANY OF THESE DEALS.

insert your picture here

TRY TO GET EVERY WOMAN YOU MEET INTO THE INDUSTRY --- NO MATTER WHAT SHE LOOKS LIKE.

insert your picture here

AND YOU'RE NOT IN MOVIES, WHY?

PURCHASE EVERY VIDEO GAME SYSTEM AVAILABLE. THIS IS HOW YOU OCCUPY YOUR TIME WHILE SHE IS ON A JOB. IF SHE HAPPENS TO CALL YOU, *CHEW HER OUT.*

WHY YOU INTERRUPTIN' MY *WORK?*

insert your picture here

DERIVE YOUR ENTIRE SENSE OF CONFIDENCE FROM HAVING A PORN STAR GIRLFRIEND BUT, AT THE SAME TIME, *RESENT HER* FOR WHAT SHE DOES.

insert your picture here

TAKE HER TO CLUBS *AFTER-HOURS* TO REHEARSE POLE WORK AND VARIOUS STAGE ROUTINES.

SLOW DOWN! MORE *EYE* CONTACT!

insert your picture here

COACH

WHEN SHE IS FINISHED DANCING, *COLLECT THE MONEY* ON THE STAGE AFTER HER. THEN MAKE YOUR CHILD SUPPORT PAYMENTS WITH THAT MONEY.

ONE FOR US, ONE FOR *ME.* ONE FOR US, ONE FOR *ME.*

insert your picture here

LEARN HOW TO TREAT A WOMAN TO DINNER *WITH HER OWN MONEY.* EXTRA POINTS IF YOU ONLY ALLOW HER TO EAT A SALAD.

YOU GONNA EAT ALL THOSE CALORIES?

insert your picture here

FINALLY, WHEN SHE IS ADDICTED TO DRUGS, AGED BEYOND HER YEARS, AND CAN'T WORK ANYMORE, HELP START THE CAREER OF A *FRESH NEW GIRL.*

WE ARE GOING TO BE *FAMOUS!*

insert your picture here

GYM

MORAL: *BEWARE THE FANNY PACK.*

SUITCASE PIMP JOKE: WHY DO PORN STARS DRIVE SUCH *BIG TRUCKS?*

A: TO PULL HIS JET SKIS.

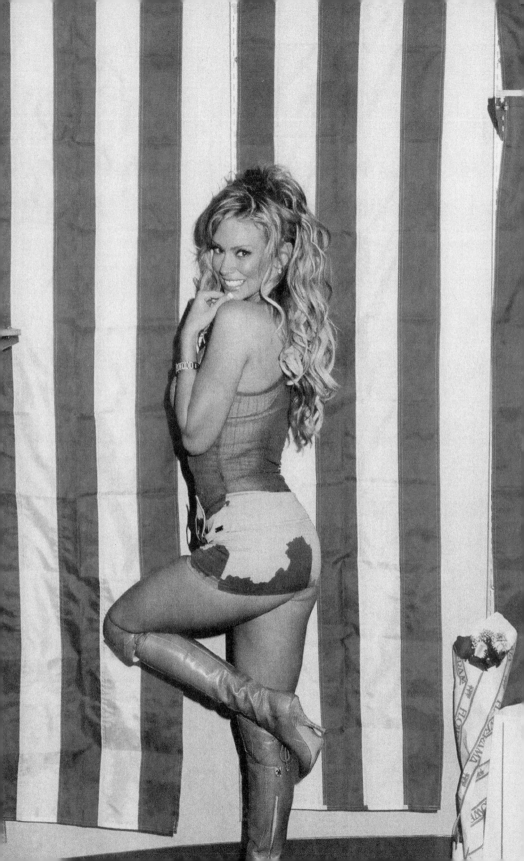

Chapter THIRTEEN

When I returned to Vegas after the *Sponge Cake* shoot, it was one of the most depressing times of my life. I had hit a wall: my career, as far as I was concerned, was over. As soon as I don't feel like I'm moving forward or don't enjoy something anymore, I tend to just give it up. And so I left the business. I was done with movies, and there was no way I was going back to the Crazy Horse.

I had no idea what to do next. All I had, once again, were Jack and Jennifer. So I started hanging out at the tattoo shop, building needles for Jack and shooting the shit with Matt. And every now and then, when I needed the money, I booked a photo shoot. After *Sponge Cake* was released, Nappy Headon, the producer, called and asked me to do another movie. I was high at the time and low on money—the two criteria for most bad decisions in the world—so I told him I would. Two weeks later, the tickets to Los Angeles arrived. I never used them, and I never called to cancel. At that point, I was too far gone on meth.

Just after my twentieth birthday I decided it was finally time to do something that had been on my mind for the last three years. Now that it was too late to give me a competitive edge, because I was no longer stripping or doing movies, I was ready to get a boob job. All those customers and box covers lost to girls with bigger, faker breasts had built a deep insecurity.

More than that, I prided myself on being able to change my appearance. For a *Hustler* cover, I'd cut my hair short. For a movie, I'd feather it

and wear heavy blue eyeshadow. But I had done so many photo sessions in the past year that I was literally being shot out of the business. I needed to do something to get more jobs, otherwise I'd lose the only source of income left to me. At least, that's what I told myself. The real reason, in retrospect, was that I wanted more attention from Jack. I thought that if I looked sexier, he would want me more. How pathetic.

I was so skinny and unhealthy from the meth that I decided to clean up, and eat up, before getting the implants. So I quit the drugs for two weeks, gained some weight, and went with Jennifer to see the wizard who had bestowed her with beautiful C-cups, Dr. Canada.

Mine didn't turn out as well.

I only wanted to go one cup size bigger, but Dr. Canada got a little carried away. He went under my muscles, which were strung incredibly tight from years of gymnastics, ballet, and pole work, and put in these huge boobs. With an implant that big underneath my muscle, it felt like fucking Barnum and Bailey's Circus was sitting on my chest.

I cried when I looked in the mirror afterward: they seemed way too big for my frame. Afterward, Jennifer bought two cakes (one for each implant) and we threw a birthday party for my boobs at a local Italian restaurant. I'll never forget it, because for years afterward I continued to celebrate my boob day every July 28.

I drank a little to kill the pain and, when I was good and buzzed, stood up and took Jennifer's hand. She looked so beautiful, and I wanted nothing more than to press her Dr. Canada boobs against my Dr. Canada boobs—gently, of course.

I led her to the bathroom, like I had so many times before, and we had sex in one of the stalls, like we had so many times before. But the routine ended there.

"I can't do this anymore," she said.

"What?" That was the last thing I expected. "What's wrong?"

"I'm pregnant."

My face fell. That asshole Lester had knocked her up.

"For how long?"

"Three months," she said.

"I guess that means you're keeping it." It was such a selfish comment for me to make, but I was in shock. I was hurt she had known before we had sex that it would be the last time, and hadn't told me until afterward.

She didn't say anything. She just looked at the floor, as if she were ashamed of having done something wrong in my eyes. And she was right: she had. I was still in love with her. My baby was pregnant with someone else's baby. And I didn't even like that someone else—the guy was cut from the same cloth as Jack. When I feel betrayed, I cut that person out of my life to protect myself from getting hurt anymore. So I stopped seeing Jennifer after that, and I lost one of the only people in my life who truly seemed to have loved me.

A couple weeks later, I was mostly healed from the surgery. I still felt like someone had built two spacious mosques on my chest. But I wanted to show them off anyway. You can always spot a girl in a bar who has just gotten a new breast job, because she's flashing them to everybody. It's not like showing someone the breasts you were born with. These are fake; they're not yours, which creates the illusion that you're not revealing anything personal and private.

I put on a white tank top that I had taken a pair of scissors to, trimming the neckline to show as much cleavage as possible and the bottom so that these strange new globes poked out of them. Then I went out with Jack and his friends to shoot pool. Jack couldn't keep his eyes, and hands, off them. When I leaned over to take a shot, and I saw half the bar trying to look down my shirt, I thought, "Oh, yeah. Dr. Canada in the house." Suddenly, too big was just right.

It never occurred to me at the time that it wasn't even that big of a boob job—or that good of one, either. Furthermore, I didn't realize until years later how stupid I was for even getting them. Drugs tend to impair your judgment and, even if you clean up for a week or two, they're still in your system. Fake breasts just weren't me. I should have just been comfortable being myself and relying on the intelligence and ambition that had gotten me to the top as a stripper and model to begin with.

Perhaps I always associate that boob job with the bad decisions I made in life, because they came at the beginning of a downward spiral. When I was younger, I followed the rules, went to school, and got good grades. On weekends, I'd drop acid for two days straight, but I never thought of it as a bad thing. We'd write down our revelations and then the next day, we'd read these papers that were covered with insights like, "My ass is like a bagel in the moonlight." It was all part of growing up and finding yourself. In my mind, the so-called bad drugs were meth, coke, and heroin. Unlike acid and mushrooms, these were addictive drugs, and I thought I was too strong and too smart ever to fall into that trap.

But slowly and surely, it happened. When I left the Crazy Horse, I thought I was going to be a star. But now, at twenty, my career was already over. Jennifer was pregnant and out of my life; my fugitive family was somewhere in northern California doing God knows what; and the only man in my life was a meth-fiend tattoo artist who resented my presence and cheated on me every chance he got.

The only activity I had that was separate from Jack was the photo shoots. But I began to feel like Suze was taking advantage of me. My pictures appeared in every sex ad and foreign nudie magazine imaginable. And since I'd signed away the rights, she was raking in all the money. Whenever I asked her for a few chromes for a promo shot or to make a modeling book, she'd refuse. I'd ask her instead to shoot an extra roll for me at our next session instead, and she'd say she couldn't. She made her living off enthusiastic new girls like myself, and I understood that and was grateful to her for making me an international cover girl. But there was a bigger problem—she was stringing me along, telling me that each shoot we did just might be a centerfold in *Penthouse*. However, nothing we did ever appeared there, and that had been my dream from day one. And with every picture of mine that was published somewhere else, my chances of ever being a *Penthouse* Pet plummeted lower and lower.

So I added Suze to my mental shitlist of people I could not trust and decided to stop working with her. Though my reasons made sense logically, they were also convenient rationalizations for my drug habit.

Traveling to Los Angeles meant flying high and risking getting caught with speed in the airport. So I started posing only for photographers in Las Vegas.

Every now and then, Nikki called to make sure I was okay. But I never answered the phone: I knew as soon as she heard me jabbering nervously at a hundred miles per hour, she'd realize that I was wasted.

While I only snorted meth, Jack was an even bigger mess. Between Vanessa's death and his falling out with his uncle, he needed to numb himself because it was easier to self-destruct than to face the truth. Soon, he was living in a permanent cloud of meth.

Usually, he just ripped a strip of foil off a cigarette pack, and inhaled the smoke through a sliced-up straw. But one night around 4 A.M., Jack and some of his friends came over and none of them had any cigarettes. So someone came up with the bright idea of unscrewing a lightbulb in the kitchen. They heated the base of the lightbulb until the glue on it melted, then they pulled off the metal base. After emptying the bulb, they drilled a hole in the top and stuffed a little meth inside. They heated the side of the bulb with a lighter and smoked out of the hole where the metal used to be. I just stood and watched the whole thing. It was a beautiful process, and the smoke smelled so sweet. When Jack offered me a hit, I decided to try it. It couldn't hurt to do it just one time.

I inhaled a little, and the smoke filled my lungs. Unlike pot or even cigarettes, it was so smooth I could hardly feel it. When I exhaled, a thin three-foot-long column of smoke escaped from my lips. Everything seemed to move in slow motion, and then someone pressed fast forward. My heart felt like a woodpecker was inside, hammering hard enough to burst through my chest at any moment.

After that, I never wanted to snort meth again. Smoking it was amazing. At first, I only smoked it when Jack was around because he was the only one who knew the mechanics of the whole foil and straw contraption. But since I had no other challenges in my life at the moment, I set my mind to figuring out how to do it for myself. And once I did, smoking meth became a daily pastime. The high was more dreamy and

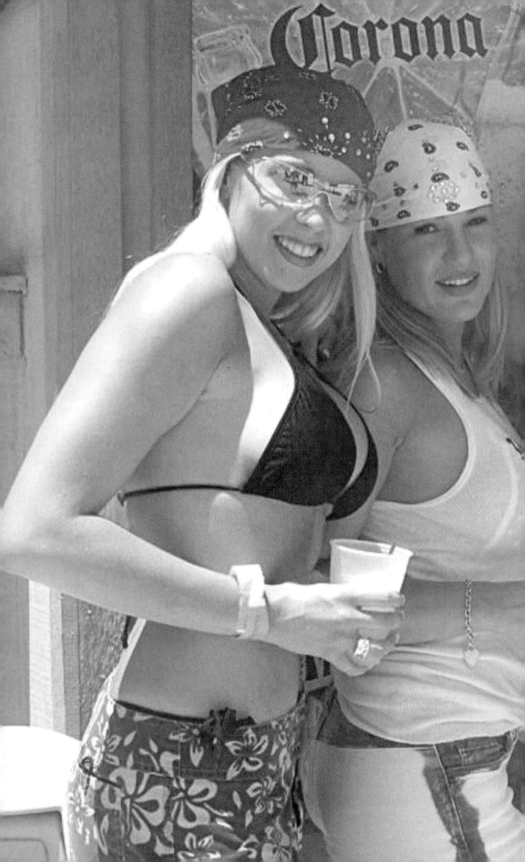

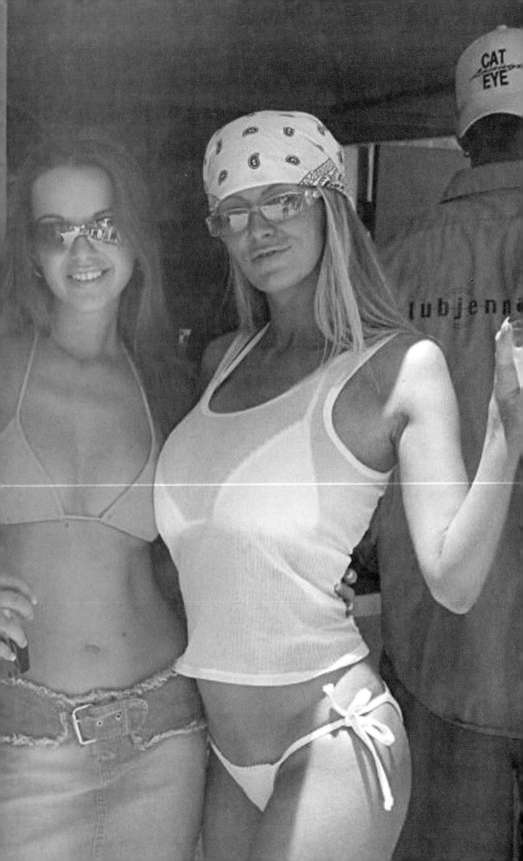

intense, but it didn't last as long. Every ten minutes I wanted another hit, so I constantly asked Jack for more.

When I was snorting meth, I felt invincible. I had no pain, worries, or even thoughts. But now that I was smoking it, I was a mess. I was blowing off photo shoots left and right, destroying what little remained of my reputation. My last vestiges of hard-won independence were fading away.

Of course, the more time I spent with Jack, the less he wanted me around. So the fights started again, more violent than ever because we were so wasted, moody, and illogical. At the time, I truly believed that in order for him to abuse me the way he did, he really had to love me. If he didn't, he just wouldn't respond or care, which would have been even more painful to bear. The problem was that he didn't know how to love: his father had abandoned him, his mother and cousin were dead, the uncle who had raised him was a monster, the aunt who had raised him had run away, and he'd never been as attached to any other girl as he was to me. Despite everything, even knowing that he was cheating on me, I truly loved him. We had been through so much together.

One morning, I had a photo shoot booked at one of the better studios in Vegas. I had stayed up all night smoking meth, and hadn't eaten anything substantial in probably a week. Jack and I were fighting again, of course. He didn't want me driving to the shoot in my condition.

"What are you talking about?" I yelled back at him. "You're more fucked up than I am, you know, you loser!"

But eventually I conceded defeat with gracious words like, "Well, I'd rather you go to fucking jail than me."

Everyone at the photo shoot just gawked at me when I entered the studio. The photographer, his assistant, the makeup artist, and the stylist all asked the same thing, "Are you okay?"

And I blathered some five-hundred-word lie that could have been communicated in two words: "I'm fine."

The shoot was grueling, not only because I kept going to the bathroom every ten minutes to smoke, but because I was having so much

trouble with everything. The makeup artist spent an hour and a half on my face, covering up my sunken-in cheeks, my jaundice, and the sallow pockets of flesh everywhere. It must have been hell for her, because I couldn't stop fidgeting. They kept offering me food, and I kept lying, "No thanks. I ate just before I got here."

Throughout the photo shoot, they told me, "Jenna, relax. Let the tension out of your face." I was clenching my teeth so hard from the crystal. Even more embarrassing, in certain poses my bones were sticking out so badly that they had to artfully drape my clothes over them so that I wouldn't repulse readers. There were no magazines for guys with fetishes for anorexic meth freaks at the time.

When I went home, I collapsed on the bed. I knew I had been a total mess at the shoot. For the first time I can remember, I was truly ashamed of myself. So I decided to stop—not meth, of course, but photo shoots. I couldn't be doing any more shoots fucked up.

I always had this idea that junkies were people who were so addicted that they got high alone. So I never wanted to get high by myself. Instead, I hung around Jack all the time. The problem was that whenever he got sufficiently high, he'd leave the house. So I'd be stuck there alone, calling the few people I knew, begging, "Come over, come over. I got a papier-mâché thingie I'm working on. Come help me finish it!"

The only person who ever came over was a Mexican girl named Lupe. We'd sit around for days and get mind-blowingly fucked up. No house I've ever lived in, before or since, has been so clean. I was like the old lady in *There's Something About Mary.* I vacuumed so much that the carpets were actually disintegrating. The house looked perfect, but if it seemed too perfect, then I had to rearrange all the furniture to make the place seem more natural. I must have organized the frigging bathroom cupboards a thousand times, sorting each item according to size or function or owner or frequency of use—all in the same night.

Some girls who get high pick at their skin all night. I was not a picker. I was a maker. I was constantly amazed by the innovative and profound avant-garde artwork I could bring to life with a glue gun. My pieces

should have been hanging somewhere, like a mental institution. Though I was infamous amongst Jack's friends for making papier-mâché dragons in the closet all night, my greatest creations were my self-collages. I would go through adult magazines and cut my pictures from the phone-sex ads in the back. Then I'd glue them to a piece of paper and stick funny little phrases from *Cosmopolitan* below them, like, "Is it a do or a don't?" "What procedures have you had done?" or "7 ways to make him beg for more." Then I'd pick up my little handheld poker video game and play it all night, until my hands literally bled.

Another one of my obsessive habits was going through Jack's things. He had a pile of pictures he had just put into his tattoo book and, as I was examining them, I saw a huge piece he'd drawn on a blond woman's broad back. It wasn't an actual tattoo, just a practice drawing of an immense, ferocious, beautiful dragon. In the background, through the tattoo shop window, I could tell it was nighttime when the photo had been taken. I was dying to know who this girl was. I flipped the page and saw her front side. I recognized her instantly: It was Lacey, the girl I had driven out of the house. That asshole was with her after-hours at the tattoo shop I had practically paid for.

I had a gun I'd bought while I was dancing. It was a little .25 with a pearl handle. When he came home that night, I pointed the gun straight at his head with one hand and threw the tattoo book at him with the other.

"What the fuck is this?" I screamed. "I can't believe you're still seeing that skanky bitch."

I wanted to hear what he had to say for himself. And then I was going to shoot him. I didn't care what the consequences were. He was my life.

He raised his hand and knocked the gun out of my fingers. It clattered on the black-and-white tile floor. I bent down to grab it, and he kicked me in the chin so hard that I flipped over backward.

We fought for hours that night, which was nothing new for us. It didn't stop until he picked me up and threw me across our bedroom. I wrapped around our four-poster bed like the business end of a whip, hitting my coccyx bone so hard that I blacked out. The next morning, I

drove myself to the emergency room, where they told me that the bone was chipped.

When I came home, I dragged my phone into the bathroom and shut the door. I needed to talk to someone. I decided to finally call Nikki back. When she picked up, I just started crying.

"What's wrong, honey?" she kept asking. "What's going on?"

"My life," I said. "It's not where I want it to be. This isn't where I'm meant to be. I'm just . . . stuck. I'm . . . addicted."

For the first time, I had vocalized it. I was addicted. Before, whenever it was time to fly to L.A. for work or when I got my breasts done, I could stop. But now it was out of my control. I hadn't done any work in a month. I looked down at my hand, and my fingertips were black from all the time spent holding hot cigarette lighters under meth pipes.

Suddenly, the words all came tumbling out of me: "Jack's cheating on me. He spends more time with his dealer than with me. And I think he's fucking her too. He's trying to kill me. I swear to God. I was in the fucking hospital today. He took this little sixteen-year-old-girl and ruined me. He's the Antichrist."

"Shhhh, shhhhh," she tried to soothe me. "It's okay."

"It isn't. I'm alone here. My family is bullshit. I don't have any friends. I've lost Vanessa. And I can't even look at Jennifer anymore. I don't know what I'm going to do. The only person I hang out with is a fucking Mexican crack whore who calls me *mija*."

"You have me," she said. "Remember, I'm always here. No matter what, I will take care of you."

But there was no way I could ever go to Los Angeles to let her take care of me. For one thing, I didn't know where to get meth there.

I hung up the phone and began to walk out of the bathroom. But something caught my eye. There was a scale in the corner of the room. I stepped on it. The dial spun and wobbled under the red needle until it stopped on a number. And that number was eighty. I weighed eighty pounds.

Chapter FOURTEEN

And then one day, it finally happened: Jack left me.

I had found out he was cheating again. Just as I suspected, he was sleeping with his drug dealer. When he came home from the tattoo shop, I planned to confront him.

But, in the end, I didn't greet him with my pearl handgun. I couldn't. I was curled up on the floor in front of my mirrored closet in sweatpants and a bra. I hadn't eaten in so long that I didn't have the strength to stand up. My legs just wouldn't support me.

"Look at your fucking self." It was Jack's voice. I could see his boots at eye level. "Look at you. You are not even a person anymore."

I struggled to get to my feet. It was useless. "You make me sick," he went on. "I want my fucking life back, you crazy whore." *Whore*—it was the same word his uncle had used when he had raped me.

Jack disappeared. Fifteen minutes later, I heard his voice again. "You need to eat something." He spoke not with care, but with disgust. He bent over me with a fistful of chicken fingers and shoved one in my mouth. I spit it out. Just the idea of food made me want to vomit. But the more I spit the food out, the more he tried to shove it in my mouth. My entire face was soon covered with grease and scratches.

"I hope you understand that you are going to die if you don't fucking eat this crap," he spat at me. Eventually, he gave up and just threw the food at me.

"Fuck this shit," he said. He pulled out his cigarette pack, ripped off

a piece of foil, took a few hits of meth and then stood up and strode straight to the closet. He knew exactly what he was doing. He pulled his suitcase off the top shelf and started throwing his clothes in it.

"Please don't leave me," I suddenly blubbered. Snot poured out of my abused nostrils like running water; greasy bubbles of mucus formed in my mouth every time I formed the words, "I love you."

As he walked through the house, getting his stuff together, I grew more and more desperate. I clung to his feet whenever he walked past, trying to keep him from leaving.

I heard the front door open and shut several times. Jack was removing everything from the house: the furniture, the bedding, the guns. He was trading up and moving in with his dealer. The only things he left behind were the cooking supplies and kitchen utensils, which I obviously had no need for, either.

This time, it was really over. I lay on the ground in front of the closet for hours. All I could hear was my heart beating so hard against my bony chest that it hurt. The blood in my body felt like lava: it burned everywhere. This was what heartbreak felt like. I needed to do something to calm down. I crawled into the bathroom and pulled myself over the sink. I wanted to get some Darvocet.

Staring at me from the door of the medicine cabinet was the devil. It had strings of brittle blond hair that had snapped off at various lengths; eyes recessed deep into the sockets and surrounded by bruised black circles; cheekbones sharp enough to draw blood; and its complexion was sickly cyanotic. The devil was my own reflection. I had made my living with my looks, and now they were gone: the beautiful blond hair, the full smiling face, the big bedroom eyes. All the curves that men paid thousands of dollars just to look at had melted away to reveal a skeleton in rags.

I opened the cabinet and knocked the bottle of Darvocet off the top shelf. It hit the ground, and I followed it. I unscrewed the cap and swallowed four pills. It was a lot of downer for an eighty-pound girl. But I didn't mind. I just wanted the pain to stop. And if my heart stopped also,

so be it. I really didn't care whether I woke up or not. When it came down to it, I just couldn't imagine life without Jack.

I don't know how long I lay there for, fading in and out of consciousness. It was more than one day and less than four. At one point, I awoke to hear the phone ringing. The answering machine picked up, and I heard a man's voice. I strained my ears in case it was Jack calling. But it was Matt, his partner at the tattoo shop. He kept saying over and over, "Jenna. Jenna. Pick up the phone." I blacked out again.

"Jenna. Jenna. Pick up the phone." He was calling again. Doesn't that guy ever give up? I finally dragged myself to the phone. My body felt like it was falling apart, leaving a trail of small bones and patches of skin strewn on the carpet behind me.

I picked up the receiver and it slipped out of my hand, hitting me square in the forehead. It swelled instantly. I didn't feel a thing. I fumbled with the receiver until it found my ear.

"Jenna? Jenna? Are you okay?"

"No," I managed to rasp. "No. Come over. Please."

Within ten minutes, Matt was in the house. When he looked at me, the color drained out of his face. "What the fuck happened?" he asked. "You need to call your dad right now."

That was the last thing I wanted to do. Asking my father for help would mean admitting that I had failed. And I'm so hardheaded that I would rather suffer the worst pain imaginable than call someone who had abandoned me and beg. But I had nowhere else to turn. I could either stay here and die or take Matt's advice. It came down to choosing between pride and survival.

I vaguely remembered my dad calling months ago with his latest telephone number, and I had actually, by the grace of God, written this one down. It took Matt fifteen minutes of searching through the house to find the matchbook I had written the number on: it was built into one of my collages.

All I said was "Dad," and he knew something was wrong. My voice was so shaky and weak.

"Are you okay?" he asked.

"I'm not okay." I tried to explain my condition.

"I'm coming right now to get you," he said.

"Dad, I won't survive the ride."

He insisted.

"Dad, I will die on the trip. I can't even walk."

I wasn't being melodramatic. My heart probably had a day and a half of pump in it.

"How can I get you here?" he asked.

Matt told him to book me a plane ticket on the first flight out of Vegas. He advised my dad to have a wheelchair ready for when I got off the plane. I was that bad.

After he hung up, Matt dressed me in an oversized T-shirt, carried me to his car, and put me in the backseat. On the way to the airport, he stopped at a drugstore and bought me a protein shake. I tried to drink it, but as soon as the liquid hit my throat, I vomited. Whatever stray morsels of food were still in my stomach came tumbling onto my shirt, along with clots of blood and who knows what else. I kept trying to drink the shake, but I couldn't keep anything in my stomach.

When we arrived at the airport, Matt borrowed a wheelchair from the airline and took me to the gate. I don't remember much about the flight, except that I was violently ill and the people next to me were repulsed. They asked if I was being treated for cancer.

When the plane arrived in Reading, I remained in my seat while everyone filed off. Then the stewardess lifted me into the wheelchair. I dreaded, more than anything, having to face my father again. I was always a good daughter. Sometimes I was headstrong or moody, sure, but that was part of being independent. Now, here I was, twenty years old, being brought back home in a wheelchair, stinking from my own vomit. Not only had he never seen me like this, but I don't think he could have even imagined it was possible.

When the stewardess brought me off the plane, I lowered my head. I was too scared to even look at my father. I didn't want to see the disap-

pointment and horror on his face. I cried so hard that every sob racking through my body hurt. All that hate I had accumulated for my father over the years, all the resentment against him for not understanding what I was going through, just released with the tears. He was here for me when I needed him most. He actually loved me.

"So, where are your parents?" the stewardess asked after a few minutes. "I can't wait here with you much longer."

I looked up and wiped my eyes. My father was standing ten feet away. He didn't even recognize me.

TIME'S SCYTHE

*"And nothing 'gainst Time's scythe can make defense
Save breed, to brave him when he takes thee hence."*

★★★

Chapter ONE

March 15, 2003

Dear Jenna,

Hello, baby. How are you? It has been a long winter here. I'm starting to enjoy retirement. I no longer feel like I need to be doing something all the time. I have the gym and my motorcycle, and I'm happy.

I will be leaving New Jersey and the woman I have been living with there this month. Her gifts no longer outweigh her neediness. I'm throwing everything I own away and moving with just a change of clothes, the leather jacket you bought me for my fortieth birthday, and a picture of your mother.

I know this book you are writing is important to you, so I think that it's time for me to tell you a little bit about your mother and how we met. Maybe it will help you understand some things about yourself.

This letter is very difficult for me to write. As you know, I have told you very little about Judy. And the reason is because I wanted to protect you. I didn't want you to spend your childhood depressed about her loss. I was trying to spare you the suffering I've gone through until I saw that you were strong enough. Of course, I underestimated you. You've always been strong enough.

Opposite: At six months old.

There was nobody else in the world for me besides Judy. She was the only woman I ever loved. For the twelve years we were together, I didn't even look at another woman. Finding her was like a fairy tale. You read about these perfect love stories but you never think they're going to happen to you.

The time when I met her was a real wild one for me. I was running around Reno with Bobby Jolson, Johnny Anastasia (the nephew of Albert Anastasia of Murder Incorporated), and Frank Sinatra Jr., who was appearing at the Harrah's club. I was going out with a Marilyn Monroe impersonator named Barbara at the time. It was nothing serious. Without all the makeup and hair, she looked more like Sonny Liston.

We used to hang out at the Golden Hotel, and your mother was dancing in a show there. Barry Ashton was the producer, and it was called the Golden Girls. They held a seat for me every night at the bar directly in front of the stage, and they wouldn't put anyone in my chair until the show started and they were sure I wasn't coming.

From the moment I first laid eyes on Judy, I knew she was the one, even though she was one of dozens of identically costumed women onstage. She just radiated in comparison with everyone else. To this day, I still can't explain it. I certainly wasn't expecting it. It's like what my mother always used to say about being struck by lightning. I looked at her and she looked at me, and I went, "Whoa!" That was it. It was amazing. That had never happened to me in my life. I was sitting there with Bobby Jolson, and I poked him in the side and said, "Do you see that girl right there with the long black hair like Cleopatra? That is the girl I'm going to marry."

After the show each night, the girls would flock around the bar and mingle with the gamblers. And every girl would come out, except Judy. Afterward I used to take everyone to Bill Harrah's house, because he was a pretty good friend. Whenever he had a party, he'd put on a show. He'd take care of the celebrities—Danny Thomas, Mickey Rooney—and I'd bring the girls. I'd hire three limos to take everyone from the revue up, but Judy never came. She would always just stay in the dressing room until everyone was gone.

Finally, one night, I went to the maître d' and gave him $50, which was a lot of money in those days, and said, "You gotta make her come out."

And do you know what happened? She got mad. She had your temper. "I'm not going to come out," she told the maître d'. "I don't want to meet that guy."

But he told her she didn't have a choice. When she walked into the bar, she radiated grace. She looked too fragile and innocent for this earth. I said to her, "I really enjoy watching you dance. Can I buy you a drink?"

She ordered a Coke. Since she thought I was someone important, she patronized me. But she would not look me in the eye. She made it perfectly clear that she was doing this against her will. We chatted for a minute, and then I said, "It was really nice meeting you." I turned around and began talking to the idiot ventriloquist in the show. Judy was stunned. She expected me to hit on her and brag about myself like every other creep in the place.

The next night after the show I bribed the maître d' again. Judy came out and sat at the bar. I completely ignored her and talked to the idiot ventriloquist and a red-headed friend named Mary.

I had never dated Mary, but she went over to Judy anyway and said, "You stay away from my man."

Judy must have been shocked. "I know he's interested in you, and he's mine," Mary told her.

I had no idea at the time that she had done this. I walked up to Judy a few minutes later and said, "Oh, hi, Judy. How are you?" And then I left again.

The next night, I paid off the maître d' yet again. But this time, I brought my mother with me. When Judy came out, I introduced her to my mother and the three of us had a nice, long conversation. I wanted to ask Judy out so badly. It was hard to hold myself back.

A couple other girls in the show told me that Judy was dating a bartender who worked down the street. I had hired a couple of bodyguards, some University of Nevada football players I was paying twenty dollars and free drinks to per night. I had made a few enemies in town and

Poochie, who was guarding Frank Sinatra Jr., had made some tacit threats against me. So, in any case, I sent my bodyguards to talk to Judy's boyfriend. After that, he backed off. She never knew why he broke up with her, other than the fact that she wouldn't have sex with him. She was twenty, and still a virgin.

Two nights later, I decided to finally ask your mother out. I invited her to join me to see Frank Sinatra Jr. perform next door at Harrah's. She accepted. When we walked into Harrah's, she towered over me in her high heels.

During the show, I excused myself to go to the bathroom and ran next door to Harold's, where Trini Lopez was playing later that night. I slipped the maître d' there fifty dollars to take care of us. Then I returned to Harrah's and told Judy that we should go see Trini Lopez.

The staff at Harold's pulled a *Goodfellas* for us. They picked up a table and walked it all the way to the front of the stage. They moved everyone out of the way, put the table down, and seated us. She just looked at me. She was impressed. She thought I had juice.

If only she knew my real job: I was working at a grocery store every single day.

For three weeks straight, I watched Judy perform at the Golden Hotel. I couldn't take my eyes off her. We went on a few dates in that time. And eventually she decided that she was ready to have sex with me. She had come to the conclusion that I would be the one. Of course, I wasn't ready yet to commit myself to her, but I didn't tell her that.

She told her roommate to get lost and invited me to her apartment. I went up there and knocked on the door, and a short woman with long blond hair, huge bangs, no makeup, and jeans answered the door. I asked her if Judy was home. And she said, "Larry, I am Judy."

I couldn't figure out what had happened to my black-haired Cleopatra. It turns out she was wearing a wig onstage every night. I had no idea.

This is probably too much information, but we had sexual relations. When it was over, we lay in bed together, side by side, and I wept. I cried.

And I knew right then and there what I wanted. I told her, "We are going to get married."

From that day on, your mother and I were inseparable. For the first time ever with a woman, I was honest. I told her everything about myself: not just about the grocery store, but that I was making money on the side hijacking trucks and selling the furs and stereos. I had a certain lifestyle and, if I truly loved her, I needed to be honest about it.

When her contract with the Golden Girls ended, she went on the road dancing. Afterward, she went into the Folies Bergères at the Tropicana in Vegas. I quit my job, sold everything I had, got in my car, and drove to Vegas. And we got married.

If she had lived, I would have still been married to her to this day. I never would have left her. Let me tell you, it was the best twelve years of my life. Even if I had the worst life in the world afterward, I knew I'd always have that. Who gets so lucky? And then to have you and Tony to carry it on? She was an amazing woman, Jenna. She never fought, she never raised her voice, she never drank or did drugs. And she never had a single blemish on her face. She had you when she was thirty-two, and she had her showgirl body back in a week. Her stomach was rock hard.

You look so much like her: your eyes, your nose, your bone structure. Your hands and your feet are carbon copies of hers. All of your mannerisms are the same: the way you walk, the way you turn your back, even the way you cock your head. She used to watch TV like that. I would always think that she was staring at me and say, "Huh?" And she'd look at me funny and say, "I was watching TV."

She was so shy, but when she was onstage she just lit up the world. And that's exactly how you are. To this day, whenever you walk in the room, I always get that feeling I had when I was around her. You may think that's weird.

I don't know if you know this, but we tried for seven years to have children. She told me back then that she knew she was going to die of cancer. I was in total denial. She was the fittest girl in the world. She never even had as much as a cold or a toothache in her life. I have no idea

how she knew. She just felt it. And she wanted to have children before she died. That was all we talked about.

We tried everything to get her pregnant. We would have gone to a gypsy and put cucumbers up our asses if it would have helped. We didn't care what it took. Eventually, we realized, the problem was not physical. It was psychological. She was blocking her ability to have a child. And you don't know this either, but we became Scientologists for a while. Judy's brother, Dennis, was always a spiritual seeker. He gave me a job at the TV station and then turned us on to Scientology. He had been on L. Ron Hubbard's boat with him.

Dennis found Scientology a little expensive, but it did us a lot of good and made me a little more compassionate and empathetic. We became clear and did the whole thing, and Judy still couldn't get pregnant. We finally decided to adopt but, seven days before the adoption went through, Judy came home from the doctor and said, "I'm pregnant."

It wasn't easy for her. After the first three months, she was so sick she had to stay in bed for the rest of her pregnancy. We believed then that anything we did while Tony was in the womb was capable of planting something in his subconscious. So we never swore, didn't watch anything violent on television, played only the best music, and sweet-talked Tony nonstop. After a very painful delivery for your mother, Tony was born. He was a sickly baby and allergic to everything, even mother's milk and almost every formula on the market. It took me nine days just to find a formula he could keep down.

Once Judy knew psychologically that she could have a child, it was easy after that. You were a snap. You came out with a big grin on your face. She had no problems at all. She didn't gain any extra weight and was active until the day we went to the hospital. I was afraid of having three more years of what I went through with Tony, but you were perfect and quiet and slept all night. You were a joy as a child.

Then, of course, everything went bad. It began when Judy went to the doctor to have a mole removed. We sent it to the lab and it came back malignant. The tentacles had gotten into the lymph nodes, which

swelled so much that Judy started feeling lumps under her arms. Even though Judy had predicted it so many times, I was in denial. But we couldn't stop it from spreading.

After my time in Vietnam, I thought I could take anything. But I was not prepared for something like this. It was the worst thing I've ever been through. Her stomach would get so bloated, like she was pregnant, and I would have to take her to the hospital and hold her down while they shoved a needle in her to withdraw all the fluid. And she would scream at the top of her lungs. They couldn't give her a sedative because they were afraid it would stop her heart. It was awful, Jenna. I'm surprised they didn't ring a bell outside to cover up the screams.

Tony and me in 1975.

And then there was the chemo. She was allergic to the medicine that stopped the nausea. I would hold her for hours while she threw up. I would have it all over me, and it would be all over the room. You don't know how hard it is to see someone you love in that much pain in front of you. I did everything I could to save her. I went down to Mexico and got this weird shit called laetrile, a cancer drug that was illegal here. And we tried so many radical surgeries that the doctors eventually said they couldn't take anything else out. It was god-awful. The hospital costs exhausted my insurance. I was making over $120,000 a year as president of Channel 13, but the bills stripped me clean.

Her oncologist finally gave us a prescription for morphine and said to just let her go home and die. I took a leave of absence and slept in a chair next to her bed. Every four hours I'd give her a shot of morphine. Sometimes I'd let her come out of the morphine a little, and I'd sit her up on the bed and bring you and Tony in. But she deteriorated so quickly that she didn't want you two in the room anymore. She wanted you to remember her while she was vital. In less than a year, she went from a beautiful thirty-two-year-old woman who turned heads to an invalid who looked like she was ninety. She lost all her hair, and was just withered skin and bones. It was so terrible. I'd take her to the bathroom and wash her and give her more morphine as the pain kept intensifying. I was so worried that you would be scarred from hearing her scream in her room and seeing me pace the house like a nervous wreck all night.

I felt so useless: I literally exhausted everything I could do. When she was sleeping, I'd go into the living room and stare at a TV that wasn't on. I'd just sit there and vacillate between wanting her to live, even if she had to live like that, and wanting her to die. After she did die, I felt guilty for years for having those thoughts.

I kept telling myself, "I spent ninety days in a dirt hole in Africa waiting to be executed. If I can handle that, I can handle this. I'm going to be okay. She's going to be okay."

But it just got worse. The last couple of weeks she was barely lucid because of all the morphine. The night she died I was sitting in the living

room, staring at the blank TV screen, when I heard her gagging. I ran into the room and her body was convulsing violently. I tilted her head back to open her airway and give her CPR. I'm sorry, Jenna. I have to stop writing for a moment and collect myself. I've never told anybody this.

Okay.

She started gurgling and aspirating, and then went quiet. I knew she was gone. I felt the artery in her neck. It had stopped. I opened her right eye and it was fully dilated. Then I went to the living room and called an ambulance. As soon as you heard the siren, you started screaming. Tony came into the hallway, and I grabbed him and put him back in his room and shut the door. I didn't want either of you to see your mother like that. I think those things stick with you, whether you are aware of them or not.

You never wanted to be alone after that. And you became afraid of the dark. You would always sleep in your brother's room with the lights on. You weren't even two, Jenna, but subconsciously I think you remember her talking to you while she was sick. I think to some degree you blocked out the memories.

For me, everything changed dramatically after Judy was gone. My mother and Judy's mother came over the night she died, but her mother left right away. So my mom and a friend of hers stayed and cleaned everything out. I couldn't touch her stuff. I went into the room a couple days later, and it was like she never existed.

Before your mother died, we were a close family. We had big Thanksgiving dinners at her family's house and we all got along great. But after she died, everyone abandoned us. We never saw her family or mine. They didn't even come to her funeral: all the pallbearers were my friends. Judy's parents took you guys out once, but they brought you back in fifteen minutes. They couldn't stand being reminded of your mother. They would call you Judy all the time.

The bank didn't even wait for her to get cold before they seized everything we had. I owed half a million dollars in hospital bills, so they came

with a moving truck and a tow truck. They took two cars, a boat, a motorcycle, all my stock, and an apartment building I owned in North Las Vegas. They even took your toys. And I was still $24,000 in debt. All I had was you, Tony, and $3,000 in cash. That was it.

We moved into a trailer. I never thought we'd end up in a trailer. No one stopped by and the phone never rang. People don't want to be around death and grief. It's one of those things a person has to go through on their own. It was such a daunting future without her, Jenna. For a year, I didn't know what to do with myself. It was a challenge just walking and chewing gum at the same time.

Do you remember going to her gravesite with me? I used to take you and Tony there every Sunday for a couple years, but then I felt that it was too debilitating for you. And for me. I was diagnosed with nervous exhaustion. I developed facial tics that didn't go away until years afterward.

That woman was my life. There was nobody else in the world for me. And I've never been able to recover from that loss. Never. You spend the rest of your life searching. And then you get to a certain point and you give up. I stumbled around for six years just trying to be happy again, trying to figure out how to raise you and your brother. But slowly I learned. And the most important thing I learned was to love being a father.

Anyway, I am looking forward to coming out to Phoenix for your wedding to Jay in June. I think you've finally picked a good one.

Love,

Dad

P.S. You asked about your childhood diary and, believe it or not, I found it. I'll bring it with me.

et 10½" Neck-13 Head 22
gh 17½" Calves-13½ Arms 28"
n 13" Tony forarm-10"
st-27½ Hips-34"
st inhale-38½" wrist 6"
ankle 8½

My Annie Diary

thum
inde
middl
ing
li t

aug 85
Feet 8¼
Thigh 15½

Hips 27
Waist 22
Chestinhal
Exhale -
Neck- 11"
Head-20½
Calves-10"
arm 8½
forarm 7"
wrists 5½
ankle 6½

" wrist 5½"
17½" ankle 7"
31" cum span 27"
4"

"
"

april
of 88'

4"
3"

Chapter TWO

Date: June 20, 2003
Time: 1 P.M.
Place: Living room, Tony Massoli residence, Scottsdale, Arizona, U.S.A.
People: Jenna Jameson
Tony Massoli, her brother
Larry Massoli, her father
Selena Massoli, wife of Tony

Jenna: The way I look at it is, I feel proud of us for making it.
Tony: No kidding.
Jenna: 'Cause I look back at some of that stuff and I'm like, "Wow!"
Larry: It was a prescription for failure.
Jenna: Absolutely.
Larry: What happened is that after your mother died, I couldn't do TV anymore. I had always wanted to be a cop, but your mom refused to let me. So I waited about a year and then decided to do what I had always wanted to do. I became this big crusader asshole. Because I couldn't save your mother, I was going to save the world. It was probably a culture shock to you two when I changed jobs.
Tony: I was a kid, so from my perspective that part of our childhood was unbelievable. Dad was busting the whorehouses, so the mob wanted to kidnap me and Jenna. They thought they could extort my dad into staying out of their business. So one of the mob guys picked up Jenna after school in a yellow schoolbus. He let off all the other kids and kept Jenna

Opposite: Christmas in Panama City, in 1977.

on the bus. He drove just with her for miles and miles. The deputies and the sheriff's department chased him, and finally pulled the bus over and got Jenna.

Jenna: I was in preschool, so I barely remember that.

Tony: Oh, it was bad. Those guys pulled up next to me in a Cadillac one day and said, "Your dad, Larry, said for you to come home with us." I knew something was wrong so I chucked my book bag and took off running through the desert. I hid in a drainage ditch. After I heard the car drive away, I still waited in there for a couple of hours.

Jenna: I remember when you came home from that, panting. That was a crazy time. We had police escorts after that. When I went to school, there was always a cop.

Larry: It was very scary at that time. They had put a contract out on me. I was so worried about the kids. What happened was that a guy named Walter Plankinton had opened a place called the Chicken Ranch, and a couple of cronies from a rival bordello came and burned the place down. So my lieutenant told me, "You are going to get a call to go to the other side of the valley. When you get that call just do what you're told and wait it out, no matter what happens."

And I said, "Not on my watch." So I kept them from getting revenge. I refused to take bribes or turn a blind eye to anything illegal, so everybody wanted to chase me out of town. It was like the Old West out there, and they didn't want anyone trying to tackle the corruption.

Tony: Remember when we had to go hide out in Johnny Whitmore's attic?

Jenna: I forgot about that.

Tony: I was sleeping in the dining room at the time, on a day bed. And I heard a crunching on the rocks, so I knew someone was out there. I looked outside and I saw a shadow. So I went to dad's room. He was married to Marjorie then.

Larry: Oh, Christ, Marjorie. I needed someone to help me with the kids. That was a mistake.

Tony: So I knocked on their door, and Marjorie was like, "Shut the fuck

up. Go back to bed." I looked out the window and saw this guy in a bandanna, and he was wearing gloves and had a brick in his hand. I was so scared I couldn't breathe. Then the brick came right through the window. And you came running out buck naked and grabbed a Thompson submachine gun and ran through the front door shooting. The gun lit up the night, and all I could hear was the *brrrraaaaappp brrrraaaaappp* from the machine gun.

Larry: He got away, so I put my uniform on and code three'd it over to the Shamrock, which was one of the brothels that had fire-bombed the Chicken Ranch. I drove the patrol car through the front door and unloaded two clips into the bar with that Thompson submachine gun. Then I said, "I want you fuckers to stop fucking with my family." And we never had a problem after that.

Jenna: I remember when they tapped the phone. I was so little at that time and didn't understand what was going on. There was a big window in my room, and I would sit on my tiny bed with the curtains open, arms around my knees, looking outside for hours because I had trouble sleeping.

Larry: It was a huge window and it was empty out there, so you could see every star.

Jenna: I would just gaze at the stars. And dad came in my room and said, "Jenna—get in bed! Don't you ever look out that window!" He was so stern about it. I had no idea why he was so mad.

Larry: I was afraid they would shoot at the house. It was very dangerous at that time. I had the government against me, the Mafia against me. I had no one to help and no place to take you. So you had a very wild childhood because I was always in the shit. We were going through a nanny a week. I couldn't keep people hired no matter what I did.

Tony: We were supposed to stay home, but we had that one babysitter who wanted to go to the store. And we were like, "If we are going, we want to ride in the front seat." The backseat got so hot in Vegas. So she said, "Yeah, sure." We went through a green light and, *bam,* we got hit. T-boned. The other car was doing about fifty. Our car flipped over and, *bang,* there was busted glass everywhere. And, remember, the fireman

took us out of there just before the car caught fire?

Jenna: And they said that if we had been in the backseat, we would have been dead.

Larry: I used to hire a Hawaiian couple to live in the house and babysit them. I tried not to work such long hours after Judy died, but it was difficult. So one night I came home around eight o'clock and Tony looked a little ragged. I asked what was wrong, and he said, "John and Marsha took us to a casino and they went in and gambled." And I said, "What did you do that whole time?"

Jenna: We sat in the car in the parking lot for like eight hours.

Larry: The couple were still at our house waiting to get paid, so I went in and dragged that son of a bitch out of there and whipped his ass.

Jenna: Yeah, it was brutal.

Larry: And then some company I hired a nanny from sent me someone from a mental institution. I didn't know. And she called me up at the office and said, "Since you're gone all the time, I don't see any reason why I can't drown these kids."

Tony: Yeah, that was the one who made me brush her hair for hours.

Larry: I drove 120 miles an hour on the way home. I got there and Jenna was in her little stroller with this mental institution son of a bitch behind her. I put this woman in the car and drove her to the mental institution that I found out she was from. When I got back to the house, there were Cheerios everywhere for some mysterious reason. That's when I decided I had to get married.

Chapter 3

January. 1, 1983

Dear Diaree,

 I'm 8 years old.
 I watched funnycar racing. And I took tinsel off the Christmas tree. "Real exciting," My dads off tomaro. I watched a new show "Battle of the Beat." I have a dog named "Ming." My Grandma came over. My brother keeps on singing "You don't want me anymore." We had a good Christmas. I got a canopy. And my brother got a gun.
 I watched the Black stallion.

With my dad in Boulder City, 1982.

Chapter FOUR

Larry: I met Marjorie when I was working at the TV station. She was a publicist, and she had been after me even when I was married. So I decided to take her out a couple times for dinner. I thought, "I need help so bad." So I eventually asked her to marry me.

Jenna: Yeah, Dad could never cook. He couldn't even make instant oatmeal.

Larry: To this day I still can't make it—or boil water.

Jenna: Tony and I would be like, "How do we tell Dad that we can't eat this?" He would make us cheese sandwiches until we had cheese coming out of our ears.

Tony: Dad worked all night, and it seemed like all day too. And Marjorie worked until nine. There was never anything to eat.

Jenna: I remember Marjorie used to buy herself a personal stash of Yoplait yogurt.

Larry: That dirty son of a bitch. I had forgotten that.

Jenna: And she would not let us eat it. We knew if we ate it, we would get in trouble, so we would starve. I used to microwave pasta. When it came out, it was still hard. And I'd put sour cream and tuna on it, trying to get some kind of nutrition.

Larry: When I found out that Marjorie wasn't feeding you, I was so mad.

Tony: Everything in the fridge was earmarked for her.

Jenna: And we were so frigging hungry. I remember sitting and looking in the fridge at those yogurts. That's burned in my mind.

Larry: Why didn't you just take one?

Jenna: She would have slapped me the fuck up, dad. If she said something and I went "bleah," she would reach across the table and backhand me across the face. It got to the point where I was too scared to say anything. One of our favorite things to do was get those vials of cinnamon, and dip toothpicks in the cinnamon.

Tony: That's right, and then we'd sell them.

Jenna: Marjorie lost her mind when she found out. Remember, she threw the coffeepot at us?

Larry: She did? You never told me that.

Jenna: Finally one day, Tony and I were so frigging hungry we called Grandma. "Grandma, we're hungry. We've been hungry for a couple of months, Grandma."

Tony: She was a raging alcoholic. Whatever she had to eat was ready-made: tapioca pudding, microwaveable food, popcorn. So she came and got us, and we got to her house and she gave us Hostess Cherry Pies. Then she went in the bedroom and got in her nightgown, and then she had us go in the bedroom and get in her nightgowns.

Jenna: Yeah, we wore her nightgowns. Tony was in a satin nightgown. *(Laughs)*

Larry: And you know, we haven't been able to break him of them.

Tony: Yeah, I still like them *(laughs),* but only with pumps. Anyway, she poured herself a full glass of bourbon after dinner. She just drank it and then, *boom,* she passed out right into the coffee table. The glass shattered everywhere and she didn't move. So we called Dad and said, "We're staying at Grandma's." And we played over her lifeless body for hours.

Jenna: We never wanted to leave Grandma's house.

Tony: She never ate. She just drank.

Larry: Eventually, I got offered a job in Panama City, Florida. We needed to get out of Vegas. It was too dangerous. I also wanted to go to the police academy in Panama City, because they send you to college and all that kind of stuff.

Jenna: That's when you got the brown Firebird. Do you remember where I used to sleep? Behind the seat. I was so tiny that I slept on the floor of the car, with my head on the hump.

Larry: You've always been easily stored. We drove all the way to Panama City and got caught in the hurricane. Once we made it into Arizona, all Jenna said every fifteen minutes, was . . .

Jenna: "Are we there yet?"

Larry: "No, we aren't, honey."

This page: With Wanna, my grandma on my dad's side.

Opposite page: With Dad on Lake Mead at age eleven.

Chapter FIVE

BOYS #1

Name: Sam
Age: 5
Location: Panama City, Florida
Status: Neighbor
Boundary Crossed: Nudity

It was my idea.

I wanted to see what a pee-pee looked like. I knew my dad had one, because whenever he went tinkle, I could see a dangling bit from the back. Thus I knew boys were different from girls; I just wanted to see how different. So I asked the boy next door to play doctor.

He and his sister had bunk beds. We'd hide underneath them and take turns pulling down our pants and touching each other. He turned out to be a little perv also. He always wanted to rub it on me. It wasn't anything malicious or dirty. In fact, it was warm and felt good. But our games didn't last long; one afternoon, his parents found us naked under the bed and sent me home. They never let me come over after that. And I can't say I blame them.

From then on, I did my exploring alone. At age six, thanks to the jets of a neighbor's Jacuzzi, I discovered that I could have an orgasm. I would prop myself up against the stream until my hips locked up and my skin

shriveled. Each orgasm would twitch through my body for what felt like fifteen minutes. Years later, I discovered I could replicate the effect with the bathtub faucet. It took me several months of sleepless nights before I learned how to get off with just my hand. I didn't consciously associate my orgasms with sexuality at that time. The tragedy is that by the time I finally did, my orgasms had become much shorter.

Tony and me in Florida.

Chapter SIX

Larry: You always lived in great houses. You always had swimming pools. You always had great cars. You always dressed the best.

Jenna: I don't know about that, Dad.

Larry: To me you did. At least, as much as a $40,000 a year policeman could give you. I guess Florida was awful.

Jenna: Ugh, Florida was ghetto.

Tony: I remember going to school and it was so bad. There was a barbed-wire fence around the courtyard. All the tricycles were chained to a pole in the middle so the kids wouldn't steal them. So the only way you could play with them was if everyone got on their tricycles in unison because they were all tied together. I was in shock. I sat back and went, "Oh my God."

Larry: Marjorie was a police dispatcher and I was a police officer. She was in another town. So we were both gone a lot.

Jenna: We ran the frigging streets and stayed out all night. It was awesome.

Larry: You were little.

Jenna: I was four, Dad. I was this little tub of lard running behind Tony. Every night we'd be out front in that huge big grass area.

Larry: Was that when you got your head caught in the . . .

Jenna: . . . staircase? That was me. They had to cut me out. We had these cement steps outside leading to the apartments. And guess who dared me to stick my head between them?

Tony: Of course. Let me tell you. I tried everything to get you out. I even buttered your head. We were screwed.

Jenna: What happens is, when you get something stuck, it swells automatically. So he was pulling and I was yelling, "Noooooo."

Tony: Then I tried pouring melted butter in your ear. But it was still hot, and you screamed even more.

Jenna: A fireman had to come and cut me out of the stairs. Tony was always doing things like that to me.

Larry: Do you remember when I had a shoot-out at the Alexander apartments?

Tony: Yeah.

Larry: I got the call, and it was in my district. There was a guy in our parking lot firing a gun. And we shot him right there.

Jenna: Do you remember the guy who had the apartment upstairs? I used to go up there all the time. He was a grown man, and he used to tell me that he was Charlie Daniels. He wore a cowboy hat. And I would go up to his apartment and play his guitar. He would make me a sandwich, and we would hang out and listen to the radio.

Larry: How come I didn't know that?

Jenna: Because I knew I'd get in trouble if you knew. But I was so hungry. I'd ask him, "Can I have a mayonnaise sammich please?" I thought, "I know Charlie Daniels, man, and he makes me mayonnaise sandwiches every day."

Larry: It could have been John Wayne Gacy.

Jenna: It could have been. But he was so super good to me. He would give me little trinkets, like statues and stuff. I would go and hide them, because Marjorie used to throw out all my shit.

Larry: The only person in the apartment you guys ever had any problems with was that boy Glen.

Tony: That sixth-grader Glen?

Jenna: Yeah, the guy who shut my head in the sliding glass door.

Larry: I think that was your first big fight.

Tony: Every day after school that kid would tackle me, get on my stomach, and punch me until my nose bled.

Larry: Tony finally came and told me. I opened the front door and I said,

"You go down there and stomp his ass. And if you haven't done that, then don't come home, because I'm stomping your ass."

Tony: I planned it out like a military mission. I skipped school and waited for him all day. He thought I was homesick. When he got off the school bus, he came underneath the staircase. And as soon as he passed under me, I dropped a big brick right on his head. *Whack.* And then I dragged him to the side of the building and just started socking him. All of the adults came out and tried to stop me, but my dad came out in his police uniform and said, "None of you people touch my kid. This other kid beats him up every day, and I'm letting him take care of the problem."

Jenna: We actually became friends with him after that.

Larry: One of the best stories about you two was when that guy tried to touch Jenna while you all were playing leapfrog.

Tony: Yeah, Ken. He touched her pee-pee, or tried to.

Larry: So you went over to the house—without telling me anything— and knocked on the door. The father answered and you said, "Is Ken home? Can he come out?" And as soon as Ken came out, you tore him up.

Tony: And then someone tried to feel up Jenna in school. Remember, I came to beat him up while his class was still going on? I was beating him and the teacher came running over and started choking me against the wall. So I punched her out.

Jenna: It was Mrs. Bland.

Larry: How do you remember that?

Tony: And then the principal came and the librarian tackled me. I was never allowed on those school grounds again.

Jenna: It was always a constant thing of you protecting me.

Tony: Why did we have to fight so much?

Jenna: But we had fun though. We had so much fun.

Tony: It sounds horrible but it really wasn't.

Larry: Every time we were around Jenna, we ended up punching someone.

Tony: It's still true.

Chapter 7

March 2, 1983

Dear Diaree,

My dad got really mad because my brother would'nt lissen to him. All I did today was sit around. My brother is bugging us as usual. My brother is gay. He hit me. He thinks he can fight. Tomarro I have to go to school. Yuck! And we painted.

My brother painted his diary green & black.

I painted a picture of a monster.

Chapter EIGHT

Jenna: Marjorie was awful. It was like the evil stepmom. She was always angry with us, maybe because we were left over from Dad's other life before her.

Tony: She walked really heavily when she was mad. And we were always so scared of her. She would scream and yell and bang the doors of cabinets.

Jenna: We had a very large Doberman named Ming, and Marjorie would accuse me—a girl—of peeing on the walls. Even at that age I could reason there was no way I could pee on the walls. Maybe on the carpet but not on the wall. I told her that I didn't do it. And she was like, "You are lying to me and I'm going to spank you. You have a choice: I can spank you inside or outside in front of people." And I was like, "You aren't going to spank me. No, no, no." She grabbed me, pulled my pants down, took me outside, and spanked me with a hairbrush until I bled. I couldn't sit down I was hurt so bad.

Larry: You told me about that. Marjorie and I had a huge fight afterward.

Jenna: She was so angry with me after that. If I said something sassy, like any kid does, she would reach across the table and smack me across the face. You don't do that to a child. I was a little thing. I was being punished constantly for everything. But the scary part was that I loved her because she was all I really knew as a mom. I constantly wanted her approval but I never got it.

Larry: Well, she was just an idiot.

Tony: She was just a bitch. Remember the time I had an asthma attack

on the way home from school, and I didn't have my inhaler.

Jenna: You came home and were beating on the door and saying, "I'm dying of asthma." And she was like, "Well, you should have thought of that before you left the house. Come back in an hour."

Larry: Why wasn't I home?

Jenna: That's when you were working swing shift and you slept during the day.

Tony: You always treated us like adults. You would reason with us. But Marjorie would get angry if anyone else was good to us. She would never buy us anything, but she'd get mad if anyone else did.

Jenna: I remember I saw this little doggie key chain that had a shih tzu on it and Marjorie wouldn't buy it for me. So I stole it. I tucked it away in my nightstand, and then Dad found it. And he knew I wanted it because I had asked him if he would buy it for me. He was so disappointed in me. I just cried and cried. I was so broken up about disappointing my dad that I fell asleep holding on to his picture. In my mind, it was the worst thing I could have done. Dad was a cop and I was a criminal. I was one of the guys that Daddy chases. And I remember I woke up and dad grabbed me and was holding me and was rocking me and was like, "It's okay. It's okay."

Larry: It was okay. I didn't even reprimand you that much.

Jenna: I always felt that I had to protect you from having any more pain because I knew how much it hurt you when mom died. So I tried to be the strong one, and when bad things happened I would just internalize everything.

Chapter 9

April 1, 1983

Dear Diaree,

I broke my arm about 5 weeks ago. I just got my cast off. While I'm talking about hospitals my dads getting a chin augmentation. Hes getting it tomaro at 10:00. Hés nervous. He wants it to come in two minutes. I played a joke on my ~~mommy~~ Marjorie. I pretended to see a giant spider. She was scared, then I said APRIL FOOLS! She said you dirty rat. I laughed so hard. She was really mad. It was funny. Then we played Legós. It was fun. Were going to paint easter eggs.
Its going to be fun.

Bye Diaree

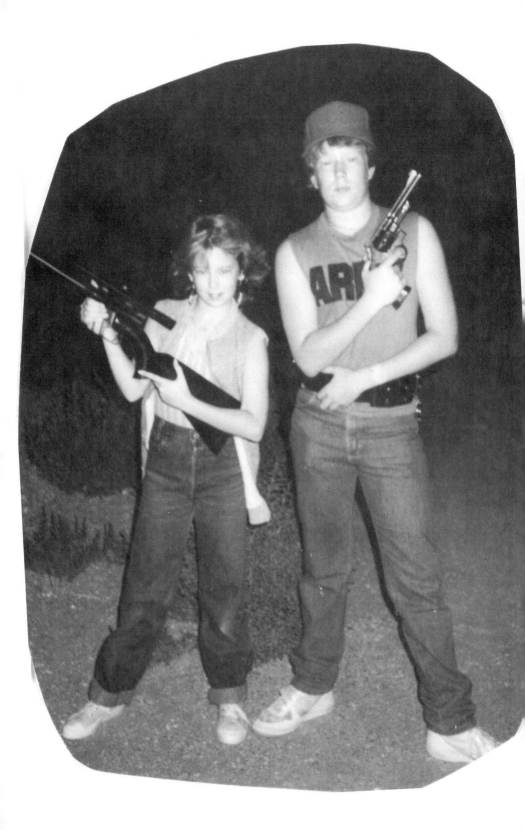

Chapter TEN

Jenna: Marjorie was a former model. She was about five feet nine inches, had long dark blond hair, and looked just like Marlene Dietrich. She even had a picture of Marlene Dietrich hanging over the couch. It was weird. She was very thin up top, and I thought she had really pretty boobs when I was little. But then she had a big fat ass and tree trunks for legs. And she would always walk around naked.

Tony: The thing that used to freak me out was when she would lay out in the backyard buck-naked. All my friends would look over the wall and see her sunbathing nude. Then I would go to school and it was like, "Ha ha, your mom is the naked chick."

Jenna: She would lay out nude with all her friends, and wouldn't allow us to play in the yard. You don't walk around naked like that in front of a teenage boy. And she had a big ole beastly ass. Jesus Christ, woman.

Larry: No kidding. You would have wanted to keep that son of a bitch covered up.

Tony: Remember that guy who tried to burglarize our place? Me and Jenna were at home. I think he knew we were latchkey kids. We thought someone had come onto our little porch area. Then we heard the door-knob wiggle.

Jenna: And Dad and Marjorie didn't believe us. They thought we were insane.

Tony: We knew the guy was going to come around the front when the door didn't open, so we had a great idea to put dog kibble on the trail and the porch so we would hear him crunching to the door. And remember,

we were watching TV in the living room and we hear *crunch crunch crunch?* And we were like, "Holy shit!" And we both ran into Dad's bedroom . . .

Jenna: . . . to get the gun.

Tony: I get the gun and I hear the screwdriver, trying to get into the door. I was ready to shoot as soon as he got in. But he couldn't get through so he left. Then we called the police and they sent Dad over.

Jenna: You were flying. And you came over to the door and you were like, "Son of a bitch, you were right."

Larry: I looked at the door and someone had tried to jimmy it open. I taught you to shoot if someone comes in and keep shooting until they stop moving.

Jenna: Tony started sleeping with guns under his pillows when he was about six years old. It was insane. Dad would never give him bullets but he gave him little Derringers and shit.

Tony: Yeah, but every time Dad dropped a bullet in the house, I picked it up and kept it in a box. So I was pretty well armed.

Chapter 11

July 16, 1983

Today me and my brother saw bash marks on the door. We think some one was trying to get in. I'm scared. My brother is going to sleep with me tonight. Cause, I asked him. I'm scared. I hope it'll be all right. Tony is setting a trap. He put dog cibble all around the windows and doors.
So if the robber steps on it it will crumbbul and in the morning we'll see if someone has been messing around the house.

Bye

Favorite Movies and Movie Stars

~~The Black Stallion~~
The Last Unicorn
The Magic Pony
Halloween II
~~Mork and Mindy~~ Alien
~~T.J. Hooker~~
Grease
Three's Company
STAYING ALIVE

Curt Russel
Olivia Newton John
Orson
My Dad know'en as Dearhie
My ~~Mom~~
Lipizzoners

Chapter TWELVE

Jenna: I read the book *Cujo* when I was really young and it scared the living daylights out of me. I wouldn't put my foot down on the floor because I thought something would get me from under the bed. So I would sit in my room and cry—more like howling—until Tony came and took me to sleep in his room. I would sneak into his bed from then on until I was about twelve.

Tony: You cried all the time. I was like, "Jenna, if you don't stop crying, I'm going to sleep in the living room so I don't have to hear you."

Jenna: And I'd say, "Don't leave. I can't sleep. I'm scared." And Tony would say, "Get up and do jumping jacks then, so you get tired." But I was too scared to touch the ground. And I'd make him hold my hand. I was so afraid of everything. I think back and wonder, "How could Marjorie not hear me crying?"

Tony: Do you remember the final straw? We had moved back to Vegas and you were jumping on your four-poster bed and you broke it. I came in and you were worried that Marjorie would spank you. I was trying to fix it really quick, and I was in my underwear. And she came in and said, "What are you doing in your sister's room in your underwear? Are you trying to molest your sister?" And I stood up and went *bam.* And she screamed and went running to Dad.

Tony: So Dad came in and said, "What the fuck is going on?" And I said, "I will not live with that fucking cunt."

Jenna: What happened was that Tony and I had a powwow and decided that we either had to run away or tell Dad we can't live with her anymore.

And Dad said, "Okay, I'm going to divorce her. I'm going to tell her tonight." That night we were all at the dining-room table. He told her, and all hell broke loose. It was like this huge bawling scene, with her screaming, "You can't do this to me." I started crying because it was so traumatic, and I remember looking at Tony and he was just stone-cold quiet. He didn't show any emotion. He always told me if he could kill her, he would. I locked myself in the room, and cried and cried because it was another upheaval. She was storming around the house, knocking stuff over and saying things like, "I'm taking everything and you will have nothing but those little brats." And I kept thinking, "Did I just fuck this up for my dad?"

Larry: God no.

Jenna: That was a major turning point for the way I felt about you, Dad, because I knew you were there for us.

Larry: You saw her a few years after the divorce, right?

Jenna: Remember, she came and picked me up? It was weird because she was saying that she loved me and I was her little girl. It really confused me. She took me to lunch, and tried to take me shopping but didn't buy me anything.

Larry: I think it was a ploy to get back with me.

Tony: I think that she realized her treatment of us was the reason why you left her.

Larry: Well, there was another reason: I just didn't like her.

Chapter 13

~~tomorrow~~

tomorrow

~~tommorow~~

June 24, 1984

Dear ~~Diarree~~ Diary,

Sorry it's been so long. I've had a lot on my mind. Well I'll tell you all what's happened.
 We moved in with grandma. We live on 7th & Franklin. I go to John S. Park school. I past into 5th grade. I turned 10 April 9th.
My brother's thirteen's. We've been having bad troubles. My mom and dad are getting separated. These last few days have been awful. Its been really hard on me a lot more than Tony cause he hates her.
 I've had her as a mother since I was 2. My poor dad is feeling awful. She's moving out today or tomorrow.

 My heart is so broken I could just cry.

Chapter 14

June 28, 1984

Today I went to dance. I do gymnastics for an hour now. I can do a backwalk-over now by my self. We had to do back-hand-springs. They're hard. We did the bar. God I wish I could do toe.

The seperation isn't doing any better. There still getting it. Wait a minute my dad just walked in. OK it's 10:51 at night. I haven't been sleeping well since the seperation.

Well got to go to bed.

Bye.

Chapter 15

July 3, 1984

Mom moved out today.

It's 11:56 at night and her
 number is ████████████.

I got her paints.

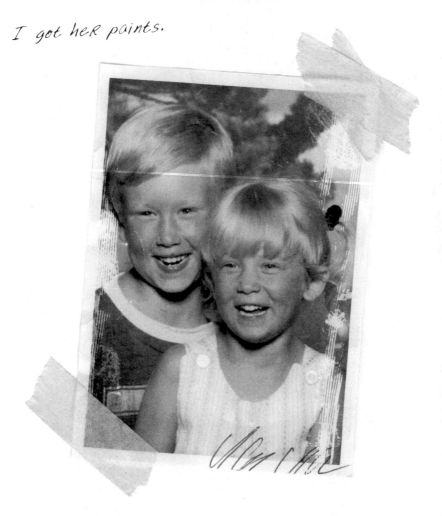

Chapter SIXTEEN

Tony: There were so many cruel things done to you. Remember when I put you on a bike without training wheels . . .

Jenna: . . . and pushed me and then let go. It was a big bike too. You were crazy. One of the major things that ruined me for about a month was when we were in front of the apartment complex and you said, "If you touch that clover, you will grow wings." Then you went off and played, and I just sat and looked at that clover for hours on end.

Finally I got up enough frigging balls and I touched the clover. I ran over to you going, "I touched the clover. I touched the clover." And you grabbed my shoulder blades and said, "Oh my god, did you see these? What are you going to do? How are you going to get by in life with wings?"

I sat and cried for days and days, and finally my dad was like, "What is wrong with you?" And I sniffled, "Dad, I'm growing wings." You got so busted over that.

Tony: Remember when we used to play ninja? We would climb walls and go into peoples' houses and hide behind their couches while they watched TV.

Jenna: And we'd be in full ninja gear. We dressed all in black. I mean, we were running around peoples' backyards in frigging burglar suits, pretty much. What if someone had shot us?

The worst thing that happened was one time at Seventh and Franklin, I didn't want to go out, but I didn't want to be in my room alone. Tony was going no matter what, so I was like, "Fuck, okay, I'll go." And he told me I had to dress in all black, and he taped that fucking

samurai sword on my back. Dad, this sword was twice my size.

Tony: It got caught on everything.

Jenna: We were walking on the walls behind peoples' houses, and Tony was always faster than me because I was small. Tony jumped these trash cans and *(starts laughing)* . . .

Tony: Oh no, let me tell you what happened. We came down off the wall, because these people suddenly turned on their kitchen light. So we were in this back alley, and all of a sudden when we hit the floor we realized, "Wow, the ground is moving." Then the clouds came past the moon and the moon shone bright, and we saw that the whole alley was cockroaches. It was a floor of cockroaches. So I just ran, full board . . .

Jenna: And I'm like, "Tony!"

Tony: I took off running like Joe DiMaggio, jumped the garbage cans at the end of the alley, and ran across the street.

Larry: You know, Joe DiMaggio was your grandfather's second cousin.

Tony: I know. That's crazy. Anyway, I'm brushing cockroaches off of me, and I turn around and see Jenna, just barely clearing the garbage can and, *bam,* she slams right into the pavement with her sword clanging and her throwing stars flying.

Jenna: And all you hear is *uggghgghhhhh.* I had to go to the emergency room for that.

Tony: Throwing stars were our favorite toys as kids. You could always tell where we'd been because there were two little holes everywhere.

Jenna: Remember when you were chasing me through the house and I was trying to hide . . .

Tony: . . . and you hid under the blanket. So I took the throwing star and was poking around, and I saw a little lump.

Larry: There was no one home. I was at work.

Tony: Yeah, we had the house to ourselves. So I saw a little lump and I threw it and, oh shit, out came Jenna . . .

Jenna: It stuck. I stood up and it was sticking out of my head.

Tony: It doesn't stick very hard. Just the skin.

Jenna: I had to pull it out. I had a bruise this big from it. And then Dad

came home and said, "What happened?" I lied. I said I was running from him and I was trying to get under the bed and I banged my head. I covered for you, and Dad fucking grounded me. I was so frigging pissed, but you made it up to me by buying me some Big League Chew.

Larry: I didn't learn the truth for a long time.

Tony: So many bad things happened that I never told you about.

Jenna: I remember one time we were at the bike track, and you got in a fight with this boy. He had you in a headlock and you were choking to death because of the asthma. You had given me this butterfly knife to hold and I was like, "What do I do? Stab him?" But I didn't have enough balls to stab him, so I ran over and jumped on the kid and started beating him with the blunt end of the knife into his spine, trying to get him off you. I was at the point where I would have killed to save my brother.

Chapter 17

July 30, 1984

We moved to Boulder City and I'm doing fine. Today I saw my old friend beth. She does toe. She had an extra pair and let me have them. I can do toe at ballet class now.
 There black. It's about 10:07 at night. My dads home late at about 12:00. I can't wait till then. I feel safer. We called into MT V Friday night video.

 Duran Duran won. Ming's sitting Right beside me watching me wRite.

My Most Treasured Things

Diary

toe shoes

canopy bed

white dRess

Real mothers neckless

dad

beth

Unicorn Collection

chapteR 18

November 24, 1984

SoRRy its been long but Ming and Bogi had to be given away because we weRen't aloud to have dogs. I'm so sad. My dad's at the gold stRike Inn. I'm lying on my bed wRiting. Im ten yeaRs old 4 foot 6. I want my dad to get home. Hes going to be late tonight. It's 11:12 at night. I almost foRgot to tell you. I'm going to get a cabbage patch doll. I can't wait till I get it in 4-5 months. TheiR 45 dollaRs. TheiR cute. I want my cabbage Patch to be named ChRystal Ann Massoli. Cute huh!

I like it do you? It's gonna be blonde with blue eyes. Im gonna get a cabbage P.K. StRolleR.

Bye.

P.S. Blonde Pig tails!

My FavoRite songs

FLASHDANCE
Richgirl
Jump
Panama
ThRilleR

Beilly Jean and P.Y.T.
Wake Me Up BefoRe You Go-Go
EveRy Thing She Wants
CaReless WhispeR

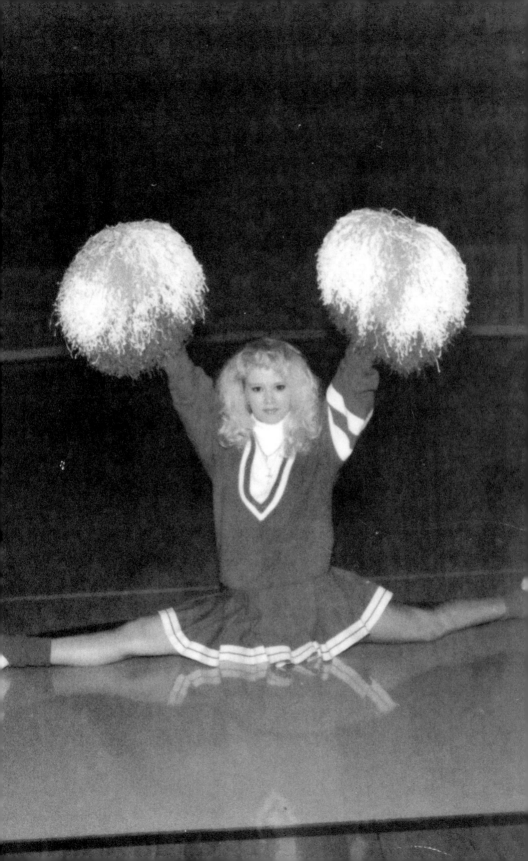

Chapter NINETEEN

Tony: We really started to have fun when you began junior high.

Jenna: Yeah, but I was a nerd.

Tony: But you had good friends.

Jenna: I was in my awkward phase. All the girls my age were coming into their own, and I looked like a little boy. I had glasses and these old clothes and this funny pageboy haircut with bangs. Actually, it was a mullet. Then I finally convinced Dad to let me grow my hair out.

I always had this really strong sense of fashion when I was young, but we had no money for it. Before the first day of junior high, all I had in my closet were three pairs of pants and two pairs of socks and ratty old shoes. I was fucked. So I started grabbing my grandma's clothes and cutting them up and trying to sew them.

Larry: It was that bad?

Jenna: I had no friends. I didn't know anybody. I had no idea where to go. I was sweating because I was so scared. All these kids looked so much older than me. But later I started hanging out with Karen and Beth. We were like *The Three Amigos*. Then my hair started to get long and I decided to bleach it. I was still kind of an outcast, because I looked like a little kid. And Dad didn't get me contacts until years later. But I felt a bit more centered.

Tony: And you were a cheerleader for a while.

Jenna: Well, we decided to go to cheerleading class. I had experience

Opposite: Montana, 1989.

with dance and gymnastics, so I was super good and they weren't. So they pretty much ganged up on me and decided they weren't going to be my friends anymore. They wouldn't talk to me, and would go out of their way to make me feel foolish. I went through about three months of being completely alone at school. I had to eat lunch by myself. A lot of the time I would skip lunch and leave school grounds to read a book. I lost a lot of weight during that time. Vivian would make me lunches in brown paper bags, and I would store them in my locker. After a couple months, the smell coming from my locker was so gnarly. They would give me notes during school saying that I had to clean my locker out. It stank like a dead body.

Larry: Vivian had been one of my students when I taught the police academy in Carson City.

Jenna: She was after Marjorie. She was kind of cool and nice to me, but by that time I was cold and turned off by that kind of crap. She would talk about things that really mattered to me and listen to what I had to say. And she was really bubbly. I remember Dad wouldn't let me shave my legs. I'm Italian, so I'm a little hairy. And I stole one of his razors and told her I shaved my legs. She saved me from Dad getting mad. But there was no way I was going to open up to another one of my dad's girlfriends. And sure enough, he eventually gave her the boot. She and Dad would fight a lot, and that pissed me off. My brother was so mean to every girl my dad brought home. He would throw stuff at them.

Tony: Anyway, back to school.

Jenna: What happened was that I eventually broke down. I had to quit cheerleading class and act as if I wasn't as good as I was so I could have friends again. That sort of sucked for me.

I remember being very confused because, after Dad and Vivian split up, I had no one to ask woman questions to. The big thing for me was when I wanted to get a bra really bad. I had no boobs. But I wanted a bra because all the girls wore bras. And I was like, "How am I gonna get a bra?" I can't ask my dad to get me a bra. So I stole it! I went into the dressing room and put it on and left.

I wore that fucker every day. It was the cool thing in school to have your bra strap sticking out of your top, because it made you look like a woman. At least, that's what I thought. So I'd always make sure that my bra strap was out a little bit. I was a wacky kid.

Chapter TWENTY

BOYS #2

Name: Cesar
Age: 12
Location: Las Vegas
Status: Schoolmate
Boundary Crossed: Kissing

When the first tremors of a strange, inexplicable attraction to boys began rumbling through my body, I was in a school that was mostly Hispanic. And the cutest, toughest-looking boy of them all, at least to my hormone-addled mind, was Cesar. He had been held back a grade, was at least a foot taller than me, and was just the kind of bad boy I wanted as a boyfriend. Even then, I had terrible taste in men. Of course, at that age you don't need to date or even touch someone for him to be your boyfriend. It's just a decision you make together during recess.

My house was down the street from school. When he came over for the first time, I was so awkward and nervous. The guy had been my so-called boyfriend for four months but I still didn't know anything about him and had no idea what I was supposed to say to him. We walked out to the porch and sat on the steps. And that was when Cesar took advantage of the moment to put his arm around me. I couldn't relax because I was worried my dad would come out and bust me. Suddenly, he grabbed me and planted this big nasty French kiss on me.

I was so grossed out I wanted to spit. The taste of another person in my mouth revolted me. I pulled away and discreetly wiped my mouth on my sleeve. Just then, I saw my grandmother's head in the door. She said, "Excuse me," and ducked back into the house.

I left Cesar on the porch, ran inside, and begged my grandma not to tell my dad. I wanted to be the perfect little daughter to him. And perfect little daughters did not French kiss junior gang-bangers. Of course, little did my father know that my brother and I were running the streets like maniacs. That was the first and last time Cesar and I kissed. A few months later, we moved and I never saw him again. For all I know, he's still sitting on the stoop, waiting for me to come back out.

Chapter 21

July 14, 1985

I'm sorry its been so long but about Marjorie she moved to Sweden. Can you believe it? Well Beth my best friend is moving to Denver. I'm really sad about that but I past 5th grade and Im going into Junior High. I'm on Summer Vacation right now. It's great. I'm doing great. So is gram. I'm 11 years old and I got another Cabbage Patch Kid. His name is Sonny Ray. Oh! And I got two others for Christmas and his name is Phillip Stacy and hers is Charissa Daria. Its 9:32 and Im lying on grams bed watching a music show. Well my favorite singers are Wham!—made up of George Michael and Andrew Ridgly. Thier reall cute. My hair is finally getting long. My dad is doing the best he has in a long time.

My brother is 14 and 5'4". Im 11 as you know + 4'7. Im starting to mature. My grandma said in about three Months she'll get me a menstrual starter kit. I still think I won't begin to menstruate until I'm older. I wish it would hurry up. My brother is going to be a freshman in High School. It's just hitting 10:00. Well I'll leave a picture of me for old times sake... I don't know why I said that.

Well bye. Jenna Massoli

Forearm 7"
Wrist 5"
Ankle 6 3/4"
Arm Span 22 1/2"

Feet 8"
Thigh 15 1/2"
Hips 26"
Waist 22"
Chest inhale 28 1/2"
Chest exhale 27 1/2"
Neck 11"
Head 20"
Calf 9 1/2"
Arm 8"

FINGERS

Thumb 2 1/4"
Index 2 1/2"
Middle 2 3/4"
Ring 2 3/4"
Little 2"

chapter 22

June 13, 1986

Yesterday I went to beths party and Alan the most
gorgeous guy to walk the earth was there.
 So we all went to his house and swam. Then we
went in and I sat on his lap + he was kissing me + hugging
me. Then he bit me on the arm softly. I think Im in love.
Beth is thinking of having sex with Randy Pelosi and
Im scared for her! I'll inform you about it tomarra
(that's when it's happening).
 Well I've turned twelve and Im almost a
teenager (though I don't look like it). But it feels good
to finally be getting older! I'm in seventh grade
next year. I can't wait.
 Dad and Vivian are getting married in California.
Well, I better go.

 Love

 Jenna

 Feet 8 ³/4" Wrist 5"
 Thigh 16" Ankle 6 ¹/2"
 Hips 26 ¹/2"
 Waist 22" FINGERS
 Chest inhale
 27 ¹/2" Thumb 2 ¹/4"
 Chest exhale 27" Index 3"
 Neck 10 ¹/4" Middle 3 ¹/2"
 Head 20" Ring 3 ¹/4"
 Calf 10" Little 2 ¹/2"
 Arm 8"
 Forearm 7"

September 2, 1986

Dear Diary,

Hi! Guess what? Where moving to Elko.
It's going to be pretty rad. Well when I told
you that Beth was going to have sex with Randy, well she did,
twice. What a dip! I bet she'll regret that the
rest of her life. But oh well! Enough of that
boring stuff.

I'm 12 yrs. old and 4 ft. 9 in. (I think).
I have no boobs what-so-ever. But oh well—maybe
someday! At least I'm not totally flat like some people!
Hair would be nice too: every other girl in gym
class has hair but me. It's embarrassing. I
feel like a little kid. I wear a size 12 or 14 in
jeans and a medium sized shirt in juniors.
Tony is 15 and is 5 ft 8 in. We have everything
packed up for we are moving Sunday at 3:00 in the
morning. Well, I have got to go and do something.

Bye. XOXO

Love,
Me

Chapter 24

December 21, 1986

Dear Diary,

This is Jenna reporting from the cold region of Elko Nevada. I really like it down here. I have a lot of friends such as Natalie Glass, Kristine Poljak, and Ginny Richey. We got a new puppy. He's a black Labrador. His name is Digby & he's two months old. Welp, it's almost Christmas & I don't know a thing I'm getting! I'm in the bath writing this! Well I've finally gotten hair and I'm starting to get some boobs.

Well I better wash my hair.

Bye,

Jen

Chapter TWENTY-FIVE

Jenna: After dad resigned from the force, we moved to Peppertree, right?

Tony: No, we moved to Elko.

Larry: We moved to Elko because I had a girlfriend in the sheriff's department who wanted me to come up there. But my girlfriend turned out to be such a shit that I packed you guys up one day and returned to Vegas. If you don't love my kids, to hell with you.

Jenna: Elko was where I began my pageants.

Tony: Dad had always taken her to dance class and tap and all that. She had always been a good ballet dancer. Not too many ballet dancers can do toe. But you were on pointe. You picked it up right away. So when you went into pageants, I thought it was a natural progression.

Jenna: What happened was I joined the cheerleading squad again in Elko and I was really good. I was the captain. I put the whole cheerleading team together, I taught everyone dance routines and cheers. We'd have fund-raisers to get the uniforms and everything. That's how I started to get a little bit popular for the first time in my life. Then I started doing pageants because one of the popular girls did them. I was like, "I can shred these people."

All the other girls had their mothers supporting them, and I was alone. Dad really didn't have any money and it wasn't something he was into, so I did everything by myself. When they would do bake sales for fund-raisers, I would make these pathetic brownies. I bought my own dress. I got all the sponsorships for my modeling sportswear.

Opposite: Me (top) at pageant.

Larry: I remember your first pageant in Elko.

Tony: All the other girls had these pageant moms and choreographers, and Jenna had just choreographed her whole routine in the backyard the day earlier. And she won overall.

Jenna: It was to "In the Navy." I shredded. There are a lot of titles you can win for the different events, but the best one is the overall title because you're competing with girls from ages three to eighteen.

Tony: And she kept going and going after that.

Jenna: I never lost a pageant. From the local pageant, I had to go to state, which is a big thing because there are probably one hundred to two hundred girls competing. To win a state title is huge, and I went in there and won for best interview, most photogenic, and modeling. I didn't win overall. There were girls who were just so stupidly talented. Besides, singers always win over dancers.

Larry: But you were probably the only one who did the whole thing by yourself.

Jenna: Trying to raise the money for nationals was insane. They are in Arkansas. And I had to pay for a cross-country trip and hotel. You have to have a certain kind of dress and makeup and everything.

I met this girl Amy at state. And we would put our crowns and sashes on, and walk around to all the businesses in Las Vegas looking for sponsors. Oh my God, I can't believe I did this. We'd go into car dealerships and ask for money. We were shameless. We would do car washes. You name it. We scrounged. I remember selling my old pageant dress.

Larry: I do remember Tony and I going down and hawking all of our guns.

Tony: That was for state. We made two thousand dollars. The only thing that paid for was the entrance fee. It's a big scam.

Jenna: I was psycho about getting the money I needed for everything else. We got turned away from places a lot. Amy would never want to go back, but I would keep going. Remember, I'd beg you to drive me by Fletcher Jones? I went in there every day. They were like, "Oh, for the love of God, she's back." And I'd say, "I'm back. Are you ready to sponsor me? It's only fifteen more days until nationals. I really need you guys. I'm going to be

famous." I was like the girl who never stopped. And I got those fuckers to sponsor me for $150. Yes! That was one of my biggest sponsors.

Tony: And then after she won a pageant, Jenna would go back and tell them, "You are the reason I won this. Do you want to sponsor me again?"

Jenna: I was a hustler. I would network all the different pageants. At the time I didn't think it was anything weird. But for someone who was so shy, it was crazy. When I wanted something I would go to any length to get it. I knew I had the talent; I just needed the money. I was so determined.

My interview capabilities were psychotic; I was able to turn it on even back then. When they asked me these generic questions, I would make each one my own. But I would always score low on my beauty because I looked super young for my age.

Tony: It gave you great stage presence and lots of practice dancing and competing. That's why you worked great at Crazy Horse. Most girls who become strippers are usually really hot but don't know how to dance and entertain. Well, Jenna went up there and did full choreographed performances. Remember when I took you to that bike run when you were sixteen?

Jenna: Yeah, and there was that wet T-shirt contest. I was crazy about winning any contest, so I did a couple shots and went up there. I got totally naked onstage and won.

Tony: You got a trophy and five hundred bucks.

Larry: I had never seen her perform outside of the pageants. The only time I saw you perform was your show . . .

Jenna: . . . at the strip club that my uncle owned.

Larry: Of course I walked out. But I was absolutely stunned at how wonderful you were. Stunned.

Tony: Even when she danced at Crazy Horse I would go in . . .

Larry: I was so proud, man. That was so fucked up but I kept saying, "God, isn't she great? She's great!" I'll tell you what: you've got a cast-iron constitution. I don't know how you do it. You have to deal with all those different kinds of guys. Twenty minutes of that and I would start stabbing people in the eye with a fork.

Chapter 26

April 14, 1987

Dear Diary,

Hi! Friday I went to Ely with my chorus class. There is a boy named Wade. I really like him and I guess he likes me too. Cause we made out. It was great. I really don't want to explain what happened because it's a long story. And my hand is already getting tired.

I turned 13 ~~Friday~~ I mean Thursday. God I'm finally a <u>teenager</u>.

I'll be in 8th grade next year.

I'm five foot and one half inches tall. I got a ring and an outfit from Desert Rain. All my friends got me something too.

Well, I gotta go, cause I stayed home sick today.

Bye.

Jenna

I Love Wade!

Feet 9"
Thigh 16"
Hips 28½"
Waist 22"

Neck 11"
Head 21"

Calf 9½"
Arm 8"
Forearm 7"

Wrist 5"
Ankle 6½"
Arm Span 25"

Fingers

Thumb 2½"
Index 3"
Middle 3½"
Ring 3½"
Little 2¾"

chapter 27

November 24, 1987

Hello. I'm in Las Vegas now. We moved back.
Vivian is history. Oh well. I will probably look back
on my childhood and laugh. I laugh at it already. I
have a lot of fRiends but I never go any-
where. Its very depressing.

I went to State and I won young Miss Modeling
Queen. And then I went to Nationals recently
and I got top ten in the country in my pageant.
I had a lot of fun.

I LOVE

~~TL~~

~~DLR~~

~~GM~~

~~David Erickson~~

~~Wade Adams~~
~~Joey Deluca~~

~~Victor Valerio~~ I love him

~~Dave Hernandez (?)~~

~~I love Ty~~

~~I love Cliff~~

I love JACK!

Chapter TWENTY-EIGHT

Tony: You know what's going to be funny is if anyone in Vegas finds out about these stories, they're going to be like, "That was Jenna Jameson that did that to me. I was just standing on the side of the road and she . . ."

Jenna: ". . . shot me with a fire extinguisher." Remember that? She totally fogged up. We barely got away.

Tony: It all started when we were younger and would egg people. Then we decided to take it to a different level.

Jenna: I came up with the idea of the fire extinguisher. I was like, "They're readily available at every apartment complex. We just gotta go break the glass and take the fire extinguisher, which sets off the fire alarm. But if we get out of there fast enough, we're fine, right?" So we had a collection of them. And we would go "fog people up," as we called it.

Tony: I'd call someone over to the car to get directions . . .

Jenna: . . . and I'd *pssssshhht* out of the window. It was great because it's like a cloud of death. And the people afterward are just coated in white. We would go down to cracktown and see the crack hos on the corner and we'd fog 'em up! I remember one time we got this kid on a skateboard and there was a cop that saw us. We were in this total car chase, and we got away.

Tony: Remember when those kids were chasing us in their car, and they pulled up next to us.

Jenna: And then you got out of the car, because they had their window rolled down, put the fire extinguisher in there, and *schpoom!* You fogged up the whole car full of six kids.

Tony: No one ever went as far as we did. We would get a camcorder and fog up all the prostitutes on Fremont Street. Remember those gang members making out with that girl? And we hit those fuckers. They were solid white. And one of the guys got in that old Impala and chased us through all of Vegas waving a gun out the window. We went through a full tank of gas in that car chase.

Jenna: We did everything that the Jackass and CKY guys did way before they did. Maybe everyone was doing this stuff. I don't know.

Tony: Remember, we'd build these giant sculptures in people's backyards and set them on fire?

Jenna: No, I'd set them on fire. You guys would run, and I'd still be out there, trying to light it.

Tony: "Jenna, light the wick!"

Jenna: Finally, *boom!* Everything would explode in flames. People would be coming out of their houses freaking out. And then a couple days later on the news, "There's been a rash of arsons across the Las Vegas valley." And we're all like, "Yaaaayyy!" Our dad had no clue.

Larry: I had no idea what you guys were doing.

Tony: Wreaking havoc.

Jenna: I still get the urge to go fog 'em up every once in awhile. *(all laugh)*

Selena [Tony's wife]: Are you hearing a lot of this for the first time?

Larry: Oh yeah.

chapter 29

April 13, 1988

~~I've done it. I murdered those filthy pigs. I~~
~~still serve him. Blood in the moonlight covers the~~
~~dragon. Charlie told me one night, "Do it, snuff~~
~~'em. They don't appease the dragon." Those~~
~~bastards.~~

~~They're all weak. All five billion of them. They~~
~~all die by the hand of the dragon.~~
~~Voy a matar los todas.~~

Tony wrote that.

You're an idiot.

Tony smells—I can't stand the odor.

chapter 30

June 9, 1986

Victor,

A boy or should I say a man moved into our apartment yesterday or the day before. Amy and I were walking & we encountered one of her classmates. We talked awhile out at the swimming pool. He speak to me about an attractive friend of his named Victor. He described him as blonde buff & tan. And of course he sounded attractive to me. I secretly inside wanted to meet this mystery man. But I was very timid about meeting strange men. But Amy said to just come and sit in the grass in front of his so called apartment. So I did.

We sat and had a few meaningless conversations, until I saw 2 dark figures moving at a somewhat fast pace. All at once they sat down in our huddle in the grass. One was dark haired and very old looking, sitting on his motorcycle helmet. The other, he was hard to take my eyes off. He struck me as the wild type, someone who could release my secret desire to be wanted in a seductive manner & to be treated & looked at as an attractive woman. And to throw away peoples tendency to look at me as a ~~cute~~ pretty but young girl. As time went on, he became more and more sexy. But I couldn't show my secret desire to touch him. I think he realized how much I wanted him & he came and made himself comfortable unusually close to my warm body. He made me feel like no other boy or man ever made me feel. It was

getting quite late so I got up and started to leave—thinking to myself it was silly of me to even think of being able to satisfy his needs.

But as soon as the thought ended and I was within two arms lengths away from him, a phrase I was secretly wishing he would say left his mouth, "When will I see you again." My heart filled with joy and passion. "Tomorrow," I said. The next day I couldn't see him at all. But at about 11:30 p.m. I peered through my window and there he was. No, he wasn't a figment of my imagination. He was real. He was standing beneath my open window, staring up at me. We greeted each other and I yearned to hold him close to me, like I so often thought about. He gave me his telephone number and he disappeared into the darkness. The next day I found myself alone in his room, him holding my body close to him.

He gave me a few playful pecks on my arms and my face. Then he gave me the most passionate and deep kiss I have ever even assumed there could be. My god. I wanted to stay here in his arms and make love to him over and over again until my body was so tired it had to stop. But I had to leave. He is the one that I want to be with day & night. But I don't think you know that. Try to understand how much I want & need to be with you. Sorry for making it so long but I couldn't tell you in any other way.

I will never ever stop wanting you.

chapter 31

June 10, 1966

Victor & I broke up because of my family.
I'm heartbroken. I just want to die.

Chapter 32

June 20, 1988

Dear Diary,

Victor & I are back together. I feel so much
 better. Tonight he put my hand between his legs.
Oh My God, he's giant! He and I both want to
make love but we're both scared.
I'm scared of the whole idea, and he's scared of
 hurting me. He makes me feel incredible!

I forgot to tell you, I gave my modeling crown
up and I have won Teen Miss Glamour Girl. I
 have Victor and he has made my life complete.
Until he came along life was meaningless.

 Talk to you more tomorrow.

 Jenna

Chapter THIRTY-THREE

Larry: Does anyone know what happened to Rolly?

Tony: He's got to be in prison. Rolly was my best friend.

Jenna: I loved him more than anything. But he was not the kind of guy you would ever see me going out with.

Tony: You were a cheerleader, and he was a big ole fat kid.

Larry: I liked Rolly. I never got mad at him. You thought I got mad at him.

Jenna: Well, yeah, because he kept stealing all your shit.

Tony: We stole everything that wasn't bolted down.

Larry: Who stole my machine gun?

Tony: The one in the hall closet? I took it.

Jenna: It was probably that Sterling nine millimeter.

Tony: After the way I used that gun, I couldn't bring it back.

Jenna: We went to such lengths. I'm surprised we never got caught.

Larry: That's just luck.

Jenna: It was jackin' and burnin' stuff and foggin' 'em up. We would laugh to the point where we were half dead.

Tony: We would have to stop and end it for a while.

Larry: You guys always had a great sense of humor.

Tony: It seems like our life has been really based around violence.

Jenna: I have anger issues from it. I always did. I was a very withdrawn child.

Larry: Jenna suffered mainly because I was overprotective of her. After what happened with Judy, I couldn't bear losing her. I had also lost my dad. We were gambling at the Frontier, and he went into the bathroom

and had a heart attack at age fifty-four. I couldn't get him to the hospital in time. So I'd lost most of the people I'd loved, and couldn't bear to lose any more.

Jenna: Dad's had an amazing life. He went into the service right after he graduated high school.

Larry: That was in 1957. I was an, um, advisor for 729 days 16 hours and 27 minutes in Vietnam in the seventh armored division. But who's counting?

Jenna: It's hard to believe that you witnessed and participated in such violent scenes.

Larry: I'll give you an example. I took twenty nuns and some orphans out of a little village sixty clicks southwest of Nha Trang and was waiting for helicopters to pick them up. But we were being followed by North Vietnamese regulars and some Viet Cong. So I placed myself halfway between the helicopters and the tree line. I had my Thompson machine gun on my back and my M14 rifle in my hands. When they came out of the tree line, I just started picking them off. The next day, they found sixty-one bodies that I had killed lying there. And that doesn't include the bodies the North Vietnamese hauled off into the tree line.

Jenna: He killed all those guys without batting an eyelash, but he was scared of bugs.

Tony: Later, he was sent to Africa to fight against a communist revolution over there.

Larry: The government came to me and said I could finish out my time if I'd organize and train soldiers in the Congo to fight the Simba communist revolution. It's interesting because when you first go over you try to be so righteous. I grew up with Roy Rogers and Gene Autry, and they never shot anybody in the back. It was the white hats against the black hats. You have to do everything fair.

Well, I found out in war the best way to come home alive is to sneak up on people and shoot them. When I got to Africa I still had some humanity left. When we captured the rebels, we would have a trial and then we would pass judgment: we would imprison them, execute them,

or send them back to their village. But after four months of walking in the bloody wake of Simba massacres, we flew the black flag. If you ran, you were a Simba rebel. If you stood still, you were a well-disciplined Simba rebel. So we shot everyone. I would come up to a village and, instead of going house to house, I would level the whole place. I would call in the P51 Mustangs. We used Napalm. I had a contingent of howitzers. We went from village to village killing them all. We just didn't care. We didn't care.

Jenna: Now it makes sense why you wanted to be a police officer.

Larry: You know, it's not something that really goes away. It's always there, but I have it shut off. It took me about ten years to be social afterward, because I was really out of my element in the world. Before I met your mom; I had contacted some people I knew at the French Foreign Legion. I was thinking of joining because I couldn't cope in the world. I couldn't carry on a conversation.

My Dad.

Chapter
THIRTY-FOUR

Boys #3

Name: Victor
Age: 18
Location: Las Vegas
Status: Neighbor
Boundary Crossed: Oral Sex

It wasn't until freshman year of high school that I was finally *ready* to kiss a boy. However, I was such an awkward adolescent that anyone I had a crush on either ignored me or made fun of me, in particular a cute surfer by the name of Bobby Wysaki. The only kid in school willing to go out with me was Aaron Pierro. We made out all the time, but he'd try so hard to get his hands under my shirt or down my pants that it usually degenerated into a wrestling match. Eventually, he broke up with me because I wouldn't have sex with him.

Not long afterward, I was tanning on the side of the swimming pool of our apartment complex with my friend Amy when an older boy who had just moved next door started talking to me. He asked how old I was, and I told him the truth: fourteen. He was Italian with long dark-blond hair, a muscular body, and a motorcycle helmet under his arms; I was small even for my age, had a baby face, and a small swelling of the chest that only a career biologist would call breasts. I couldn't believe he had picked me to talk to over my friend Amy, who was ten times hotter than

I was. No guy had ever singled me out like that before. Looking back on it, I can't help wondering if he was some kind of perv. Either way, my hormones were raging, and snagging an eighteen-year-old guy was a very cool coup for a fourteen-year-old.

After we talked, I went home. Every night he'd throw rocks at my window to get my attention and leave notes for me underneath a tree. He lived with his mother, but she worked nights. So one night I snuck over there and made out with him. I yearned to be kissed, to be desired, to taste a man in my mouth. When our tongues met, my knees melted and my heart soared. I was in love. I wanted to be needed. I needed to be wanted.

But this time, my dad caught me. "I am going to go over there and kill that boy," he raged. I burst into tears, called him every curse word I knew, and stomped up to my room. It felt like I'd been waiting my whole life to be swept off my feet, and now my dad was threatening to ruin it. He marched to Victor's house, threw him against the wall, and told him to stay away from me. The next day Victor told me we had to stop seeing each other.

Fortunately, Victor's fear was short-lived. Soon, he was pelting my window with rocks again. And so we started dating. At least, that's what I thought it was. All that really happened was I would go over to his house after school, while my dad slept all day, and Victor would feed me alcohol and pot and see how far he could get with me. His room was the ultimate teenage pad. It was plastered with posters of girls; a Dixie flag was draped across the ceiling; his bed was on the floor; and his windows were covered with tinfoil, so that the room was always dark and black-lit. I had never been so obsessed with a boy and his world before.

I wasn't fully developed yet, and I was very embarrassed by my boobs. They appeared so strained and misshapen, and one was bigger than the other. Their worst features were the nipples, because the areolas were so puffy they looked diseased. I refused to let even my girlfriends see them. But Victor worked and worked at it, employing every persuasive device in the arsenal of the male species, until he wore me down and I let him put his hands under my shirt.

"Oh my God!" he exclaimed. "You have the most amazing boobs I've ever felt—in my entire life! You are going to have really big natural boobs when you're older."

"How can you tell?" I asked. They were just one step above mosquito bites.

"I can just tell," he said, with the knowing air of an expert, which he probably was. For the following ten minutes, he praised them to the heavens until, finally, I whipped my shirt off. If he thought they were so great, he might as well see them.

Every time I saw Victor, we would make out until it felt like my lips were going to fall off. He'd shower me with compliments about how beautiful I was, which allowed me to slowly develop confidence in myself and my body. I would get so turned on by the way he talked about me that I'd leave a wet spot on his bed, right through my underwear and pants. The whole time his body was pressed against mine, he was so hard I imagined it leaving telltale bruises on my skin.

It took him several nights of constant pressure to talk me into putting my hand down his pants. I was so shocked to feel something like that. It was huge. I kept thinking, "Tree! Tree!" It took several days more before I had the courage to actually look at it.

After that, he talked me into licking just the end of it. And so, step by step, he begged and sweet-talked me into rubbing it for a minute and then licking it for ten seconds. The poor guy must have had such a painful case of blue balls every night.

Eventually, he had me licking and rubbing it at the same time. And then, one day, it happened. He came. I was freaked out. I wasn't sure if that meant we had just had sex or what. He felt so bad about it. "I'm sorry, I'm sorry," he kept apologizing. "I was trying to hold off. I couldn't stop myself."

But it didn't gross me out at all: nothing Victor could have done would have grossed me out.

However, no matter how hot I got, I refused to have sex with him. I wanted to do it so badly, but I just couldn't. And the main reason was

because his penis was the size of a tree trunk. It was huge, even in comparison to the professional cocksmen I've been with since. I was afraid it was going to hurt me. The other problem was that I hadn't had my period yet, and for some reason I had the idea fixed in my head that I couldn't have sex until I was actually menstruating.

Eventually, he laid it on the line. "Listen," he told me, "I'm eighteen years old and I have to have sex. You have your chance now: If you want to start having sex, then we can stay together. If you don't, well . . ."

With my face red and streaked with tears, I told him I was sorry. I just couldn't.

I was so distraught afterward that I didn't go to school for two weeks. In a cruel twist of fate, my period started a month later. But by then, Victor was dating somebody else—a girl who probably put out. In my eyes, it was an innocent puppy-love experience, though I'm sure in his eyes he probably just wanted to pound me.

Three years later, I was in a bar and saw Victor across the room. He was on leave from the army. As soon as he said hi, a locked box inside my heart opened and the long-gone feelings I had for him flooded back through me. We turned into kids again, scrambling for a room to finish what we had started. But this time I was ready, or so I thought. It still hurt. I couldn't walk normally for days afterward.

That was the last time I ever saw him.

Chapter 35

August 7, 1988

Hello,

Well, I have had a lot happen to me this week. Last Thursday I got my period.

I'm relieved I finally started. Victor and I are broken up and I'm seeing his best friend! I must sound like a hoe!

But he's so nice. He helps me cope in this confusing world...

I must go now...I will write soon...

Love,

Jenna

Xoxo

Chapter 36

August 15, 1988

Dear Diary,

Heres what happened. I have told my dad about
Victor & I ... I still have feelings for him...
because he really was my first relationship...
I really feel love for him in my heart...

but I need to go on with my life...

Love,

Jenna

FAVORITE MOVIES

Nightmare on Elm Street Part 1 & 2
Aliens

BeetleJuice
Stealing Heaven
Terminator

chapter 37

October 4, 1988

Oh god,
I feel awful. I can't live without Victor.
I think about him day and night....
 I miss him so much! I just want to die—

 I don't know what to do. My life is
living hell. I don't think he wants me back
 because his new girl friend screws him day in
and day out. Oh well I'll just have
to suffer.
 I don't think this is just puppy love.
 I hate my life cause he's not in it...

 Jenna

Feet 9'1/2"
Thigh 17"
Hips 31'1/2"
 Waist 24"

Chest Inhale 33"
Chest Exhale 32"
 Neck 12"

Head 23'1/2"
 Calf 11"

Arm 9"
 Forearm 7'1/2"
Wrist 5'1/4"
 Ankle 7"
 Arm Span 26"

Fingers

Thumb 2 3/4"
 Index 3'1/2"
Middle 3 3/4"

Ring 3'1/2"
 Little 3"

Chapter
THIRTY-EIGHT

Jenna: Acid was a good thing for me. I would drop acid on weekends with Tony because I thought I would never ever fall into the hardcore drugs. And during the week I was still a good girl at school. I was finding myself and everything was beautiful.

Tony: We got pretty crazy, though. Remember the time when we went to the Tropicana and dropped acid by the pool? We took the lawn chairs and tried to ski them down the fountains. And all the security guards came with guns in force. As soon as they let us go, we walked right into the hotel and wandered around looking at the carpet and the walls.

Jenna: How about the time when we did acid and you set me on fire? *(All laugh)*

Tony: Selena fired a bottle rocket into the back of your head. We were all frying on acid, and then she . . .

Jenna: I tripped over this rock . . .

Selena: . . . running. And the first thing I see is Jenna screaming, and her head is flaming. And she's flying through the air, and when you're watching that while you're on a couple of hits, it's . . . *(All laugh)*

Jenna: How about me being high and on fire? You can't think to stop, drop, and roll.

Tony: Remember Puffensquish, that chick?

Jenna: She took so much acid that she would wander the streets in Vegas touching all the tar repairs on the cracks in the asphalt—puff and squish.

Tony: Yeah, and we used to go out in Mount Charleston and take acid and walk around in the snow. Everything looked like a gingerbread house with frosting.

Jenna: Oh it was soooo . . .

Tony: Weird.

Jenna: . . . beautiful.

Larry: The first time I ever did acid was with you both in Mount Charleston. We were all sitting there laughing, and I had excluded this girl who was with me. Jenna said to me, "Look up." There was this huge pink ceiling with stars and stuff. And I looked up and the whole world went *zooom,* and we were gone. We were gone.

Jenna: My dad was cool enough to say "cool."

Tony: He came up in the Rat Pack era of the sixties, and for them drugs were cocaine or drinking. He didn't realize he was about to be propelled into another universe. *(Laughs)*

Larry: You know, the incident that sticks with me is when we were at the corporate apartment and we did coke. I did it with you, and you looked at Tony and said, "Go, Dad."

Jenna: Get down with your bad self, Dad.

Larry: That's exactly what you said. I will never forget that. I completely reversed myself from being the self-righteous stupid ass that I was to a psycho.

Tony: Remember when I was dealing coke, and Grandma stole an eightball?

Larry: My mother stole an eightball?

Tony: She would hide them in her coat pockets and sneak off to do them. Remember, she was usually as mean as a snake, but all of a sudden we were like, "Why is Grandma being so nice?"

Larry: You know what? I don't miss any drug. But the only drug I ever liked was crank. It's the best drug on the planet, but smoking it. Not sniffing it.

Jenna: When did you smoke crank?

Larry: When I was managing the strip club. I did just enough to stay high all day.

Jenna: Well, that's every five minutes.

Larry: No, it would last me a good two hours. This little girl at the club had an unlimited supply. I would take a baggy and smoke it all night long.

Tony: To someone who really does drugs, smoking crank or snorting crank is wasting it. If you want to get high, you shoot up.

Larry: I never wanted to do that. I loved the fact that I could control how many hits I had, so I could stay at that perfect level.

Tony: You can do that by banging it also.

Larry: Really?

Tony: You can control your exact high. You can feel all day, or you can be tuned completely to the gills.

Larry: Interesting.

Chapter THIRTY-NINE

BOYS #4

Name: Cliff
Age: 19
Location: Las Vegas
Status: Neighborhood rich kid
Boundary Crossed: Intercourse

My first period brought with it a whole new set of problems. One was that I still had my hymen. It was a thin, flat layer of flesh completely blocking my opening, making it impossible to use tampons. I would push at it until it hurt, but it still wouldn't give way. I even called my dad's ex, Vivian, but she was also stumped.

The other problem was that new kinds of hormones began to surge through my body, impairing all mental functioning. I walked around with a constant craving to be penetrated.

I had met some older boys in the neighborhood who were having a party, so I decided to try my luck there and see if I could solve two problems with one man. I saved my money and bought a slinky black tube dress, which I wore with black stockings. Then I called my best friends and we pooled our money, rented a limo, and went out to celebrate the loss of my virginity before the fact.

Thanks to the memory of my grandmother's coffee-table wipeout, I

wasn't a big drinker. But I made an exception for this special occasion. I downed seven tequila shots over the course of the night and tried to act like the sexpot I thought I looked like. The target of my lust was the leader of the pack, Cliff, a rich pretty boy who had recently wrapped his dad's Porsche around a tree. I was only fifteen and a half, but I was finally starting to fill out, so I felt like the star of the whole party.

All night long Cliff worked me—teasing me, feeding me shots, telling me how beautiful I was, leaving his hand on my waist a little too long. Eventually, he led me to the bathroom. He pinned me against the wall, and we started making out.

His hands were all over my body—squeezing my breasts, my hips, my ass. He grabbed my stockings around the thigh and ripped a huge hole. Then he pushed me backward onto the toilet, lifted my dress, and started eating me out.

He stood up, unzipped his pants, and began a difficult balancing act. He steadied himself with one hand against the wall, lowered his penis into range with the other hand, and poked at my leg, trying to maneuver through the hole in my stocking. It was all happening too fast. That's when I realized: This was it. I was going to lose my virginity forever to this drunk homing missile. My next thought was, "This isn't right. I can't do this."

I started to panic. The word began building in my head before it exploded out of my mouth in a short, sharp scream: "Stop!"

He jumped back, shocked, and then testily zipped up. When we walked out of the bathroom, all my friends were gone. They had taken the limo and left me, assuming I was getting what I had gone there for. Now I was stuck. I had planned to sleep over at a friend's house. But I couldn't just show up at her place and wake her parents. And I couldn't call my dad to pick me up at a party full of college-age guys. Besides, I was wasted.

So I drank a little more, considered my plight, and then asked Cliff to drive me home.

"Sure," he said. "No problem. Jeff can give you a lift."

We climbed into the backseat of his friend's truck and made out the

whole ride. I loved every moment, because it felt like I was being accepted and initiated into this cool adult world. Now I know better.

When the truck stopped and we got out, we weren't at my house at all. We were in front of Cliff's. "You can stay in my brother's bed," he said. "He's out of town."

By then, the last two shots of tequila had kicked in. I was not only too trashed to complain coherently, but too trashed to walk. I kept collapsing on his lawn and slurring gibberish. He picked me up and carried me inside. I shut my eyes until I heard a deep gurgle. He had dropped me onto a cheap, black lacquer waterbed. I looked at the sheets: they were a hideous collage of red and blue stars. Even though I was shit-faced, I remember thinking how disgusting his bed was. I just wasn't in the mood anymore. He kissed me. I was grossed out. And that's the last thing I remember.

When I woke up, I was completely naked. I looked down at my body and saw a huge pool of blood.

"Oh my God," I thought. "That bastard stabbed me."

It was so eerily still in the room, with Cliff sleeping noiselessly, I thought for a moment that I was dead. Then I realized what had happened.

I grabbed a scratchy wool blanket at the foot of his bed and gently lifted myself up, trying not to create a wave large enough to wake him. The only decoration in the room was a poster of a woman in ripped jeans with ultra-green eyes and cut-off jeans. The first thing I wanted to do was not to run out of the house screaming, but to check and see if my objective had at least been accomplished.

I crept into the bathroom and sat on the toilet. Dried blood streaked down my legs to below my knees. When I tinkled, it stung so badly my body curled like a burning strip of paper. Afterward, I tentatively put a finger inside. There was no resistance. I pushed it in further and felt, for the first time, my cervix. Was I upset at having been fucked while passed out? Hell no. I was ecstatic: my hymen was gone. And it must have been quite a feat for valiant Cliff because, judging by the blood everywhere, it was a pretty strong membrane.

Not having had a mother figure in my life, the thought that this was a textbook case of date rape never even crossed my mind. I thought it was a good thing, the start of a new life. And, like an idiot, I fell in love with the guy who had ignominiously given me this new life.

So we started dating. The next time I was in his bedroom, I asked about the poster of the gorgeous woman with the colorized green eyes. He said it was Traci Lords. I had no idea who she was. I just knew I wanted to be that gorgeous.

Once I had conscious sex with Cliff for the first time, I was a convert. I loved it. It was all I thought about. I would call him every night, begging him to come over and take me into the bushes behind my house and fuck. I don't know what was going on in my body: My hormones were having a fucking party. Seven times a day was not enough. The most unexpected side effect was that I started having mother pains: an intense desire to have a baby overwhelmed me. Even at the time, I understood that it was a normal, evolutionary instinct—that's what sex is for, after all—and was able to repress it as I acted out my innocent, seemingly unquenchable desires.

But one night when Cliff and I had plans, he didn't show up. I called, and no one answered the phone. So I decided to drop by his house. I buzzed the bell; nobody answered. However, the door was unlocked, so I walked in. I climbed the stairs to his bedroom and pushed open the door. And there he was, in bed with another girl—a girl I knew.

I looked at them. They looked at me. No one spoke a word. I just turned around, shut the door behind me, left the house, and vowed to get revenge. I wasn't hurt, because the love I felt for him was an illusion anyway. I just regretted having lost my virginity to this asshole, and wished that my period had come a month earlier so I could have lost it to a guy I actually cared about.

The second I returned home, the phone was ringing. It was Cliff, groveling, telling me that he was so sorry and I was his girl and he loved me. I was completely over him.

Three weeks later, I went to a party at his house. There were about two hundred people there, including his best friend, Owen, a blond, six-

foot-four-inch gymnast and surfer. I had a thing for surfer boys, but I didn't want to have sex with him because he had a reputation for having a really big dick. So, after I prepared with the usual shots of tequila, I took Owen by the hand and dragged him into Cliff's bedroom. We rolled around on the waterbed, making out.

Before Cliff, everything I had ever done—every piece of myself I had ever given a man—was because it was something I had wanted to do with someone I felt an emotional connection to. But now that he had hurt me, it was on. Sexuality became a tool for so much more than just connecting with a boy I was attracted to. I realized it could serve any purpose I needed. It was a weapon I could exploit mercilessly. So, just to mess with Cliff, I continued to see Owen.

Cliff picked a fight with Owen a few days later, but since Owen had a good fifty pounds and six inches on him, he pretty much squished Cliff. Not long afterward, Cliff went off the deep end: he got addicted to drugs and ended up in prison for dealing.

As for Owen, even though we dated, I never actually had sex with him. There was no way that was going to happen: his thing was so thick it took two hands to encircle and so long it stretched past his belly button.

Somehow, I've always ended up dating guys with big dicks. I guess I have a radar for them.

Chapter 40

March 25, 1989

A lot has happened to me since I have last wrote you. Victor, for one thing. I'm over him, even though I still love him, but I have new people in my life. I met someone named Patrick, and I new from the very beginning it was not going to work but I was bored so I accepted to go out with him, what a mistake! He is the biggest dork I know! Oh well that's over with.

He had a best friend named Ty and I met Ty's brother Cliff at Ty's house. I was imediatley attracted to him. I didnt follow up on Cliff because I was still going out with Patrick. So Friday rolled around and I was invited to Daves party so, Michelle, Dawn & I rented a stretch limo and went.

Well the weird thing was Cliff was going to be there (I didnt know that). So when I got there I was after Cliff. So was Michelle, but Cliff went for me. Well I got blasted and ended up back at Cliff's house. And I had sex with him. I couldnt believe it—

Well now I'm going with Cliff and I'm happy! Its spring break and I've never partied so hard in my life! It's so fun.

My life is going great! I'm really happy. Write ya.

Later,

Love

Jenna

Favorite Songs

You Give Love a Bad Name by Bon Jovi

Summer Girls—Dino Cassanova

Rippin' Sir Mix A Lot

Pour Some Sugar On Me—Def Leppard

N.W.A

Eazy-E

Bobby Brown—Rock Witcha

Perogative

Don't Be Cruel

Roni

FAVORITE NAMES

1. Bunny*
2. Nikki
3. Viper
4. Cherri
5. Fallan
6. Jade
7. Stormy*
8. Sheen
9. Breezy
10. Barbie*
11. Stryker
12. Cody
13. Madison
14. Asia
15. Vanity
16. Honey
17. Vegas
18. Hunter*
19. Morgan
20. Royce
21. Rayne
22. Cameo
23. Dior
24. Marilyn
25. Ashlyn
26. Cheyenne
27. Skyler
28. Candy
29. Savannah
30. Velvet
31. Medina*
32. Walker

Chapter FORTY-ONE

Jenna: I remember when Tony was so deep into his drug use. It was probably the scariest thing I've ever seen.

Tony: I used to walk around with a doctor's bag.

Jenna: I've never seen anybody that fucked up. He used to carry a ball-peen hammer in his back pocket and would use it.

Tony: Anyone that would piss me off, I'd hit them with that hammer.

Jenna: You were into the whole motorcycle, body-piercing scene.

Tony: Hanging out with Hell's Angels, robbing people.

Jenna: I remember at Taco Bell one time when you bashed someone's window out.

Tony: That was another situation. That was Mike and I. We were making fun of these guys on the CB one day, and they tracked us down and started throwing rocks at our car. They all had pipes and bats. So Mike and I came out with our guns and said, "Drop your weapons." One guy dropped the lead pipe and the other guy turned and ran. Mike chased him across the street into the 7-11, shooting at his back.

I holstered my gun, picked up the pipe, and chased him into Taco Bell. I clipped him, *whack,* right behind the ear. He flew and landed on a table where a family was eating with little kids.

Jenna: That was a bad scene, especially Mike shooting up the 7-11 like that.

Larry: What ever happened to Mike?

Jenna: Oh, he's dead. You were so fucking paranoid by that point in your drug addiction. A helicopter would go by and you'd be like, "They're following us."

Tony: Yeah, we'd pull into a covered garage.

Jenna: I'm like, "Tony, this is ridiculous." And you'd say, "Do you see those guys? Those guys are watching us."

Selena: I was there. I remember that.

Jenna: But you were the voice of reason. I'd say, "Selena, you've got to do something because he's going to go off the deep end."

Selena: Well, that shit makes you paranoid. A couple months after we got married, I said, "It's either that or me. And he picked me."

Tony: Remember that guy who ended up biting his tongue off?

Selena: Wasn't he the guy you beat up because he wouldn't say gargoyle? (All laugh)

Tony: I was sitting in the truck and he walks by and I said, "Say gargoyle. Say gargoyle. Just fucking say gargoyle. I dare you to say gargoyle." And ten minutes later he said the word gargoyle, and it was on.

Selena: It was like a cartoon.

Jenna: Oh god Tony, you were crazy.

Tony: Yeah, those were some wild times. I had several bouts where I did so much dope I didn't even recognize Jenna.

Larry: Unbelievable.

Tony: I'm pretty calm now. I love tattooing. I'm the biggest family man in the world. I like hanging out with my family and playing with my son. I don't seek out the adrenaline rush anymore.

Jenna: Oh, how things have changed.

Larry: For the better, my dear. For the better.

Chapter 42

Well, here's what happened. I'm out for summer. I'm now a sophomore and my life is fabulous, even though I'm grounded. Anyway, so far I like this guy named Paul Petrullo. I was going out with him, but he found out about my other boyfriend Owen, and he got highly pissed. But now he wants me back so I think I'll go for it! While I was going out with him I slept with him. I don't find anything immoral about it. I already lost my virginity, by mistake, but that's life! So why not enjoy it while you can! Because I definitely plan on it!

I do need to get this out in the open, so I'll right it down. I have a very bad insecurity about my body. I feel there is something wrong with it. I'm slowly getting over it, but I hate being seen naked. It makes me very uncomfortable.

I'll get over it someday ... hopefully!

See Ya,
Jenna

Favorite Songs

1. Shook Me All Night Long
2. Drive it Home
3. Cajun Panther
4. Girls Girls Girls
5. Paradise City
6. Yankee Rose
7. California Girls
8. Summer Girls
9. Pour Some Sugar On Me

10. You Give Love a Bad Name

Chapter FORTY-THREE

Jenna: I remember they called me Mozzarella. My hair was really long and bleached white from the pageants, and I would crimp it. So they gave me the nickname Mozzarella because it looked like string cheese and maybe also because of my last name, Massoli.

Larry: Why did you stop doing the pageants?

Jenna: I just wanted to move on. I was the one girl without a pageant mom, so everybody always talked behind my back. It was the same old shit: even though I succeeded, it made people hate me more. It was irritating. I just came, I saw, I conquered, and now I'm leaving. So I said, "Okay, now I'm going to concentrate on getting popular at school."

Larry: And how did that turn out?

Jenna: That didn't turn out until I was about fifteen. It took a few years of practice. Before my first day of high school, I made all these plans that I was going to do all this stuff. I failed miserably. I didn't talk to anybody. The first day, I threw up in the trash can in the bathroom. I made a habit of doing that in high school because I was so scared all the time.

Tony: That was when we moved back to Las Vegas and were living at Grandma's because we were out of money. I was in a room with you, Dad had the bedroom, and Grandma slept in the dining room on a daybed.

Jenna: I don't think anyone would even remember I existed freshman year. I felt transparent. Eventually, I realized I could make friends with people easier with extracurricular activities than during school. Most of the girls on the cheerleading team were catty, but the captain became a real good friend. She was a junior and, at the very end of the year, she

would come and talk to me after my classes. All my classmates saw that, and they were like, "Whoa!"

Then, over the summer, it really got good. My boobs got huge, like a C cup. I had spent so many years being so far behind everybody else physically that once I did get them, I was like, "Ha-ha. Revenge time!" I would wear a tight T-shirt and no bra out all the time, because I wanted to throw it into everybody's face. But, fuck, right when I was starting to get popular, we moved again.

Larry: That's when we moved to Montana. You were both getting kind of wild, and I wanted to get you both away from Vegas. I wanted to take you to a place where America was America. Tony and I were pretty happy on the ranch, but you hated it there.

Jenna: You get these harebrained schemes. "Okay, we are going to buy a cattle ranch, and we are going to raise cattle." Um, Dad, what part of "I'm a city girl" do you not understand?

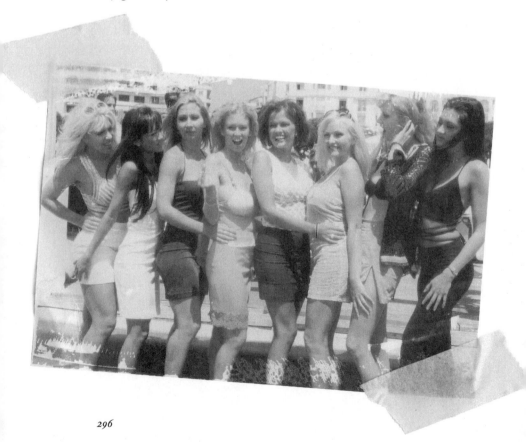

chapter 44

September 20, 1989

Hi there! Well I moved to Montana and I'm not really very happy here. I miss Owen. He was my latest boyfriend in L.V. before I left.

Well here is whats been happening since I got to this place. Well, I am very popular but some of the girls at school don't like me.

Feet 9¹/₂"
Thigh 17¹/₂"
Hips 33¹/₂"
Waist 23¹/₂"
Neck 11"
Chest Inhale 36"
Chest exhale 35"
Head 22"
Calf 11¹/₂"
Arm 9¹/₄"

Forearm 7"
Wrist 5¹/₂"

Ankle 7¹/₄"
Arm Span 28"

Fingers

Thumb 2³/₄"
Index 3¹/₂"
Middle 3³/₄"
Ring 3¹/₂"

Little 3"

Chapter FORTY-FIVE

Jenna: So Dad dragged us up to frigging Fromberg, Montana, which is an hour outside of Billings. It had a population of about 450 people. I went from a school that had thousands of people to a sophomore class with nine people in it. It was pure hell.

Tony: All the girls hated you. They'd beat you up after school.

Jenna: They would gang up on me, like four of them, and they'd knock me down and kick me. Even the frigging teachers hated me. From the minute I walked into my first class, all the whispers started because, now that I had my boobs, I was the flaunter of every piece of flesh. I would wear tight shirts and tight pants. I had a cute body and I was going to show it off.

Larry: You just blossomed all at one time, and these little farm boys were hanging on the fence. Beginning with that guy Victor, there were about forty people I wanted to stab in the throat.

Jenna: Yeah, the way I dressed worked in Las Vegas; it didn't work in Montana. But I was popular with the boys, and I wasn't going to give that up for these jealous girls in school. So it just got more violent because their boyfriends would leave them for me. There was this one corner that I had to pass on my way to school, and the girls would wait for me there and chase me. They were corn-fed, so they were pretty tough. One girl would get me by the back, and one would punch me in the stomach. They didn't really hurt me, but Jesus Christ I got the wind knocked out of me. Or they would rip out my hair. During school, they would draw on the back of my shirt with markers, put gum in my hair, stuff like that.

Larry: You did have horseback riding.

Jenna: Yeah, I spent most of my time alone. I would go out in my bikini and I would ride my horse. I was super tan. We had 256 acres, and I would just ride. I got to be less of a prima donna because I herded and castrated and vaccinated the cattle and everything. So it was good for me in that way, I guess.

I just didn't want to tell my dad that I was getting my ass whupped every day because it was embarrassing.

Larry: I had no idea. One day they called me and said, "We are going to put your child in a foster home if you don't get her to go to school."

Jenna: Oh, Dad. The worst thing happened in Montana. I never told you but I just can't talk about it. It was so bad. And that's why I stopped going to school. So when you told me that, I slipped a gear. I was like, "Okay, these people are threatening my life and trying to send me to a foster home? They want to play a game? Fine! We'll play a game!" I wasn't going to take this shit anymore. So I marched into school, and the girl who picked on me the most was leaning into her locker to get a book or something. I walked up full force and, *boom,* I slammed the locker door so hard and busted her head wide open. She was out cold when I walked away, and there was blood everywhere. I fucked her up. Then I went to my locker and grabbed all my things because I was never going back there. I remember walking out of school for the last time and having this huge rush of power. No one was going to take control of my life again.

Larry: Then she came home and told me what she did and everything she'd been through. I told her to pack her stuff: We were leaving Montana.

Chapter 46

July 31, 1990

I haven't written in ages, I know. My life now has drastically changed. I live in Montana, and I am very unhappy. This god-awful place has taught me a great deal, though I am very confused and I feel way alone. I wish I could just run away. But I have nothing, or rather no one to run to. Plus I wouldn't hurt my father for anything in the world.

I have so often thought of gathering my things and wandering until I have found my correct place, a place where someone needs me. But I wonder if there is such a place. To people I am either a self-centered bitch or just another pretty girl. I wish someone would love me for me, not for my looks or my body.

I thought Pat loved me but he was just like all the others. I now know that only god could give me a true love. I don't think god acknowledges my existence, not that I deserve it. I hope when I look at this Diary, or my children read these lines, that all this is just a bitter memory and I am happy and loved. I pray my children, if and when I have them, never have to experience the kind of pain I have had in my life. But I am trying as hard as I possibly can to get through this part of my life, and maybe I will get through without permanent damage, just scars. My brother is my crutch that keeps me from falling, and my love will never die for him, never . . .

Until Later,

Jenna

chapter 47

October 1, 1990

Dear Diary,

The WORST thing in the WORLD happened today.
It's so horrible I can't even write it down or tell my
 dad or my brother anything.
I HATE Montana. I WANT to KILL MYSELF.
 But that wouldn't be fair to my dad. I am not going
to write anything down anymore. I am going to get out
of here and forget all about this place.
 I am so sad and torn apart and confused. I don't
understand people. How could this happen to me? I
don't know what to do. Life sucks.

 Goodbye Forever Diary,

 Jenna

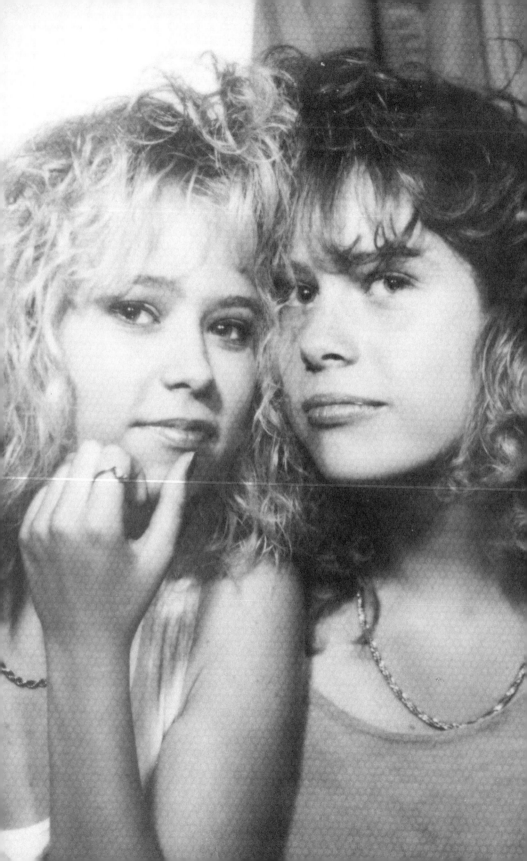

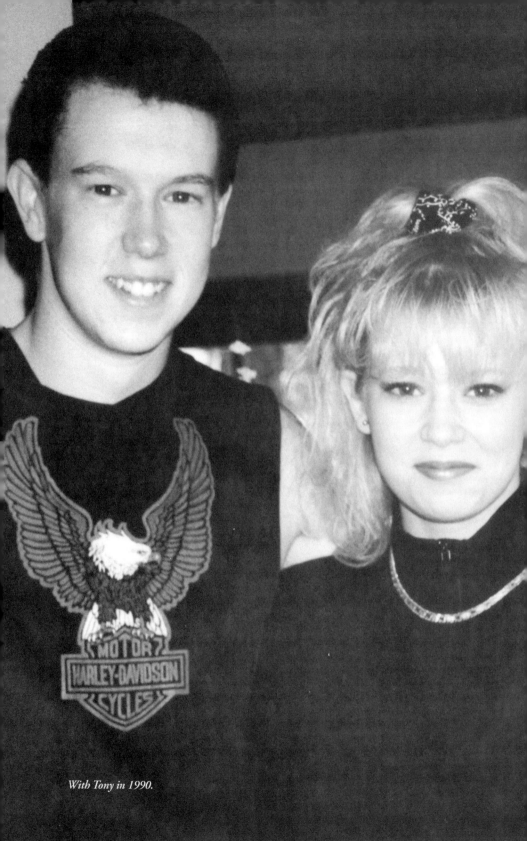

With Tony in 1990.

Chapter FORTY-EIGHT

Tony: If you really want to delve into this, there are a lot of things that happened.

Larry: I'd like to know what happened in Montana.

Jenna: I don't know if I'll ever be ready to talk about it.

Tony: Dad, we moved once a year. So, though that didn't make us confident, we became adaptable and grew up fast.

Jenna: We rarely had any friends, so it was usually just the two of us.

Larry: I was a workaholic. I was gone all the time.

Jenna: You worked such long hours, and when you came home you were exhausted.

Larry: I was a part-time father, and I don't care what anyone says, you can't crowd quality time.

Jenna: But I wouldn't say, "Oh, my life was horrible."

Tony: No, it was great.

Larry: You both certainly had no fear of blood. All that you went through makes the everyday machinations of living very trivial.

Jenna: And you always supported us.

Larry: You have to look at your cup as being half full. It made us stronger and it certainly made us closer than the average family. Because we have an unspoken bond between all three of us: no matter if we are a thousand miles away from each other . . .

Tony: . . . it's always been us against the world . . .

Jenna: That's right.

Larry: . . . and it always will be.

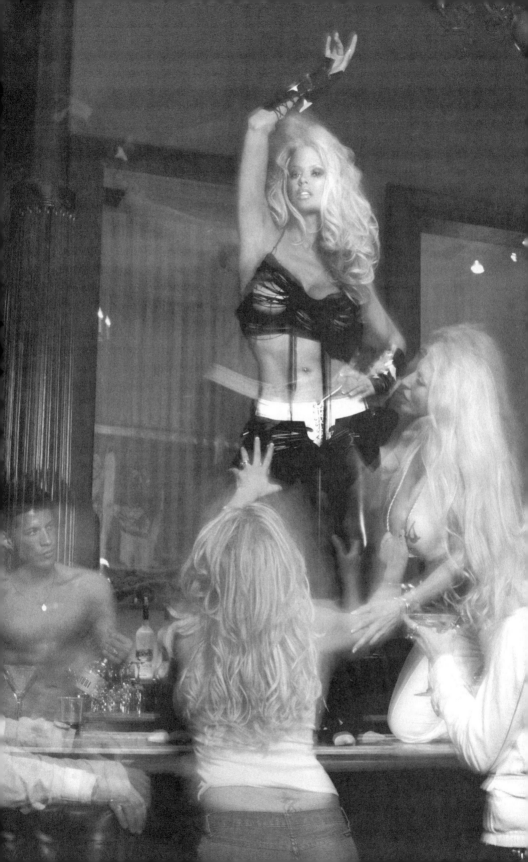

JENNA JAMESON

Book

IV

QUEEN OF PORN

XXX XXX

AN IMPERFECT ACTOR ON THE STAGE

"As an imperfect actor on the stage,
Who with his fear is put beside his part."

★ ★ ★ ★

Chapter ONE

And so it was that, four years after I had first run away from home, I found myself with my family again. My father and grandmother nursed me back to health not with pills or herbs or chicken soup, but with butter. Butter-soaked focaccia bread was their palliative of choice. They stuffed my face with pure fat trying to get my weight back to normal.

The sum total of my gratitude was zero. My heart was still lying on the floor of the apartment Jack and I shared, where four days before I had been hours away from failing the game of life. All I did was vomit and cry myself to sleep over Jack. It was impossible to separate where the depression from meth withdrawal ended and the depression from Jack withdrawal began. My entire adult life, up until this moment, had revolved around him. I was down to seventy-five pounds, and for every two bites of soggy focaccia I digested, I spit one back up. I was so weak that my grandmother had to walk me to the bathroom whenever I went.

When my senses began to return, I told my dad what had happened. Everything. His eyes were wet when I finished. Being on the run had given him time to think about the things he regretted. And one of those regrets, he said, was not being a good enough dad. When my mother had died, he had no idea what to do with the two kids who were suddenly his sole responsibility, so he let us run wild while he busied himself with his vigilantism.

"I tried my best," he said. "But the best I could do was not very good."

Now, seventeen years later, I had given him the chance again.

I lay in bed for two more weeks. Slowly, my hair became less brittle and

the color returned to my skin. I eventually regained enough strength to get up and walk to the kitchen by myself. My grandmother, who had loaned me her bed while she slept on the sofa, would feed me chicken fingers while my dad sat in the corner of the room in silence. I was sobbing so hard I couldn't keep the food down.

Tony and Selena were also living at the house. As the depression began to lift, it dawned on me: he was no longer a frigging monster. He was clean. My brother was back again. Leaving Las Vegas was the best thing that had ever happened to him, because he knew no one in Reading to buy drugs from. Soon, he started coming into my room and we'd play cards and laugh about how fucked up we'd each gotten. It was as if no time had passed since the days when we were so close.

More than anything, I wanted to know what had happened to Tony and Dad, and why they had left home and run around the country like a couple of fugitives. But I didn't ask. I had enough problems of my own at the moment and didn't want to burden myself with theirs. I knew that my brother and father had been in league in something bad, but I also knew they wouldn't be comfortable talking about it.

Six weeks into my recovery, the phone rang. No one was home, so I answered it.

"Hi, Jenna."

It was Jack. "What do you want?" I asked.

"I'm back in the apartment, baby," he said. "It doesn't feel right without you here. When are you coming back?"

"I'm not, Jack," I said. "I just can't."

"What are you talking about? Listen. Everything is going great. I'm making a lot of money at the tattoo shop, I'm going to get cleaned up, and I've been doing a lot of thinking. I'd really like to try this again."

"Listen, I'm a different person now. I can't go back there. That's not me anymore."

I really meant it. Going back to Jack would be like returning to the Crazy Horse: I couldn't go backward. I had let myself become out of control and weak with him. I never wanted to be that person again.

Jack begged, pleaded, and yelled. It felt good to know that not only

was my physical strength returning, but so was my emotional strength, which I had lived without for so long.

My father and grandmother would have been glad to nurse me forever. They were happy to have something to do. But I couldn't sponge off them forever. I needed to kickstart my life. And there was another person who had offered to help me when I was down. It seemed like so long ago since I had last seen her: Nikki Tyler.

The next day, my dad drove me to the airport. I had cried when I first saw him at the gate nearly two months ago, but this time I cried a very different type of tear.

"Jenna," he said as we hugged good-bye, "just don't fall. Don't fall."

As I sat in the window seat watching Reading recede to a crisscross of streets and shrubbery, I thought, "I'm never going to let that happen to me again."

L.A. beckoned.

⌒

"Oh my God, baby girl! What happened?"

Those were the first words out of Nikki's mouth. I had gained fifteen pounds but, evidently, I still looked like a corpse. Dark sunken circles sagged around my eyes, and my pelvis jutted out of my sweatpants like the handles of a baby stroller.

"We are going to get you back on track," she said as we walked into her apartment. "You'll be fine."

She showed me to my bedroom: the couch in the living room where we had first fooled around. Always motherly, she helped me get my body back and my head straight.

After a month of binge eating, I was ready for magazine work again. But even now, when I look back at the pictures, I'm repulsed by how skinny I was.

Whenever I changed into an outfit to go out, Nikki laughed at me. My suitcase was full of tank tops, rolled-up boxer shorts, zipper-covered jackets, spandex pants, and black Lycra dresses. I looked like a heavy-metal groupie who had been living on a tour bus for a month. It was time, Nikki said, to complete my transformation from hoochie mama to

full-grown woman. She gave me magazines, took me shopping, and drove me to auditions for bathing-suit pictorials, which were hard to come by at first because I was so skinny.

But I didn't want Nikki just to be my mother. I wanted her to be my girlfriend. After Jack, I didn't think I'd ever be able to open up to a man again and allow myself to be that vulnerable. After working at the Crazy Horse for so long, every man in my mind was a cheater, a liar, and a shitty human being. I was angry, and more than ready to become the heartbreaker tattooed on my ass. Add to this my experiences with Jennifer and Nikki, and I was pretty sure I was gay.

The slight hitch in my plan was that Nikki had married Buddy. And, though we continued to fool around, my efforts to separate her from Buddy were useless. She insisted that she wasn't gay. I insisted that she was in denial.

I was broke, so Nikki put me in touch with a manager at the Riviera Hotel, who flew me into Vegas for a week and booked me in the spot-light revue of their Crazy Girls show. Suddenly, I found myself in Sin City again—the hellhole I thought I'd escaped. But even though I was there physically, my mentality was different. My body was clean, my head was clear, and I was independent. When I caught a whiff of meth in the dressing room one night, it served only to remind me of the sad-ness that had been my life just a few months before.

On the last night of the show, Jack showed up unannounced. He looked terrible: his beautiful chestnut hair was completely shaven and he was so emaciated that his bones were practically ripping through his flesh.

After the performance, he asked me out to lunch and I accepted. I knew that I was over him like a butterfly is over a cocoon. He said every-thing he could to win me back. But when I looked into his eyes, I didn't feel a thing.

When I left him that afternoon, it was a turning point in my life: the insecure sixteen-year-old tagalong who first had a crush on him was dead. And he had killed her. I now had the confidence to rebuild my life by myself.

Chapter TWO

A s I eased myself back into the world of Suze Randall and photo shoots, my attitude began to transform. Before, I never had an opinion about what I would wear, who I was working with, or how they wanted me to pose. But, slowly, I realized that they needed me as much as I needed them. I could have some sort of control.

So I started opening my mouth: "This lipstick doesn't match this outfit"; "What do you mean there's no lunch?"; "You're shining a backlight through my head, and it's making me look bald"; "I'm not eating cold cuts again." Remarkably, I found that people listened—and obeyed, because they knew that the more comfortable I was, the better the pictures would be.

I wasn't a terror to work with—that would come later—but I was making my first tentative steps toward diva-dom, not necessarily a good thing.

Off camera, I lacked any sort of stability. Getting away from Las Vegas was probably the biggest decision I'd made in my life since running away from home. Suddenly, I really was independent. Living on Nikki's couch without a car, I felt the immensity of the world outside of Las Vegas. I was in a city in which no one knew or cared about me besides her. I knew my living arrangements were only temporary: one day, I would have to leave. And then I'd be truly alone. The problem with sobriety was having to deal with reality. I needed to make some real money. I couldn't suck off people—Dad, Jack, Nikki—anymore. And

there was no way I was going to end up like one of those old strippers dancing with worn-out heels and a worn-out smile.

Weeks later, at a photo shoot, I met a producer who worked for a company called Heatwave. He wanted to put me in a movie, *Silk Stockings* starring Tiffany Million. I had really only dabbled in adult movies before, primarily as a way of getting back at Jack. I was through living my life in response to Jack's actions, but I wasn't exactly sure what to do instead. Heatwave was a respected company at the time and the pay would be five thousand dollars per scene, nearly twenty times what I made from photo modeling. On one hand, those sweat droplets from *Sponge Cake* still hung vividly in my mind's eye. On the other hand, there was the memory of the polished, professional set of Andrew Blake. I wrestled with the decision for weeks. Nikki was dead-set against it. In fact, she was devising her own exit plan from modeling; her parents were covering her (and thus my) rent and car payments as she put herself through makeup school for film.

"You're making a big mistake if you go back to that world," she said. "You've done magazines, but movies are entirely different. You're really compromising yourself. Are you prepared to deal with the psychological effects of having sex with men you don't know? You got lucky with Randy West. But what about *Sponge Cake*? That's what all these movies are like. Whatever you go on to do in life, these films will be with you forever. Think about how it will affect your future relationships. And, God forbid, one day you are going to have to explain them to your children."

She was such a mother figure to me that I thought about every word. I lay on her couch, unable to sleep for entire nights sometimes, wrestling with myself. I couldn't invade Nikki's space like this forever. I had to make a life for myself. I was good at this whole sex-on-camera thing. I enjoyed it; and, if I only chose high-quality projects from reputable directors, I could avoid the less savory side of the business.

Everyone I talked to told me not to get into adult films. They all had their reasons. And they all made sense. But the notion wouldn't leave my head. I just wanted one person to say that it was a good idea—one person to support me—and I'd be able to move forward. My instincts kept

screaming that it was the right thing to do, but they kept fighting with my brain, which said it was sheer idiocy. That support eventually came from my father.

I called him in my usual state, upset and holding back tears, and told him that I was alone, scared, and considering accepting an adult film offer.

"Ignore what everybody else says," he said. "They have their own reasons. How do you really feel?"

"I want to do it," I blurted. "I really think this can be my life."

"So you've made your decision," he said. "I can't say that I agree with it, but I support it. The only thing I ask is that, if you do it, make sure you do it right. Don't ever compromise yourself and don't let anyone get the best of you. When you show up for work, know that you are an asset to them and not the other way around."

When I hung up, I was relieved. Not only had my dad given me advice, but he'd actually given me *good* advice. The closer I came to deciding to say yes to *Silk Stockings,* the more vehement Nikki became in trying to dissuade me.

"Don't fucking do this," she'd yell. "You are destroying your life."

This was the type of reaction I would have expected from my father. And as I always do when confronted with authority, I rebelled. I was upfront with Nikki about everything, so when I later told her that I'd called the producer and accepted the offer, she blew up. "If you do this," she screamed, "I do not want you living here. You can pack your fucking bags and get out."

Nikki was so upset that she wouldn't even drive me to the first day of shooting. She'd always been a blunt girl. That's what I had liked about her in the first place. Of course, she loved me too much to boot me out.

I pulled up to the studio in a taxi. The first person I met was an actor named Lyle Danger, a dark, moody, well-built Slovenian with smoldering eyes and a day of stubble on his chin. Like me, he was also new in the business. So we both sat quietly around the set, nervous and shy, afraid to make eye contact with anyone. I liked him right away. Of course, the business would eventually change him into another creature entirely.

We didn't shoot our scene that day, but afterward I asked him for a ride back to Nikki's. He was hesitant, but I pleaded and eventually he gave in. When I saw his ride, I realized why he had been so reluctant: it was a bucket truck with a cherry picker in the back and the words ONE TWO TREE on the side. His day job was running a tree-trimming business.

When he dropped me off, he agreed to pick me up the next day for work. Finally, there was another friendly person in this town. Nikki, of course, neither liked nor approved of him (though that would soon change).

It was beginning to get very uncomfortable in her house. It wasn't just because of the movie, but also because I noticed a glue gun in the kitchen. Nikki was staying up all night working on strange art projects that meant a lot to her but made no sense to anyone else. I recognized the behavior. And I also recognized the cause. Buddy was telling Nikki every day, in subtle and not-so subtle ways, how fat she was. He'd push her out of the house and order her to go to the gym. Instead, she became so depressed she'd go to Winchell's, buy a dozen donuts, and sit in the car eating them.

Then, in the middle of shooting *Silk Stockings,* I was fast asleep just before daybreak and Nikki was up organizing her shoes for the tenth time, when all of a sudden the dishes in the kitchen started shaking, followed by the bottles in the bar. Then books and videos started falling off the shelves until, finally, the TV set smashed to the floor.

We ran outside. An earthquake had struck in Northridge nearby. Before our eyes, Nikki's windows shattered—now we were all homeless—and the house next to us collapsed, killing the people inside it. We sat on the side of the street, stunned and in silence. And I was supposed to be at work in less than three hours.

On set, I was scheduled to finally shoot my scene. As soon as the camera started rolling and the male lead, Bobby, walked in, I felt the air fill with tension. It was so thick that I could almost feel the resistance as I moved through the room. He stood there, smoldering and sexy yet nervous and intimidated.

All the tension and fear of the day just exploded out of me. It was as if I needed to prove to Nikki that she was wrong, that this was my calling. Every part of my body—my hands, my mouth, my legs—began pumping in a different but perfect rhythm. I suddenly understood where the phrase sexual dynamo came from; I was a frigging machine. And I was so in the moment—more connected to life and myself than I had been since my last scene with Randy West. I was fucking good at this. When the camera stopped rolling, everyone applauded.

After the shoot, I asked Lyle to give me a ride back to Nikki's. Bobby hitched a ride with us as well and squeezed into the cab of Lyle's ridiculous truck with us. As we drove back, our hormones were still whizzing around from our scene together. We never made it to Nikki's. We had Lyle drop us off at a motel instead. I felt bad for Lyle because I could sense that he really liked me, and was new in the industry and reaching out for someone. But my body wanted Bobby. As soon as we entered the room, we tore each other's clothes off and fucked savagely. But the passion only lasted five minutes—not because either of us came, but because it just felt weird having sex together in real life. The chemistry on screen was not that of attraction but a different kind of partnership, the bond of two new actors emotionally invested in creating a perfect scene together. I don't know who said it first, but we both thought it at the same time: "This is not right."

A few days later, Nikki and Buddy moved into a new house. It was bigger than their last place, so I had my own bedroom. But I never unpacked. I knew it wasn't going to last long. Our friendship was turning to rivalry as Nikki began accusing me of competing with her and lying to her. But I couldn't have a rational conversation with her, because her personality had been taken over, eroded, and replaced with paranoia. Whenever I said anything about her partying, she accused me of trying to drive a wedge between her and her husband. That may have been true when I first moved in, but I had quickly realized that she was under his thumb. It was interesting to observe their relationship now that I wasn't in

one. I could see the way Buddy would make fun of her weight or encourage her to party, just like Jack had with me.

The final blow-up came when I confronted Nikki about her partying, and she responded by accusing me of slutting around town and lying to her about it. She was my only support in Los Angeles, and now she was screaming at me like a lunatic.

"I opened up everything to you—my home, my life, my love—and all you've done is disrespect me," she yelled. "I want you out of this house tomorrow."

"I want you out of this house," she yelled, so loud that her voice went hoarse. "Tomorrow."

Only Nikki's brother, Michael, shared my concern for her and understood what was going on. From the moment we met, there was chemistry between us, if only because I couldn't have Nikki and he was a tall, strapping male version of her.

I had no idea how to find my own place in L.A., so he bought a paper and circled a dozen apartments to look at. The first day we went hunting for a place, we passed a piercing parlor in Studio City. I had Michael stop and walked inside. I had an impulsive idea of commemorating my new independent self with a memento: a belly-button piercing, which was poked by a creepy little white guy named Flavia with dreadlocks down to his knees. Then we drove to see the first apartment, a little studio on Dickens and Van Nuys, across the street from a newsstand. I loved the place, not to mention the fact that I didn't have far to walk to pick up the magazines I was in.

We moved my worldly possessions—one small bag of clothes—out of Nikki's house. It was one of the most painful things I had to do: I felt grateful to her for so much. Since I'd first met her, she'd been a voice of sanity in the craziness of this business. Without her, I probably never would have gotten back on my feet and in the game after Jack. I would most likely have been taken advantage of by someone who saw my desperation, neediness, and confusion as vulnerability. But when I left her house, we didn't say a word to each other. Not even good-bye.

Chapter
THREE

Anal sex. Anal fucking sex. Brown-hole-spelunking rusty-can-expanding colon-tickling anal fucking sex.

I know I have your attention now, because just about everyone is interested in doing it up the butt, whether it's because they want it, their partner wants it, or they're just curious. Evolutionarily speaking, the dick was never meant to go in the butt. Besides the fact that you can't procreate from that direction, there's no natural lubricant in there. But there are still pleasure centers and, moreover, there's an emotional component. Anal sex is an exchange of power. And every man I've ever met loves the idea of dominating a woman by pushing his massive dick into her tight sphincter so that she loses control.

For me to allow a man to have anal sex with me, I must have trust first. Because to be on the receiving end of anal sex is to give yourself completely to your partner. And that's why, despite the fact that it is practically an industry standard to have anal sex in every sex scene, I've never done it in a film.

It has become a constant issue for me. I've been offered hundreds of thousands of dollars to do anal. But even if I walked away with $300,000 for having done it, I would also be taking away the feeling that I gave up something that was really important to me. This is almost embarrassing for a porn star to admit, but I've only given that up to three men, all of whom I really loved. Doing it on camera would be compromising myself. Sex, on the other hand, is something I'm comfortable giving

up—albeit not often—to a stranger in a one-night stand. The fact is, I've only had about fifteen different male partners on camera.

Most people I talk to in the business can't believe I made it this far without having done anal in a scene. But the fact that I got to the top of the game without having done it should tell them something: you can set your own rules. When I agreed to do *Silk Stockings* and return to the industry, I promised myself that I wouldn't do anal or double penetration. I don't know exactly why I drew the line there, but I've never doubted that decision once. If you come into this industry as a woman, you need to have a clearly defined set of guidelines and boundaries for yourself. That's how you maintain your sanity. And every person I know has a different standard they hold themselves to.

Thus, for both the interested and the curious, I present to you:

How To Make It As a Female Porn Star

An informative guide for the inquisitive reader

SHORT VERSION

1. Show up on time.
2. Don't do drugs.
3. Don't date or marry any man.

EXPANDED VERSION

Let's begin with the premise that it's very easy for a girl to get into the industry, but it's very hard for her to stay there.

For most girls, it starts at the World Modeling Agency in Sherman Oaks. That's the company that places dozens of classified ads in newspapers with variants of messages like "Female models wanted" and "Figure models needed for immediate placement."

World Modeling is run by a big Texan named Jim South and his son. Raised as a strict Catholic, Jim moved to Los Angeles in the late sixties

and found a job recruiting clothed models for retail store advertisements and mail-order catalogs. But at some point in the late seventies, a director offered him two hundred dollars a day to find girls to appear in super-8 porn movies. Within months, finding girls to pose nude was a full-time job.

Every day, World Modeling recruits for nude magazines and movies. Dozens of girls arrive, strip down, get Polaroids taken, and then fill out a questionnaire. On the form, they check boxes next to what they are willing to do: girl-girl, boy-girl, anal, double penetration, and so on.

The main event comes once every three months when World Modeling holds a massive day-long cattle call. Most of the directors and producers in the industry come down, meet the girls, and inspect them like, well, cattle. Some of the gonzo guys arrange to wait in the office, so that they can nab the best new girls before anyone else sees them.

In a worst-case scenario, a gonzo director will take a girl to a hotel room and have their friends shoot a cheap scene in which she is humiliated in every orifice possible. She walks home with three thousand dollars, bowed legs, and a terrible impression of the industry. It'll be her first and last movie, and she'll regret it—to her dying day.

In other scenarios, she'll work for two weeks until she's only getting paid seven hundred dollars a scene and then, finally, no one wants to use her anymore. So she'll agree to do double penetration or drink the sperm of twelve guys just to stay working. It can be a terrible experience if you don't go about it properly. And you can get very sore, physically and emotionally.

The job of porn star is not a calling—or even an option—for most women. However, if you make the right decisions and set the right boundaries for yourself, it can be a great living, because you'll make a lot of money while doing very little work. And you'll get more experience in front of the camera than any Hollywood actress. Though watching porn may seem degrading to some women, the fact is that it's one of the few jobs for women where you can get to a certain level, look around, and feel so powerful, not just in the work environment but as a sexual being. So, fuck Gloria Steinem.

However, there are many pitfalls—more than nearly any other occupation. So it's best to start slowly, rather than being thrown into a filthy bedroom with five naked guys. (As a woman, it's smart to remain conscious to some degree about the way in which you are portraying your gender to the world.) The other advantage to starting slowly is that people will pay you more as you add extra sexual acts to your roster. Beginning with nude modeling is a nice way to ease into it.

There's no reason to run out of the offices of World Modeling with the first gonzo guy who waves money in your face. Every girl who walks in that door, no matter what she looks like or weighs, is going to get used because, to put it crudely, she is fresh meat.

The biggest challenge is the psychological preparation you need before you walk in the door, to keep yourself from getting screwed (metaphorically). What's key here is to set your boundaries and never allow them to be crossed. If you do, it will break you down, and you won't have longevity because you'll be freaked out about the things you've done. You must not be afraid to say no if you're uncomfortable with something. It's nice to bring someone with you, be it a girl or a guy, to help you hold your ground.

You need to know what is expected in a normal scene, so that when you get to the hotel or the set, the producer doesn't suddenly say, "Okay, in this scene, two guys are going to fuck you on this bed and then we're going to move into a different room and another guy is going to fuck you." I've seen them convince girls that this is all part of the one scene she's getting paid for. There are a lot of scumbags in the industry. They'll tell girls they need to "test them out" first to see if they give a good blow job. Fact: you don't have to have sex with anyone in order to get a job having sex with people.

Another decision you must make is whether you want to have sex with a condom or not. Though every performer is required to have comprehensive monthly testing for sexually transmitted diseases, STDs are still a valid concern. I would suggest checking the box on the World Modeling questionnaire that says "condom only." Unless you're working

with a man with whom you have a monogamous relationship, it's better to be safe than sorry. You never know what type of lifestyle people are leading off the set. So you should be as selective with your partners on camera as you (hopefully) are in real life.

You should also know what the standard pay is. I recently saw a contract for a new production company. For a girl-girl scene in a regular feature, the pay is $500; a boy-girl scene is $1,000, with an extra $250 for anal. However, because the gonzo guys are paying so much, the talent is getting spoiled and asking for more money, so the prices are going up.

If you're very hot, however, you can make a lot more money. Every company wants a fresh new face, especially if the girl is driven and actually cares about the profession rather than just wanting quick cash. The perception of the industry has changed a lot in the last ten years, and now for the first time girls are rolling in who are drop-dead gorgeous. They're seeing that not only can you become a millionaire and call your own shots, but you can actually become a household name of sorts as well.

But there is another path through all this: one in which the business can be a good experience. However, this path is reserved for women of particular beauty. We all get paid kickbacks for finding gorgeous girls for films, so we're always on the lookout for new talent. If you fit the bill, all you have to do is go see a porn star when she's dancing on the feature circuit and talk to her. In fact, if I like a new discovery enough, I'll even use her in one of my movies. Why give her away to someone else?

If a girl who's young, attractive, and has a good attitude comes up to me at a show and says she's been thinking about getting into the industry, I always ask: "Is this something you are serious about? Is this something you want to do long term? Because you have to understand that if you are only planning on doing this for three months, it will affect the rest of your life. You will always be thought of as a porn star, even if you become a nun afterward."

If I feel that she's in it for the long haul, I'll take a Polaroid of her, write her phone number on it, and then bring it back to the production

company I'm working with. If a girl is good enough for me to bring into a company, the owner will usually contact them and fly them out for a meeting. Some companies like Vivid will do a test shoot with a photographer; others will throw the girl in a movie the next day to see how she performs.

If the company wants to use her, I'll always show her the ropes and teach her how to keep from getting stepped on. I've actually found a lot of girls on the road: Brittany Andrews, Gina Lynn, and Devon, in addition to lesser-known models whom I got into magazine work.

When a new hot chick arrives on the scene, the news spreads quickly. Suddenly everyone is competing for her. So, if the company likes how you look on film, then, in a best-case scenario, contract negotiations begin. If a contract girl appears in ten movies a year, she'll typically make about $75,000 to $100,000. Of course, since the average movie only takes two days to film, this is only twenty days of actual work. That leaves 345 days to do whatever else you want with your life. Of course, there's always a lot of other work to do for collateral cash, whether it's extra scenes or feature dancing in strip clubs around the country.

Amazingly, even though the workload is so small, some girls still don't show up on set. And when they do, they're often late and hung over, with ratty hair and nails that haven't been done in a year. They think that becoming a porn star means just fucking and doing drugs, but it's a job. You punch the clock and you go to work.

And before you even get into it, realize that it's not easy to have sex with strangers in front of other people. When you're having sex, you're at your most vulnerable. Only a handful of women look good fucking: everyone has a little cheese here and there. At the very least, most girls have to battle eating disorders at some point from seeing themselves jiggling naked on camera so much. And, speaking of exposure, every time you're on set you're swapping fluids with someone, so your body is constantly fighting colds and flus. You get sick. You get run down. And you get bored, because the hours are long.

You also need to prepare those around you before your first movie.

Do not attempt to hide it from lovers or family, because that will only stress you out and they'll eventually find out anyway. So tell everyone ahead of time.

Then pick a name. Don't use another star in the industry's moniker, like so many other girls do for some reason. Pick a name that's original and not cheesy. A classy name like Julia Ann will take you farther than a cheesy one like Craven Booty. Next, make sure you register or buy the Internet domain name for your pseudonym before someone else does.

So let's say that you've made it through. You've set your rules and gotten into the business in a respectable way. There is so much more to learn, hundreds of little pieces that add up to the difference between a sucker and a star.

For the initial few films, first impressions are everything. So show up on time, sober, in a good mood, and well-groomed—which means shaving or waxing your legs, your ding-ding, and especially the hard-to-reach areas so there isn't a long hair coming out of your butt when you bend over.

The act begins when you first get on set and ends when you leave. When you arrive, be bubbly and happy. Make friends with the crew, especially the cameraman and the lighting guy, because if they don't like you they can make you look like Phyllis Diller. The same is true for the hair and makeup people: sit still and be friendly, because they can make you look like Dr. Evil.

On the other hand, you don't want to be too talkative on set. It's better to sit there quiet and cute initially than to be a loud know-it-all. For the first few movies, watch and learn. The girls who are difficult to work with, who act like everything's a chore, and who don't befriend the crew, generally don't last long. The girls who go the farthest tend to be laid-back, easygoing, approachable, and, most importantly, smart and business-savvy. Because she was so laid-back and real, Jill Kelly was constantly given starring roles in Vivid movies above girls who actually had a contract with the company. In fact, she's an example of someone who actually reached the top without a contract. She did it through working hard and often, showing up on time, and kicking ass.

When you are doing a sex scene, try not to be too detached. Help the guy you're with. If a guy is having wood problems, a lot of girls get pissy. That only makes it even more difficult for the guy, which means that you'll be stuck on set with him even longer. Realize that the more you give and the harder you work to turn a guy on, the more you get back and the better the scene will be.

An even bigger danger for new girls is taking it personally when a guy can't get it up. It's easier said than done, because when you're in the middle of a scene making strong eye contact with a guy as you're going down on him and he suddenly goes soft, it's difficult not to feel like it's your fault. Recognize that it's not you, but the pressure of the entire camera-and-crew circus around him. In fact, some of the best performers in the business actually get intimidated by really good-looking girls, because they build up the scene so much in their minds that they end up psyching themselves out.

And while enthusiasm in a sex scene is important, overdoing it is as bad as not doing it at all. Girls who scream and flop all over the place into new positions don't get many jobs, because the sound guy is pissed that she's maxing out the levels and the camera guy is upset because he needs a new setup to capture each position. Besides, it doesn't look real. So let the cameraman control the scene. At the other extreme, nobody wants a starfish. So it's better to err in the direction of too much, and then tone it down if the director asks you to.

Another aspect is the physical control. A lot of girls will get so lazy they'll just put in a ton of lube and lay there, so that the guy feels like he's putting a hot dog in a hallway. A little bit of consideration will really help. If you can actually clamp down on the guy, you're going to get a better performance. You don't even need to squeeze your PC muscles to do this. If you're in doggie, you can just put your face all the way down and arch your butt, and the angles will rub the dick better. Or if you're lying on your back and you spread your legs, try rocking your hips back because it narrows the opening and really squeezes the dick, instead of rocking your hips upward to give them deep penetration.

When it comes to acting, don't be a deer in the headlights. Always be peripherally aware of where the camera is without looking at it. You also need to know where the lights are, so you can keep your face and body out of the shadows. And do not look at the director when he says something. If you want to talk to him, turn your face away from the camera, so that your mouth is out of the shot, and ask him to repeat it.

The great thing about becoming a porn star is that you don't need a manager, an agent, or anyone taking giant percentages of the money you're earning. Never let anyone represent you or sign away anything to another person. Just be headstrong, stick to your guns, and have the ability to say no, and you can keep it all. If you need advice, find a successful porn star to take you under her wing. There are just a few basic things you should know: when signing a model release, for example, don't give them Internet rights or permission to use the material in other products. And never allow any company to own your name. *You* are the product.

The biggest challenges for girls doing movies regularly are drugs and dating. A boyfriend can be a nightmare for your career and your emotional health. Some girls come into the industry with creepy guys already attached, and they'll be doing anal, gang bangs, and bukkake all in one film just to support his drug habit. By the time the girl cleans herself up, she's twenty-six, done nine hundred movies, looks like Margaret Thatcher in the morning, and has nothing to show for it. On top of it, she'll have no respect for money or sex anymore. Her pussy will have changed from a pleasure center to a cash machine.

Other girls meet boyfriends after getting into the industry. And while most guys may think it's cool at first, ultimately they'll hate you for what you're doing. Some guys even rationalize that if you're having sex with other men on camera, then they can have sex with other girls in real life. Even if you end up leaving the industry for him, he'll always hold your past against you.

Also, never bring a boyfriend to the set, because they usually stare needles into you and everyone else the whole time. You'll be so afraid you're going to upset him that you won't be able to perform. And the guy

in the scene with you will either be unable to get a hard-on because he's so uncomfortable or he'll want to fuck you to death, just to piss your boyfriend off. Some of the bigger loser boyfriends will even hit on other performers. These are the aforementioned suitcase pimps.

Because few outsiders truly accept and understand the lifestyle, most people in porn date within the industry. However, dating a male performer is also a kiss of death for most girls. As soon as emotions come into play and you both really love each other, you're not going to want him to perform with anyone else and he's not going to want you to perform with anyone else. So now suddenly both of you are off the market. There are only so many times you can work together before everyone gets bored of it.

The other option is to have an open relationship and fuck other people, but then that's not a relationship at all. It's nothing. I've never seen a swinger couple work out: usually, one person will fall in love with the other first, but will keep their mouth shut until one day they just blow up and let it all out. And when they do, it's such an overload of emotions and feelings that it scares the other person off. Even to those of us behind the camera, sex is an intimate thing. This is borne out by how hard it is for anyone in the industry to have a healthy relationship off camera. No male is wired to watch his lover having sex with another man on camera, especially if he is better looking, has a bigger dick, and fucks her better.

Of course, being in the industry can be a great experience. It's rare to have a career in which you are making money and in complete control of your own destiny at the age of eighteen. And, believe it or not, you can actually become a role model for women. More women come up to me with thoughtful praise than men. So now's the time to take advantage of the opportunity, before the field becomes too popular and Julia Roberts is getting pile-driven by Erik Everhard.

All you have to do is be smart and strong enough to find the right team to work with. You'll never meet a nicer bunch of people than your crew, from the caterer to the makeup artist. Because we are shut out by the mainstream world and there are so many misconceptions about what we do, we bond and support each other like family. I've been on regular

Hollywood TV and movie sets, but none of them have the love, cama-raderie, and respect that we do for one another. In every industry there are people who will try to take advantage of those who are new and naïve, and that's what these warnings are for. When you're dealing with sex, the risks to your emotional well-being are greater.

Of course, none of the above rules are iron-clad. The only reason I know about these mistakes is because I ended up making so many of them.

Chapter FOUR

Michael was as good to me as Nikki had been. After helping me find an apartment, he took me shopping. I foolishly squandered five thousand of the six thousand dollars I had saved from my modeling gigs on a white loveseat that was big enough to sleep in. I didn't have enough money left over for a real bed, so I bought a mattress. A distressed coffee table from Modernism Artisan Furniture on Ventura completed my decorating.

Before I knew it, Michael and I were breaking in the mattress together. And, suddenly, I was dating the male Nikki. He was a sweet, nurturing, incredibly bright guy and a marketing genius who was in the process of starting a handbag line (which I now see at Nordstrom and Neiman Marcus). Suddenly, I was feeling good about this whole L.A. caper. For once in my life, I thought things might be easy for a while.

The only problem with living alone was being alone. When Michael came over, he'd just have sex and leave. He never spent the night. I wanted someone to stay with me because throughout my life, from my brother to Jack, I had always slept with someone in bed beside me. It made me feel safe.

To substitute for human companionship, I bought a little television. Every night, I slept on the loveseat in my small windowless living room with the TV on. Soon, it was my only friend. Michael came over less and less. As usual, my dependency on him was driving him away. But I had learned my lesson from Jack; and when I complained to Michael about the distance he seemed to be putting between us and he didn't do any-

thing about it, I cut him out of my life. That was my new attitude: either you're on the bus or you're off the bus. I wasn't going to put up with half-assed commitment.

Now I had no one. I had no car, no money, and no survival skills. It was a fate I met kicking and screaming every day. My father had always warned me that the most dangerous place for a woman to be alone was a parking lot. And my new apartment had a desolate gated underground parking garage that looked like the set of a slasher film. The only way to get to the apartments was through the garage. A little doorway there led to a narrow, dimly lit staircase. I was perpetually scared that someone was going to jump me.

When I called photographers for work, they told me they couldn't shoot me for another three months because my pictures were, once again, saturating the magazines. With the little work I got, I could afford rent and some food. I refused to go back to stripping, though the temptation for the easy money was strong. I would sooner have walked dogs.

Every night, I would order food from a little Italian restaurant around the corner and then leave it half-eaten on the floor as I cried myself to sleep, just like when I was a little girl. One evening, I opened the door to let the deliveryman in. It was always the same guy: a hairy, thick-armed doofus with stringy black hair and a wardrobe consisting only of grease-stained button-down white shirts. But today, he looked different. His jaw was set, his eyes blazed, his voice trembled. When he passed me the food with shaking hands, he just stared at me.

I left the door open and walked to the loveseat to get my wallet. He followed me in and closed the door behind him. "I saw you naked in a magazine," he said. "Yeah, you looked real good. You and I are going to—"

I screamed at the top of my lungs. I just kept screaming and screaming. I was sure I was about to be raped. But instead the guy abruptly turned around and ran out of my apartment. I collapsed onto the loveseat, shaking. My whole body felt cold, and I curled up and stared at the wall. I must have lain there for hours, comatose. I slowly came to the realization that I

was going to be one of those homeless burnouts on Hollywood Boulevard unless I did something for myself. I had no one to rely on—no Jack, Dad, Nikki, or Michael—to help me or push me or chauffeur me. I needed to take control of my life and do something if I ever wanted to get out of this rut. And that's when I decided to shop myself.

Chapter
FIVE

Hi, I'm Jenna Jameson. You may not know me, but I was in a movie for Heatwave called *Silk Stockings*. Is it possible to make an appointment with Steve Orenstein for sometime next week?"

To my surprise, his secretary said yes. She didn't even ask what I was coming in to talk to him about.

"How about Friday afternoon at three-thirty?" she asked.

"Let me see," I said, rustling through the pages of a magazine to make it sound as if I were checking a day planner. "I'm pretty booked that day, but I can juggle some appointments around. I'll see you then. Thank you."

Steve Orenstein had founded Wicked Pictures just two years prior, in 1993, but was already making over a dozen movies a year. His mother was a bookkeeper who had taken a job accounting for an adult-magazine business. Like any good mother, she procured a job for her son there, and he gradually rose through the ranks of the industry until he decided to form his own production company—with his mom as accountant, of course.

On Friday, I dug into my shoebox of rent money and pulled out thirty dollars to cover the taxi ride to and from Canoga Park. Then I put it back in the box: If I didn't get the job, I wouldn't be able to cover my rent. I called Lyle Danger and begged him for a last-minute lift to Canoga Park.

I was so nervous on the ride there that thick droplets of sweat were running down my body. The words of encouragement my father had

spoken to me on the phone rang through my head. I kept repeating to myself, over and over, that I was the prize. I needed to walk into Steve's office with the attitude that I had just bench-pressed the world. It had to be conveyed not just by what I said, but by how I moved, the way I held myself, and the sound of my voice.

I knew I wanted not just a job, but a contract. Wicked was a small company and so far Steve Orenstein had only granted a contract to Chasey Lain, a beautiful brunette stripper from Florida.

The only problem was that I had no idea what a contract entailed, how much money I should ask for, or what terms I wanted. But I came up with a plan: I was not going to discuss money whatsoever, but instead tell him that I was all about the fame. This way, I figured, they'd be more likely to back me because asking for money was taking something from them. But with fame, they had something to gain: cachet and, more importantly, cash. In addition, they knew I would work hard for them, and not just try to get away with as little work as possible for the paycheck. It was like the old Hollywood studio system, in which actors and directors signed exclusive deals with studios, which in turn harnessed their entire marketing power into making them household names. Although this system was seen as exploitative by modern Hollywood standards, it also produced some of the most awe-inspiring females in cinema history: among them, Betty Grable, Marilyn Monroe, Bette Davis, Mae West, Greta Garbo, and Joan Crawford.

I sat in the waiting room sweating for fifteen minutes before the secretary told me to go to the first office on the right. As soon as I crossed the threshold, I started shaking. The office itself was unimpressive: a tiny cubicle with bare corrugated steel walls in an industrial park. But I'd never been so nervous in my life, because this was it. I didn't have a backup plan.

The room contained only a black lacquer desk and a leather couch, which revolted me. It looked sleazy and disorganized, and I reevaluated my goals on the spot. But then I took a good look at Steve.

He sat behind his desk, with assorted stacks of paper piled up to his chin. He was little, with red curly hair and an easy smile. Then there were

his eyes; he had really happy eyes. And he had a tic of blinking a lot, which made me comfortable because he was nervous in his own way too. Even rarer, during the entire time I spoke, he never once looked below my chin. He let me talk, and didn't interrupt at all. He only had two main questions: "What are you about?" and "What do you want out of this?"

"Listen," I said. "I've done a billion magazines. With no one's help, I made myself the most photographed girl in the business. The movie scenes I've done have been pivotal. A lot of people know who I am. I know what I'm worth, and I'm ready for the next step. The most important thing to me right now is to become the biggest star the industry has ever seen."

As soon as I said that last phrase, Steve's eyes lit up. Either he really believed in me or he thought the delusions of grandeur coming out of the mouth of a baby-faced twenty-year-old were humorous.

I assumed the best and went on. "You and I want the same things," I said. "You are a new company in the industry. You care about quality and perfection, because you want to be the best and the biggest. I want the same thing for myself. And together we can change things. So you can either sign me or I can go to another company and take them to the top. It's up to you. I'm going to be a star with or without you, so let's do this."

I had nothing to back this up whatsoever. I was just talking out of my ass. I glanced at Steve. He was looking at me in awe, and I thought, "I did it."

"Okay," he said. "Come with me."

He walked me out of the room to where his assistant was sitting and dictated: "I, Jenna Jameson, agree to be under contract to Wicked Pictures. I agree to star in eight Wicked productions a year for a fee of six thousand dollars per film."

Suddenly, I had a thought: what if my novelty wore off for them one day and they ended up signing a bunch of girls? "If you want me to do this, I need to be your main priority," I insisted. "So if you want to sign any other girls, I need to approve them first."

Steve's assistant looked up at him and, to my amazement, he nodded his consent. She pulled the sheet out of the typewriter. This was my contract.

And, because I felt comfortable with Steve, I signed it on the spot. Afterward, we all stood there beaming like long-lost friends. Steve asked me what I wanted as a signing bonus, and I requested something I desperately needed: a refrigerator.

No girl goes into the business saying, "I'm going to be a big star and conquer the world," especially then. But that was what set me apart. I knew Wicked could help me achieve that. However, by putting myself entirely in their hands, I was being very naïve. Signing a two-sentence contract without a lawyer could have been a career-ending mistake. But luckily, I happened to walk into the office of the most honest man in the adult-film business. And, even though we don't work together anymore, that's still true today.

With Steve Orenstein, on the far left.

Chapter
SIX

RÉSUMÉ

Name: Steve Orenstein
Age: 38
Position: Owner, Wicked Pictures

FAMILY BACKGROUND

My father was an auto mechanic in New York, until he developed arthritis in his hands. His doctors suggested he live in a drier climate, so we moved to Southern California.

Searching for work, my mom answered an advertisement in the newspaper for a manager/bookkeeper at Lyndon Distributors. She never asked what they distributed until she started working there, and discovered it was adult magazines.

WORK EXPERIENCE

For a summer job after high school, I went to work in the Lyndon warehouse. After a while, the owner's nephew, Fred Alfano, hired me at his company, which distributed magazines, toys, and eight-millimeter films to adult bookstores.

I continued to work for him on-and-off during college, until, during sophomore year, I decided to drop out altogether. Fred didn't have a full-

time position available, so he offered to pay me to learn everybody's job at the company. He wanted me to spend two weeks with each person, so that if they were out sick, I could take their job.

One day, I showed up to work and all Fred's store managers, along with their supervisor, were lined up outside his office. Fred was making them all take lie detector tests. He even gave me one, which I passed, of course. But the supervisor failed. Fred had me follow the guy around, learning his job, for two weeks. And then he fired him. Suddenly I found myself, at age twenty, managing all his stores.

One of the companies we bought a lot of our product from was called CPLC and, in dealing with them, I became friends with the owner's son, Stuart Tapper. The year was 1982, and distributing adult movies on videotape was rare. Stuart wanted to start a video division at his company, so he hired me to help out.

But three weeks after I started, Stuart was diagnosed with Hodgkin's disease. And since Stuart was the brains behind the business, positioned to inherit it all when his father retired, his idea for a video division went into a holding pattern while he spent two years in treatment. In the end, both Stuart and his father died within thirty days of each other.

I continued to run the warehouse at CPLC until I received a call from a friend in the business, who told me that there was a guy named Ruby who had a video distribution company called X-Citement Video and was looking for someone to run his warehouse. I wasn't interested, but I met with Ruby anyway. And he was such a good salesman that I wound up working for him from 1984 until 1993.

Around 1990, he told me, "Remember, when I hired you, I said that one day you'll have your own money and we'll do something together?"

I remembered. He had promised me a lot and, so far, had delivered.

"Well, I want you to start doing production—as my partner."

So we started X-Citement Productions. But becoming partners changed our relationship, and we had a falling out, as most partners do, over money. We had made twenty-four movies, so we split them evenly between us and I left X-Citement.

For the first time since high school, I wasn't working for anyone. And I didn't want to again.

COMPANY PROFILE

By now, I'd had over thirteen years of experience in the business, mostly in distribution, which I was pretty burned out on. So I decided to start my own production company. My goal was simple: to replace the paycheck I had just lost.

The original staff was just myself, a salesman I knew from X-Citement, and my mother, who worked as receptionist and bookkeeper. We chose to name the company Oasis. It sounded classy, and my plan was to make films for the couples market that had a relatively high-end production value. I wanted to put out a small amount of movies, and be proud of each one. But then someone in the industry heard me talking about Oasis, and informed me that it was already taken—and registered.

I had rented an extra office to a friend of mine, an independent salesman. One day, I sat in his office and we tried to brainstorm a new name. He said it first: Wicked. I liked it instantly, because one of the titles we had made at X-Citement was called *Wicked*. It just sounded right: Wicked Pictures.

COMPANY TALENT

CHASEY LAIN

Soon after we opened our doors, an agent named Lucky Smith, who I had known from my X-Citement days, came into the office. He wanted me to sign one of his clients as a contract girl. But I told him that I had no interest in putting any girl on contract. I wasn't in the business of girls; I was in the business of movies.

But after we made our first movies and they weren't flying out of the door, I began to worry. It was hard to convince buyers that we were making a better, higher-quality product than the competition, because that's what every other company was saying. So I called Lucky and told him, "I want to see pictures of that girl you were talking about." I figured that if the distributors didn't believe we had a company that was different and more special than the others, perhaps they'd believe us if we had a girl who was different and more special than the others.

"I thought you weren't interested," Lucky replied.

"I changed my mind."

So he returned to the office and showed me pictures of Chasey Lain. She was a beautiful brunette who had never done a movie before. I knew that if we could build an image and following for her, then people would only have one place to go for her product: Wicked.

Of course, we had little experience managing talent. In the middle of shooting her first movie for Wicked, she had a boob job and both sizes were ultimately seen in the film. But that movie, *The Original Wicked Woman,* was such a success that it put the company on the map.

JENNA JAMESON

When Chasey's contract expired a year later, she decided to stay at the company a few more months while she figured out what to do next with her life. In the meantime, my friends Brad and Cynthia Willis, photographers who were (and still are) responsible for our box covers and brand development, called and said that they had just shot a cover for another company with a beautiful model. Her name was Jenna Jameson, and they suggested I try to lock her up. I had never heard of her, and I was in no rush to find another contract girl. The company was doing well now and more and more girls were coming to us, though none of them stood out like Chasey did. Whoever I signed next would just be compared to Chasey, and I didn't want that to happen.

I made a few inquiries a month or so later about the Jenna girl, but I was told that she was going through personal issues and had left the busi-

ness. About nine months later, Chasey told us she was leaving the company for good. And, by coincidence, Brad and Cynthia called. They said that Jenna was back, and looking even better than before. So when Jenna and I set up a meeting on the phone, though she didn't know it at the time, I was ready for her.

However, I had never seen any of her movies. I'd never even seen a picture of her. As soon as she came through the door, I was surprised. She looked so sweet and innocent (though whether she was or not is another story). I couldn't believe that a girl who looked like that would want to go into this business. I wondered for a moment if she had walked into the wrong office.

In those days, adult film stars were making a lot of money touring strip clubs. So a lot of strippers were crossing over into movies, just so they could make more money dancing. So the first thing I asked Jenna was what her motivation was and if she was looking to feature dance. And she said, "No, I've already danced. That's not what I'm looking for."

"Then what is it you're looking for?" I asked.

And she said, "I want to be the biggest porn star ever."

"Well, that's a great goal," I told her. That was exactly what I wanted to hear.

I asked her a lot of questions, about everything I could think of, for three hours—where she came from, what her family knew, how involved they were, how comfortable she felt doing this, what her goals for the future were, if she was okay with everyone knowing. But what stands out most in my mind was when I asked her how comfortable she'd be with the sex scenes, and if there would be any issues for her I should know about in advance.

She looked me in the eye and said, "Don't worry about the sex. It won't be a problem."

She had the right answers to everything. I told her I'd sign her to a contract right then and there.

Chapter
SEVEN

*T*he following is a sample adult-film contract, with all identifying infor-
mation removed. It is presented here in its final form, after negotiation.
However, like most contracts, it is still biased heavily in favor of the produc-
tion company. If you take the time to read it carefully, you will notice the
many ways in which a female performer can get shafted —both literally and
metaphorically. When signing a contract, most girls don't add in their own
demands. But any good lawyer will tell them: contracts aren't just for the ben-
efit and protection of one party—they're for two parties.

THIS DOCUMENT HEREBY SERVES AS AN AGREEMENT BY:

[Production company]
Herein referred to as "the Company."

Between:

[Porn star]
Herein referred to as "the Talent."

1. Term: The duration of this contract shall be twelve (12) months beginning on
January 1, 2004 and expiring on midnight of December 31, 2004. There are
four (4) options of one (1) year, which the Company may exercise with sixty
(60) days prior notice in writing that it intends to pick up the option.

2. Production: The Talent will be required to act, play, perform, and take part in rehearsals, acts, roles, and scenes of a sexual hard-core nature over the duration of the contract mutually agreed to by both parties as needed to promote the career of the Talent. The scenes may be in the form of any of the following combination (at the discretion of the company): Girl/Girl, Girl/Girl/Girl, Boy/Girl, and Multiples. Involvement in any scenes involving Anal, Interracial, and DP [Double Penetration] is at the sole discretion of the Talent. The Company will feature the Talent in at least six (6) features each year and may increase this number based on marketing. The Company will use the Talent in other productions during the course of the year and will have the Talent on a minimum of six (6) box covers each year.

3. Exclusivity: The performance of the Talent in video and film of a hardcore nature for the duration of the agreement shall be exclusive to the Company unless otherwise agreed to in writing by the Company. The Company shall have the exclusive right to photograph and/or otherwise reproduce any and all of the Talent's acts, poses, scenes, and appearances of any and all kinds and to reproduce and transmit the same in any media. The Talent grants to the Company solely, exclusively, and perpetually all rights of every kind and character whatsoever in and to all such photographs, reproductions, and recordings and all other results and proceeds of her services hereunder. All other outside work including but not limited to still photography, film and video work, dancing (feature or otherwise), "bachelor parties," and any and all other services in the entertainment industry must be approved in writing in advance by the Company, not to be unreasonably withheld.

4. Advertising and Promotion: The Company will promote and advertise on an active basis the films and videos of the Talent, as well as promotions in any other area that will assist in making the public more aware of the Talent. The Talent will attend all such promotional events, including signings and parties, that are necessary to help promote herself and the sale of the videos, DVDs, and films produced by the Company. The Talent shall cooperate with the company in connection with any licensing arrangements ("Licensing Agreement") entered into by the Company to license, manufacture, and/or distribute adult novelty products or any other product using Talent's name, image, or likeness. The Company will assist in promoting the Talent through the Internet and the

Talent may have her own website linking to the Company website. The Talent's Website and all income earned from her website is her sole property.

5. Compensation: The Talent will receive monthly compensation of $3,000 paid on the first day of each month. If the Talent fails, for any reason, to perform at least four (4) scenes in a given month, compensation for that month shall be reduced for each scene in which she fails to perform, by the greater of a) $800; or b) the cost to replace the Talent for such scenes. The Talent will receive five (5) percent of the net profit on videos or DVDs in which she is featured on the box cover, after the Company recoups its cost. Costs are defined as any money spent on the production and postproduction of each video in addition to advertising, marketing, and overhead costs allocable to the Production. Notwithstanding the foregoing, residuals are split among all the Company talent appearing on a box cover for a production so, for example, if Talent and a second Company performer appear on a box cover for a Production, the Talent will receive 2.5 percent of the net profit for a production. Additional compensation based on Schedule "A" attached hereto and incorporated herein for reference.

6. Physical Appearance: The Talent agrees that she will, during the entire Term of this Agreement, take diligent care of her health, weight, and appearance. The Company may declare a Default under this Agreement at any time after the Talent fails to maintain her appearance, as determined by the Company in its sole discretion.

7. Law and Morality: The Talent agrees to comply at all times with all laws, rules, and regulations and shall refrain from drug or alcohol abuse and prostitution (including legal prostitution). The Talent agrees to conduct herself with the appropriate recognition of the fact that the success and best interests of the Company depend largely on the audience approval and interest in the Talent as a performer. The Talent therefore agrees to conduct herself at all times with due regard to social conventions and public morals and decency, as the same may apply to an adult entertainment performer. The Talent shall not commit any act or become involved in any situation or occurrence that would be detrimental to the best interests of the Company; or that would bring it into public disrepute, contempt, scandal or ridicule; or that shocks, insults, or offends the community; or that may reflect unfavorably upon the Company, whether or not such

information becomes public. The Talent agrees that the Company may, at its sole discretion, suspend Residuals upon the Company's finding that the Talent has engaged in acts or conduct detrimental to the Company.

8. The Company shall have the right to cancel this agreement at any time if any portion of this agreement and terms are not met.

In witness whereof, the parties hereto have duly agreed to this agreement:

[Production company]

[Porn star]

SCHEDULE "A"

Additional Compensation:

Same Sex Anal Intercourse (excluding DP and Air Tight): $125.00 per scene

Opposite Sex Anal Intercourse (excluding DP and Air Tight): $250.00 per scene

Opposite Sex Double Penetration (excluding Air Tight): $400.00 per scene

Air Tight (three males with three simultaneous penetrations): $650.00 per scene

Multiple Partners: $250.00 per partner over three

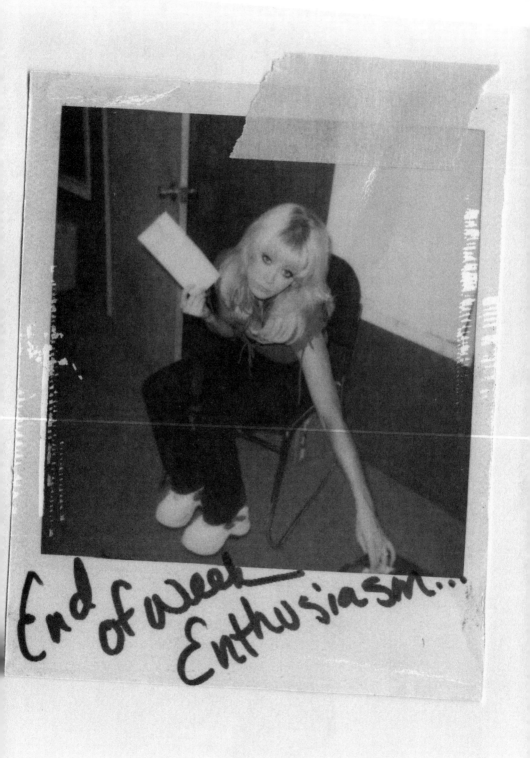

End of week
Enthusiasm...

Chapter EIGHT

While filming my first movies for Wicked, I went out of my way not to make any friends. For the first time, I could feel myself getting bitter. I was upset at Nikki and Michael for dumping me, and realized that if I wanted anything done in this world, I would have to do it for myself. Ultimately, no one else cared; they all had their own agendas and ideas of who they wanted me to be.

In my mind, every girl was jealous and every guy just wanted to sleep with me. One of the worst was Rodney Hopkins. He was on the crew of a Wicked movie, and he told me he was a photographer and wanted to shoot me in a boy-girl spread for *Oui* magazine. I told him I'd do it only with Lyle Danger and we agreed to meet for the shoot on Thursday at noon.

That morning, I checked my calendar and I had double-booked myself. I was shooting a layout with Suze. So I called Rod, lied and told him I had to do some promotion for Wicked, and then rescheduled for 6 P.M. And, even more deviously, I said that to compensate, I'd come in full makeup (so that way I wouldn't have to explain why I'd arrived already made up for a photo shoot).

I jetted over from Suze's studio to meet Rod, who had created a cute set in a diner with ice-cream sundaes on the counter. However, it was the most irritating shoot of my life. When I spread for him, he joked about there being an echo in the room. When I went into doggie position, he commented on needing a fish-eye lens for my ass. All evening, he kept making comments that one shouldn't make around a woman, especially

if one wants her to feel sexy. So I whipped through the positions as fast as possible to get it over with. I was so experienced by then that we were done in two hours, which impressed Rod.

Rod called almost every evening after that. I had never given him my phone number, but he must have gotten it from the model release. I hadn't given him any encouragement either, so who knows what he was thinking. It didn't matter anyway; every time he asked me out, I told him I was busy.

The fact is, even if I had liked Rod, I would have told him that I wasn't available. I had no interest in getting caught up in anyone else's bullshit or jealousy. A new relationship, in my mind, was just a stepping stone to a new betrayal. So every day after work, I went home alone and watched TV. I even stopped returning Lyle's calls. And the lonelier I became, the angrier I got at the world. I was trying to build a chip on my shoulder big enough to block out the rest of the world and protect me from ever getting hurt again.

One night, the phone rang. It was my brother's wife, Selena. She had good news and bad news. The good news was that she was pregnant. She put Tony on the phone. He was still clean. "I'm a changed man," he said. He was taking his pending fatherhood seriously, and had gotten a job as a dry-waller in Reading. The bad news was that my grandmother on my father's side had been diagnosed with breast cancer, and had to have a double mastectomy.

Even though my social life and material circumstances remained practically unchanged, my star began to rise in the adult world, starting with a two-page spread in *Adult Video News (AVN)*, the industry's biggest insider publication. Afterward, *AVN* decided to produce its first feature ever, in collaboration with VCA, one of the biggest adult-film production companies of the moment. They asked me to be their star and, just like an old Hollywood studio, Wicked loaned me out to them with the expectation that they would eventually receive a favor in return.

A week into shooting, I did a scene with Kylie Ireland, Felicia, and Vince Voyeur. That night, when I returned from work, I had a sore throat. I didn't worry about it, because I had always been somewhat

sickly as a child. But by the end of the movie, my throat was so swollen it hurt to swallow and I was so weak I could barely hold a conversation. When I returned home, I looked in the mirror and there were huge white lumps all over my throat. I had no idea what was going on with my body and, even worse, I realized I didn't know where anything was in L.A.: a hospital, a pharmacy, a hardware store, a friendly face. I'd never been this sick and had to deal with it alone before.

I knocked on the door of my neighbors, an older couple who I had never even exchanged a "hello" with, and asked them where I could go to get looked at. It was 9 P.M., so they sent me to a nearby clinic. I waited for two hours in a musty room full of screaming children. The doctor who finally saw me was a hack. He had me open my mouth, peered inside, and said, "Okay, you have strep throat."

I told the doctor I was allergic to most antibiotics, so he recommended a new drug called Biaxin. I filled the prescription at a nearby pharmacy, went home, mixed it with water, shook it up, and forced the vile liquid through my closed throat. After about ten minutes, I began to feel loopy and light-headed. I knew exactly what was happening: that asshole had given me an antibiotic I was allergic to.

I lay in my bed, and tried to go to sleep. I still have a belief that everything is going to be better in the morning. However, as soon as my head hit the pillow, my arms, legs, and fingers began to swell and break out in hives.

I ran to the bathroom and looked in the mirror. I was so big I looked like an extra in *Shallow Hal,* but with chicken pox. My mouth was completely discolored, as if I had sloppily applied cheap pink lipstick; my tongue was so swollen I couldn't even close my mouth without biting it; and my skin was peeling as if sunburned. Then an itchy red rash grew around my nose and mouth.

My body was disintegrating before my eyes. I sat down to go to the bathroom, and it burned like an open wound being doused with salt water. I began to panic: maybe I was misdiagnosed, maybe I had caught something far worse on set. When I went to the bathroom again half an hour later, it hurt so badly I screamed aloud. I had to hold it and push it

out in spurts because the pain was so intense. When I wiped, skin came off in flakes and then sheets. The color drained from my face; my heart started beating quickly; my body went ice cold. I had no idea what the fuck was happening. I stood up from the toilet, yelled some unintelligible word that sounded like "Fuck!" and, mid-scream, passed out cold, smashing my head on the toilet seat on the way down. I don't know if it was the impact, the shock, or the sickness that knocked me out.

When I awoke (it was still daylight so not too much time had passed), I was delirious. Somehow, even though I was unaware that I was sweating, shaking, and bleeding from the head, I knew that I needed help. I crawled to my living room and swiped my arm across a box that doubled as my coffee table. Receipts, change, and business cards came tumbling to the floor. I desperately tore through them, looking for the name of someone who seemed friendly, someone who could help me. It never even occurred to me to call 911.

Finally, on the back of a receipt for Fritos, I saw Rod's number. It must have been a sign. If he wanted to go out with me so badly, here was his chance. I called him and he was at my door in five minutes.

When he saw me, he shit a brick. I was pale, perspiring, convulsing, disfigured by rashes and hives, and choking on my own tongue. He drove me to the emergency room of the North Hollywood Medical Center. As soon as they saw me, they put me on a gurney, rushed me into a room, hooked me up to IVs, and paged a doctor.

The doctor walked into the room and slammed a six-inch needle into my thigh. As the cortisone rushed through my bloodstream, my body steadied, my temperature dropped, and my life force returned. Just feeling like myself again was the greatest high I have ever experienced.

"Your airway was fifteen minutes away from being completely closed," the doctor informed me. "If you hadn't come in, you would have suffocated to death. We almost had to intubate you."

It had all been an allergic reaction, but such a traumatic one that I couldn't work for another six weeks. I called the other girls from the movie and told them that someone on set had given me strep throat. And

it turned out that Kylie knew exactly who that person was: herself. So I lay on my couch recuperating, watching crap TV day after day and eating fifteen-cent packages of ramen noodles because I had no money coming in. (I still eat ramen to this day—though sometimes I add a little rice; some pepper helps too.)

Suicide, I've read since, is a triggered behavioral mechanism, like throwing up. It has to do with feeling not needed, with seeing your existence in the social hierarchy as superfluous. It is something certain animals do, evolutionarily, so that their offspring can survive on a limited food supply. All that makes sense intellectually, but, looking back on it, I still don't know why I even contemplated it. I had gotten signed to Wicked; I'd taken the first difficult strides toward my goal; I'd accomplished something by myself for once in my life. Yet I still wasn't happy.

And that's because nothing had really changed. I was still in the same shoebox apartment with no furniture. Not only was I alone and miserable, but I was too sick and broke to even get a gun or pills. When you're young, that's the first out you think of because it seems like the easiest. There were nights when I thought I wasn't going to make it until the morning. I would go to sleep and my heart would feel so weak I thought it would give out. Then I'd have failed my dad because I didn't have the tools to go out into the world and make it on my own.

I understand how new girls in the industry feel now. It's a difficult industry to be in. You make money, but you sacrifice the chance ever to have a normal life. No one comes equipped—mentally, emotionally, or socially—to deal with the recognition, the pressure, or the psychological repercussions of the work itself. Most have no support system to lean on. They don't realize that the strength they need has to come from within. And, as a result, they often get involved with the wrong person, or the wrong drug.

I needed someone. I couldn't do this alone. It was a very depressing realization because deep down I knew it wasn't true. I had done it alone. I could do the rest alone. But there were those moments—of being scared, of being sick, of being suicidal—where I needed to know that

there was a warm, sentient human presence somewhere who would walk through my door at whatever hour, like my father arriving home from work when I was a child, and reassure me that someone on this earth actually cared about me. It has been said that maturity comes in three stages: dependence, independence, and finally interdependence.

I looked at my calendar and it was March. I had spent seven months in Los Angeles without making friends, going on dates, or even really leaving the house. I needed to stop being a hermit, or I was going to rot in that place.

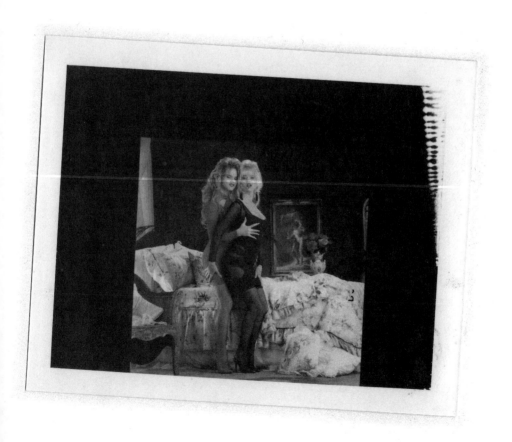

Chapter NINE

The first film I appeared in under my Wicked contract was *Priceless.* We filmed it at a place called Sterling Studio, a beautiful soundstage run by a cocky, condescending asshole named Jay Grdina, who seemed to have been given a mandate to make me uncomfortable, perhaps because he was dating my predecessor at Wicked, Chasey Lain.

Since I was allowed to choose the guys I worked with, I decided to try Peter North. I wanted to prove myself, and he was known as the best dick in the business. He was the size of a Coke bottle and could come ounces. On top of that, he had a reputation for being very professional. He barely said a word on set: he just showed up, did his business, and left. To this day, I've only heard him utter three sentences.

Our scene was on the hood of a vintage automobile, and it was phenomenal. When he began to fuck me, I was literally in shock. He tore me wide open, so that it was impossible to do anything but be in the moment. And when he came, he covered the car and me. The guy was amazing.

The next day, a male performer stopped by the set: Steven St. Croix, an in-demand square-jawed character whose look and intensity people often compared to Ray Liotta. Though we never did a scene together, he took a liking to me. A few weeks after my decision to socialize, he called and asked if I wanted to be his date for an event called Night of the Stars, an annual charity gala run by the Free Speech Coalition. For the first time in months, I said yes to an invitation to leave my apartment.

I put on a dark blue velvet dress, and he picked me up in a limo he had rented with some friends. I had never made a public appearance before, but as soon as I entered the convention center where it was being held, every head turned in my direction. I felt like Cinderella at the Prince's ball. Everyone wanted to know who this new girl in town was.

This was great for Steven's ego. The guy didn't leave my side all night. Photographers taking pictures of other stars kept asking them to pose with me. Of course, I didn't utter more than twenty words all night because I was so unused to being social. I hadn't made small talk in over a year, and didn't really know anyone there except for Steven.

By the time we pulled up at my house, I had a good buzz on. Steven walked me to my door, gave me a kiss on the cheek, and left. I was surprised that he didn't try anything, but ultimately it was a good move on his part because we ended up seeing each other after that.

The next thing I needed to do to get a life was buy a car. But at six thousand dollars a film, and only eight films a year, it was going to take forever to save the money. One day, however, Steve made the mistake of asking what he could do for me, and I said I needed a truck. So he took me to a dealership and offered me a Corvette instead. I pointed to a beautiful black convertible, and it was mine. Life was beginning to look up. Now that I could drive myself around, I didn't need to treat sweet Lyle like a slave boy anymore. Besides, his star was beginning to rise in the business as well.

Once Buddy saw me driving around in a new Corvette, he started pushing Nikki to get back on the other side of the camera. And the minute he was cool with it, she was cool with it. However, the damage was done and, though I sometimes saw her on set, we never exchanged a word off camera.

For my first Wicked movies, I kept my mouth shut and absorbed everything that was going on. I looked at how the other girls were being treated (basically, like Tinkertoys) and what type of people got to call the shots (the male directors). I was determined not to just be a fuck toy but also to retain as much power as possible off camera.

And that was where Joy King came in. Joy had come into the adult

industry by accident. In 1984, her roommate turned her on to a temp company, which placed her in the accounting department of Caballero. She started out working on the company's children's films, but was transferred to the adult division after a couple years.

As Caballero's profits began dwindling, Steve was starting Wicked. Though he wanted to work with Joy, he didn't have the money to add her to his skeleton staff. But the week he hired me, he decided that there might be a use for her after all. So he worked out a deal where she'd take care of an account with a mail-order company, Adam & Eve, on commission, in addition to doing marketing and public relations. It was clear to both Steve and me that making movies was only part of my job. The rest was to promote myself, to work the entire world as if it were just one big Crazy Horse club. So Joy's number one objective was simple: to get my face in the media. However, she accepted the job before even seeing the product.

Steve brought us together one day in his office. I took one look at Joy and thought, "This bitch is hot. How can she be a publicist?"

She looked like she belonged on my side of the camera. She had huge knockers and didn't wear a bra. In the meantime, I was wearing jeans and tennis shoes. I could tell as soon as she saw me that she was disappointed. "You're it?" she asked. "You're so tiny."

"Looks are deceiving," I told her.

Within fifteen minutes, we were best friends. We had a similar sense of humor and outlook on life: she too was a person who didn't take no for an answer. A vivaciously friendly party girl, she was also a hard-core motherfucker whom no man dared to mess with. And she radiated sexual energy: I was probably the only girl who worked with her back then that she never slept with.

When I told her what I had told Steve about my plans for the future, she smiled so hard her cheeks practically inflated to the size of her breasts.

"Okay," she said. "Let's add this up: Steve wants more market share and you want to be the biggest star ever. This is going to be a breeze."

And I thought, "Finally, I have a partner in crime."

Chapter **TEN**

"When you uttered your first line on the set of *Priceless*," Steve Orenstein, or Blinky as I now called him, told me, "I breathed a sigh of relief. You could act."

I didn't think I could. All I really did was deliver my lines without looking like a complete imbecile. But I guess that was good acting to him. Steve wanted to shoot a big-budget production on actual film, a six-day $120,000 job—his biggest movie ever, by far. So he pitched me a bizarre story that a sweet grandmotherly woman, a painter named Raven Touchstone, had written. It was a take-off on the real-life story of Ed Wood, a cross-dressing director responsible for movies that were so bad they were good, like *Plan 9 from Outer Space*.

Raven's script was a movie within a movie about a cross-dressing porn director filming a camp classic. Steven St. Croix was cast as the Ed Wood character. Blinky had a high-concept, campy John Waters–like movie in mind, except with more nudity and sex. He was so serious about the film, which would go through several working titles before finally becoming *Blue Movie,* that he even loaned us his own car to film on set.

It was convenient that I was dating Steven, whose oddball sense of humor was starting to grow on me, because we would walk around all day running lines and improvising in character. I spent hours studying my lines. Blinky's words kept ringing in my ears about having faith in my acting, so I knew I had to deliver. Here, finally, was a new challenge for me, something I had never done before. Of course, in the back of my

mind, I imagined the audience with one hand on their dicks and the other on the fast forward button skipping over the acting scenes, but it didn't matter. I just wanted to prove to myself that I could do it.

I arrived on set in my pajamas at 6:30 A.M. for the first day of shooting. I was so eager that I beat the entire crew there. So I sat around in my duck-covered flannel with built-in feet, writing in my day planner and waiting. Half an hour later, the makeup artist, a dramatic, highly cultured queen named Lee Garland walked in and asked me where my mom was. When I told him I was the star of the movie, he did a double-take. I wondered when I was ever going to look my goddamned age. Lee later became one of my closest friends and confidants in the business—he still does my face on set to this day.

I was relatively unknown in the industry at the time, and everyone else on set seemed to know each other from hundreds of previous productions. The girls, most of whom had been in the industry longer than me, were extremely catty, probably because I was starring in the movie over them. It didn't matter, because there was only one girl I was excited to see: Jeanna Fine, who had been Savannah's best friend and lover. The first porn I ever saw had the two of them in it. I idolized them both.

My hair was up in rollers for my first scene, a solo masturbation in bed. There's nothing quite like looking like crap in front of a bunch of girls who want nothing more than for you to look like crap. Off camera, a production assistant threw me a big blue ball that I was supposed to catch in the scene. But I was so nervous I kept dropping it. Fifteen takes later, after exasperating the crew and making my competition very happy, I finally caught it.

I didn't know if I'd be good at acting, but it was so easy to draw from all the bad things that had happened to me. I didn't even need words to convey anything, just my eyes. As I sat on the bed, playing with a big blue ball that symbolized some cross between a lost childhood and a lost lover, I could see the director, Michael Zen, in my peripheral vision and he had an ecstatic look on his face, a mixture of relief and optimism. It was all the encouragement I needed.

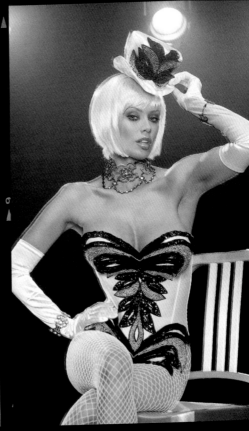

49 KODAK E100

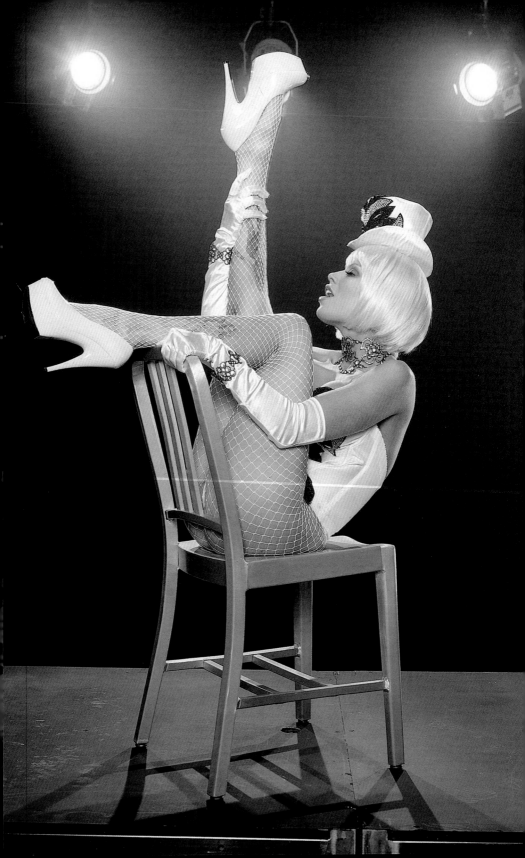

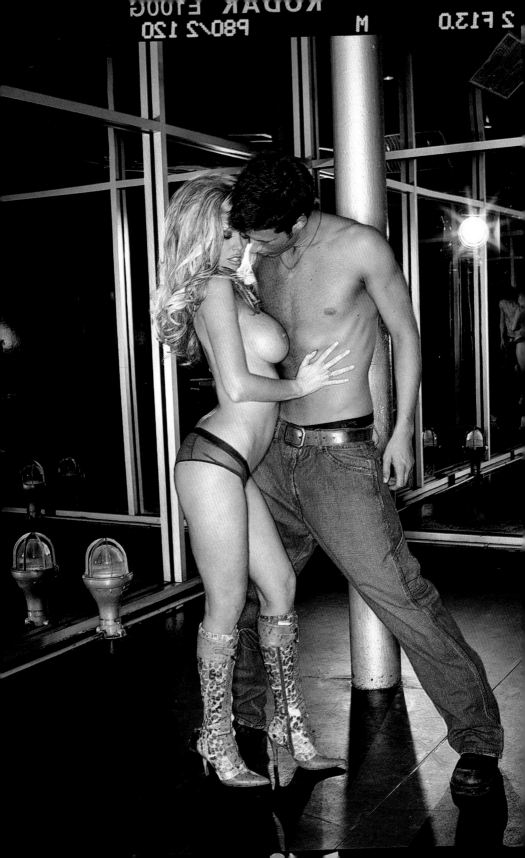

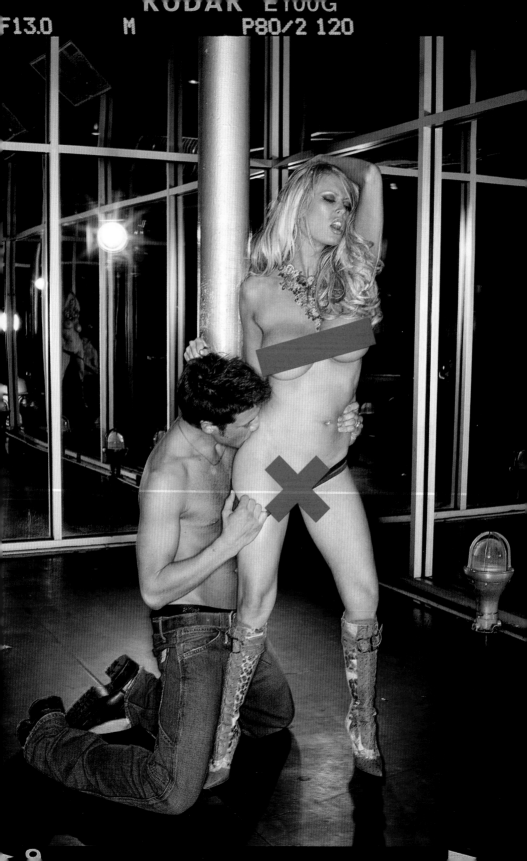

I'd never worked with a director like Michael Zen before. He's a heavyset, meticulous, and soft-spoken visionary, with an odd little haircut and glasses that give him an Elton John aura. I always thought he was gay until I found out he was married. The oddest thing about him is that he doesn't direct sex scenes. He labors over the acting and filmmaking, and if anything goes wrong he gets extremely flustered. Then he leaves the room just before the sex scene and lets his assistant director take over. He is one of the few true artists making adult movies.

His set was the first one I had been on that felt comfortable, clean, and professional since the Andrew Blake movie. I looked around and thought, "This is my niche. This is what I want to be doing." After all the drama of the last few years, I just knew that this was where I belonged. This was what my life had been leading to.

In the movie, I play a budding young reporter for *Sleaze* magazine who goes undercover to get an interview with a reclusive award-winning director (who's dressed as Carmen Miranda). The director ends up casting me in his B-movie epic, *Legend of the Golden Oyster,* as a barmaid who hooks.

My partner was to be T.T. Boy. I had never met him before, but I'd heard about him. He'd been working since 1989, and had a reputation as one of the roughest woman-handlers in the business. He hates kissing. He hates blow jobs. And he loves fucking. (He is the only male I've ever met who doesn't like blow jobs.)

When I first saw him, he was walking on set eating a super-size can of tuna fish. He had a very strong, dominant presence. He walked up to the assistant director and started talking rapid-fire, with a slight twang and his lips tightly pursed, almost like a yokel from a Puerto Rican remake of *Deliverance.* Then he looked at me and shoved a forkful of tuna in his mouth. He looked like he was going to tear me a new one.

Before the scene, I found a quiet room and tried to psyche myself up, repeating words and phrases over to myself like "confidence," "dominate," "come out on top," "don't look like Bambi in the headlights." Once on set, T.T. and I positioned ourselves in a dimly lit tent that was supposed to be somewhere on the African savannah. Michael left the

room and, as soon as the assistant director yelled "action," T.T. Boy became the first man ever to take control of me in a scene. I'd never been with anyone so aggressive. I felt like a chew toy.

He raced through the foreplay—a little kissing, a little oral sex—and then all hell broke loose. He slammed me so fast and hard that it took every ounce of control I had to stay focused and in the moment. Trying to maintain eye contact with him was like trying to read Dostoevsky on a roller-coaster. I could feel my thighs bruising against his. Then suddenly it all stopped. He pulled out and shot straight into my mouth. I wasn't expecting him to pop so soon.

"Is that all?" I asked.

"No," he said. He grabbed my hips and held me just over his lap and started slamming me into his dick. I was in decent shape cardio-wise, but he moved with such force and speed that I was winded. It felt like my insides were going to fall out. And then, finally, he popped—again.

"Is that all?" I asked.

"No," he grunted.

And he put it right back inside. The guy was a machine. There was no lull. His focus never dimmed. His intensity never wavered. He'd throw me into position after position, and would come in each one. I was in shock. I'd never been fucked like this in my life.

I couldn't wait for him to finish. I was starting to get sore. Finally, after four pop shots, he said, "Hold on. I have to go eat something."

"Are we done?" I dared to ask.

"Not by a long shot," he said.

I didn't think I could take anymore, but I kept my mouth shut. I was curious to see what he was up to now. He walked off, devoured three cans of tuna, and was back with a raging hard-on still pulsating in the air. Within minutes, he was pounding me over and over, in every position I'd ever imagined and some I hadn't, until finally, with one last climactic pop, he was done. Time elapsed: 156 minutes.

Nobody said a word. The crew was as flabbergasted as I was. He must have been totally into me, because no one had seen him—or any other

guy—perform like that in their lives. We didn't even think it was humanly possible. (Even today, with the advent of Viagra, Cialis, and Levitra, a scene like this would be miraculous.)

I literally limped away from the set, licking my wounds, and followed him around for the rest of the day. I had to know what was going on in his mind. All I got in exchange were a few words of wisdom: "Damn, that's a bomb-ass pussy."

"What?" I asked.

"You've got bomb pussy," he repeated, and walked away.

It was one of the most explosive scenes I had ever filmed. However, I never watched it afterward. I have no problem with having sex on camera, but I don't actually like *watching* myself doing it. It's uncomfortable. There's too much of me to see.

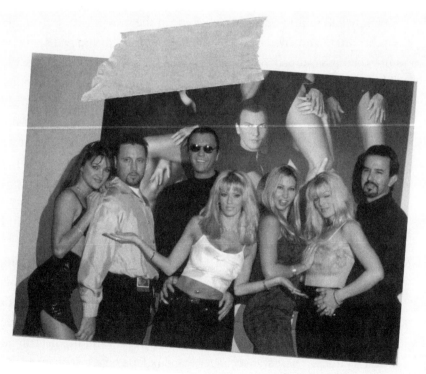

Me and the Wicked crew.

I hounded T.T. for the rest of the production, fishing for more clues to his performance. The only other thing he said was, "I wish I could take your pussy out of you and keep it at my house." So, the best I can come up with is that he has a major fetish for certain types of pussy. And when he finds one, he tries to knock it out.

I wanted to work with T.T. all the time afterward because that kind of adrenaline charge and moment-to-moment surprise is hard to come by in the industry. Other male actors were creepy, and looked at me as if they wanted me to be their wife afterward; or they had erection problems and, even worse, hygiene problems; or they were so professional that they just went through the motions, timing each position for five minutes and then switching. T.T. even became a great friend afterward, a perfect gentleman who would only be too glad to pummel senseless anyone who dared to say a cross word to or about me. It's always good to know a few people like that.

I only had to film one other sex scene in the movie, with Jeanna and another girl. Jeanna was smart, confident, and candid, and had a million stories about Savannah. She was everything I wanted to be. But the scene didn't live up to my expectations. She just went through the motions, and seemed disconnected the whole time. I kept thinking, "If we are going to do this, let's do it right." There was no passion, no connection, and no energy invested in the moment. The final insult came when we were done and she yelled, to no one in particular, "Why do you guys put me with these little girls? You make me look like I'm one hundred years old." I don't think she realized how bad that made me feel.

After the scene, Joy came by with a giant cake with my name on it. I had completely forgotten that it was my twenty-first birthday.

The next few days passed quickly. Everything seemed to be coming together perfectly. The director was great, the vibe was great, the actors were great, the sex was great. And, though I didn't have any scenes with Steven, I loved watching him goof off. He was horrible to people. He would rip farts in the middle of big dramatic scenes and flip his cum at the cameramen. There was such great camaraderie on set. It changed my entire view of the adult industry and showed me what was possible if

every piece was functioning properly. In addition, T.T. had given me a new perspective on what a sex scene was all about. It wasn't until writing this book that I learned that, before filming, T.T. struck a deal with Michael Zen in which he got paid one hundred dollars for each extra pop shot he did.

Of course, no shoot is perfect. When I arrived on set for the penultimate day of shooting, everyone was walking around in a daze. The lights and cameras weren't set up, and no one was in makeup. The talent was walking around the set in shock. Some of the girls seemed to be having panic attacks. I asked Michael Zen what was going on, and he said that a woman in the industry had contracted HIV. She had received her test results the day before, and they were positive.

In order to do a sex scene on camera, regulations require monthly early-detection HIV tests. Thus, every month, I stop by my doctor's office—or he comes by the set—and he sticks a needle into my arm to take some blood. It is just part of my routine, like brushing my teeth or buying a new purse. Before this announcement, no one in the industry to any of our knowledge had contracted the HIV virus before. And condoms were rarely used in films at that time. We canceled shooting that day because no one could work.

The next day, Steve told us that it had been a false positive. Everyone was relieved, but at the same time, we had all changed: we were now aware that something like this could happen.

Chapter ELEVEN

How To Make It As A Male Porn Star

An informative guide for the still-inquisitive reader

There are few heterosexual males in existence who have not, even for a brief moment, wanted to be a porn star. It's a great fantasy: get paid to have sex with young, beautiful, big-breasted women. If you value that fantasy and want to hold on to it, do not read any further.

What follows is my interview with one of porn's leading men. In order to speak candidly, he only agreed to this interview on condition of anonymity.

How does a guy get into the business?
It's a lot harder for a guy to get in than a girl. You have to work your way in or swindle your way in. Either you have to know someone in the industry, like a cameraman or a producer, or you have to be brought in by a girl. The truth is, no one wants a new guy on the set because they hold everything up.

So if some guy has no connections, the best thing to do is to find a girl first?
He either needs to have a girl in the industry who he's already friends with or find a girl who's interested in being in the industry.

And what if he can't do that?
Then you go to a cattle call at the World Modeling Agency. You stroke your weenie up and they take a Polaroid of you and your weenie, and put it into a book.

But, in general, people won't hire you just from your picture. They need to see you perform.
Right. So another way you can do it is to shoot home videos of yourself, or of you and your girlfriend. But, honestly, no one wants new guys. The gonzo guys might try someone but it's rare. The only way to really get hired from a video is to have the girl you are with be really hot. And, then, once you send in the tape of you guys having sex, she has to be willing to say, "I'm not willing to work with anyone but my man." Then they are forced to use you if they want her.

Who would they send the tapes to?
The production companies.

At Wicked we used to get videotapes of people all the time. We would look at them and laugh. There was always one video a week of a really fat guy sitting on his bed jacking off. Or a sad little guy sitting on a giant dildo. So the truth is, a home video still isn't the easiest route.
The easiest route is to go to clubs in Vegas or Miami, find a smoking-hot girl who is eighteen, put her in films, get her to only work with you, and then practice cock control. Even if you are not one hundred percent a great performer the first few times, your girlfriend will be able to pull you through it by being hot and giving them what they want. The companies will forgo how bad you are because they want her in their film.

And then how do you get to work with the other girls in the business?
Wait until you are really good at having sex with your girlfriend on camera. In the meantime, she will make friends in the industry with other

girls. If your girlfriend is cool enough, she will tell the other girls, "You really should work with my guy because he's a great performer."

Look at Travis Knight and Gina Lynn. He got in because of Gina, and now he's working with other girls because the other stars saw how good he was with Gina. He's done more films than Gina now. That's a textbook case right there.

Also, some girls are so competitive that they'll jump at the chance to fuck another girl's man. And if a director sees a guy that performs well, he's going to remember also. For me, the only time I get to work with new higher-up girls is if their relationship breaks up.

The worst is when new guys come in and hit on everyone.
They generally don't last long. None of the girls like it if you are too forward with them. You have to be a little mysterious. Don't hit on them, and don't try to kiss them before the scene. Girls get so turned off when guys act like it's a date. They like it when the guys are kind of stand-offish, do their shit, and leave.

Tell me about an average day.
You come in at eight o'clock for makeup because you're told you are in the first scene. Then you find out that you weren't in the first scene but they just wanted to make sure you got there on time. So you are in the second scene, but the guy in the first scene couldn't get a hard-on, so it took six hours to film. You've been sitting around for seven hours and your makeup is all cracked and crusty, because you are tired and you fell asleep in the green room because you were on set until 3 A.M. the night before. Then, ten minutes before it's finally time to film your scene, they give you eight pages of dialogue that you weren't expecting.

How do you learn to perform well on camera?
It's tough when you get on set, and there's a thirty-person crew sitting there waiting for you and a girl filing her nails saying, "Don't look at me like I'm your girlfriend." It's a lot of pressure for a guy to get hard. You

have to be horny, you have to be athletic, you have to be a good performer, you have to have good cock control, and you have to be able to get it up at will. You have to keep an erection, go a long time without coming, and then come on command.

And what's the secret to doing that?
It's all about focus. You have to be able to leave your surroundings. Most guys the first time can't get a hard-on at all. Or if they get a hard-on, they cum in two seconds. And it's difficult because people think when you get on set, you are actually having sex, but you aren't. You are performing for the camera. So you lean back so you can show the girl's whole body, when normally you'd fuck pressed real close to her. So you have to lean back with your arm holding onto a rail with another guy breathing down your neck, and you're all twisted up. And you have to pretend like you're having the time of your life.

So do guys train themselves?
Yes, because nobody performs well at first. They don't know camera angles or how to position themselves or all the necessary dick tricks. And no one looks pretty having sex, especially guys.

One thing that girls are good at is making ourselves look beautiful during sex, which is hard. For guys, they have to concentrate on keeping their dick hard, not holding their stomach in, flexing their arms. We are able to relax and think, "Okay, I need to arch my back right now" or "Oops, I'm making a really funky face right now."
For a guy half the time you have to move your face out of the way, because the director doesn't want your face in the shot. So you are leaning way back and you can't put your arm down for support, so you have your hand on your hip like a sailor. You look like a fruitcake.

Is it easier for good-looking guys to get in movies?
If you are too good-looking they think you are gay.

What about if you're hideous, but you have amazing cock control?
That's fine. You don't even need acting skills. It's ninety-nine percent
about your sexual ability. But you should be really well-groomed. You
should be bathed, shaved, and super-clean, though body hair is okay. You
want to make sure you clip your nails, especially so you don't scratch a
girl while your fingers are inside her. Brush your teeth and use Altoids,
but at the same time, don't be an egomaniac. Vanity in guys is not good.

Is there any way to practice?
That's the thing. There is no real way you can practice. And it's hard to
get aroused if there's no chemistry or you're under pressure. Maybe you
can do live sex shows on stage at a club. Or you can try masturbating in
front of your dad. "Hey, Mom, start cooking dinner and I'll whack."

Seriously.
What I'll do is sit at home, distract myself mentally, and try to get a hard-
on. I'll be on the phone with the gas company, trying to get a hard-on.

Any other tips?
Stretch out. Keep yourself loose. Focus on one thing that turns you on.
Eventually you'll learn dick tricks where, if you're about to come, you
hold off by making it look like you're doing something else. For example,
you'll pull out and make the girl suck your dick, which will give you
enough time to stop yourself from coming. Or you'll pull out, beat your
dick on her pussy, go down on her real quick, spit on her pussy, and then
start fucking her again. Every single performer has a trick. I know guys
who will take it out and smack the head to decrease their sensitivity.

**I've seen guys smack themselves in the face, pinch themselves, hit
their balls, and do all kinds of really weird stuff. When you are
having sex with a guy and he does that, you are like, "Huh? Are you
all right, you freak?"**
The hardest part is just getting in the zone where you can get a hard-on.
And the thing is, you have to know when you are going to come and be

able to control it. You have to be able to stay on that edge. But after you control it for so long, it's really hard to have an orgasm. With a true performer, if the director says, "Give me a pop shot," he'll do it within thirty seconds.

How can you do that?
I just concentrate. I focus on the sensitivity of my dick. You have to be really in tune with your body.

What about coming? Is there a way to make it shoot farther?
The trick is just to have a lot of build up. It's like when you jack off, if you jack off and come in a minute, you don't come very much. But jack off for an hour and a half without letting yourself come and, by the time you do, you'll shoot the next wall.

That's really what happens. You get it right there and pull back, get it right there and pull back, get it right there and squeeze off, squeeze off, then let it go. An extra trick is to push with your PC muscle after each contraction, and then the jizz really goes flying.

What about reloading?
Some guys can do that right away, like T.T. Boy. On the other hand, some guys have no self-control. Once there was a new guy on this huge production that was so much money. The minute before the director lowered the camera on him, he came. He could not get another hard-on at all. It ruined the whole scene.

When a good director is shooting a new guy, he will say, "Don't get embarrassed if you are going to come right away. Just let me know, so I can get it. Don't sit there and come in the girl. If you are close, I don't care if you are stroking your dick and waiting to get it up for the scene, squeeze that thing off as tight as you can and tell me. We will position the scene and get you all set up, so you can come." This way, the director can go back later and get the hard-core.

A lot of guys will pound the girl so hard to make themselves come.
Most girls I know like it more if he just jacks off and comes on her.
The hardest thing for guys is, if you're doing a scene with a girl and
another guy and the other guy gets it up right away while you are still
jacking off. It hurts your confidence. It's better to be quick on the draw.

Are there are any other mistakes that beginners make?
The worst thing a male performer can do is grudge-fuck a girl or try to
prove something. A lot of guys think that having rough sex is a way to
show that he is a good performer. But he will fuck the girl up. Every girl
will complain and no one will work with him. You have to make sure you
are aggressive to a certain point, but not so passionate that she thinks
you're a stalker. There are a lot of little mind games a guy has to play in
order to make the chemistry work with the girl. It's super-important to
do everything right, because once you get higher-end girls on your side,
they will consistently use you.

**That was true for me. I would not work unless it was with one of
three or four guys. And then, once the other girls saw that those
guys were being picked, they all wanted to work with them, too.
When I wanted to change things up and try a new performer, it was
a nightmare every single time. The interesting thing is that unlike
the girls, the guys never age out of the business.**
They are in it until they want out. There are guys in their forties, fifties,
and sixties fucking eighteen-year-old girls.

**However, they do have an amazing talent. All a girl needs is lube
and she's ready to go. Guys have to be turned on right from the
beginning. I find them much more interesting than the girls.**
The best is watching guys perform with their wives or girlfriends. If a girl
is with a normal guy, she will work through any problem to get a good
scene. But if it's her husband or boyfriend, she'll start saying things like,
"Don't go that deep; you know that doesn't feel good" or, "You know I

don't like that" or, "Don't treat me like that; I'm your wife." You never see guys and girls who are just performers arguing on the set, but I've seen couples in knock-down drag-out fights. The problem with couples is that they are overly sensitive to each other's behavior.

What about Viagra?
Almost every guy uses it, except for the original hardcore guys. But even most of them use it, though they claim they don't. It keeps it hard for a long time. But with Viagra, you want to practice at home to see how you react to it. There are tricks of the trade to make it work its best. Here's one: Do not eat. Sometimes I think that the sex is worse when you take Viagra, because there's something different about it. It's better to just relax and go with the flow. Besides, no matter what you're on, if you are mentally done, you are mentally done.

And what about Caverject?
That's when guys inject their dick with a medicine that keeps it hard all day on the set. No matter what you do, you have a hard-on. Imagine being filled with blood for that amount of time. I don't think it's good for you.

Any other tips?
Practice your orgasm face.

A lot of guys want to get into porn to get laid. What are your thoughts on that?
Getting into porn is a death sentence. As a male performer you are doomed to be single for the rest of your life. A contract girl does eight to ten scenes per year. A guy performs seven to ten scenes per week at least. The number one performers do fifteen scenes per week. So what girl is going to go out with a guy who's pounding fifteen other girls every week? No one. The guys don't have any social life, because they are on set so much. And when they do go out, they are like lepers. Girls won't touch

them. Even girls in the industry avoid them, because it's bad for their career to get stuck having sex with just one guy on camera.

So do guys in the business become freaks?
That's actually true in a way. Every guy in the industry has one fetish or passion that keeps him going. You have to realize these guys are working with a girl who's beautiful one day, and then the next day they're with a girl that they wouldn't normally want to touch, let alone fuck. So they have to go somewhere in their head to keep themselves interested and aroused.

What is the top of the game for a male star?
Guys don't get a lot of money: maybe three hundred to five hundred dollars a scene, though some are getting eight hundred dollars. So the top is graduating into directing and owning your own line of videos. There are also certain guys who have gotten contracts with companies. I think Steven St. Croix was the first, but it doesn't happen often. Basically, you are at the top of your game when you are working every day, you're doing scenes with the top chicks instead of beasts, and you're getting starring roles where you are acting. When you do a signing with a girl, then you know you've really arrived.

So the real message here is: Don't be a porn star if you want to get laid.
Exactly, because that's not what it's all about.

So why would anyone want to do it then?
It's a good steady job, you make decent money, and, despite everything we've talked about, it's fun.

Chapter TWELVE

For six months straight, Joy had been blitzing the *Howard Stern Show* with videos, pictures, and letters. And not once had they called back. This whole breaking-into-the-mainstream thing was proving to be more difficult than we thought. It was easy to get a picture or article in *AVN,* but as far as getting anyone in the real world to show any interest, it was nearly impossible. It wasn't as if they weren't watching the videos: they just didn't want to admit it.

Joy and I weren't the biggest Howard Stern fans. She thought he sounded like a dick, and I was scared shitless of him because he shredded people on the air. But Blinky was obsessed. I was in Joy's office one morning, looking over pictures I had done for Adam and Eve Productions, when Joy pulled out a glamour shot of me topless, holding a dildo, and making a goofy face with my eyes crossed.

"Here's this week's photo," Joy said.

She had it blown up into an eight-by-ten and sent it to Howard Stern with the usual press materials. We didn't expect to hear back from them. A week later, they were talking about it on the air. Joy called to let me know.

"He's talking about you right now," she said.

"What's he saying?"

"He's saying you look like you should be a Guess model and he can't believe you're a porn star."

As soon as the show ended, they called Joy.

"Can you be here next week?" they asked.

"We'll be there tomorrow," Joy replied. We were scheduled to leave that day for a photo shoot in New Jersey anyway.

On the plane ride there, I was petrified. Not only had I never been to New York before, but I hardly even had my feet wet at Wicked and already had to represent them on a live radio show with a host who specialized in humiliating women. I was sure Howard was going to rip me to shreds. For hours, I rehearsed what I was going to say in my head. I didn't want to come off like all the other girls on his show. They either pretended to be voracious sex kittens or poor wounded birds. I wanted him to see who I was, with no act. I wanted to hold my own against the pressure and manipulation.

I woke up at 3 A.M. the next morning to get ready. They had just started filming his radio show for the E! Channel, so I was going to have to look good. I slipped into a midriff-baring white sweater and tight jeans.

The office building that housed Infinity Broadcasting was big and empty except for a security guard at the desk. I walked to the elevator, and he chased after me. Evidently, I had to sign in first. I'd never actually been in a high-rise office before: I had no idea I was supposed to sign in and tell him what floor I was going to and get a badge and all that crap. I felt like a complete idiot.

As I waited in the green room upstairs for my turn on the show, my tension reached a new plateau. I needed to be quick-witted; I needed to be incredibly smart; I needed to defy every stereotype. Few girls left that studio without looking like bimbos. And, unlike with moviemaking, I had to get it right in one take or risk national humiliation. Joy had given me a list of movies and products to promote, which lay crumpled in a sweaty ball in my fist.

I could hear Howard talking about me on the monitor. He was discussing the photo he had seen the day before. "This girl could be a model," he said. "She doesn't have to be in porno. She must have had one screwed-up childhood, man. She's probably got a great story in her."

When he said he wanted to take a "real hard look" at me to see if I measured up, I literally couldn't breathe. I was so frightened I was gasping for air.

An assistant entered the room and led me down the corridor. The minute I saw the door with the "On Air" sign above it, I thought, "Put it on, girl. Put it on." I grabbed the doorframe and swung myself playfully into the studio. Suddenly, the queasy feeling in my stomach left me, my posture straightened, and a flirtatious smile spread across my face.

"Wow, super," were the first words out of Howard's mouth when I walked in. I had done it.

Instantly, the grilling started. He seemed determined to know what had made a girl like me become a porn star. I told him I loved sex. I told him I loved the attention. But it wasn't enough for him.

He kept saying that something didn't compute. He asked if I had a screwed-up childhood, and I said no. He asked if my parents had been strict, and I said no. He asked if my dad and I still talked, and I said we did. He asked if my mom minded what I was doing, and I said no. I had decided in advance that it was better not to discuss her death on the air. I didn't think I could handle it.

But then Howard asked me if I'd ever been molested or abused. It was the one question I wasn't prepared for.

My mind flashed back—not to Preacher but to something far worse. It hadn't even crossed my mind in years. I think I had successfully managed to block it out. But as soon as Howard asked that question, the images came flashing through my mind like a flicker film. The red pickup truck door. The blinding sun. The mosquito bites. The desert.

It didn't actually occur in a desert. But when I relive it in my mind, I always imagine the desert, for some reason. It actually took place on the side of a dirt road. A dirt road in Fromberg, Montana.

During sophomore year in high school, my dad dragged us to the tiny town of Fromberg because he wanted to raise cattle and keep me out of trouble. I was miserable there because the girls at school were vicious. I didn't want to let them get the better of me, so I decided to make an

effort to socialize with the boys instead. To that end, I had my brother drop me off at a football game we were playing against a school twenty minutes away.

I had a great afternoon, and talked with everyone. I spent most of my time hanging out with four players from the rival team. They were funny, good-natured guys, and I thought that maybe my luck was going to turn in this town. There were other people to hang out with besides the jealous bitches at my school. When they offered me a ride home, I didn't hesitate to accept. It was a small town, everyone knew each other, and crime was so low that no one even bothered to lock their car or home doors.

We squeezed into their pickup truck and started down the road to my house, chatting away merrily. Looking back, I can't even remember what we talked about or even what they looked like. I've blocked it out. They were just backwoods boys, but I never could have imagined what they were capable of.

When they turned off the highway onto a dirt road, my suspicions still weren't raised. I just asked where we were going, and they said that they had to pick up something quickly at a friend's house. It was when they stopped in the middle of the road, with no house or humanity in sight, that I began to panic.

"What are you guys doing?" I asked.

"We just have to find something under the seat," one of them said. "You need to get out for a second."

"I need to get home," I told them as I climbed out.

"You're just fifteen minutes away," one of them said. "You're fine."

"Seriously. You need to take me h—"

It came out of nowhere: a loud, cracking sound—the sound of a fist connecting with my face. The first two letters of the phrase "What the fuck?" escaped from my mouth as the hand was on me again. It grabbed a clump of my hair close to the scalp, and slammed my head against the car door. Once. Twice. And I was out.

When I came to, one of the boys was on top of me. I could see his face, flushed and furious, bobbing over mine. I knew what he was doing. I

couldn't move. I don't know if I was pinned to the ground, if I was too weak to move, or if I had somehow gone catatonic. The details are so foggy. I tried to think about riding my horse. I imagined that I was galloping across my dad's farm, all by myself, with the sun shining and my hair loose in the wind. I kept telling myself, "Everything is fine. Everything is fine." Then suddenly something cracked solidly into my skull just above my right eye. It was a rock. I saw white fireworks for a millisecond, and then the world went black again. Everything wasn't fine.

When I woke up, I was lying in a rocky field just off the dirt road. The sun was warm on my face, and a thick cloud of mosquitoes had settled on my body. I turned my head, and the side of my face splashed into a puddle. I reached up and wiped my cheek dry. My ribs ached. I inspected my hand, and it was smeared with red. It hadn't rained in Fromberg for weeks. The puddle was my own blood.

I looked down at myself. My clothing was shredded and stained with big red blotches. I had no idea how long I'd been lying there. My exposed flesh was covered with welts, crusted with dried blood, and dotted with mosquito bites. I knew instantly what had happened: They had gang-raped me and left me for dead. I tried to push the thought out of my mind. I couldn't allow myself to dwell on it. I needed to get home.

There was no sign of civilization in sight. I would have to walk. I knew that the football game had been east of my house. So I looked up at the waning sun. My right eye was so swollen that I could only see through the other eye. I followed the path in the general direction of the sun for half an hour until I reached the main road. I was about five more miles from home. I walked fifty yards off to the side of the main road whenever I could, so that no one would see me. I thought that if anyone pulled over and found out what had happened, I'd be put in a foster home.

As I trudged forward, there were two thoughts on my mind: What if the guys come by again and see me, and what do I tell my dad?

"Jesus, honey, what happened to you?" my dad asked when I finally stumbled through our front door.

"I got in a fight with a girl from school," I told him.

Without waiting for his response, I made a beeline for my room. When I looked in the mirror, I burst out crying. I wasn't supposed to have lived through this. It was clear.

The guys must have planned everything in advance, because the whole time I was conscious, there wasn't a word about it exchanged between them. I wondered how many other girls they had done this to. But I didn't tell anyone. To this day, my dad doesn't know what happened. No one knows. I should have at least called the police. I wanted those guys to pay for what they'd done, but if I told my brother or father, they'd kill those guys. And then my brother and father would be in jail and I'd lose them forever. Ultimately, I cared more about my family than my well-being.

I needed to shut it out of my mind forever so that I could try to go on living like a normal girl. It was all just another test that I had to deal with on my own. I was angry. But more than that, after everything else I had endured in that town, I was broken.

I didn't leave the house or speak to anyone for days afterward. I constantly lost my temper, and would trash my room for no reason. My dad thought I was just having problems at school. So when the principal called and threatened to put me in a foster home for being truant, I snapped. This town was going to destroy me, body and soul. That was when I marched into school and channeled all my anger and frustration into the head of the girl who bullied me the most, slamming a locker door on her skull. It was pure catharsis. I left the building afterward, and never looked back. To hell with Fromberg.

When we returned to Las Vegas, I left that whole part of me in Montana. With Preacher, at least I had been able to fight back. It impacted me in a different way, because the man I thought I loved was so complacent about it. But ultimately it was easier for me to get over, because I hadn't been as powerless—by and large, I had stopped him short. I'm sure a lot of other girls weren't able to fight him off. But the Montana thing was such a brutal, horrible experience, and I was power-

less to protect myself. If I could have one memory erased, it would be that one.

It had only flashed through my consciousness a couple times since then, but Howard's question—I'd never been asked anything so direct—brought the images flooding back. I understood what he was trying to get at. The question had crossed my mind before: Was I in this business because I was victimized or because I wanted to succeed at something? I examined it from every angle I could, and every time came to the same conclusion: that it didn't make a shred of difference. It occurred too late in my development to be formative. Whether it happened or not, I still would have become a porn star. I've been to enough therapists to know that.

I've never told anyone about either the Montana experience or the one with Preacher because I don't want to be thought of as a victim. I want to be judged by who I am as a person, not by what happened to me. In fact, all the bad things have only contributed to my confidence and sense of self, because I survived them and became a better and stronger person for it.

Nearly everyone has some sort of skeleton of their own or their family's hidden in the closet. There are people who have suffered terrible abuse and grown up to be lawyers and doctors with stable families. Others suffered some small indignation and turned into violent sociopaths. Ultimately, what really matters is not just the experiences you have at a young age, but whether or not you are equipped—by your parents, by your genetics, by your education—to survive and deal with them.

"No," I told Howard in answer to his question. I lied like a rug. I wasn't ready to tell anybody about any of this, and I certainly wasn't ready to deal with Howard's reaction. I didn't want anyone to think that I was in the business because I was a victim. It was a choice I had made on my own, and was proud of.

Fortunately, Howard soon moved on to easier subjects. "I want to go out with you so bad," he said, his eyes never leaving my body once throughout the show. "Please date me. I'll pay you to date me."

I realized that a lot of what Howard does is an act also. On the air, he pretended to be horrified when he saw the dragon tattoo on my neck. "That's the ugliest tattoo I ever saw," he scolded. "It is ugly. You are really a psycho."

But during the break, he asked if he could see it again. "That's really cool," he said. Instantly, I knew we were alike: we both had fronts we presented to the world. Years later, he even got a tattoo himself.

During the show, Howard invited me to a party for his staff at Scores that afternoon. When Joy and I were in the green room afterward, Gary Dell'Abate, the show's producer, walked in to make sure we were coming. They had rented out the entire strip club.

At Scores, Gary handed us two thousand dollars each in funny money to tip strippers and buy champagne. Joy and I were the only people there who didn't actually work on the show, outside of about thirty strippers. Because the club was closed, there seemed to be no limit on what they would do.

After an hour or two, Fred Norris, the show's engineer and cowriter, came over and said Howard was looking for me. When I found him, he was surrounded by girls. They were all over him but he wasn't grabbing them or mauling them. He kept telling them to stop if they started going too far. Instantly, I realized this was a guy who had his shit together and really did love his wife. And that made him more attractive to me.

When I sat next to Howard, he said, "I was telling these girls that you can probably give a better lap dance than them."

His instinct was correct. I had certainly racked up enough experience in the art at the Crazy Horse Too. But I wasn't sure if it was appropriate to grind on Howard since I was representing Wicked. I looked over at Joy. She had six strippers crawling all over her—I figured I was in the clear. I then proceeded to give Howard what must have been the best lap dance of his life. He was speechless for once. When I straddled his lap, I was shocked. All that talk about how he had a small dick was just an act too. I could feel it through his pants: The thing was huge.

After the lap dance, Joy and I left the club. A limo was waiting out-

side to take us to the New Jersey photo shoot. We were nine champagnes into the afternoon and dreading it.

As I sat there in the limo, thinking over the events of the day, I was elated. Not only had I aced the interview, but I had befriended Howard and his whole staff. I knew I could get on that show whenever I wanted now. And, more importantly, I knew Steve would be proud of me. I'd even squeezed in the promotional plug for *Blue Movie* that he wanted. I had finally taken the first steps down the path I promised Steve I'd be on. When I told him that I was going to be a superstar, I didn't know if I could really do it. And, sure, this was just Howard Stern: Any hot girl could get on the show—and get humiliated. But I had aced it, and they loved me.

With Joy King (left) and Sydnee Steele.

Chapter
THIRTEEN

I did a lot of thinking as I flew to Cannes. Thanks to my scene with T.T. Boy, I had been nominated for the top awards at the Hot D'Or Awards, the biggest adult-film event in Europe, which coincided with the Cannes Film Festival and a convention for foreign buyers of adult movies. Between this and Howard Stern, I realized that I really had a life now. I was no longer just dabbling in the adult world for money or something to do. This was my identity and career. I would be representing Wicked and myself at the biggest film festival in the world. And nobody really knew yet who I was or where I came from. I could get off the plane and be anyone I wanted. I could be an untouchable icon, a slutty party girl, an uptight prude with a dark side, or the living embodiment of the fantasies of every male in the western world—and some of the females, too.

I was twenty-one years old and finally beginning to get comfortable with myself. My boyfriend, Steven St. Croix, had absolutely no control over me; neither did Steve Orenstein or my dad or Joy King or anyone. I was my own person, and every one of those people believed in me. Cannes was going to be the start to my new life.

Steve Orenstein and Joy were with me. I had lost my passport the day before we were supposed to leave, so Steve had taken me to get a new one. Afterward, I spent twenty-four hours packing ten suitcases, because I knew Cannes was a big deal and I wanted to be prepared for

Opposite: On the red carpet in Cannes.

anything. They were bringing over two other girls, Juli Ashton (a former high school Spanish teacher) and Kaylan Nicole (the reigning queen of anal at the time), both of whom were more experienced and popular than I was. As catty as it sounds, I wanted nothing more than to prove myself over these chicks. But it was going to be hard, because I was trying to learn from them at the same time. They had realized that with their beauty, boobs, and status, the rules that applied to the rest of the world didn't apply to them. They had the attitude that they could do absolutely anything they wanted. (Little did I know that this would be Kaylan's last trip to Cannes: soon after, she quit the business, denounced porn, and became a Sunday school teacher; Juli went on to host *Playboy Night Calls*.)

On the flight, they ordered drink after drink, traipsed around the plane like it was their living room, and acted openly sexual with each other, much to the excitement and consternation of the male passengers. Even though I'd been in lesbian relationships, I'd never been that forward in public. My dad the cop had taught me to follow the rules, and their behavior confused me. On one hand, it made me uncomfortable; on the other, I wanted to have the guts to act that free. I'd say, "Oh my gosh, you aren't supposed to get up and go to the bathroom right now while the 'fasten seat belt sign' is illuminated," and they'd look at me as if I were the stupidest girl they'd ever seen.

The minute we got off the plane, we were in another world. It was one I'd dreamed about since I was a little girl, imagining what it would be like to be an international jet-setting model. In fact, it was wilder than my dreams. Flashbulbs went off everywhere. The paparazzi screamed and fought to take pictures of me, even though they had no idea who I was. It was so overwhelming and disorienting being pushed through the admiring crowd toward a waiting limo. I knew, for the first time, what an actual celebrity must feel like. I had only been playing at being one, but I now felt it was within my grasp.

As we raced away in the limo, I realized that if I worked this right, it could be a big opportunity for me. I could get my name everywhere.

When I got into the business, I thought being an adult star was just about doing scenes and selling videos. But I never thought that this psychotic melee would be part of the bargain.

We arrived at what looked like a palace: the Royal Casino hotel. I'd never stayed in a room that immense and ornate before. Joy had booked interviews and photo ops for me every ten minutes. And I was excited to do all that work. I was willing to do anything to be someone who everyone loved. Looking back on it, it was just a new type of insecurity replacing the old one, and I was giving myself away to the needs and expectations of the public instead of the needs and expectations of the men in my life. It was just a new form of dependence developing. And it was equally detrimental to any sort of mental stability.

A press conference promoting the Hot D'Or awards kicked off the schedule. This would be my first chance to show everybody what I was about. Of course, I had no idea what I was about. But I knew what I needed to do. So while every other girl at the conference wore her sluttiest stripper and hooker clothes, I changed into a beautiful blue Versace suit. The press conference started at noon; I waited until 1 P.M. to arrive in order to make the biggest splash possible. There is a little girl who is still inside me, and that little girl doubts everything I do, but I always force myself to go out and do everything—no matter how trivial—bigger and better than everybody else does, just to spite her.

When I entered the room, everyone suddenly went silent. I didn't know if that was a good or bad thing, because they were all looking at me like I had arrived late to class on my first day at a new school. Suddenly, all my mental preparation vanished, and nervousness seized hold of my body: I started shaking uncontrollably and hives popped out on my arms and neck. As I walked toward the table where all the other girls were sitting in awkward silence, I kept telling myself, "Calm down, calm down." People were talking to me. I couldn't process a word they were saying.

When I sat down, the noise resumed and everyone began clamoring to interview me. It was my first press conference and I wasn't very pol-

ished. But I had my training from the pageants, so I just made strong eye contact and told each journalist the answer I thought he wanted to hear. Afterward, I couldn't remember a single word I'd said.

At the time, porn was huge in Europe, and fans and photographers chased our cabs and limos every time we left the hotel. They'd mob us in the street, asking for photos and autographs. More excitement surrounded us than the mainstream actors, because we made ourselves more accessible.

I always made sure I had the best outfit on. If there was a photo op, I made sure I was front row and center. If there was a television camera in the vicinity, I made sure I grabbed the microphone. I don't know what came over me. I took over absolutely everything. I was competing with some of the best girls in the industry, and I had to prove why, out of all of them, I deserved to be starlet of the year. Even when photographers would yell "Pamela" at me, I'd play along, mugging for photos and letting them think they had Pamela Anderson. Looking back on it now, I'm ashamed at how selfish and opportunistic I was, but at the same time, success requires some familiarity with the fatal flaw of narcissism.

On day two, we had to sign autographs at the convention. It was a complete anticlimax. The Cannes administrators had stuffed all the porno people in a horrible little cubbyhole in a basement underneath the theaters where the mainstream films were being shown. As we walked in, I picked up a book-size guide to the premieres, which the festival had published and handed out to everyone attending. I flipped it over and noticed a giant picture of my face on the back. The only text on the page was the word "Jenna." Wicked had sprung for a lavish color advertisement.

Unbeknownst to me, everyone in the mainstream film industry was asking who this blond girl on the program was. So a producer at the E! Channel decided to hunt me down and solve the mystery. As I was leaving the convention late that afternoon, an E! cameraman saw me and yelled, "Jenna!" I turned around and he approached me. "Who are you?" he asked. "You have to tell us."

And then, in one of the boldest moves of my life, I snatched the microphone out of his hand and an alter ego I never knew I had leaped out.

"Hi, I'm Jenna Jameson, and I'm reporting to you from Cannes, France, where the biggest celebrities in the world have gathered to spend a week sunning, partying, and watching movies."

I think a part of me had always wanted to be a television show host. I had been watching Cindy Crawford on MTV's *House of Style* recently, and thinking about how much better of a job I could do—if only I looked as fabulous as she did.

"I'm here because I work for Wicked Pictures, where we make adult films so hot that if you don't cover your eyes, you'll probably explode. I'm up for the top awards this year. And I'll probably win them too, but you'll have to come along with me to see."

On one hand, I was completely seized by the moment and blathering; but on the other hand, I knew exactly what I was doing—trying to

I wasn't surprised when Jenna Jameson made her way into the awards on the arms of Juli Ashton and Kaylan Nicole. She blushed saying that she had the girls help her decide what to wear and before I could press her for details, Wicked Pictures president Steve Orenstein scooted her off to his table. This Jameson girl is red hot and a shoe-in for Starlet of the Year. Remember, you heard it here first!

trap E! into covering the awards show in the process. When I was finished, everyone was in shock. Not necessarily because of what I said, but because, like Howard, they had no idea a girl who looked so young and innocent could actually be a porn star. Fortunately, the producer was standing nearby and, as soon as I finished my ridiculous monologue, she ran up to me and said, "Would you mind being our correspondent here for the whole festival?"

"No problem," I said coolly.

The minute she turned her back, my whole face twisted with excitement and the words "Oh my God!" resounded loudly through my head.

For my first appearance on E!, I walked down a pier and bought an ice cream cone while discussing a premiere that night. Behind me, the camera captured crowds of people chasing me trying to take pictures, thinking I was some sort of star. Perception, I quickly learned, is reality.

That night, I interviewed actual stars, none of whom had any idea who I was or what I did. They just thought I was the pretty new face of E! And they actually respected me for it. My heart was beating so fast it felt like I was on meth again. I was twenty-one years old and living out my dreams. And the strangest thing of all was that I had no fear. I was the most self-conscious person I knew, but somehow, I wasn't afraid to step up to the plate for E!, as if somewhere in the back of my mind I'd been preparing for it my whole life. I was actually reinventing myself. All those months of eating ramen had paid off.

That night, we all dressed up and Joy took us to a club which opened at midnight. All of Cannes, it seemed, was packed into this immense place and stripped half-naked because there was no air-conditioning. I was so full of adrenaline from the E! experience and alcohol that I climbed up on the bar with Juli and Kaylan, and stripped down to my bra and bikini bottoms. Then, half a dozen random girls climbed up on the bar with us, and we all started groping each other. This was nothing unusual for the club: there were couples making out all over the dance floor, and even fucking in the stairwell.

Suddenly, I looked down and saw a black-haired waiter with a per-

fectly chiseled jaw staring up at me. One of the things I liked about France was that the guys were hot but the girls weren't, so the odds were in my favor. But I was never the type of person to pick up a guy. I had never made a first move in my life. I'd just wait until a guy propositioned me, like Victor and Jack had. But I was no longer Jenna Massoli, or even Jenna Jameson. I was *Jenna!* with an exclamation point. So I jumped down from the bar and knocked the tray of drinks out of his hands. Looking back on it, I can't remember whether I was just drunk and clumsy, or trying to be forceful and sexy. Probably both.

Then I raised my left leg up, rubbing it against his outer thigh, and thrust my fingers into the tangles of his hair. As he started to open his mouth and say something, I pressed my lips against his and thrust my tongue down his throat. The words died in his mouth, and he wrapped his arms around me and started kissing me back. It was the greatest feeling in the world. Here I was, a fucking porn star, and I was so excited just to be kissing some waiter.

He grabbed my hand and led me across the dance floor and through a door that led to the employee bathrooms. We stopped in the hallway and our lips met again. I massaged his back, and worked my way down to his ass. He slid his mouth down to my neck, and grabbed a handful of flesh with such force that I broke out in goose bumps.

I reached around to the front of his pants. I had to see what it felt like. His cock strained against his black pants, throbbing every time I squeezed it through the material.

"Don't you have to get back to work?" I asked him.

"No," he said slowly, in an adorable accent. "I don't have to do anything."

He cupped his hand over the front of my bikini bottoms and just left it there, letting the heat spread through me until I was dripping wet. Then he moved my bottoms aside and rubbed his middle finger against my lips until it just slipped inside. With his thumb, he worked my clit as I ground against his hand to a shuddering orgasm. I hadn't expected to come so soon.

"Let's take this somewhere more comfortable," I told him.

We left the club through the employee exit, went back to my hotel room, and fucked until the sun came up. I had always heard that French men were great lovers, but between his stamina, his sensitivity, and the French phrases he kept cooing in my ear, he surpassed my expectations. I had no idea what he was saying, but it totally turned me on, even though for all I knew he could have been whispering, "You stupid American bitch."

When it was all over, he wrapped his naked body around mine. Instantly I stiffened. I hate cuddling. When I'm hot and sweaty and sticky, the last thing I want to do is be pressed up against something else that's hot and sweaty and sticky. I pulled away, and he looked hurt.

"How old are you?" I asked. I didn't know anything about this guy.

He looked at me sheepishly and turned away.

"You can tell me," I said. "It doesn't matter now anyway."

He muttered his answer, and my jaw hit the floor. What I'd just done was probably illegal in many parts of the world.

The next day, I met a director who gave me an extra ticket to a premiere that night. "I want to see the reaction when you walk the red carpet," he said. I had just a few hours until the movie, so I ran through Cannes, looking for something to wear until I fell in love with a black Valentino dress that, at $3,800, cleaned me out.

I changed in the back room of the shop and took a cab to the premiere. When we pulled up outside, it was a mob scene. There were limos everywhere, and the press was packed around the red carpet like gamblers at a cockfight. My biggest fear was that no one would recognize me, or care. When I was about a quarter of the way down the carpet, someone suddenly screamed "Jenna!" and the pandemonium began. It was a moment I wanted to last forever: it felt like I had arrived.

When the movie started, I couldn't even pay attention. My head was spinning. I left after fifteen minutes and found the E! crew waiting for me at my hotel. They wanted to film me at a members-only swingers club that night.

For the rest of the week, I spent my mornings autographing at the convention dungeon, my afternoons filming for E!, and then I would

party until dawn, sleep for two hours, and start all over again. I couldn't remember ever having so much fun in my life.

I swept up at the Hot D'Or Awards on my final night in Cannes, winning Best New American Starlet and Best American Actress. Afterward, I looked around the room and thought, "I did it. I'm the most popular girl here." As shallow as it is, that's what I thought at the time. Life was like high school, a popularity contest in a classroom as big as the world.

Mainstream fame, or at least the tantalizing possibility of it, had now entered my bloodstream. I was never the same afterward. Returning home on the airplane, swigging miniature bottles of Jack Daniel's with Juli and Kaylan, I was now one of them: I could do no wrong. And I could get away with anything, because I was *Jenna!* with an exclamation point. I thought I was finally finding myself, but in reality I was turning into a monster.

Laure Sinclair and me at the Hot D'Or Awards.

Unprecedented.

Jenna Jameson. Winner, 1996 Best New Starlet Award.
HOT D'OR, AVN, XRCO, & FOXE
Winner, 1996 Best Actress.
HOT D'OR, AVN
Congratulations Jenna, From Your Family at Wicked Pictures.

Chapter FOURTEEN

I was lying in bed at Steven's apartment the night the E! Cannes special premiered. I was overwhelmed watching it. It was the first time I had accomplished anything in my adult life that didn't involve taking off my clothes. Without even trying that hard, unlike most of the people I saw in L.A., I was on national TV. I didn't feel like society's dirty little secret anymore. And to be perfectly honest, I was completely enamored with the sight of my own image on television.

"Oh my God," I kept telling Steven, "I actually look like a real star."

Finally, he turned to me and, with derision in his voice, said, "Why do you keep saying you are a *star*?"

Instantly, something clicked in me.

"You selfish bastard," I muttered. I stood up, put on my clothes, left his apartment, and never saw him again. Whether I was being shallow or not, it was one of the proudest moments of my life and he was shitting on it. I couldn't have people around me like that anymore. I was the only person I would allow to hold me back. Nobody else.

After Cannes, my career seemed unstoppable. Every month, a new movie of mine hit the stands. And the buzz just grew louder. At every awards show—Nightmoves, XRCO FOXE—I took the top honors. It seemed as though I was on every page of *AVN,* which had nominated my movies in almost every category at their awards show, the most respected in the business, and even asked me to host the ceremony that year.

I knew just who I wanted to bring as my date: my father. He had left

Reading, and would sporadically call me from parts unknown. He rarely gave me the phone number of where he was, and I didn't ask. I still had no idea what kind of trouble he was in, but if the cops ever came knocking on my door, I knew I was better off without his contact information. Besides, he never seemed to call to ask me how I was doing. It was all about him: where he was and how he needed money for moving costs.

So when he called from yet another payphone somewhere in this great land of ours, I invited him to the awards show. Despite everything, I wanted my father to see me win. I wanted him to know that I was no longer a little girl who couldn't take care of herself. I wanted him to see that I was successful and respected and admired. I wanted him to be proud of me. I wanted him to care. And perhaps I also felt that his approval would set in stone that I had made the right decision getting into adult movies.

In the intervening years, I had talked to Tony every few months, which was much more than I had talked to my dad. When we were kids, Tony and I were so incredibly close. We'd talk to each other all day, compete against each other in burping contests, and live in a world of our own invention. But as my life filled with work and he focused on being a good husband and father, we grew apart. Every time we talked, we simply exchanged facts: His son, Gage, had started walking; Selena had just undergone a hysterectomy; he was bartending at TGIF's; our grandmother had recovered from her double mastectomy, but now had throat cancer and was having an artificial esophagus put in. It was uncomfortable to speak to Tony. Everything we said seemed devoid of genuine emotion and sincerity, so I talked to him less and less. Even if it was partly my fault, because I had unfairly transferred some of my hostility for my father onto him, it hurt me so much. After all, I owed my only happy childhood memories to him.

Before my father's pending arrival and the awards show, I kept myself as busy as I could so I didn't have to think about them. I wasn't too worried about whether I would win, though of course it would be nice to show off for my dad. I just didn't want to look pathetic and undeserving

as a host. I felt a tremendous amount of pressure (which was probably mostly in my mind) to impress everyone. I wanted to be funny, relaxed, charismatic. I didn't want to embarrass myself and Wicked. To this day, I still put pressure on myself to be the person that everyone wants and expects me to be.

I bought a shimmering silver midriff-exposing five-thousand-dollar outfit that I felt was befitting of a star. And I hired a makeup artist and a hairdresser, who spent six hours sticking in extensions and spritzing my hair into some kind of futuristic ponytail. In retrospect, I looked like a cross between Barbara Eden and a disco ball.

When we arrived, they whisked my dad and me backstage. The first award they announced was Best Sex Scene. And next thing I knew, the tuna eater and I were on stage accepting it. As I left the dais, the show producer pushed me back into the spotlight. I had to introduce the next presenters, who came out and announced the next award: Starlet of the Year. While they were doing that, I took the opportunity to go to the bathroom. I was up against some hard-core talent, and there was no way I was going to win.

When they called my name, I sprinted back onstage. I was overwhelmed, hugging the presenters with unwashed hands. I remembered seeing Savannah's acceptance speech. Everyone in the industry resented her success, so she walked onstage and spoke two words: "fuck you." For a fleeting moment, I thought about doing that, too, just because so many of the girls sitting in the audience had been so catty with me. But I chose to accept the award with dignity, and thanked Steve and Joy.

By the end of the show, everyone must have been sick of seeing me onstage. *Blue Movie* won Best Film of the Year, Best Editing, and Best Director, and I won for Best Boy-Girl Scene and Best Actress, which meant the most to me. Starlet of the Year was just an award for a pretty new thing, but Best Actress meant I had talent—at least in relation to everybody else. No one had swept the top awards like that in the history of the show.

Everyone kept joking around that it was the Year of Jenna. My arrogant speech to Steve Orenstein was turning into prophecy. Backstage, I

overheard a couple of the other girls talking. "Oh, isn't it so funny?" one said. "They pick her to host, and she wins all the awards."

"I wonder how many guys she had to blow," the other said.

In reality, I had won because I'd busted my ass. In one year, between Howard Stern and the E! Channel, I was opening doors that no one before me had. And even though they were just speaking out of jealousy, it hurt—and it still hurts when I hear people pissing on the work I've done.

As I sat there at the end of the night with all my awards in my lap, my head was spinning. I had come through for everyone. And just like the pageants, I had done it for myself. My dad only came to see the end result.

But this time I didn't mind. Even though I had invited him there expressly to get his approval, I realized that I didn't need his praise or his involvement. The success instilled a measure of confidence in me; I was finally on my way to truly being independent. It was a turning point in my relationship with my father, because in that moment I didn't expect him to be anything more than what he was: a guy who loved me but didn't know how to show it. Sure, he'd never learned how to be a father. But there was more to it than that. When he said how much I looked like my mother when I went onstage, I had a moment of complete clarity: it hurt him to get close to me, because I reminded him too much of the wife he had loved and lost.

After the ceremony I was too tired to celebrate. I went back to my room, shut the door, and cried. "My life is at a fucking peak," I thought. "There's nowhere to go from here but down."

A strange sort of arrogance took hold of me after all the accolades. I began to think I was smarter than everybody around me, which may have been true but didn't give me any excuse to act that way. On set, I acted as if I were the only one who knew what it took to sell movies. I knew what kind of sex to have, whom I had to work with, and how many scenes I needed to be in. And if anyone disagreed with me, I'd pull rank. I realized all I had to do was threaten to quit the movie or sic Steve Orenstein on a director, and he'd do whatever I wanted. When you are twenty-one and have the kind of power I did, you enjoy brandishing it.

But after watching me for a while from the sidelines, Steve pulled me aside. "You have to understand, Jenna," he said. "You are in the spotlight. You are the spokesperson for this industry. A lot of people look up to you, so you have to watch what you say. I'm not asking you to change the person that you are, but just think before you talk."

I suppose the last thing one would expect on becoming a porn star is a lecture on how to be a role model, but that's exactly what Steve Orenstein gave me. And he was right. I'm already doing something that can put women in a bad light, I realized, so it's particularly important to hold myself to a higher standard of behavior than other women.

The opportunity to live up to that resolution came days later. After the AVN Awards and all the mainstream exposure, everyone wanted to interview me, even people who had passed on the offer before. One of them was Al Goldstein, the publisher of *Screw* magazine, who was writing for *Penthouse* at the time. Joy set up something after the awards show, and Goldstein came by to introduce himself. He's an obese, greasy, slovenly man, and was very touchy-feely with both of us. When he discussed the interview, he seemed to be dropping hints about going on a date or getting sexual favors from me in exchange for the article. He didn't say it explicitly, but it's the feeling that Joy and I got. As he walked away, Joy and I looked at each other and said, "No way." If any journalist makes me feel uncomfortable or shows any disrespect, I'll cancel the interview. In this business, you get to see all the double standards that women are held to in society, and it is important to keep from perpetuating them. One way is by refusing to allow anyone to disrespect you.

Goldstein never forgave us for canceling the interview. And so I made my first enemy in the business. He published a screed against Joy and me on the front page of *Screw,* accusing us of practically every offense imaginable—and a few that were unimaginable. He even attacked my family. That was a turning point because up until then, I could do no wrong. I was the golden girl of the industry. When I read that story, I was heartbroken. I wanted to give up and quit the business.

It went beyond just Al Goldstein. I had become the main attraction in this whole circus, and it was taking a much bigger toll on my life than I realized.

Opposite: With Larry Flynt.

JENNA JAMESON

Book

V

QUEEN OF PORN

xxx xxx

TROPHIES OF LOVERS GONE

"Thou art the grave where buried love doth live,
Hung with the trophies of my lovers gone."

★ ★ ★ ★ ★

Chapter 1

March 2, 1996

Dear Diary,

So I have found you again after all these years. I only seem to need you when I'm sad. I can't possibly catch you up on everything that's been going on in my life, but let me at least let you know what's going on now.

Travel is a major staple in my life. It seems it's all I do. I'm not sure the effect it's having on me. I guess I haven't taken the time to reflect. Obviously that's one of the major problems. Reflection. I close myself off. Not wanting to let what's in the mirror of my life stare back at me. I never take the time to feel the effects of my choices. Maybe it's because I would be ashamed, maybe afraid. I realize I have avoided my pain for as long as I can remember. It's what I've been taught. Be strong little one . . . Things can only get better. As life goes racing by me, all the while my soul goes on with sickness. Yes, sickness. It feels like it's ailing. Because the one that should be nursing it is too busy trying to succeed and be accepted. I'm certainly scared that if I try to fix what has broken in me, so long ago, I may not succeed. So I go on faking that I am whole, proud, and strong . . .

I almost laughed aloud when I turned my head down to wipe my tears on my shirt and saw the pen I was pouring my pain through.
It's a Radisson Hotel pen. Point taken.

Sometimes everything seems so surreal.

Nikki used to call me her "Gypsy." I always laughed when she said that, because I know it's not only from all my travels. My heart is a gypsy—continuously searching for a home, fighting within itself, wondering whether it is weak or even right for that matter to be searching in the first place. Loneliness is what it feels like.

I don't really know what the urgency is I feel: Loneliness or complete heartbreak? But I fight it, saying it can't be broken. I still have hope that I will find peace within myself, and that must be what it's about.

—Confusion—

JENNA

Awards Show *c.e.s.* SPECIAL REPORT

ALADDIN

13th Annual
AVN
AWARDS
SHOW
JANUARY 7, 1996

JAMESON

Chapter TWO

If anyone in North Hollywood had the courage to approach a turbo-breasted, kiddie-faced blonde in the summer of 1996, they could have been dating me. I was lonely after breaking up with Steven—not because I missed him but because I was tired of living by myself. As my star rose, it became harder to live in that tiny studio. I wanted someone to share my excitement with. And, more than that, there was the issue of safety. Not only was I afraid to order food, but my deathly fear of the parking garage wasn't assuaged when my Corvette was broken into and thousands of dollars in clothes I had stored in the back for photo shoots were taken.

Rodney Hopkins, in the meantime, hadn't stopped pestering me to go out with him. And since he had saved my life by taking me to the hospital, I felt a sense of obligation. My reluctance to see him again was nothing personal: there was just no chemistry. But I was lonely and grateful so I relented.

He picked me up and took me to an Italian restaurant on Ventura Boulevard. (I rarely went over the hill to Hollywood.) With the dim lighting and obsequious staff, it could have been an incredibly romantic evening. But it was, as I had feared, a night of ennui. I am a talkative person. It's easy for me to make conversation; at the Crazy Horse I'd learned to entertain even the dullest of the species. But every time I asked Rod a question, he answered with one word. Whenever I made a joke or acted silly, he just looked at me blankly. So as dinner progressed, the awkward silences grew longer. I couldn't wait to get away from him. When he

pulled up in front of my house, I leaped out of the car and told him there was no need to walk me to the door.

Any other man would have realized there was no connection and left me alone, but Rod was either oblivious or obsessed. He continued to call me incessantly. And every now and then, if I was bored and hungry, I'd let him treat me to dinner.

Gradually, I began to grow attached to him. As he became more comfortable with me, he began to laugh at my jokes, which always gets a man big points. And it was really sweet to watch the way he reacted to me: he seemed to get such a kick out of everything I did or said. An insanely talented director, he had just started making films for Wicked, and he knew a lot about the business. So I quickly realized he could help me. Was that superficial of me? Yes. Was it unusual for me? Sadly, no.

Rod was five feet ten inches, with brown hair, a goatee, and earrings. To most people, including me, he seemed unfriendly because he never smiled, barely talked, and was unable to express himself emotionally. He didn't seem to have a deep side, a hidden sensitivity, or an ounce of adventure and spontaneity. His shortcomings may have been due to his upbringing. He was an only child and never close to his parents. Formerly a dancer in Canada, he had since let his body go slightly. However, his male-dancer fashion sense never changed. He was always wearing a leather jacket with built-in shoulder pads that even Goodwill would have rejected.

The first movie we worked on together was *Cover to Cover.* I participated in everything: script writing, preproduction, wardrobe, set decorating. I was so gung-ho about the experience that I put myself in every scene, which was ridiculous. Unlike *Blue Movie, Cover to Cover* was not plot-driven—and it was made on one-tenth of the budget. It was all vignettes, strung together by the not-too-original motif of a librarian who fantasizes about being a character in the books she reads. So, as the librarian, I did three boy-girl scenes, three girl-girl scenes, and one solo masturbation in a two-day shoot.

We switched locations for every fantasy, and I was constantly being put into different wigs and costumes. The challenge ultimately wasn't the

acting; it was in saving my private parts. When it came time for my first boy-girl scene, Rod, of course, cast himself as my partner. His very first thrust banged my cervix wrong. I doubled over in pain, rocking and moaning and clutching myself for fifteen minutes. It took another six hours before I was ready to have sex again. I'm still not sure why the pain was so sharp—I may have been swollen from the workout I had already been through in the previous girl-girl scenes.

Even though I had made love to Rod on camera, I still wasn't ready to do it in real life. The turning point was a film called *The Wicked One,* which required even more acting than *Blue Movie.* Throughout the shoot, Rod paid constant attention to me. He seemed to really care about how I came across on camera, and, naturally, I liked that. He had a great eye. And he even started to relax and open up a little, so he became more fun to be with.

It was one of the most perfect shoots of my career: I came in almost every scene, which is extremely rare. And I had my first three-way, with Peter North and Mark Davis. I found it unexpectedly difficult to pay attention to both guys at the same time.

I also had another three-way in the movie that came about accidentally. The scene was supposed to be just Tom Byron and Channone, a new French girl who barely spoke English. I was supposed to be bossing Tom around, telling him what to do with her. He loved it and kept looking up at me like an obedient gimp. The more he was into it, the more I got into it, until I was grabbing Channone's ass cheeks, spreading them open, and yelling at him, "Is that all you've got?"

Midway through the scene, Channone started begging me, in her cute French accent, "I want to eat your poosie." I wasn't supposed to have any sex in that scene but Rod didn't stop us.

The strangest moment, however, came in my scene with Tiffany Million. She was eating me out, and everything was great. But then suddenly, she raised her head, stuck her right boob inches away from my ding-ding, and started squeezing her breast milk into it. I was horrified. I knew she could squirt milk from her breasts on command, but I had no

idea she was going to do it with me. And I certainly wasn't prepared for what happened next: she stuck her face back between my legs and started licking her own milk up. I tried to go with it, and I probably fooled most people. But when I think back on that episode today, I still get grossed out. Ever since then, I've tried to avoid that kind of surprise by meeting with girls before a scene to discuss exactly what we want to do together.

After the shoot, Rod moved into a huge five-story house in Studio City, which he rented for four thousand dollars a month with his directing partner, Greg Steele. They planned to earn the rent by leasing the place for shoots. Soon I was spending more and more nights over there. He had pursued me for so long, set me up as such a fantasy object in his mind, that when he finally got me, he never wanted to let me go.

But, as if *Cover to Cover* had been an omen, sex with him was not right. He was the first man I'd dated with a Madonna-whore complex. Whenever we were together, he treated me like a princess. But in bed, the sex had to be dirty and he'd treat me like a slut, shouting obscenities and constantly trying to stick his finger up my asshole while fucking me, which is an acquired taste that I just never acquired. So, as the relationship progressed, it became harder and harder for him to fuck me, because he was caught in a double bind. It seemed like in order to get pleasure during sex, he had to humiliate the woman; but it was impossible for him to humiliate the woman he loved. The only advantage to our near-celibacy is that I never had the baby I still wanted so badly. Since the first time I had sex with Cliff, I'd find my thoughts drifting unavoidably to motherhood every now and then. I was never sure whether it was simply a biological urge that all girls felt, or the result of never having had a normal family of my own. But even though my body was screaming for it, I knew that I wasn't really ready—mentally, emotionally, or career-wise.

Despite the problems, I really wanted to make our relationship work. It just made sense. Thanks to our films, Rod became the first director to sign an exclusive contract with Wicked. He was on his way up in the adult film world. I was their top contract girl, and I was heading in the same direction. So, since we were collaborating together in our movies, it

just made sense to be together in real life as well. This way, I could focus entirely on my career.

I kept searching for reasons to love him. As I look back on it, I find myself going through a similar process: I'm reaching to remember the fondness and the happy times, but I keep coming up empty-handed. Everything was fine while I had my own place and independence, but soon he had to move out of his mini-mansion. It turns out his neighbors were assholes and wouldn't let him rent the place for movie shoots, so he couldn't afford it anymore. Instead, he rented a charming little house with a pool on Topanga and Ventura, and asked me to move in with him. I said yes.

I always try to analyze why I fall in love with people. And usually it is for the wrong reasons. So, even though I knew something was lacking between us, we were both enjoying riding each other's wave. When we moved in together, we made a pact that we were only going to work with each other— he as my director and me as his star. He was incredibly talented, and not just as a filmmaker. I was going to hire someone to do the drapes, and one day I returned home and discovered that he had made beautiful silk and velvet drapes himself, with wall partitions made from folded Chinese fabric. It was more beautiful than anything I could have paid for. When I had an outfit that didn't fit right, he'd sew and mend it for me.

For once, I was dating a guy who focused one hundred percent of his attention on me. I was confident that he loved me and, even better, he allowed me to be in charge. I learned an important thing about dating: The person who wants the least amount of commitment in a relationship is the one who holds the reins.

One would think that after what I'd been through with Jack, I'd be a sympathetic partner. But, instead, I became just as bad as the men I had dated. I took out all of my negative experiences on him and really fucked him up, because I had nothing to lose. By the end of our first month living together, we were fighting all the time. I would insult every aspect of his masculinity and threaten to leave, because I truly did not need him.

Whenever I said I was out of there, he would cry. And once a man cries, it's over. Show me any weakness, and I'll stomp all over you. I

clearly wasn't ready for a relationship: I was still living out unresolved conflicts from my past.

Some would say that Rod was smart with his money, but at that early point in my maturity I saw it as being cheap. He drove a beat-up white van and refused to buy a new car. I constantly told him that he was going to return home one day and discover the thing burning in the driveway.

Of course, Rod wasn't entirely innocent himself. He seemed to be taking out all his bad experiences with women on me as well. He had a passive-aggressive way of trying to keep me under control, and that was by playing off my insecurity. It's a time-honored tactic among men who feel like they are dating a woman out of their league: never be impressed and always put her down. He would walk into the room when I was putting on makeup naked and say, "You can tell the first thing that's going to go is your ass." Or he'd tell me that the only women who turned him on were Asian girls. When I replied that I was as far from Asian as a person could get, he'd say that he was attracted to me because I had Asian eyes.

Slowly I went from being this thriving, confident woman at the top of a new career to questioning everything about my body and myself. It was his way of getting revenge by making me as dependent on him as he was on me.

When he was angry, he would call me a whore. And that pissed me off more than anything, because Preacher had said that word to me when he was raping me. Hearing it since—no matter who spoke it—sent bubbles of anger boiling to the surface of my skin. I told him when he first used the word, "You can call me anything you want, but do not call me a whore. It will save you a lot of pain and suffering."

It was a big mistake to tell him that, because now he had a button he could push whenever he wanted. Of course, he still had to suffer the consequences: I'm not by nature a violent person, but I would throw books at him and pummel him with my little fists.

If I hadn't really cared about him, I wouldn't have responded to his provocations at all. So, somehow, over the course of all this madness, I must have fallen in love with him. And the more I fell in love with him,

the more he pulled away and neglected me. Instead of spending time with me when he was home, he would lock himself in his room for days and write scripts.

Eventually, our sex life dwindled to nothing—and I needed it, not just for the pleasure itself, but as reassurance of the love that we both supposedly felt for each other. It wasn't just because of his demeaning comments and his sexual neuroses: being in business with your lover will typically squeeze the last drop of energy and passion from both of you. Some say that work is the enemy of all natural erotic impulses, that it kills off your sexual desires and channels them elsewhere. And this is doubly true when your work is sex.

I started scrambling to save the relationship. On some level, I wanted to make it work because, professionally, we were a good team. The movies we made were some of my favorites. So, in a last-ditch effort to make the relationship work, we decided to get married. I thought we'd fall back in love—and I convinced myself that I was overemphasizing sex, that perhaps it wasn't really that important in a relationship. So I immersed myself in planning the wedding of the century. I even bought my own wedding ring.

In retrospect, I knew it was a mistake at the time. But I thought that the key to happiness was having a family, something I'd never really had. I always romanticized the years of my life that I couldn't remember, the picture of bliss that the Massoli family had been before my mother died and our lives went haywire. I thought that I could build it back with Rod. I liked the idea of being married and I'd dreamed of being a mother since I was a child. After all, I was twenty-two: the same age my mother was when she married my father.

The wedding was on December 21, 1996. It was a beautiful $45,000 affair at the Wilshire Ebell Theater. My dad flew in and met Rod for the first time before the ceremony. As I was downing my third glass of champagne, I suddenly had a moment of clarity.

I ran out of the room and found my dad. I still had an hour left until the ceremony.

"Dad, I can't do this," I said. "I don't want to marry this guy. This is a big mistake. What should I do?"

I braced myself for some good advice, prepared to follow through on any plan of his that would save the day. What followed instead were the worst words of wisdom I have ever received in my life.

"Just do it," he said. "It's not like you're going to be nailed to the cross. You're getting cold feet, that's all. If you don't like it, you can get out of it easily."

Mind you, I was asking for advice from a guy who had been through five marriages.

So I went ahead with it. The wedding would have been a fairy tale if Rod hadn't been waiting at the end of the aisle for me. As I stood on the altar, I kept thinking that I should pretend to pass out. I'd always been told that fainting at the altar was the best way to get out of a wedding.

The sure sign that it was more than just cold feet was that I didn't cry once. Generally, I bawl all the time, even just watching *A Wedding Story* on television. Instead, I just wanted to get the fuck out of there. I felt like such a hypocrite. If you see our wedding portrait, our faces say it all: I look horrified and he couldn't be more pleased.

The next day we were scheduled to fly to Hawaii for our honeymoon. So I booked a room for us that night at the Beverly Hills Hotel. When we checked in, we said good night and went to sleep. We didn't even have sex. And the scary thing is I didn't even want to.

Chapter THREE

W hen we woke up on our first morning as a married couple, nothing seemed to have changed. He was shuffling his feet across the floor to the bathroom, and all I could think was, "Pick up your fucking feet, loser."

Perhaps if he had leaned over and kissed me and said, "Oh my God, you're my wife," I would have felt differently. But instead, he just asked, "Do you want anything from room service?" in his meek little voice. I wanted to smack him and say, "Speak up!" Bitterness was taking hold of me.

The night we arrived in Hawaii, a major storm hit. It rained every day. And all Rod wanted to do was take photographs of me, because he could sell them and make money. I couldn't stand being cooped up in the hotel with him, so I suggested going snorkeling in the rain. But the water was so murky it was like looking into a cement mixer. Then I got scared a shark would attack me and I wouldn't see it coming, so the whole outing lasted less than half an hour.

"So should we see a movie then?" I asked when we got back.

"I can't," he said. "I really need to write this script."

When the rain let up one day, I agreed to a photo shoot. We hiked along the beach and set up in a mosquito-infested alcove. By the end, I was covered head to foot in bug bites.

It was a miserable honeymoon. I spent most of the time on the phone with Joy. When New Year's Eve rolled around, Rod and I dressed up and went downstairs to celebrate with the other hotel guests. Everyone was sixty or older. We had nobody to talk to, and God knows we had nothing

to say to each other. So we went upstairs at 10 P.M. and were both fast asleep by midnight.

By the end of the trip, I knew it was over. The only words I said to him on the way home were, "Fine. Go ahead and write another mother-fucking script. I couldn't care less. They're bad anyway."

Naturally, I only acted this way with him in private. But it was only a matter of time before it leaked into our professional life. We began to argue over every little thing on the set, which made the entire crew uncomfortable. One of us would tell the other what to do, and the other would bristle and snap back. Of course, I only had a problem when he was ordering me around, not when anyone else did.

We tried to make each other's jobs as hard as possible. He knew how to get me, because the most important thing to me was the way I looked on camera. And I knew how to get him, because it was so important to him for the production to run on time, especially because he'd cram an entire big-budget movie into six twenty-hour days. It soon became *The War of the Roses* between us.

He would berate me in front of the crew; he would compliment the other girls but ignore me; he'd pretend not to hear me when I asked him something; he'd tell me I wasn't smart enough to learn two lines of dialogue; and he'd chastise me for expecting to be treated like a star when I acted like a little kid.

In return, I would spend longer in the makeup chair than I needed to. And if he dared to poke his head into the room and ask how much longer, I'd tell the makeup artist that I needed more eyelashes or tell the hairstylist that we needed to re-wet my hair and start over.

Making movies became a miserable experience, because my dysfunctional relationship was staring at me in the face on the other side of the camera. And sometimes, on my side of the camera. He was a great director, but he wasn't a great performer. And since it takes two to make a good sex scene, I felt that he was fucking my career up. When your sex life is bad off camera, you can't expect chemistry to magically come into existence on camera.

The other problem was that he had trouble getting a hard-on. So I would do something for him I wouldn't do for any other performer: I'd clear the set and give him a blow job until he was ready, which sometimes took so long I practically had lockjaw. In the business, we call it a slinky when someone can't get hard while you're giving them a blow job.

For one film, we had arranged a three-way, with Rod, Mickey G., and myself. But Rod couldn't get his dick firm to save his life and Mickey was like a rock, so Rod had to be dropped from the scene. It wasn't anything personal: it was just about getting the film done. But it was a major ego blow to Rod. I took him aside and said that we could just scrap the scene.

"I insist that you do it," he said. "If you don't, I'm going to be mad."

"Well," I told him. "You're going to be mad either way."

I did the scene. It was the first one I had done with another man since we were married. But Rod got his revenge.

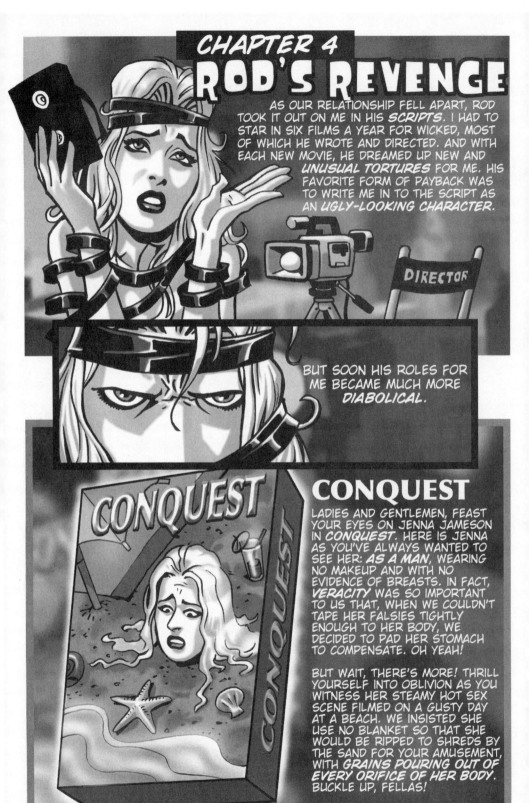

CHAPTER 4
ROD'S REVENGE

AS OUR RELATIONSHIP FELL APART, ROD TOOK IT OUT ON ME IN HIS *SCRIPTS*. I HAD TO STAR IN SIX FILMS A YEAR FOR WICKED, MOST OF WHICH HE WROTE AND DIRECTED. AND WITH EACH NEW MOVIE, HE DREAMED UP NEW AND *UNUSUAL TORTURES* FOR ME. HIS FAVORITE FORM OF PAYBACK WAS TO WRITE ME IN TO THE SCRIPT AS AN *UGLY-LOOKING CHARACTER*.

DIRECTOR

BUT SOON HIS ROLES FOR ME BECAME MUCH MORE *DIABOLICAL*.

CONQUEST

LADIES AND GENTLEMEN, FEAST YOUR EYES ON JENNA JAMESON IN *CONQUEST*. HERE IS JENNA AS YOU'VE ALWAYS WANTED TO SEE HER: *AS A MAN*, WEARING NO MAKEUP AND WITH NO EVIDENCE OF BREASTS. IN FACT, *VERACITY* WAS SO IMPORTANT TO US THAT, WHEN WE COULDN'T TAPE HER FALSIES TIGHTLY ENOUGH TO HER BODY, WE DECIDED TO PAD HER STOMACH TO COMPENSATE. OH YEAH!

BUT WAIT, THERE'S MORE! THRILL YOURSELF INTO OBLIVION AS YOU WITNESS HER STEAMY HOT SEX SCENE FILMED ON A GUSTY DAY AT A BEACH. WE INSISTED SHE USE NO BLANKET SO THAT SHE WOULD BE RIPPED TO SHREDS BY THE SAND FOR YOUR AMUSEMENT, WITH *GRAINS POURING OUT OF EVERY ORIFICE OF HER BODY*. BUCKLE UP, FELLAS!

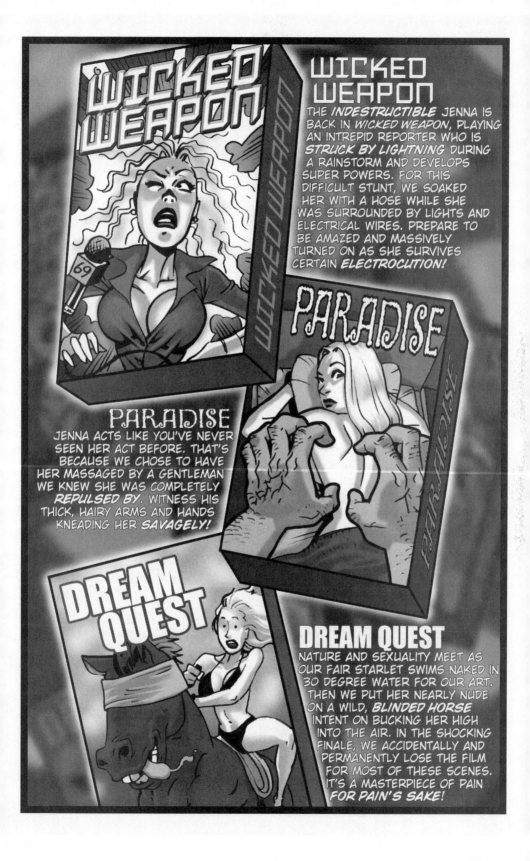

WICKED WEAPON

THE *INDESTRUCTIBLE* JENNA IS BACK IN *WICKED WEAPON*, PLAYING AN INTREPID REPORTER WHO IS *STRUCK BY LIGHTNING* DURING A RAINSTORM AND DEVELOPS SUPER POWERS. FOR THIS DIFFICULT STUNT, WE SOAKED HER WITH A HOSE WHILE SHE WAS SURROUNDED BY LIGHTS AND ELECTRICAL WIRES. PREPARE TO BE AMAZED AND MASSIVELY TURNED ON AS SHE SURVIVES CERTAIN *ELECTROCUTION!*

PARADISE

JENNA ACTS LIKE YOU'VE NEVER SEEN HER ACT BEFORE. THAT'S BECAUSE WE CHOSE TO HAVE HER MASSAGED BY A GENTLEMAN WE KNEW SHE WAS COMPLETELY *REPULSED BY.* WITNESS HIS THICK, HAIRY ARMS AND HANDS KNEADING HER *SAVAGELY!*

DREAM QUEST

NATURE AND SEXUALITY MEET AS OUR FAIR STARLET SWIMS NAKED IN 30 DEGREE WATER FOR OUR ART. THEN WE PUT HER NEARLY NUDE ON A WILD, *BLINDED HORSE* INTENT ON BUCKING HER HIGH INTO THE AIR. IN THE SHOCKING FINALE, WE ACCIDENTALLY AND PERMANENTLY LOSE THE FILM FOR MOST OF THESE SCENES. IT'S A MASTERPIECE OF PAIN *FOR PAIN'S SAKE!*

LADIES AND GENTLEMEN, THANK YOU FOR ORDERING THE JENNA JAMESON COLLECTION. OUR WRITERS ARE HARD AT WORK AS YOU READ THIS ON A NEW, IMPROVED LINE OF ACTION-PACKED ADULT FILMS.

AMONG THE TITLES:

LUST WITHOUT A PARACHITE, FEATURING OUR LUCKY YOUNG STARLET IN A SOLO MASTURBATION SCENE IN MID-AIR
MIDDLE EASTERN LOVE AFFAIR, IN WHICH WE PLACE OUR FEARLESS HEROINE NAKED IN THE GAZA STRIP WITH AN ISRAELI FLAG IN ONE HAND AND A PALESTINIAN FLAG IN THE OTHER
ATLANTIC OCEAN SEXCAPADE, IN WHICH WE COVER THE STUNNING MS. JAMESON WITH SEAL BLOOD FOR AN UNDERWATER LOVE SCENE IN TIGER SHARK BAY

NEWS UPDATE

MS. JAMESON HAS JUST BEEN CAST AS THE LEAD IN *"HELP, PA! I'VE BEEN KIDNAPPED,"* A NEW REALITY TELEVISION SHOW ABOUT WHITE SLAVE TRADERS.

BREAKING NEWS

R.I.P.
JENNA JAMESON

donations, film ideas containing unusual forms of torture, and letters of condolence can be sent to:
THE JENNA JAMESON MEMORIAL FUND
c/o The Adult Film Screenwriters Guild
1823 Wicked Way, Heavenbound, CA 90405

Chapter FIVE

I t was my first audition for a real, legitimate film. I stood outside the office with dozens of beautiful six-foot-tall blond women who could have been making much more money (and getting more parts too) in porn. Inside the office was the producer Ivan Reitman, who was auditioning actresses for the role of "the lesbian" in Howard Stern's movie *Private Parts.*

As the girls chatted and gossiped, I hunched down in a folding chair and studied the script. My eyes were dry because I was nervous. When I squinted to read a line, one of my contacts popped out. With all those blue eyes on me, I crawled around the floor for five minutes trying to find it. It was gone. I was blind.

"Jenna Jameson," beckoned a voice from the doorway.

I walked into the casting office with my now-useless script, and proceeded to stammer and sweat through the whole reading. I was too scared to look up in case I saw the expressions of mockery or pity on the faces of the panel of experts in front of me. I blew the reading so badly that my wish, when I saw a shooting star two nights later, was that the audition tape would never get out publicly. The part went to Amber Smith.

I thought that was it for my one shot at a real movie until the casting agent called me a few weeks later. She wanted me to try out for the part of Mandy, an eighteen-year-old who was the first nude girl on Howard Stern's radio show. By then they were already in the midst of filming, so they flew me to New York to meet with the director, Betty Thomas.

This time I rehearsed my lines well in advance. When I got to the airport, I looked at the ticket they had sent and it said 2A. I did a double-take, and then went to the gate agent.

"Is this first class?" I asked.

"It sure is, sweetheart."

I had never flown first class before, and it showed. When the stewardess tried to take my coat from me, I looked at her like she was trying to steal it. I didn't know how to pull the tray out of the armrest, and I didn't order any wine because I didn't realize it was free. Man, I was a hick.

A lot was riding on the audition. The producers obviously had me in mind for the part; all I had to do was not blow it. A driver came to the airport and took me straight to the set. I walked into the director's trailer and every heavyweight working on the film was there. They sat and talked to me for ten minutes, then Howard entered the trailer. He was going to be my scene partner. I felt like I was going to throw up on the spot.

I sucked it up and did my dialogue. Fortunately, the great rapport we had on the radio wasn't just an illusion: we still had it in this artificial situation. After the reading, Howard and Ivan looked at me. Ivan said it first: "You've got the part."

I reacted like a little girl. I screamed and jumped up and down in front of everyone. I flew home and, one week later, they flew me back for the scene. This time, first class was old hat and I had no qualms about ordering four glasses of wine at a time.

I had never seen a set like Howard's before. It was ten times as nice as any adult movie I had done. They even had a stand-in for me, which seemed so decadent because I was used to doing it myself all the time. And instead of shooting an entire movie in a day, we'd spend a day on just one scene. I wasn't accustomed to doing two dozen takes of a single line. It seemed incredibly inefficient.

Everybody was much more uptight on set than they were in adult movies. When I walked around the set buck naked (because it was a nude scene), the production assistants kept trying to wrap me in a robe.

It made them uncomfortable to see me walking au naturel to the Kraft services table. But I was so unaffected and inhibition-free that it didn't matter to me. When I removed a new belly button piercing and replaced it with clear fishing line so that it wouldn't show on camera, the crew was completely grossed out. I was in makeup for five hours each day while they airbrushed over my tattoo, and in order to even out my skin tone, they had to do the rest of my body.

Howard, of course, loved it all. We shot for four days. On the third, one of Howard's bodyguards said that the man himself wanted to see me in his trailer. As I walked over, it dawned on me that this could turn into an uncomfortable scenario. I didn't know exactly what he wanted. But when you're a woman on set and the male lead wants to see you alone in his trailer, it generally means only one thing.

When I arrived, Howard was sitting alone watching videos. I joined him on the couch. The tension in the room was not sexual but awkward. We sat on the couch watching TV for what seemed like an eternity. He was waiting for me to make a move. I was waiting for him to make a move. And I had no idea how I would have responded if he did. On one hand, I liked him and wanted to have sex with him. On the other hand, however I responded to an advance, I would have been the loser. If I rejected him, he might hold it against me. If I accepted, then maybe he'd get uncomfortable afterward and things would become weird between us.

With every minute of small talk that passed, we grew more and more uncomfortable until I finally said, "You know, I should probably go back to my trailer and study my lines."

It was our defining moment. If we were ever going to get physical with each other, that was our chance—and we let it slip by. The window had closed. The next day, he pulled me aside and said, "Jenna, I really believe in you."

I could tell he was serious, because he didn't want anything from me. "I really think that you are a good girl and a good person, and I'm going to do anything in my power to help you get to where you need to be because you deserve it."

I never had anybody say that to me when they had nothing to gain. We became great friends over the course of the shoot, and I gained immense respect for him. However, to this day, I still wonder what would have happened if we'd had the guts to tear each other's clothes off.

As soon as the movie wrapped, Howard booked me on the show. The first thing out of his mouth was, "Why didn't you make a move?"

"Why didn't *you* make a move?" I responded. "After all, you are the man."

It doesn't matter anyway, because everyone still thinks I had sex with Howard, probably because he hasn't been close to that many girls on his show.

When it came time for the premiere, Joy and I were in New York. I didn't want to have the night ruined by fighting with Rod the whole time, so I took Joy as my date and told Rod they had only given me one ticket.

I had no idea *Private Parts* was such a big movie. It made the velvet rope experience at Cannes seem like child's play. There were stars everywhere, the paparazzi knew who I was instantly, and every news channel was shoving a microphone in my face. It was overwhelming, and by then I was starting to get used to being overwhelmed.

After the red carpet, we went to a cocktail reception before the movie. Joy and I didn't know anyone, so we just stood there stupidly. I looked into the tangle of celebs and VIPs and saw, towering over all of them, Marilyn Manson. I wanted to meet him, especially since I used to strip to his music. Before the thought left my mind, he was standing in front of me.

"Oh my God, hi," I squeaked.

He just stood there, staring right through me. It was a little creepy.

Then he grabbed my hand and started walking around the party with me. Nearly every rock star on the soundtrack was there: Perry Farrell, Billy Corgan, Flea, Angus Young, Sting, Jon Bon Jovi, LL Cool J, Rob Zombie, Joey Ramone—basically, everyone I idolized. I was a little porn girl thrust into this world of rock superstardom. I was in heaven.

The first thing Manson asked me was how I draw my eyebrows on. He kept pumping me for makeup tips. After dragging me around the room for half an hour, he asked, "Do you want to be my date?"

I agreed. I followed him to his seat. Corey Feldman was a few rows in front of us, and for some reason Manson was obsessed with Corey Feldman. He kept throwing popcorn at the back of his head all night and reciting lines from *Dream a Little Dream*.

Then he saw Amber Smith, who is a gorgeous girl, but that night she looked like a drag queen, so he started throwing things at her too. Everyone was a target to him. In that way, he reminded me of my brother.

When he grew bored of pelting Sherman Hemsley with foodstuffs, he put my hand in his. For the rest of the movie, he just held my hand like we were teenagers on a first date. Every now and then I'd look over and see this tall character with long stringy hair, black lipstick, pancake makeup, and mismatched eyes, and think of how surreal the moment was.

Throughout the movie, he kept making very witty comments. I couldn't believe how intelligent and thoughtful he was. When I came on screen, he cheered for me. As I became more comfortable, I put my hand on his leg. I didn't consciously mean anything sexual by it, but as soon as I touched him, he got shy and uncomfortable. It was very cute, or at least as cute as a self-proclaimed Antichrist can get.

Afterward, he invited me out with him and his band. I was in a better limo, because I had insisted on a Mercedes, so Manson, his bassist Twiggy Ramirez (who didn't say a word all night), and Billy Corgan from the Smashing Pumpkins all piled into my limo. "Watch this," Manson said. He poured a handful of different colored pills into his hand, and then popped them into his mouth and laughed, like it was all one big joke. If I had done that many painkillers and muscle relaxants, I'd be dead in half an hour.

When everyone else became incapacitated—Twiggy's eyes were rolling into the back of his head and Billy was drooling on his shirt—Manson took the opportunity to kiss me. I had a good buzz and thought, "Bring it on." So Manson and I made out while Joy snapped photos.

When we got out of the limo and arrived at the party, everyone was looking at me funny. I thought it was because of the company I was keeping, but when I passed by a mirror I realized that I had his black lipstick all over my face. I looked like I'd been eating mud.

Manson didn't leave my side all night. Even when he went to the bathroom (which was often because of all the cocaine he was doing), he'd ask me to wait for him outside the door. He didn't want to let me out of his sight. We finally found a couch, and Manson threw his coat over my lap and slipped his hands under my yellow Versace dress. All I could think was, "How can this guy remain so focused after taking so many drugs?"

We were a bizarre couple: I looked like a cartoonish exaggeration of the all-American California blonde and he was an exaggeration of the anti-American bogeyman. I was so different than most of the girls he'd been with, he said, so all night long he introduced me as his beach bunny. Yet, though we couldn't have been any more different, between us, we represented everything that religious fundamentalists and right-wing conservatives want to stamp out in American culture.

After fifteen minutes, we left to go to another party. When we got out of the limo, paparazzi were everywhere, blinding us with their flashbulbs. The first person we saw when we made it through the gauntlet was Prince. Somehow Manson knew him, and he introduced us. Prince said "hi" and reached to shake my hand. I'd never been so tongue-tied in the presence of anyone else before. He was hot, and beautiful like a girl. Five steps later we bumped into Lenny Kravitz. Then we met Sheryl Crow and the girls from TLC and Quincy Jones, who squeezed my hand so hard I thought he was going to break it. It was all too much.

Up until then, I had lived in the sheltered world of the sex industry. And I had come to believe that I was a star, especially after Cannes. But when I met all these people, I realized I was nothing. I was just a niche icon, not a real celebrity. I had sex on screen; I did some perfunctory acting. These people moved and inspired millions of people with their music. All I did was contribute to Kleenex sales. There must be something more I could make of myself.

When we got back to the hotel, Joy returned to our room and I suddenly found myself alone with Manson. That's when it dawned on me: we were going to have sex. And I was cool with it: I was on such a high, and I liked him a lot.

"Let's take a bath," he said in a voice numb, deep, and slow from painkillers, when we walked into his room. He didn't give me time to respond. He just drew the bath, took off his clothes, and got in. It was strange to see him naked. He was tall, girlish, childlike, massively endowed, and covered in scars in various stages of healing.

I had a preconceived notion that the sex would be crazy, but he was so tender and loving. He washed me from head to toe, working on my feet for a good five minutes. My tan lines seemed like such a novelty for him. Then he went down on me for nearly an hour. It took me that much time alone to even assimilate the image of the naked God of Fuck eating me out, his white butt in the air.

Without drying off, we moved to the bed. He started sucking on the soft underside of my arm, which I'd never had anyone do before. It was a turn-on at first, but he didn't stop and it got to be vampirish. That was the only thing he did that seemed the slightest bit kinky.

He asked me to get on top, so I lowered myself onto him. We had slow, searing sex. But every time I came close to orgasm, he'd pull me off to keep from coming himself. I would have told him, "Do me a favor, and start thinking about baseball so I can come," but he hated sports. Finally, I couldn't take it anymore. When he tried to push me off for the tenth time, I slammed my body down against his and rubbed my clit back and forth along his pelvic bone until we both came together. I collapsed onto him and then, when I got my breath back, got out of bed and began dressing to leave.

"Where are you going?" he asked.

"To my room," I said.

"You can stay here and sleep with me if you want."

"No, I really should be going. I have a lot of stuff to do tomorrow."

"Why don't you just stay and cuddle?" he asked.

"Did you just say the c-word?!"

I don't cuddle, but I lay with him for a little while longer and listened to him talk about religion. Then I made my escape. Rod was still waiting in my room for me.

Afterward, Manson started calling me—every day. When I wasn't there, he would leave me half-humorous, half-insane messages about wanting to set me on fire or feed me to Corey Feldman.

Since my marriage to Rod was loveless and sexless, I started seeing Manson on and off. But the more I got to know him, the weirder he became. He would talk about wanting to see girls fuck prosthetic limbs or sucking Twiggy's dick, and I'd never be able to tell to what degree he was joking and to what degree he was serious. And he wanted to fuck me in the ass a little too often for my comfort. Every time we were naked, he'd be going for my butt like a rat to cheese.

I still like him to this day, but I couldn't envision him as a boyfriend. It wasn't that I was falling in or out of love with him. It was just that I was still married, and the whole strange affair was beginning to seem like a bad idea.

Of course, I was very discreet about the fling. However, as soon as the paparazzi photos of us hit the press, Howard Stern was on the phone asking about it. I denied the whole thing on the air and told him we were just friends. But the next day Manson was on his show, blabbing about the entire thing. I never pegged him as the type to kiss and tell.

—

Just when I thought life couldn't get any more insane, a producer at the E! Channel called. She said that she wanted to fly me to Bangkok and Singapore to host two episodes of *Wild On . . .*

"We also want you to do the openings of Planet Hollywood in each city," she said.

"What do you mean exactly by 'do'?" I asked.

"Just interview the stars as they walk in on the red carpet," she replied.

"No problem," I told her with my usual lie. Actually, there was a problem: I didn't know how to interview anyone.

The night of the Bangkok Planet Hollywood opening, I swooped my hair up, so that I looked like a reporter. At the time, most people didn't know who I was—if they had known they were being interviewed by a porn star, half of them probably wouldn't have done the interview. The first celebrity to arrive was Jackie Chan. As soon as he saw the big white E!, he ran over, picked me up, and kissed me. Then Bruce Willis, Arnold Schwarzenegger, and Sylvester Stallone all arrived at the same time. I was sandwiched between the three biggest action stars of the moment, and awestruck. I had to get them to say something to E! It needed to be a good question: something smart, perceptive, and classy.

"Do you eat here?" I asked.

Interviewing Bruce Willis for E! at the opening of Planet Hollywood.

I wanted to shoot myself.

To my surprise, all three answered. I noticed that I was the only reporter they were talking to. Now was my chance to come up with a question that could elicit a headline-making response. This was going to be a test of my split-second thinking.

"What's your favorite dish?"

I wanted to stab myself.

Still, they answered and stayed for more, perhaps precisely because I was asking such soft-ball questions instead of asking them about their personal lives.

Much more impressive than the big guys was Cindy Crawford. Just watching her walk up the stairs was inspiring, and she was so nice to me when I interviewed her.

Once the lights and cameras switched off, the party began. I sat down with my new best friend Cindy Crawford and we talked. However, I kept getting a weird vibe from her. I knew what it meant, because I'd experienced it so many times before, but I kept dismissing it. It couldn't be true: she was Cindy Crawford, after all. When I turned my back to her to talk with an E! crew member sitting on my left, Cindy reached over and rubbed the back of my neck.

"Ooh," she cooed. "Look at your beautiful tattoo!"

She touched my neck so softly and sensually. Was she making a pass at me? I froze. It was too much. She was so larger than life that I couldn't even imagine running my tongue along that trademark mole of hers. So I excused myself to get a drink.

I walked past a table full of beautiful girls, with Wesley Snipes sitting smack in the middle of them all. He waved me over.

"So you're the reporter from the E! Channel." He smiled. "Why don't you join us?"

Hesitantly, I sat down next to him, and all the other girls at the table shot me dagger looks. He was trying to get in their pants; they were trying to get in his pants; and I was confused. "So," he leaned over and whispered in my ear, "do you like it up the ass?"

Being a porn star, I was used to such questions. But Wesley had no idea I was a porn star. Either way, I was offended. I looked at him blankly, stood up, and walked away. That was the first and last time I ever saw him.

I never made it to the bar. Bruce Willis walked in front of me. He looked fine. Instantly, I felt my chest flush and tingle. Even though he was wearing a creepy pair of shorts, I was still attracted. He didn't say a word. He pushed me up against the wall and kissed me. After thirty seconds of passionate tonguing, he just walked away without a word.

I was overwhelmed. I felt like I was in the middle of a cartoon. This couldn't be real. Every single celebrity there, it seemed (with the exception of Sylvester Stallone, who was a perfect gentleman), was chasing me. After a few more drinks, I asked the E! camera crew if they were ready to leave. As we hit the fresh air, a bodyguard walked up to me and said, "Mr. Willis is waiting for you in his limousine."

"He's going to be waiting a long time," I responded. There's a fine line between confidence and arrogance, and he had crossed it. So I left, my head spinning. And E! was so happy with my work that they said they'd send me a contract to work for them regularly.

It had been a solid month of fantasy, and fantasy is a wonderful thing. It's how I make a living. But it was time to return to reality—Los Angeles and Rod. I was still a married woman.

Opposite: With Kid Rock.

Chapter
SIX

Every bond that held Rod and me together—except for that proclaimed by church, state, and Wicked contract—had crumbled to dust. The final blow came when we concluded that I needed to work with other directors and performers in order to maintain the momentum of my career. So I decided to return to the glory days of *Blue Movie* by collaborating with Michael Zen, and Rod decided to pick Asian girls instead of me for his sex scenes.

Unfortunately, filming didn't get any easier. The Michael Zen movie was called *Satyr,* and it was such a miserable experience that I don't even remember what it was about. All I can recall is that I was supposed to turn into a unicorn in it, so they made my legs really furry and gave me a horn that looked like a zit. Rod was my co-star and, interestingly enough, he had no trouble getting hard for Asia Carrera in the movie but couldn't get an ounce of wood for me the next day to save his life.

By 2 A.M. on day three, I was exhausted. I had been in every scene, and still had two sex scenes left to film, which meant at least five hours of work to go. Michael was fighting with the production manager, J.B., and the crew about the lighting setup and I interrupted and asked if they could hurry it up because we were all getting too exhausted to give our best performances.

I'm sure I delivered the comment a lot bitchier than I remember it. Either way, the lighting director took it personally, and complained to J.B. When they were finally ready to shoot, J.B. came into the makeup room and ordered: "Get your whore ass on set and do what you do best."

He had just used the wrong word. I ran after him in a Tasmanian Devil frenzy. The crew had to pull us apart. It was late and my nerves were frayed, but nonetheless J.B. was out of line. And I was right: they were wasting time arguing about the lighting. When he left, I collapsed in my makeup chair and started crying.

Lee, my makeup artist, shut the door and tried to soothe me. Just then, Rod came bursting into the room. "You stupid fucking whore," he yelled. "You are going to ruin this whole production. You can't treat people like dogs after how hard they've worked. Who do you think you are?"

"How hard *they* worked, you selfish bastard? I've worked just as hard. And I'm the one who has to be on camera and look beautiful at four in the morning."

We yelled at each other for ten minutes, making Lee so uncomfortable he cleared the room. Finally, I packed my shit and left the set.

As soon as I arrived home, the phone was ringing, as I knew it would be. "Everything's okay now," Rod whimpered. "We're sorry. We fired J.B."

So I returned to the set and everyone was obsequiously nice to me, kissing my ass and making sure I was happy. In many ways, it was just as uncomfortable as having people yell at me. But I learned who was in control and who had the real power. If anyone else had walked off the set, even Rod, they'd have been fired and taken off the project. The movie needed me.

Even at my worst, however, I never pulled rank for no reason. There are times when I wish the industry had a union, because the shooting schedules are inhumane. It generally takes a good three weeks to shoot even the crappiest independent film; we do it in one to six days.

So many factors contributed to my attitude at the time. Mostly, I wasn't going to let anything get in the way of my fame. I also wasn't going to allow anyone to treat me disrespectfully because of what I did. But a lot of it was my relationship.

My marriage showed no signs of improvement. In bed, I would move my foot over to touch his, and he would move his leg away. I needed so badly for him to do something to show that he loved me, something to

counteract the constant drama on the set, but instead, he'd shut himself in his room for days and say that he had scripts to write. I had been much better off living alone: I didn't realize that it's a lot worse to be lonely in the company of someone you supposedly love than it is to be lonely by yourself.

After we wrapped shooting on *Satyr,* I couldn't take it anymore. The exact words I used were: "If you aren't going to fuck me, I'm going to find someone who will."

"Go ahead," he said.

There was no love, or even consideration or good will, left between us anymore. So I packed my shit and left without another word. The minute I left, I knew I was doing the right thing.

I piled everything in the car and drove off. I didn't know where I was going. But somehow, I found myself at the door of a place I recognized: the Vagabond Inn.

It was all still there: the bug stains on the sheets, the light-phobic roaches, the asshole at the front desk demanding a credit card. But I was different. The little girl, wide-eyed, innocent, and fearful, was gone. I was a star now, supposedly; a married woman, on paper at least; and a confident adult in control of her own destiny, at least in other people's perception. But in truth I had traveled so far and gone nowhere: I was still alone, looking for someone to help me make my way through the wilderness of the world. Every clearing I thought I had found turned out to be just a chimera.

I threw my bags in the corner of the room and lay on top of the bed in my clothes. I turned my mind off and stared at the ceiling, waiting for an epiphany. It never came.

Chapter SEVEN

For as long as I can remember, I've had the same nightmare. I am being chased through a large dilapidated house. There is someone directly behind me, but I can't see him. I hide in the closet. I'm terrified. My heart is heaving in my chest. I know he's right outside. I try to hold my breath so he can't hear me. But I can't stop gasping. It's deafening. I know if he hears me, he's going to open the door and get me. But there's nothing I can do to quiet my fear. He's coming closer. He can hear me now. It's over. I'm going to die.

And then I wake up. To this day, I've never seen that person. Knowing that someone who wants to hurt me is so close by and that I am giving myself away is the worst feeling in the world.

I also dream of tsunamis. I'm sitting on the beach and I see the wave coming toward me. It towers thousands of feet into the sky. There is no escape. It crashes over me, and I'm overwhelmed. I can feel the water rushing into my lungs. I wake up choking every time. In other nightmares, I'll be fighting someone, but I'll be moving like I'm underwater and unable to deliver a connecting blow. I am perpetually getting the shit kicked out of me in my sleep. I also often dream about my dad dying.

What connects all these dreams is that I'm always alone, scared, and powerless in them. For as long as I can remember, this has been my nocturnal landscape. A lot of the decisions I've made in my waking life have been attempts to escape it: Is fame going to help me sleep? Is getting married going to stop the nightmares? But nothing worked. Every suppos-

edly safe choice I made just ended up scaring me more. And the more wrong turns I made, the more I woke up crying. My dad couldn't console me; Jack couldn't console me; Nikki couldn't console me; Rod couldn't console me. No one could.

Of course, I should have been consoling myself. And leaving Rod was the first time I had the balls to take a step on my own—without running back to Daddy. I was sick of the fucking vampires in L.A. The only people I trusted were Steve and Joy. And I was in their bad books for flaking on appointments, arguing with Rod, and blowing up on set. The budgets of the movies we were making had grown from $20,000 to $200,000, and the pressure mounted accordingly. I needed a way out—from L.A., from Rod, and from the movies.

So when I woke up at the Vagabond Inn that morning, I decided to take some time off. I phoned an agency called the Lee Network and arranged a dance gig at a Florida club called Miami Gold. It's funny that booking a dance engagement was my idea of taking time off.

The next day I drove to LAX, flew to Miami, and checked into the Fontainebleau hotel in South Beach. I felt free, like the old Jenna again. Rod didn't cross my mind once. After all I had been through in past relationships, I had taught myself to turn off every emotion I had for a person—be it love or hate—if I needed to protect myself.

In the daytime, I lay out at the pool in my G-string, worked on my tan, and watched older men gaping at me over the shoulders of their complaining wives. I didn't know a single person in the whole city, and I didn't care. I'd start conversations with anyone and end them when I was bored. It was a great big world out there, and I still had so much to learn and experience.

In the evenings, I danced at Miami Gold, raking in thousands upon thousands of dollars. It was easy, mindless work—just splay and smile. Between shows, I'd kill time by finding a friendly group to sit with and order drinks on their tab. One night I ended up at a table with three guys named Wonky, Juan, and Jordan. Juan and Wonky were like a professional comedy act, and made jokes nonstop, but Jordan didn't say a

word. He just sat brooding in his chair, paying no attention to me whatsoever. He was Colombian, with dark smoldering eyes, full sensuous lips, and a football player's body. I always had a thing for Latin men, ever since my first horrible kiss with Cesar, so I tried to talk to Jordan as his friends ordered another round of shots. He didn't seem interested. I didn't know it at the time, but his reticence was due not to a lack of interest but to a lack of experience.

However, in my ignorance, I figured that I had to try a little harder to seduce him. I stood up, took him by the hand, and guided him out of his seat. His hand was warm and strong in mine. Just feeling the heat made my heart flutter. It had been so long since I had been attracted to another man at such a gut level.

I led him to my dressing room backstage. There was one folding chair in the otherwise bare, mirrored room. I gestured to the seat and he sat down, bewildered. Then I sat on the floor, spread my legs, and dug the heels of my shoes into the ground. With one finger, I pulled aside my G-string. Then I lowered my head to the floor behind me and arched my back, thrusting my chest into the air. I put my right middle finger in my mouth and slowly pulled it out wet. Then I brought my hand down between my legs, parted my lips with my index and ring fingers, and rubbed my middle finger along the opening until it grew slick with my juices.

Jordan stiffened in his chair. His body looked like it wanted to run out of the room in panic, but his eyes weren't going anywhere. He'd clearly never seen anything like this before. And the more horrified he became, the more I wanted to give him a show.

I brought my middle finger up to my clit and worked it in gentle, quickening circles. As each wave of pleasure rolled through my body, I arched my back further and rocked my pelvis forward. I exaggerated each move for his benefit, shutting my eyes, licking my lips, and moaning softly. I wanted to get him so hot he'd come in his pants. With my left hand, I pulled my bra down and my left breast burst to freedom. I rubbed the nipple in circles of shrinking circumference until it was so hard that every pore on my areola stood at full mast. I thrust my right finger deep inside me and

then pulled it out glistening. I brought it to my mouth, licked it clean with the tip of my tongue, and then placed it on my clit. Beads of sweat were forming on Jordan's forehead. With both hands in rhythm now, I forgot about Jordan and concentrated on my own pleasure.

The first contraction set my legs a-tingle. The second contraction sent a euphoric rush up into my stomach. The third contraction loosened a flock of butterflies in my chest. And the fourth contraction burst my whole being into flames. I let out a moan that felt like it shook the whole club and my whole body stiffened, then collapsed. It was impossible even to think about looking sexy anymore. My body was out of my control. My right hand remained on my clit, rubbing and rubbing, as I shook and spasmed under the influence of an orgasm that lasted as long as the childhood ones I used to have from my neighbor's Jacuzzi jets.

Afterward, I stood up, brushed myself off, and led Jordan out of the room. I didn't say a word—and he didn't know what to say.

I returned to the stage, danced with more raw sexual energy than ever before, and, at the end of the night, slipped my number to Juan and asked him to give it to Jordan. I'd never hit on a fan so blatantly before. But, then again, I'd never felt so free before. I'd never had the chance to truly enjoy my sexuality, because I was dating Jack the whole time it was blossoming.

The next day, Juan and Jordan called. I invited them to come over. Instead, Jordan arrived alone. Good move on his part.

We relaxed by the pool and ordered daiquiris. I was instantly drawn to him. He was so different than any guy I had met before. And that's probably because I'd been in a world of strip-club owners, porn directors, and suitcase pimps for most of my adult life. He wasn't loud or obnoxious; he didn't feel a need to brag or prove himself; and he was unaware of how good-looking he was. He had no game. And because of that, I felt comfortable, like I could let down my guard and be myself without worrying that he wanted anything from me.

We just talked for hours and got along very well. We came from different worlds. He knew nothing about what my life was like. He still lived with his parents and led such a simple, happy, worry-free existence. I felt like I

was reconnecting myself to the real world through him. With Rod, everything was work. My entire life was porn. I needed escape and balance.

After dinner that night, I brought him back to my room. It was a beautiful night. I pushed open the window, and the moonlight lay across the ocean like the trail of a paintbrush. The room was beautiful, spacious, and glowing. Everything seemed perfect. But there was one problem: Jordan couldn't get a hard-on. I still scared the fuck out of him. We lay

together naked and discussed it. It turned out that he had only slept with three other girls in his entire life. I found it so endearing. And now I knew why he was so freaked out when I masturbated on the floor in front of him.

I told him not to worry, and I decided it was best not even to try to get him hard and make him feel more ashamed. To compensate, he went down on me for two straight hours. I was really starting to like this guy. Afterward, I turned over and went to sleep.

I awoke in the middle of the night to see him looming over me, with a big smile on his face. His black hair was plastered to his forehead with sweat, and his hard dick was deep inside me. He was fucking me. I couldn't figure out whether he had spent hours trying to get himself hard or had just woken up with premature morning wood.

The second I started to respond, however, he came. The poor guy only lasted a couple minutes.

At the end of the week, when my gig was up at the club, I decided to stay with him in Miami for another two weeks. There was nothing for me back in L.A. Jordan offered the solace I needed: he was normal; he made me feel comfortable; he gave me my space. He was the exact antithesis of the life that I was so irritated with.

I called Joy and told her, "I'm coming back to L.A. and I'm packing my shit and moving to Florida."

"You are insane," she said. "What are you doing?"

"I'm going to follow my heart and move to Florida."

"What about your contract? You still have two movies left. Are you just going to leave us?"

"No, I'm staying with you," I said. "I just want to cut back my schedule a little and take time for myself. So I'll just fly in for the movies."

"Well, baby, you gotta do what you gotta do. Take care and relax." I could hear the disappointment in Joy's voice. She had helped build me, and now she was losing me. Even though she knew I was making a bad decision, she didn't utter a word of criticism because, ultimately, she cared more about my sanity than my contract.

Away from L.A., life seemed much more simple. I realized that my whole adult life, I had been in control: I had the power to make my life easy or difficult. I had just been giving that power away to other people. Taking it back was just as easy—and as hard—as stepping back and making a decisive change.

My stay in L.A. only lasted for a day. I went to my house, packed the rest of my belongings, and shipped them to Miami. Waiting in the mailbox for me was the contract from E! But I never even had a chance to sign the thing. The E! Channel was bought by Comcast, which didn't want a porn star on its payroll, so the offer was rescinded.

With weeks on his own to think about our short-lived marriage, Rod realized that he had blown it. He had taken me for granted and lost me. He followed me around the house, telling me how much he loved me and begging me to stay. His eyes reddened, his voice squeaked. It actually seemed like he might act like a man for once and punch the wall. But it was all too late.

In my head, I prepared a response: "You have only yourself to blame. I gave you your chance. I would cry myself to sleep at night begging you to just fucking hug me, and you would tell me to go fuck myself. You see where it got you? I fucking hate you."

But I didn't say a word. I didn't press a single one of his buttons, even though they all lay exposed in front of me. Like most men, he didn't realize what he had until it was gone. So much of his yelling, his lack of affection, and his self-imposed workaholism had come from the simple fact that he was insecure. He didn't feel that he deserved me. And now, it had become a self-fulfilling prophecy. He was getting what he deserved: I was leaving.

Chapter EIGHT

What got me was when Jordan told me at dinner one night, "I love you for who you are. You could be stripped of everything—your fame, your money, your beauty—and I'd still love you, because I'm attracted to what's inside."

That was something I had never heard before, and I knew he meant it, if only because he was so inexperienced with women. A month later, he came home with a huge tattoo of my name stretching from one shoulder blade to the other. It covered half his back. As a show of faith in return, I had the words "Jordan's Crazy Girl" tattooed on my ankle.

Jordan lived with his parents. They were great people, but their home was a sty. It was weird having sex in the room next to them. His mom was a subservient housewife; his father ran a corner grocery store. Jordan told them that I was a Hawaiian Tropics girl, which wasn't a hard lie to maintain since they only spoke Spanish. Because they were the only people I knew in Florida, I got close to them fast. When they took me to their family functions, I stood out like a lightbulb. No one except Jordan's immediate family accepted me.

I eventually grew so tired of commuting back and forth between the Fontainebleau and his parents' place that I decided to build a house. I found a nice lot, pulled my finances together, and started construction.

Opposite: In front of my house in Miami in 1997.

It wasn't that I was settling down. I was escaping. While I waited for the house to be built, I booked a three-week feature dancing tour.

When I started making movies for Wicked, Joy wanted me on dance tours right away. However, not only did I not want to go back to stripping, but I also knew that the longer I waited, the higher my rate would be. By now, I had become one of the most in-demand girls on the circuit, largely because I had reached top status in the porn world and never appeared in clubs. The money was ridiculous. I was paid three thousand dollars per show, and performed four shows per night. And each time onstage, I'd make an additional three hundred dollars to one thousand dollars in tips. Then I'd make thousands more selling merchandise and posing for Polaroids after each show. Many strippers get into porn solely because they want to up their rates. Plus, dancing is a lot easier than being on set, a great way to build up your fan base and mailing list, and a convenient escape from problems at home.

Every girl in the industry had told me that to give the clubs—and the guys—their money's worth, a feature dancer has to put on a big, themed show with candle wax, lotion, and as many outfits and props as possible. So I rehearsed a huge extravaganza. I planned to walk onstage to the theme music from *Terminator,* wearing a custom-built metal outfit with a built-in headset and a massive prop gun. Then I had a little *Alice in Wonderland* costume with a baby bottle, and I had a showgirl outfit with feathers which reminded me of Vegas but didn't work very well onstage because the headdress was still fifteen pounds. I could barely get through the door to the stage without feathers flying everywhere; it looked like someone had slaughtered a chicken onstage. You name the fetish, I had the gear—six trunks worth of it.

Jordan helped me lug the stuff to the airport and I flew to Columbus, Ohio. When I arrived, I discovered I'd been booked into a bikini bar. This meant I couldn't get nude, so I wouldn't make as much money. They hadn't promoted the show well either. When I walked out in my Feminator outfit, I felt foolish. Maybe I'd overdone it: It wasn't like the pageants. These guys didn't care about seeing a show. They just wanted

to see some skin. So much for my delusion of actually being respected in the world at large.

On my second night there, the club owner brought a friend of his in to dance. Her name was Teri Weigel and she was famous largely because she was the only *Playboy* Playmate ever to do adult movies. And that was fine and dandy, but here she was doing a guest show during my week.

She had been feature dancing for years and had thousands of dollars in lights, her own PA system, and a jungle-gym of stage props to pose and dance on. It was a great show, I'll admit.

Afterward, while I was performing my rinky-dink Feminator number, she had the nerve to pose for Polaroids. I watched helplessly from the stage as my customers handed her fistfuls of bills. The whole point of waiting so long to tour was to sell out and rake in the cash.

I walked over to her afterward and the first words out of her mouth were, "Who in the hell are you?"

That's when it got ugly.

"I'm the girl whose show this is," I said. "What the fuck are you doing here?"

"Making money," she said. "Same as you. If you can't compete . . ."

"Compete?" I blew what was left of my cool. "Whose name is that on the marquee? Mine. What could have possibly gone through your mind to make you do something like this? Put the shoe on the other foot: How would you feel if you were brand-new on the dance circuit and some legendary dancer chick came in and took your fucking money?"

She began to stammer something that sounded like an apology. I looked at her body and complexion; she seemed to have fallen on hard times. But I wasn't going to pay for her mistakes.

"Pack your fucking shit," I told her, "and get the fuck out of my club."

And so Teri and her loser suitcase pimp left. Next I had it out with the club owner, and finally my agent.

"If this ever happens again," I screamed at him over the phone, "I will personally come down there and cut your fucking throat."

Looking back on it now, I still would have chewed them out, because I was right. This was solely about business. And what the club owner had done was straight-up bad business. I was on the road alone, with no one to stick up for me. And if I was going to stand up there all night bending over for alcoholics, no one was going to take my money.

I flashed back to the first time I stood up to Suze Randall and squeaked something about not wanting to put oil on my ding-ding. I was a different person now: fearless and terrifying. I wasn't sure if that was necessarily a good thing.

I also learned to keep a close eye on my G-strings and bras, because every time I removed one, it disappeared from the stage. I still wonder what guys do with them, and how stinky and crusty they get when they remain unwashed in their rooms for so long.

The other thing I learned that week was that guys don't give a shit about thousand-dollar light shows and Feminator outfits. The best way to make money is not with a Broadway-caliber show, but by being enticing and engaging onstage—by making them want to splooge in their pants. And so, by the time I arrived at my second engagement, Al's Diamond Cabaret in Reading, Pennsylvania, I had shed all pretensions of performance art. I was back in stripper mode.

I had been told that Al's was a high-yielding club. But even though it allowed fully nude dancing, I was disappointed when I saw it. It was a total dump (though it's since been remodeled). Of more concern, it was poorly designed. I was supposed to dance in a pit surrounded by a runway for other dancers and, far on the outside, a railing. Since the guys were along the railing and I was stuck in the center, there was no way they could hand me—or even throw me—money. So I kissed my tips good-bye. On top of that, Al took a five-dollar cut from each Polaroid in exchange for providing the camera and film (even though I had my own).

In most of the other clubs I'd been to, thirty to a hundred girls worked on a peak night, but at Al's there were only six other dancers. And there was no lap-dancing allowed; only stagework. Even stranger, all

49 KODAK E100G

the guys hanging out had their own coolers. It was strictly a B.Y.O.B. situation. I was definitely in the boondocks, and I had bad associations with the boondocks.

My dressing room was a tiny cubicle covered with graffiti from the other girls who had been there. I spent half an hour just reading catfights that stretched on for years. When I sprinted onto the stage, the guys began screaming and whistling like they were at a Molly Hatchet concert. It was the first time I felt the frenzy of an audience.

I walked offstage with three crumpled dollar bills that had been tossed hard enough to reach the inner sanctum. But the consolation came when I went to do Polaroids: two hundred guys were waiting in line, at twenty dollars a shot.

There was a wall outside my dressing room, and I could just make out the stage over it. While waiting for my next show, I looked into the club and saw a gorgeous creature in the midst of a slow, sexy dance. When she licked her upper lip with her tongue, demurely but not lasciviously, I knew she was one of the special girls—she had sparkle. When she came off the stage, I approached her. "You are a really sexy girl," I told her.

As I spoke those words, I remembered having said almost the same thing to Jennifer at the Crazy Horse. It wasn't my pickup line or anything. I was simply being honest. (But if the compliment happened to have the side effect of picking a beautiful woman up, so be it.)

"Thanks," she said, blushing. "I saw you watching me, so I tried extra hard. My name's Melissa."

After my show, she knocked on my dressing-room door.

"Jenna," she began, "do you think maybe you can give me some pointers when it comes to makeup?"

She laughed nervously.

I looked at her. She was a big-boned girl with a round face and a jaw that reminded me of the state of Texas for some reason. She wasn't fat, but there was something about her that was just perfectly round. Her legs were thick and muscular, with dancer's calves and short, impeccably painted toes. But what attracted me most was her mouth; she had a full, beautiful top lip that dipped in the center and scraped against her tiny teeth whenever she spoke. There was something intensely seductive about it. When she spoke, she seemed trustworthy, like she had a good heart; but at the same time she was slightly nervous and guarded, as if she were hiding something vulnerable. She exuded an air of mystery that I liked. Yes, I liked her. And she had given me the perfect opportunity to seduce her.

"Why don't you come over to my room tomorrow?" I suggested. "I'm staying at the Holiday Inn."

The next afternoon before work, she knocked on my door. I sat with her for hours helping her out: I told her not to wear red lipstick, to go lighter on her eyes, and how to put her hair up better. She had just had a

baby three weeks before and said she felt fat, but there was not an ounce of loose flesh on her.

I didn't hit on her once. It would have scared her off. With most girls, you have to make them comfortable first and build a friendship without compromising the attraction. Because of this, when she told me that she lived an hour away from the club and I invited her to spend the night at the hotel after work, she had no qualms about accepting. She knew that I was interested in more than just licking those cute little teeth of hers.

That night at work, she sat inside the ring around the stage and studied every move I made. Wherever I went in the club, I could feel her watching me. It's funny how if a man did that, it would be creepy; but

with a woman, it was such a turn-on. Maybe it's because worship is a submissive act, and men are supposed to be dominant.

When we returned to the hotel, I washed my makeup off and put my glasses on. I wanted her to feel comfortable, especially because women are often intimidated by other pretty girls. I wanted her to feel like I was a real chick, not just some stripper looking for sex.

We sat on the bed and talked for hours. I let her know I understood her problems and told her personal things about my life. I wasn't gaming her, at least not consciously. I just knew that I would want someone to do the same thing for me.

She sat at the foot of the bed, soaking in everything I had to say. I was keenly aware of her every movement and change in intonation. Every now and then, she'd grab my hand to look at a ring or ask me to French braid her hair. I understood these to be hints that she was interested and

wanted physical contact. Whenever I touched her, her breathing would quicken and a quiet moan would escape from her mouth.

The way the night was going to end now seemed inevitable. I didn't make any passes at her. I'm generally not one to make the first move. So I eventually wore Melissa down, and she lunged across the bed and kissed me. It was a clumsy move, which made it all the more endearing. When I kissed her back, her whole body relaxed with relief, as if she had been worried I'd spurn her.

We lay side by side, kissing and touching each other for an hour. I moved slowly, focusing entirely on her. She seemed amazed by what was happening. Eventually she confessed: She'd never been with another woman before. After having sex with men for so long, she wasn't used to making love without being rushed and pressured toward a climax. More than that, she was blown away by the feeling of being so close with someone who not only understood everything about her, but who had gone through it as well. There is no comparison between the experiences of a man and those of a woman.

"Oh my God," she whispered in my ear as we lay there in the universe-for-two we had created. "I've been missing out on so much."

I explored her body until dawn. She was like a mixture of Jennifer and Nikki, with the demure femininity of the former and the old soul of the latter. Over the course of the night, we fell in love. It wasn't about lust because, first and foremost, in those twenty-four hours we had become friends—friends with benefits.

And so began a relationship that lasted for years. She went on to become *Penthouse's* Pet of the Year. I definitely know how to pick them.

Chapter NINE

Suitcase pimps aren't made; they're born.

I returned home to a very different Jordan from the one I had left. My three-week absence had brought out a possessive, patriarchal, and jealous side of him. He insisted that the next time I go on the road, he come along, ostensibly to protect me and make sure I got paid. But the real reason was because he wanted to make sure I wasn't sleeping with other guys—which, technically, I wasn't.

His suspiciousness made some sense since I had met him in a strip club and was in the middle of finalizing a divorce with Rod. But as his attachment to me (and fear of loss) deepened, he didn't want to share me in any way with another human being.

The guy knew from day one that dancing was what I did for work—and the reason I could afford the two hundred dollar tennis shoes he had on his feet. But now he couldn't stand it. On the road, new demands came every day. He didn't like me making certain suggestive moves onstage. He didn't want me talking to other guys. He didn't want me sitting in their laps for Polaroids—I was only allowed to put my arm around them.

Every so often Joy would call with an offer to do an interview for VH1 or E!, and I wouldn't call her back. Jordan didn't want me to talk about anything sexual in public that would embarrass him.

Of course, I would fight him on everything tooth and nail, but he made my life so miserable with his constant temper tantrums, guilt trips, and harangues that I would eventually give in. It was easier to play along

than to fight. I don't know how he turned the dynamic between us around and ended up in charge. Although I didn't admit it to myself at the time, it was what I wanted to some degree, because he was the exact opposite of Rod: a real man—and manly to a fault.

When I did photo layouts, he would come along just to make sure I didn't do any spread shots. He didn't want people to see the inside of me, he explained, because it belonged to him. In fact, he insisted that I stop shaving so that the pubic hair would grow long enough to cover up my opening when I was naked. Telling him I was blond and had very fine hairs that wouldn't hide a thing was useless.

Eventually it got to the point where he didn't want me to wear tampons. His reason? "I don't want anything else inside you."

His jealousy wasn't just limited to the work environment. When I was driving, I wasn't allowed to look into other cars, because he thought I was making eyes at the men inside. So I had to keep my head straight forward, like a horse with blinders. Eventually, it got to the point where he launched a guerrilla campaign to make me look ugly. He would say, for example, that he preferred bigger girls who wore less makeup. And, subconsciously, I responded, slowly gaining weight and spending less time in front of the mirror.

I loved him to a certain extent, although he wasn't intelligent enough for me. He had no drive or ambition of his own. His life consisted of eating meals with his family, playing basketball with his buddies, and watching me like a private investigator.

I couldn't believe that this sweet, normal, inexperienced guy I had picked out of the crowd was just as bad as the rest of them. I had wanted to be in love so badly—and now I was screwed.

Because I couldn't get back at him for his possessive control over me, I took it out on everyone else. I became the angry dancer. There was a part of the show when I'd give away posters for my movies to the guys who screamed the loudest. But one night, no one yelled or showed any enthusiasm. So I dropped the posters, flipped everyone off, and walked offstage. It was a total Axl Rose move.

I was good at reading lips because my dad's mother had lost her voice from old age. So if I caught a guy saying something obnoxious to his friends, I'd knock his hat off or spill a drink on his pants. At one show, when a guy threw a penny at me, I kicked him in the throat with my heel. I got in constant fights with local dancers—I even hocked a loogie in one girl's face—and had guys thrown out of the club on a nightly basis. If some asshole dared to touch me, I'd reward him with a backhand to the skull. I was out of control. It was awesome.

Oddly, the more I acted out, the more guys liked it. It riled up the crowd when I was a fucker. I'd never dared to act like that at the Crazy Horse, but I'd never been that angry there. I didn't know it was an option.

At a club in Boston, a skinny guy came up to me and said that he had worked as a roadie for Tool. I gave him my usual response: "Right on." At the time, I had no idea who Tool was.

"The singer, Maynard, is a big fan of yours."

"Right on."

"He even has a picture of you on his road case."

"Right on. That's super. I really should be going."

It had been a terrible night. The club owner said he wouldn't allow me to take tips, because it wasn't in my contract. It was pouring rain outside. And my dressing room was in a trailer behind the club, so I was soaking wet. The last straw came when someone snuck into my dressing room and stole a two thousand dollar outfit, and the manager didn't do a thing about it.

So when the manager came back to remind me not to take any tips, I blew up. That was how I made my money. We argued for five minutes until I finally said, "Fine, no tips. I'll be out onstage soon."

I packed my bags and prepared to quickly ditch the club before he caught me. Roadie boy saw all this and said, "Watch this." He proceeded to superglue the club-owner's wipers to the windshield of his Mercedes. Then he keyed both sides of the car.

I thought the wiper prank was funny, but the keying was a little too much. That should have been a warning sign right there. But I liked him:

he had cheered me up, and he said he'd be willing to leave the Tool tour and work for me for free just to have the experience. So I hired him as my own personal roadie intern to deal with clubs, costumes, money, and all the practical details that were such a headache.

At rock shows, I'd seen what bands asked for, so together we came up with a rider for my tours. My dressing room had to have flowers, a sofa, linens on the table, and a fully stocked bar. No stripper made demands like that. And it wasn't just that I was a diva, it was also because if I was going to be pulling all that money into a club, I shouldn't have to deal with outdoor trailers, filthy stools, no ventilation, and yellow tap water. Roadie Boy even had a laminated all-access pass made up for the tour, just to make it official.

I quickly learned to forbid clubs from playing any songs from my set lists when I wasn't onstage. It would kill my performance if I had a routine designed to Marilyn Manson's "Beautiful People," and then some girl danced to the song right before I came out. Often, after I stripped to a song by the Revolting Cocks in some small club, the DJ would burn the CD so he could play it for other girls after I left town. My riders grew the more I took on Jordan's mind-set that everybody was out to screw me over, and I needed to protect myself. But, at the same time, my shows got better as I invented simple little male-exciting tricks like dangling a string of saliva from my mouth to my ding-ding.

I knew that the protocol was to remain silent onstage, because saying anything ruins the fantasy for the guys. Everything can be conveyed in the expression on your face and the language of your eyes, but as my anger built, fuck subtlety—it was all about whatever I wanted to do.

Every night became my birthday. I realized I could pull in more money if I told them that I blew off the chance to celebrate my birthday because it was so important to me to be there dancing for them instead. "So I'm here, happy birthday to me," I thought. "That's right, fuckers. Cough it up."

At first, I refused to do lap dances and private shows. But when Jordan wasn't around, I was willing to sell out, but not for less than five hundred dollars per song—and even then only if I was in the mood.

Behind the scenes, I would make club owners move my hotel room every night for some dumb reason: if the hotel didn't have room service— or if it did and there weren't any burgers on the menu. I didn't know these jokers, so it didn't matter to me. But actually, it did matter, because I ended up getting a reputation as a cunt. That was never my intention. I was acting out because I came from shit, my relationship was shit, and my life was shit, so I needed an outlet. When I look back at the people who had to deal with me, I feel terrible. I'd call my agent at 2 A.M. screaming, "If there isn't a limo here to take me back to the hotel, I'm flying home right now." That guy definitely worked for his commissions with me.

In the meantime, my father's side of the family decided to take advantage of my small renown. My uncle Jim opened a strip club in Anaheim, just outside Los Angeles, and offered to pay me a percentage of the take if he could use my name. And so the ill-fated Jenna Jameson's Scamps was born. Its manager: my dad, who had hit the road again, and moved to California to run the club with my brother.

The main problem with Scamps was its location: Anaheim is home to Disneyland, so when I performed at the opening, there were families protesting outside. And a big poster of me that my uncle had put up outside had already been taken down by the city. The only other thing I remember that night is being so deep in money I could barely walk onstage. I must have made $2,500 in singles.

However, the romance was short-lived. I had originally thought going into business with family was a great idea, because your blood relations are not going to shaft you. But I was wrong: your relatives will screw you more quickly than anyone, because they feel a sense of entitlement. He used to be my favorite uncle, a guy with a cool Corvette who would let my brother and me stay up all night and watch movies; soon, he became just another blood-sucking leech. And he was dragging my father down with him. My dad, a former cop, whose sense of righteousness was so strong when I was growing up that he neglected his own children and risked his job to fight corruption on the police force, was now living this squalid life on the margins of society—running away from some sort of trouble in Vegas, dating a stripper,

and, unbeknownst to me at the time, smoking the exact same drug he had seen nearly kill his daughter. I had managed to drag my whole family down.

So when Steve Orenstein called one afternoon and said he had a film for me—worded not as an option but as a gentle order—I was grateful. I needed a break from my break. With my permission, he had hired a second contract girl, a friend of his named Serenity. Steve liked her because she had everything I lacked. She was meticulously organized, dependable to a fault, and always on time. However, she came complete with her own suitcase pimp; and he was upset that Serenity wasn't getting as popular as me, so he was constantly accusing Steve and Joy of not try-ing hard enough.

Jordan didn't take the news that I would be doing another movie very well. He put me through hell. Every waking moment, he poured poison into my ear, telling me that I had no respect for myself or him; that the company was taking advantage of me; that I was destroying the chances of my children ever having a normal life. But I had no choice—I was under contract. I'd been doing these films for years, so there was no great harm in another one. But Jordan was turning me into a mess.

I had never been confronted before on my choice of lifestyles since I'd moved out of Nikki's house and, in retrospect, it was a good experience to have, because it made me think about the decisions I'd made. And, because I was ultimately comfortable with them—my conscience was clean, my star had risen, and my fucked-up lifestyle was at least exciting—I was stuck in an emotional tug-of-war. I couldn't continue to do movies without hurting Jordan; yet to leave the industry for Jordan would mean throwing away everything I had worked so hard for.

As usual, when my life was at a low, I thought of Nikki. We hadn't spoken much since I'd moved out, but she was always on my mind. She was my first friend in the industry and I'd formed a bond with her that was impossible to replicate with anyone else. So one night, I called her—not only because I needed her but because I missed her and wanted to hear her voice. I told her that I loved her and that it was silly to be ene-mies after all we'd been through. Our whole disagreement over my entry into the industry was moot now anyway since she had signed a contract

with Vivid and become an adult star in her own right. Though it only took minutes to recapture the tenderness we used to have for each other, we talked for hours. She had been through rough times herself, had finally divorced Buddy, and was now actually dating Lyle Danger.

For the two days before I was supposed to leave for L.A., Jordan didn't speak a word to me. And then, the afternoon I was leaving, he blew up. He couldn't believe I was actually going through with it.

Because of his constant haranguing, my self-esteem was at a new low. He had ingrained in me the idea that I was just a slut with no self-respect. I was so wracked with guilt that it wasn't until I was on the plane that I had time to consider the movie itself. It was being helmed by Wicked's number-one contract director: Brad Armstrong, né Rodney Hopkins.

The movie, *Dangerous Tides,* was shot on a boat on Catalina Island, off the coast of Los Angeles. When I saw Rod, I felt nothing. I was fully over him now and in love with Jordan. Rod didn't say a word. He just glared at me with sad, mute anger. His revenge came in passive-aggressive ways: He had booked himself in a threesome in the movie, with my good friend Jill Kelly and, of course, Asia Carrera.

Everyone on the boat seemed to be having a blast. It was like a carnival on the water. But I moved through it all in slow-motion despair. I threw up constantly. Whenever I wasn't on set, I sat in my dressing room with puffy eyes, crying about how much I hated myself for hurting the man I loved.

After every relationship, I always said, "I've learned my lesson." And I never made the same mistake twice. But each new relationship always presented a fresh mistake to be made never again. If mistakes and failures are really nothing but learning lessons, then I was well on my way to a Ph.D. in men.

When shooting wrapped (and, as a parting memento, a five-thousand-dollar Gucci dress of mine was stolen), I told Steve I needed to go on hiatus for a while. I couldn't go through this again.

On the plane back to Miami, I thought about the words I had chosen in that conversation with Steve. I hadn't told him that I was quitting. Instead, I had used the word "hiatus." I must have known, somewhere in the depths of my mind, that I'd be back.

Chapter TEN

Tony: The only time you ever lost it onstage was when that guy threw change at you.

Jenna: I put a heel in his throat. I was on my back and a guy nailed me hard with some change. My first reaction was to kick, so I did. I knew I had to get up right away, because I'm vulnerable when I'm on my back, so I got up and he came flying onto that stage after me. A security guard got in between at the last minute, thank God, because he was a big Memphis boy.

Tony: How about the time when you were on the top of the pole and you turned upside down, but you had too much oil on your legs, so you slipped off and fell right on your head? Then the next song came on, and you were dancing all dizzy.

Jenna: I was pissed at Jordan that night and was starting to drink, for the first time in my life. I think I downed a full bottle of Ketel One that night, in three hours.

Tony: Was that the night you met the Undertaker and he knew you from Las Vegas?

Jenna: Yeah, the Undertaker was one of the biggest WWF wrestlers at the time. He would put people in coffins and set them on fire in the ring. And the scary thing is, that character he played was not an act. Back when I used to hang out in Jack's shop and make needles for him, the Undertaker used to come in and get tattooed. I obviously never talked back then, because I was so shy. And he was very serious. So I met him that night dancing, and we hung out and became really good friends. And he told me that he took Jack aside one day and said, very serious, "I

don't want your girlfriend to be here any more. I think she's a cop."

Tony: You were like sixteen years old and eighty pounds.

Jenna: Yeah, I never knew that he was the reason why Jack wouldn't let me hang out at the shop. The Undertaker said I'd sit there for six hours and never move or say a word. I guess I creeped everyone out. It's funny that the Undertaker was scared of me. He's probably the most psychotic man I've ever met in my life. He came to one of my dance gigs and this guy asked me, "Can I buy you a drink?" The Undertaker looked at him totally stone cold and said, "Yeah, you can get me a shot of Jaeger and you can get yourself a shot of shut-the-fuck-up."

Jordan was there at the time, and the Undertaker said, "I'm going to kick your boyfriend's ass and take you away with me." I knew he was serious. I ran upstairs and told Jordan we had to leave, because this guy was going to beat the fuck out of him and kidnap me. So I never saw him again. I think that was when Jordan forbid me to talk to any more guys on the road.

Tony: There were a lot of crazies on the road. Remember, you had a lesbian stalker who came to your hotel one night and tried to beat down your door? She was a big woman, too.

Jenna: I was in Columbus, Ohio and I met this girl. I'm nice to everyone. So my next gig is in Reading, Pennsylvania, and I say, "If you want to come down, come down." Next thing I know, I get a dozen roses at the club in Reading, and they're from her, so I'm obligated to talk to her more. At the time I was going out with Melissa, so Melissa and I were in bed in my hotel room later that night and we hear *boom boom boom* on the door.

I look out the window and this girl is freaking. She's yelling, "I'm going to fucking kill you. If I can't have you, no one will. I'm going to kill that bitch you're with." Finally the cops came and took her to jail.

She tried to reach me for months afterward. I found out later that she was the assistant of an older porn star. I'm like you, Dad. When something like that goes down, I get calm.

Larry: Sure.

Jenna: I told Melissa, "Okay, lay down behind the bed. Call 911. Don't say a word. Turn the lights off." Inside, though, I was frigging scared she was going to come through that window. She was cuckoo, and you don't want to fight those kinds of people.

Larry: Then there was that guy at the AVN Awards. You were sitting there signing autographs, and there was a big crowd. And this guy with long blond hair walked in between the bodyguards and said something to you.

Jenna: Yeah, he was yelling, "What would your mother think? What are you doing to your mother?" I can take a lot of stuff, but if anyone says anything about my mother, it's on. And none of the bodyguards did anything, so dad walked over and socked him in the stomach.

Larry: I saw the look on your face and I ran right between the bodyguards. I nailed this son of a bitch and said, "Motherfucker, I'd love to fight!" I grabbed him by the fucking hair, and everyone was like, "Wait, wait." So they grabbed me and I let him go. As soon as they released me, I hit him right in the stomach and it was like, *boom.* He went down, and they dragged him off.

Jenna: I seem to attract that sort of thing.

Chapter ELEVEN

Before I returned to Miami, I went to see Dr. Garth. He was one of the most popular men in Los Angeles because he provided a service every woman there wanted: not dispensing painkillers indiscriminately, but perfect plastic surgery.

On the set of *Dangerous Tides,* in addition to everything else that had gone wrong, my left boob began capsulating, which happens when scar tissue forms and tightens around the implant.

The first thing Dr. Garth said when he saw me was, "No wonder. Your implant is too big for your rib cage."

So I made an appointment to come in the next day and get the scar tissue cleaned out. As long as he was going to be in there, I asked him for a smaller implant with a little more hang to it, because the old ones from Dr. Canada stuck out like water tanks. Jill Kelly took me to the office and let me recuperate at her house afterward.

I had first seen Jill on the set of a movie we were both in, *Cover to Cover.* She was strong, beautiful, and bossy, and I was dying to meet her, but I didn't have the guts to. Years later, at a Vegas strip club called Bob's Classy Lady, we finally met. But that's only because I thought she was Janine Lindemulder. Jill had started stripping at eighteen, but then, at a Consumer Electronics Show one year, she met Tiffany Million, who brought her into the industry.

When Jill walked into Bob's with her girlfriend P. J. Sparxx, I said, "Hi, Janine." She corrected me, I felt like an idiot, and a friendship was

formed out of mutual respect. We were two of the only girls who took the industry, and our roles in it, seriously. So we began hanging out on and off, and I knew she was someone I could rely on to take care of me—without an agenda—while I had my breasts fixed.

I don't remember much after the surgery because I was hopped up on Vicodin to kill the pain. However, I remember Jill talking on speakerphone to a guy named Jay, the bossy asshole who owned Sterling Studio, where I had shot a lot of my movies. When she told him that I was in her bed recovering, he joked, "Can I come over and molest her while she's out cold?" Guys were such creeps.

My boobs healed quickly. When I looked at them in the mirror, a huge smile spread across my face. They were perfect. I still wished, however, that I'd never gotten them done. I had big boobs to begin with, but in this industry, a girl has to be larger than life. The problem is that big implants are a magnet for creeps and a hindrance to most physical activity. That's why you'll never see retired porn stars playing golf.

When guys talk to a girl, they always ask whether her breasts are real or what her bra size is. But when girls talk among themselves, the question is always, "How many cc's do you have?" My implants were only 400 cc's, but because my chest was so big to begin with they look like they're 900 cc's.

When I returned home after the surgery, Jordan was furious. I think that girls often experiment by dating different types of guys, to see what will work for them. A dominant, possessive guy who wanted me to be a barefoot and pregnant housewife definitely didn't jibe with my unhealthy sense of ambition. It takes a certain kind of man to be able to live with the fact that the woman he loves has sex with other men on camera for a living. And I haven't met that man yet.

We lived together uneasily for a few weeks, until my agent called and asked if I wanted to do a few dance gigs in San Francisco with Jill Kelly. I jumped at the chance to get away from Jordan. And Jordan, of course, did not want me to go, because he didn't want me dancing onstage with another girl. He was actually jealous of her, too—even though I'd never told him about the women I'd dated.

With Jill Kelly.

Eventually, we compromised, and he came along as a suitcase chaperone. Our first show was at the O'Farrell Theater, which was the worst place possible to have taken him. The club had no rules: Girls were stuffing themselves with dildos onstage and, in the back rooms, grinding guys silly. The audience was so jaded that our show fell flat. It was too tame and softcore for them. But not for Jordan.

When I returned to the dressing room, he noticed that there was lipstick on my G-string. Evidently, Jill had inadvertently brushed her lips against it. As soon as he saw it, his face turned red, the veins in his neck bulged, and he screamed and put his fist through the door with a splintering thud.

"You fucking whore," he screamed. "How could you? Pack your things and we're going. You are done with dancing. Do you hear me? Done!"

I looked at Jill, and her jaw was set. She didn't say a word. But her eyes communicated everything: How could I let a guy treat me like this?

But Jordan was right: I was done. Done with him. Once again, I'd allowed a guy to control me and, in the process, lost my entire sense of self. I looked into the future, and imagined what life would be like if I chose to stay with him. I saw myself in that little house in Miami, with kids running around and a potbellied husband in a dirty wifebeater demanding more French onion dip for his Ruffles. And I realized that I was throwing my career away for a guy who gave me absolutely nothing in exchange—emotionally, physically, or financially.

When we returned to Miami, I told him I had to go to a Video Software Dealers Association trade show in Las Vegas—alone. Even though the convention was still a month away, I had to get out of there. I had no plans of ever returning. I left for the airport a few hours early, so that I could stop by a tattoo parlor. I wanted to cover up his name with flowers, not unlike a cemetery plot, though I kept the words "crazy girl." They definitely still fit.

Even though Jordan couldn't handle my lifestyle, he had somehow become addicted to it. For some reason that I will never know or understand, a few months after we broke up, he started working for Jill Kelly, which was a surprise, considering what she'd seen. She hired him to watch her house for her, and then later to be her roadie. He ended up dating one of her contract girls—even though she was married. He's still dating—and managing—girls in the industry to this day.

Homeless again, I returned to the one place I knew best: Nikki's couch. But our circumstances had changed: for once, she needed me more than I needed her.

Nikki had moved into Lyle's house in Irvine. It was my first time seeing Lyle since we both started in the industry. I could barely recognize him. He was wearing a dirty white T-shirt with a stretched-out collar that had holes in it. His jeans hung loosely around his waist, held up by a belt of rope. The veins in his neck permanently bulged, and his gentle eyes now seemed angry at the world. Once, he'd driven me everywhere; now

I no longer trusted him behind the wheel. He was paranoid, temperamental, and addicted to everything from crack to steroids.

Five years of hard living had erased the Lyle I once knew. I may have felt lost at times, but never for that long. It was like seeing an alternate reality: If I hadn't gotten my partying out of the way when I lived with Jack, perhaps I would have made all the mistakes he seemed to have made. Lyle's self-esteem was shattered, and he took his own failures and inadequacies out on everyone around him. To be in this industry, you need to have strong grounding—because you are questioned by everyone, even yourself, on a daily basis. And if you fall into the trap and start hating who you are, then you are going to start taking it out on yourself and everyone around you. So, in short, Lyle had become one mean son of a bitch.

Day after day, I watched that son of a bitch take Nikki's money, accuse her of cheating on him, and fly off the handle for no reason whatsoever. It got to the point where Nikki had to hide her jewelry so he wouldn't steal it. I'd never seen anyone go through such abuse in my life.

One night, while I was on the couch, I heard him yelling at Nikki as she cried. Then I heard a loud crack, like an ice-hardened snowball hitting the side of a building. I went to check on Nikki and saw them in the bathroom. She was crouching in the corner and he was hovering over her menacingly, his elbows pumping back and forth. I felt my chest tighten and I was seized by the horrible impotent panic that I used to feel with Jack. I wasn't about to let the same thing happen to the girl I loved.

I ran into the bathroom and tackled him. I wasn't operating with logic. I didn't care whether he hit me or not, but he didn't. I had been like a sister to him. And somewhere in the back of his scrambled mind, he must have remembered that.

The next morning, he was gone. Six days passed and he still didn't return. That was when Avis Rent-A-Car called. Lyle had apparently rented a Pontiac Grand Am under Nikki's name and sold it.

"Oh my God," Nikki said when she hung up. "What am I going to do?"

"You're going to pack your shit right now," I said, "and you're not going to let that psycho know where you're going."

"I can't, Jenna," she cried. "I can't just leave."

"I will get an apartment with you," I told her. "I need somewhere to live anyway."

Suddenly, with those words, I had clarity. I knew exactly what I wanted. "Let's go back to the way we used to be," I gushed. "We can start our lives all over again, just you and me. And this time we can make all the right choices. And we can make them together. No guys."

We were so scared Lyle would come home, we packed that apartment in a day. If he caught her leaving him, I have no doubt that he would have killed her and I would have been helpless to stop him.

As we drove to Hollywood, I kept thinking about the old Lyle. It was largely through his kindness and selflessness that I had been able to get ahead. The Lyle I had known didn't seem capable of treating a woman like he did Nikki. I swore I'd never trust a man again. I should have just listened to the message the world kept sending me: Men are for money, taking care of things, and sex, to be enjoyed only with a leaden shield around your heart.

Nikki and I found a two-bedroom apartment with a loft, which I claimed as my own. But I never slept up there. I crawled into bed with Nikki every night, and we'd talk until we fell asleep in each other's arms. We were best friends again. We never had sex, though: our relationship had evolved beyond that.

Without Jordan or Lyle, we entered a new phase in our lives. Nikki had been bulimic when she was younger, so she took Prozac to keep herself stable. But it wasn't enough. So she started medicating herself with vodka—which she'd drink straight—and a little bit of Vicodin. We found a doctor who gave us giant bottles filled with five hundred of those evil white pills. Because it was a prescribed medication, it didn't seem wrong—like meth or crack. And I had enjoyed the drug when I took it after my breast reduction, so I started swallowing a pill on special occasions. Then I started drinking vodka every now and then. And that's when the unhealthy living started again.

I had always thought that it was men who were bad for me. But the problem with guys, ultimately, was always one of control—who had it and how they chose to use it. All that was nothing compared to the trouble that Nikki and I got in to. With her, there was a control problem of a different magnitude—we were out of control. I slid back, day by day, to the Jenna of the Vegas days. But I had confidence now. Half the male population of the country was jacking off to me, and I was laughing all the way to the bank. I wasn't going to take shit from anyone and neither was Nikki. So we let everyone we came across know it. And in return they gave us the nickname we deserved: Hell on high heels.

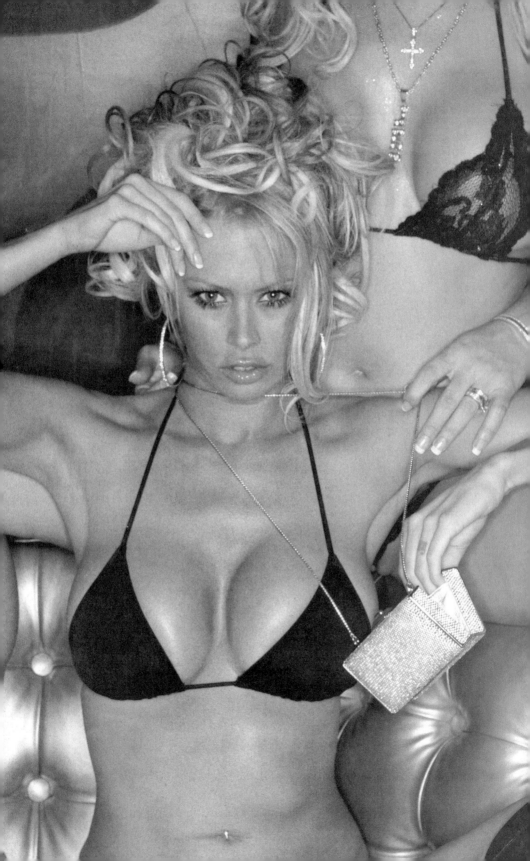

JENNA JAMESON

Book

VI

QUEEN OF PORN

XXX XXX

THE GENTLE CLOSURE OF MY BREAST

"Within the gentle closure of my breast,
From whence at pleasure thou mayst come and part."

★ ★ ★ ★ ★

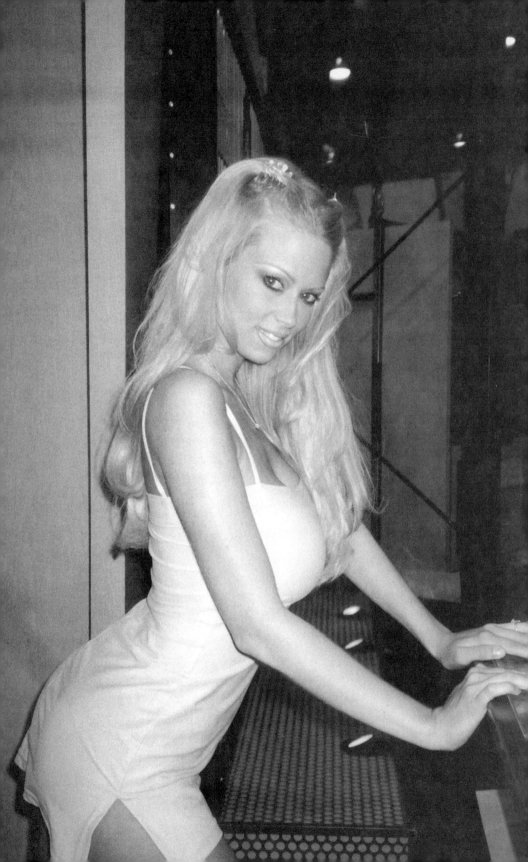

Chapter ONE

*O*_{*ink.*}"

It was just a small sound, nothing really. It wasn't even that loud, or really that close to the noise an actual pig makes. But, as I walked through the Rio All-Suite Hotel and Casino, it ricocheted through my Vicodin-numbed mind like a BB in an empty water tank. I had heard it in passing only, as I walked in front of that distant cousin of a pig, a reporter. And I knew exactly what it meant.

I still hadn't slimmed all the way back down since leaving Jordan. And I was so insecure about my looks that I put myself on an instant crash diet after that barnyard jab. All I ate each day was plain lettuce and one Power Bar. Men can be so cruel.

I was at the Rio for the VSDA, a video-industry convention, and the next day, *Playboy* had its annual Wet and Wild party at a water park nearby. With me at the bikini-fest were Nikki and Jill Kelly. In the distance, somewhere amidst the tangle of pressed flesh, I saw a familiar face. He was well-built, with a strong jaw and blond hair down to his butt. It was the asshole who used to run Sterling Studio. And he was looking fine.

Jenna	*Jay*
The first time I saw Jay was when I started filming Wicked movies at Sterling Studio. Right away, I thought, "Oh my God, that guy is cute. But	The first time I saw Jenna was when she started filming Wicked movies at my studio. Right away, I thought, "Oh my God, that girl is cute. But

Jenna

what a dick." He was bossy, irritating, arrogant, and didn't seem to give a shit about anyone but himself. He walked around like he owned the place, which of course he did.

Other than that, Jay didn't make much of an impression. I remember him pinching my ass and winking at me one afternoon while I was getting a massage in the makeup room. I thought it was kind of obnoxious. That was the only time we interacted. When I came on set, I tried to run the show and he'd look at me scornfully. I don't think he liked control freaks, but it didn't matter because he didn't have to deal with me.

He had enough on his hands as it was, because he was going out with Chasey Lain, the original Wicked girl, and she was drama. One day, I saw her outside the studio in her car, screaming at the top of her lungs for him. He ran out, and she was bashing her head against the steering wheel. Blood was pouring down her face. He kept saying, "Honey, what's the matter with you? You have to relax. I'm at work."

I remember actually feeling sorry for him for a change.

Jay

what a total brat." She walked around like she was all this and all that, and I thought, "Whoop-dee-fucking-doo." She was the kind of girl you just wanted to put in her place.

I actually thought about being a priest when I was a kid. But when I was thirteen or fourteen something went wrong.

I came into the industry in 1982 as an investor, because a friend was shooting a porn movie. I wanted to learn about filmmaking, so I started working for him on the crew as a video tech. Soon after, Russ Hampshire gave me a job managing a studio he had purchased. When Russ left the business, I took over the studio.

Any guy who saw Jenna back then flipped out. She had that spark. But she was dating a director in the industry named Rod. When he was with us, he was one of the guys. But when he was on set with her, he was so emasculated. All he said to her was, "Yes, whatever you want." I thought, "Holy shit, have some fucking balls." So that was my first impression of Jenna.

We didn't hit it off very well.

Jenna

When I spotted him at the Wet and Wild party, it was like seeing him for the first time. I asked Jill if Jay was single now, and, fearless chick that she is, she took it upon herself to tell Jay that I was interested.

From a distance, I saw an expression that looked like anger flash across his face. Then he made a beeline for me, put me in a headlock, and dragged me to the gate of the water park. I thought he was going to kidnap me.

I wriggled loose and told him to call me in the hotel room I was sharing with Nikki. He phoned me late that night and invited me to his room. I agreed, but as soon as I hung up, I chickened out. He had a reputation for being very sexually rough with women. So I blew him off.

When I saw him the next day at the convention, I walked up to him and said, "Sorry about last night. I fell asleep."

It was, of course, a total lie. He was pissed off, so I invited him to come to a party I was having that night as my date. He stood me up.

After the party, around 3 A.M., he came up to me at the hotel bar and

Jay

When I spotted her at the Wet and Wild party, it was like seeing her for the first time. She looked amazing. We had both grown up a lot since we first met, and I'd retired from the business and moved back to Arizona with my family.

I was at the party with T.T. Boy and some friends from Vivid. I'd known Jill Kelly since before she was in the industry, and she came up to me and said, "Jenna thinks you're cute."

So the next time I walked by her, I said, "Well, are you ready to go?"

She looked at me blankly, so I grabbed her and threw her over my shoulder. I was just joking around, trying to scare her. Then I put her down and gave her my number.

She called me at three-thirty in the morning while I was lying in bed. I invited her over, but she never showed up. She blew me off.

When I saw her the next day, I said, "You're fucked." She said something catty back. So I was about to move on when she invited me to a party for Wicked she was hosting that night. I told her I'd be there, but I knew as soon as I accepted that I wasn't going to go.

Jenna

told me I'd gotten what I deserved. We were even now. We had an early breakfast together and went back to his room to watch TV.

I've been alive long enough to know that we weren't really going to watch TV, and I was extremely scared of him because of his reputation. I sat on the corner of his bed, totally uncomfortable, as we watched *Species,* which was funny because I'd just auditioned for *Species 2.*

Then he grabbed me, threw me onto my back, and kissed me.

Jay knew how to kiss: the secret is to keep your lips soft but still apply pressure with the musculature of your mouth around it. It was perfect. From then on, there was no stopping. He ravished every inch of my body. Just like when I had first met him, he was bossy. He bit me everywhere, from my neck to the insides of my thighs, and ordered me around, which I don't normally like. But he made it work, because he did it for my pleasure, not his. He would tease me, and then back off and make me beg. When we finally fucked, he put his dick in for just three or four strokes and then pulled it out. He wrestled

Jay

I saw her the next day at the Venetian casino, and she tried to be all nonchalant. I was sitting with a group of people, and Jenna and I didn't want anyone to know there was this spark between us, so we arranged to meet next to a certain slot machine in five minutes and go to breakfast together. She got up first, then I excused myself to get a drink.

As soon as we were finally alone, we walked ten steps and ran into a Japanese reporter. Of course he asked if we were an item, but I told him I was going to direct one of her movies.

The restaurant was empty, but just to be safe we sat in a booth in the back. Talking to her was so different than I had expected: she was cool, intelligent, articulate, and funny.

Suddenly, I looked up and Joy King and the entire Wicked crew were being seated at the table in front of us. We sunk in our seats, and then decided to escape to my room.

Usually at that hour of the morning, there are only stragglers left in the casino. But everyone in the adult industry was still up. We zigzagged to the elevator, but every ten feet we'd run into someone. David Schlesinger

Jenna

and teased me for four hours, until we both fell asleep. The amazing thing is that he didn't come once. The guy had incredible self-control.

The next afternoon, he joined me for the walk of shame back to my hotel. No one seemed to believe that we'd just been at a meeting. We must have given off that we-just-fucked-like-animals-all-night vibe.

He had to drive back to Phoenix that day. I didn't want him to go, which was a strange reaction for me to have. Usually I can't wait to get rid of a guy I've just slept with.

Jay

from Vivid was playing craps and asked what we were doing. I told him I was walking Jenna up to her room.

"I thought she was staying at the Rio," he said.

"Um, she changed hotels," I told him.

By the time we made it up to my room, everyone in the industry knew we were dating except us.

The next morning, I hopped in my car because I had to go to a birthday party.

I remember seeing her heartbreaker tattoo just before I left and laughing. I said, "That's funny. You're about ready to get broke."

Chapter **TWO**

After the convention, I stayed in Vegas to dance at Crazy Girls. I hadn't heard from Jay since he'd left for Arizona, which was very frustrating. In the meantime, Nikki had disappeared. She had gone to the Wicked party and never come home.

Between Jay, my newfound eating disorder, Nikki's disappearance, and the Vicodin, I was thrashed. I had started out just taking half a pill, but tolerance levels for the painkiller rise as fast as addiction to it does. There were girls I knew who were taking nearly one hundred pills a day. Nikki and I called them .357 magnums, because they had a 357 printed on them and felt like a gunshot to the stomach.

On the last night of my engagement at Crazy Girls, I popped two Vicodin as I was changing into my costume. Just before I went onstage, one of the girls said that Tommy Lee from Mötley Crüe was in the audience. He had flown in from Los Angeles just to meet me.

After the show, I took three more pills. On the elevator up to the after-party, my head began to spin. I felt like I was transparent, and could walk through doors and windows. Small chunks of time began to disappear from my memory soon after they occurred. I made a mental note to myself: Don't take so many Vicodin again.

When I arrived at the suite, I saw Tommy sitting on the couch, grinning like a tattoo-covered monkey. I was so high that I just flopped down in his lap. He began to talk to me, but I had no idea what he was saying.

Opposite: With Jay.

I just watched his lips flap. He was kind of sexy, in a simian way, though I still preferred Nikki Sixx.

Suddenly a photographer appeared out of nowhere and asked to take a picture of us. "No, no, no," I protested.

"Yeah, yeah, yeah," Tommy translated.

The flashes made me dizzy. I stood up, walked to the bedroom, and collapsed onto the bed.

Moments later, Tommy came in and closed the door. Within ten minutes, we were having sex. I must have been really high, because his dick is so big and I didn't feel a thing. If I were fully conscious, I would have been stuck to the ceiling.

In addition, I had just gotten a piercing for the hood of my clit and had lost the little blue bead that holds it in, so the piercing kept coming out. My memories are vague and fragmented, but I remember having difficulty keeping my mouth closed. And I remember passing out. When I came to, Tommy was still fucking me. He seemed so into it. I drifted in and out of consciousness as he continued to slam me.

I woke up and discovered, to my horror, Tommy curled around me. I hate cuddling. I lifted his arm off my side and rolled quietly off the bed. I had to get out of there, and the last thing I wanted to do was wake Tommy and have to make nice to him.

I ran back to my hotel room, stumbled through the door, and found Nikki there in bed—with Lyle Danger.

I didn't know how to react. All kinds of chemicals and emotions were zipping around inside me. I was coming down off the pills, I had no idea what I'd just done the night before, that monster Lyle was naked in my bed, and my ding-ding was in incredible pain. I knelt down in front of Nikki, buried my head in the sheets, and started crying.

She walked me into the bathroom, and we inspected the damage. My pussy looked like someone had punched it a hundred times: the lips were swollen to the size and color of an unripe plum. I remembered having used a condom, so at least we were safe, but I was worried that maybe I'd caught some kind of infection. I couldn't remember what he looked like

naked, so it didn't dawn on me at the time that some guy with a monster cock had just shredded me.

Two minutes later, the phone rang.

"Hey, where are you?"

I recognized Tommy's eager puppy-dog voice. "I'm back in my room," I told him.

"Come back," he said. "I'm starving, bro. Let's chow down."

Bro? Chow down? "Um, I'll call you back," I said, and hung up.

I never called him back. I got on a plane that afternoon and returned to L.A. Nikki and Lyle sat next to me. I couldn't believe she was with him again, after all we'd done to get away. To his credit, he claimed to have cleaned up, and so far seemed sober enough. They had even made an appointment to get counseling.

Back in L.A., Tommy started calling ten times a day. He pretty much stalked me. If I told him I was going to the airport, he'd offer to drive me there. If I was going to a club, he'd offer to put me on the guest list. If I was washing my hair, he'd offer to lather it for me. The lies I told him to get out of meeting kept getting longer and more convoluted until, finally, I broke down and agreed to see him again. Sober, I found him incredibly cool and sexy, a happy-go-lucky maniac who also happened to be irritatingly affectionate. So we started dating. I probably spoke the phrase "Tommy, get off me," twenty times a day when we were together, even in my sleep.

When he went on the road with Mötley Crüe, I joined them at various tour stops. It's strange how life comes full circle. Only a few years before I was sitting on my brother's shoulder at the *Girls, Girls, Girls* concert in Vegas, hoping to be noticed and taken backstage. Now I was practically part of the entourage.

On the tour bus, I spent hours bonding with Nikki. He kept talking about how he never wanted to touch another woman besides his wife, Donna D'Errico, and I thought, "Wow. What an incredible turnaround." I never said to him, "Remember me from the *Easy Rider* photo shoot?" I didn't want him to think I was that naïve little thing, because I wasn't that girl any more.

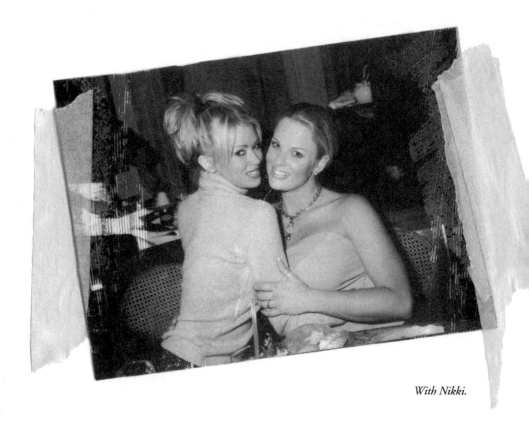

With Nikki.

Everything with Tommy was an adventure that he saw through the excited eyes of a little boy at a zoo. When we were in his hotel room on tour, a pelican would suddenly fly in the window and he'd start feeding it. At airport cafeterias, I'd turn around and he'd be fighting with some businessman over salad dressing.

After meeting Tommy on the road, I flew to Miami. I had unfinished business to settle there. First, there was Jordan. Though we both knew it was over, I needed to say it to his face. He took it like a man, and got extremely angry. I just walked out; I owed him nothing. It was simply a fling that had lasted too long, and it was mainly my fault, because I valued passion over pickups.

The other item of business was my father. I had pulled out of my uncle's strip club and, depending on who you believe, he either sold it, the city closed it down, or, most likely, both. As a result, my father was jobless and homeless, so I let him, Tony, and Selena move into my place in Miami. After all, I had no intention of living there anymore.

As I was packing my stuff to bring back to L.A., the phone rang.

I grabbed the receiver. "Hi," came an effeminate voice on the other end. "This is Michael Drake from *Cosmopolitan* magazine, and we are just dying to do a fabulous piece on you. I'm not saying it's a cover story or anything, but we're very excited here and want to have Annie Leibovitz photograph you."

"Oh my God, are you serious?"

"You've heard of her? Super. I'm going to put my best writer on this. Here's what I'm thinking for the photo shoot: We'll have this big fiery hoop with flames, and we'll have you jumping through it."

"Okay."

"And we'll dress you up like a poodle, with a leash and a collar and a little pink bow in your hair."

"Sounds exciting," I said. "Weird but exciting."

Suddenly, the voice changed, replaced by something much more masculine. "What's up, Jenna? It's me."

"You dick! I'm going to kill you."

It was Jay, calling three weeks later. My heart swelled with excitement, tempered only by a tiny shard of anger because he'd taken so long to get back in touch.

Chapter THREE

J ay picked me up in Los Angeles a week later and drove me to Phoenix, where he was living with his brother. It was Thanksgiving, so the first thing we did was go to his parents' house for dinner. Big happy families always make me uncomfortable, and there were at least forty people there I didn't know—brothers, sisters, cousins, nieces, nephews, aunts, uncles, in-laws, outlaws. It was the exact opposite of my nearly nonexistent family. His parents had been together forty-five years, and Jay talked to them daily.

Throughout the party, Jay would introduce me to his sister or someone, and then go talk to other people, leaving me alone. As if that weren't enough, his sister said, "You aren't the most beautiful girl Jay's ever gone out with, but you have the best personality." By the time we left the house, I was having second thoughts about him.

Afterward, we went to his brother's bachelor pad, shut ourselves into a leopard-print bedroom, and put on a Joe CD. Then he redeemed himself with the best sex of my life—and not because he was so rough, had a perfectly shaped dick, or knew Tantra. It was because there was genuine emotion involved. I really liked this asshole with the big happy family. He was confident and dominant in a way that wasn't overcompensating for any hidden insecurity. When we embraced, it was as if a bubble formed around us and the rest of the world disappeared. I'd been missing out on this my whole life.

Opposite: With Jay.

We must have listened to that Joe CD ten times. We'd nap for fifteen minutes between sessions, and then go at it again. I'd made past boyfriends wait at least six months before agreeing to anal sex. But when we were in the bathroom, Jay pushed me up against the mirror and pried my legs apart with his knees. When I felt his pee-pee probing around my backside, I made a split-second decision, and that decision was: yes, submit.

The next day I ached everywhere. When we went jet-skiing on the lake with his brother, I wiped out so many times that I thought I'd never walk normally again. At the end of the weekend, Jay asked me to move in with him. The problem was that I wasn't ready for another man. After my disastrous relationship with Jordan in Miami, I didn't want to be under someone's thumb. As I flew home from Phoenix, I could feel myself pulling away from Jay already.

The following week, I joined Tommy on the road. The band was touring with half a dozen dancers, one of whom was a wild, raven-haired beauty named Jen who was going out with Joan Jett. Behind Tommy's back, I started fucking her, too. I was doing everything I could to keep from committing to anyone.

While I was in Jen's hotel room, surfing the usual porn gossip sites on the Internet, I discovered that Steve Orenstein had put three new girls under contract to Wicked. I flipped out. The whole reason I had signed with Wicked was so that I wouldn't have to compete with tons of other contract girls for time and attention. It even said in my contract that Steve couldn't sign any other girls without my approval. But what hurt more was that he hadn't even called to tell me. By the time I called Joy, I was hysterical.

"How could he do this to me?" I asked. "How could he sign those girls without talking to me?"

Joy was silent. It was an awkward situation. But I knew what she was thinking. In my anger, it hadn't occurred to me that the reason he'd signed them was because he had a business to run. Since I had joined Wicked, they had doubled their staff. And my complete lack of reliability and communication over the past year certainly weren't helping them with

their overhead. They couldn't just sit on their hands and wait for me to come back. I had believed that it was all about me, that I was Wicked. But Steve was Wicked, and always had been.

I didn't find out until much later that the reason Joy sounded so rushed and nervous on the phone was because she was standing in a studio the whole time supervising a photo shoot for two of the new contract girls.

When I returned to L.A., Nikki was in the front room of our house, folding all my clothes with her usual obsessive-compulsive charm. Her eyes were red and puffy from crying. Clearly, the old Lyle was back.

I was desperate and confused; she was desperate and confused. Our pledge to stick it out together without men had lasted only a few months. We slept in the same bed that night for the first time in weeks, and in the morning we vowed to get away from it all. We were going to go on tour: together. I called my agent and roadie boy, and within a week it was all set. I had nothing to lose, or so I thought.

The tour would prove to be one of the worst mistakes of my life. I just wasn't ready to interact with the general public again.

Chapter FOUR

Generally speaking, people are not very original. No matter who you are or what you do, you will inevitably be asked the same questions by every stranger you meet. Typically, your interrogators will show a degree of tact. After all, they don't want to offend you. But if you happen to belong to that small segment of the working force that has sex on screen for a living, tact goes out the window. Since you are revealing so much of yourself on camera, most people figure that no question—no matter how personal—is off-limits.

I am not just referring to men here. Women actually hit on me much more aggressively than men, who generally stammer a few words while staring at my breasts and then run away to a safe distance where they can stare at my breasts some more.

So, I present to you a list of answers to the most common questions I am asked. Now, when you see me, you'll have to think of something original to say.

Question: Are those real?
Answer (Good Mood): Yes, real expensive.
Answer (Bad Mood): Yeah, right. It's natural to be 110 pounds with double-D's.

With Melissa.

Question: What do I have to do to date you?
Answer (Good Mood): It's all about confidence. It doesn't matter what you look like or how much money you have. If you are self-assured, and you act like you can have me if you want me, then I'm yours.
Answer (Bad Mood): Get reincarnated.

Question: Hey, do you remember me? We met at the [convention/strip club] ten years ago. I'm [Generic Name] from [Generic City].
Answer (Good Mood): Um, sure. I meet a lot of people, but I guess you look familiar.
Answer (Bad Mood): Oh my God, [Generic Name]! Where the fuck have you been?! I've been thinking about you. In fact, I was just about to call. How's that data-entry job working out for you?

Question: Do you ever eat?
Answer (Good Mood): I lack too much self-discipline to starve myself. I just have good genes.
Answer (Bad Mood): Yes, I eat a lot more than you. But I also work. I'm not sitting on my ass watching some girl burn calories in a strip club.

Question: Do you get off when you have sex on camera?
Answer (Good Mood): One hundred percent of the time.
Answer (Bad Mood): One hundred percent of the time when I say I do, I'm lying.

Question: Don't you get sore?
Answer (Good Mood): I probably have sex less than you. I only make about three movies a year, so there's no real chance for me to get sore.
Answer (Bad Mood): Yes, in fact I'm having orgies so often that I need vaginal rejuvenation surgery weekly.

Question: Is your sex life at home different than in the movies?
Answer (Good Mood): It makes you a little selfish at home. I give less oral and I hate being on top. I'm lazy. The last thing I want to do when I'm home is act like a porn star.
Answer (Bad Mood): No. I always say to my man, "Let's pound away on the stove for three hours."

Question: How much money do you make a year?

Answer (Good Mood): Millions.

Answer (Bad Mood): I'm just scraping by, trying to put myself through real-estate school and support my three children. So how about giving me one hundred dollars for talking to you?

Question: How many people have you slept with?

Answer (Good Mood): Somewhere between sixty and eighty people—men and women, on screen and off.

Answer (Bad Mood): More than you, less than my bodyguard Clay.

Question: Do you have a significant other?

Answer (if it's a hot chick asking): No.

Answer (if it's not a hot chick asking): Yes.

Question: How do I get in the business?

Answer (Good Mood): See Book IV, chapter 11.

Answer (Bad Mood): Whip your dick out and get hard right now in front of all these people.

Question: Were you molested/raped/beaten/abused?

Answer (Good Mood): I don't like to talk about it. I'm not one of those girls who goes into detail about it on Howard Stern. I don't want to be an open book free for the entire world to read—I need to charge at least $27.95, hardcover.

Answer (Bad Mood): No.

Question: Does size matter?

Answer (Good Mood): Oh, no. I like all sizes. It just depends on how you use it.

Answer (Bad Mood): Of course. Any woman who tells you otherwise is lying. It's like asking, "Does the size of a woman's pussy matter?" If it's too big or too small, it's not going to work for you.

Question: Will you come visit me in prison?*

Answer (Good Mood): Thank you for writing. Here's a signed glossy photo for you to whack off to.

Answer (Bad Mood): Thank you for writing. Here's a signed glossy photo for you to whack off to.

Question: My girlfriend loves you. Would you get together with her while I watch?

Answer (Good Mood): Let me see your chick.

Answer (Bad Mood): Let me see your chick and, if I like her, you can leave.

Question: How much would I have to pay to have sex with you?

Answer (Good Mood): Well, my husband bought me a $2.5 million house. Can you beat that?

Answer (Bad Mood): Even if there was a nuclear war and we were the last two people alive and the entire future of the human race depended on us breeding, and you had a gun to my head and said you'd kill me if I didn't have sex with you, I'd still want a $2.5 million house first.

*I get a lot of mail from prisoners, half of which have a visitor's form enclosed in case I want to drop by and say hi.

Chapter

FIVE

His name was Steve, but they called him Mr. 187. The nickname came from the police code for murder. Nikki and I met him at one of our first tour stops: the Pink Poodle in San Jose, California. He was exactly the kind of bad influence we were looking for.

The Pink Poodle was a wild place, an all-nude strip theater that was always at the epicenter of some major scandal. The girls there were among the raunchiest performers I've seen onstage in this country. Nikki and I weren't willing to do much more than get fucked-up and fall all over each other onstage, so our tips suffered accordingly.

The only thing that redeemed the night was meeting Mr. 187—a former marine, an erstwhile middleweight boxer, and the sergeant-at-arms for the West Coast chapter of the Hell's Angels. Mr. 187 was a badass motherfucker who was angry at the world and enjoyed nothing more than snapping a guy's arm for looking at him wrong. So naturally, we took him on tour with us.

Nikki and I were angry at the world in our own way, and Mr. 187's function was to justify and enable it. He'd fan the flames of our Vicodin-and-vodka-fueled rage to the point where we got so out of control that even he couldn't handle us. I'd smash out mirrors in dressing rooms; Nikki would clamp guys in leglocks until their heads turned purple; we'd kick drinks in guys' faces; and we'd pass out on top of each other onstage.

We were as destructive—and self-destructive—as a rock band. With both of us at the top of our game as porn stars, it was our greatest-hits

Opposite: With Lil' Kim.

tour. Most guys will watch a favorite porn clip more than they watch *Star Wars* or *Zoolander,* so when they saw us standing three inches from their faces, they went insane. Hundreds of people would chant our names before each show and fight to get close to the stage.

We brought feature dancing to a new level: Where some girls were getting $250 a show, we were getting $5,000, simply because we had the balls to demand it. Add to that Polaroids, tips, and merchandise, and we were pulling in over $100,000 for a three-night engagement. We insisted on five-star hotels with room service, limos to and from the club, and at least two security guards accompanying us at all times.

And we got away with it all until Toronto, where there's a no-touching law for strippers. I was so shit-faced I forgot that in Canada, there are coins (as opposed to bills) in the amounts of one and two dollars. So whenever a guy threw one of those coins at us, I'd whip it back at him because I thought he was trying to insult us. During our second show, Nikki and I were grinding on the pole simulating sex with one another, when we were literally yanked off the stage by the police and put in handcuffs.

In order to stay alive and out of trouble, we sent Mr. 187 home, where he went on to achieve modest local fame by beating a Pink Poodle patron to death. His spirit, however, hung over the rest of the tour. If we weren't getting enough money from a show, we'd flip off the guys and walk offstage. At a Déjà Vu club one night, I swung around the pole and nailed Nikki in the eye with my heel. Even though her face was gushing blood, she kept dancing, probably because she didn't feel a thing. My platforms ended up doing six stitches' worth of damage. I don't even know why anyone paid to see me: I was so thin from the crash dieting that my bones were sticking out everywhere.

For us, living wild, free, and fucked-up wasn't about sex, like it is for most people. It was about using our sexuality to get away with as much as we could. Our life became a never-ending bachelorette party. I found the party girl inside me that I had never explored. It was also one of the best times of my life, because since leaving Jack my entire existence had revolved around work.

When we weren't dancing, we'd go out on the town and wreak havoc at local clubs. After downing enough Sapphire, I'd dance on the bar while Nikki pulled my clothes off. Then I'd lay down on the bar half-naked, and Nikki would grab a candle and drip wax all over me. We never failed to attract a crowd.

I remember looking around one night as the wax fell hot on my breast and thinking, "What the fuck have I become?" I was in a downward spiral, but I was enjoying it too much to stop. I had never been a drinker and, after downing a bottle of Grey Goose a day on that tour, I knew why: I'm not a good drunk. Alcohol brings out the anger that is, and always will be, inside me. I enjoyed abusing the little power I had won since my success at Wicked.

Every so often, however, reality would intrude on my good time. I'd go backstage and see a huge bouquet of roses in my dressing room with a note from Jay. That bastard wouldn't let me forget about him.

And then, one afternoon as I was waking up, the phone call came from my dad. As soon as I heard his voice, I knew he wanted something. That's all he called for any more. Ever since I'd started making money, I'd been taking care of him.

"I need your help," he said.

I tried to ignore my massive hangover and focus on his words.

"There are six—no, seven—bounty hunters outside," he continued. "They have us surrounded."

I would have thought he was joking, but I'd never heard my dad joke before. Instantly, my hangover disappeared and my brain snapped into alertness for the first time in months. I wasn't mad, upset, confused, or even curious. Just as my father did when I called him on the brink of death after Jack had left me, I went into instant fix-it mode. I needed to save my family.

"Where are you?" I asked.

"In Miami, at your house," he said.

I heard Tony's voice in the background. "Dad," he screamed. "They're coming through the door."

There were footsteps. My dad was running through the house. I couldn't believe this was happening. "If you take another step, I'll blow your fucking head off," my dad said coolly. "I'm well-armed, and in range."

"What the fuck is going on?" I asked.

"Jenna, I'll explain later. I need a lawyer."

"Should I call the police?"

I could hear more commotion in the background. Tony was yelling something about the windows. "A lawyer!" he repeated.

I called Jay, who put me in touch with a lawyer he knew. I had never wanted to know about the trouble my father and brother had gotten into in Las Vegas so many years ago, but now suddenly I was in the middle of it all. With the lawyer's help, I began to put the pieces together: Tony and my dad had been running a construction company for my uncle in Las Vegas, and were building multimillion-dollar homes for rich and powerful clients. However, one of their office managers was commingling funds, taking hundreds of thousands of dollars of clients' money and spending it as if it were his own. Evidently, one client found out and put a contract out on my dad and brother. (I know my father and brother couldn't have been at fault, because they didn't have any money or new, expensive purchases.) It didn't matter to him whether they were directly involved or not; it was their company, and thus they were responsible. My dad paid the client back as much as he could, until he simply ran out of money. Next thing he knew, he was criss-crossing the country trying to escape from bounty hunters.

Evidently, they had tracked him down, through Tony's social security number, to my home in Florida. At the suggestion of the lawyer, I got on the phone with the bounty hunters. They demanded that either I paid the $25,000 my father still owed, or they'd bring him back to Vegas to serve time. I ran out to a branch of my bank, withdrew the money from my account, and wired it to one of the bounty hunters in Florida. I would have paid a million dollars if I had to: he was, despite everything, my father. And if anything happened to him, it would kill me.

One of the bounty hunters ran to a bank to pick up the money, while the rest of his men stayed in position around the house. When he returned with the money in his hands, they all left.

I never thought I'd see the day where I had to save my father's life. After that, our relationship seemed to reverse itself. He started to reach out to me more, while I pulled away. I felt used by him. It seemed like he was only calling me now that I had the money to save him and put him up in a half-million-dollar house in Florida.

Soon after, my father moved in with a rich woman in New Jersey, and basically became a kept man. When he told me he was driving a brand-new Harley and wearing a gold Rolex she had bought him—without even halfheartedly offering to pay me back the money I'd wired the bounty hunters—it only confirmed my disappointment in him. He seemed to have hit rock-bottom as a human being. So for several months, I simply stopped talking to him. Fortunately, I was on the road, where escape from all trouble was only a bottle and a pill away.

Chapter SIX

The memory of the bounty hunters began to seem like a distant dream as Nikki and I continued to numb ourselves on tour. We became so close that sex seemed unnecessary. We got our fix onstage. If one of us either left a club with someone else or brought someone back to the hotel room, the other would be mad. I found that out the hard way.

In New York, Roadie Boy spiked my drink with Ecstasy, which was a terrible experience. I don't like the drug, and would never take it intentionally. When it hit me, we were at the China Club and Derek Jeter was hitting on Nikki and me. He bored me, so I went to talk to Joe Montana, who looked like he was a hundred years old. He could hardly move from all the beatings he had taken in his heyday. When he put his hand on my leg, I realized two things: the first is that I should never be in public on Ecstasy and the other was that I should have stayed with Derek Jeter.

The next day the tabloids reported that Joe Montana and I were having an affair. But what actually happened was that I went back to the hotel to have sex with a woman instead (Paige Summers, a *Penthouse* Pet of the Year whose heart mysteriously stopped in the middle of the night following a routine surgery shortly afterward). Nikki ended up fooling around with a guy from the Minnesota Twins. The next morning we had a platonic-lovers' quarrel and didn't say a word to each other for days.

After that, we made a deal: we could only bring someone back to the room to share in a three-way, which was highly unlikely considering

that we never even slept with each other anymore. We had only tried to have a threesome once before, in Los Angeles years ago, and it was a disaster. A very forward girl at a bar threw herself at us, and started talking about sex and how much she loved women. She was beautiful, with raven hair and mammaries that could crack nuts, so we took her home and got right down to it. Nikki and I were very sexually aggressive with each other, and the other girl suddenly panicked, gathered her clothes, and ran out the door without even a kiss good-bye (or hello). We still have no idea how she got home, because we had given her a ride to Nikki's place. Afterward, I realized that the mistake was ours: we believed her boasting, and ignored the cardinal rule of starting things slowly.

After our pact, the only person I remember ever trying to take home was Damon Wayans. We were at the MAGIC clothing convention in Las Vegas, and decided to down a liter of Grey Goose and go to a hip-hop club. We were the only white people in the place, and we were so fucked up we didn't care. And because we didn't care, no one else seemed to mind either.

Not long after we arrived, I spotted Damon Wayans sitting on a couch, looking hellafine. So we walked over to him, sat down on either side of him, and started blathering nonsensical drunk talk. When we started dancing for him, he was remarkably laid-back considering how out-of-control we were.

"Damn," he said to me. "Look at that body."

"But I don't have a butt," I protested.

"You've got enough ass for me," he said.

We ended up jumping in his limo and going to his suite at the Bellagio. Nikki and I flopped down on his bed and started making out while he sat there coolly and watched. I'm rarely forward, but I had been mixing alcohol with the pills, so I was feeling frisky. I looked up at him and demanded, "Kiss me."

"I can't," he said. "That's just not me."

"You know you want to," I persisted.

"You have no idea how much I want to."

"Then kiss me."

I crawled to the edge of the bed, and his face met mine halfway. All we did was kiss. Immediately afterward, Nikki and I got up, left the room, and stumbled out of the hotel. We checked into a run-down little fifties motel called the Tam O'Shanter, which was my idea because when I was a teenager, I used to go to parties there in room 22. We checked in and ordered pizza, but by the time the pizza guy arrived, we had both passed out on the well-stained carpet.

As soon as we returned to our regularly scheduled tour together, I got dosed again. I was stupid enough to accept a glass of champagne from a guy, and there was something in it—either GHB or Rohypnol or Ketamine. Afterward, I was walking backstage and the hallway began to curve and stretch. When I got to the dressing room, I looked in the mirror and my pupils had tripled in size and were convulsing epileptically. I lay down under the makeup table and passed out. When Nikki woke me up for our next show, I was gone.

"I can't go out there," I told her, my voice aquiver. "I can't walk."

"Don't worry about it, honey. Just stay with me."

"No, you don't understand. I can't walk."

"Okay," she said, bending over. "Wrap your arms around my neck."

She dragged me behind her, my useless legs trailing against the cement floor. When we neared the stage and the industrial version of "Do Ya Think I'm Sexy" by the Revolting Cocks started, Nikki was seized by adrenaline and took the stairs too fast. I lost my grip on her and tumbled down the steps. I hit the stage like a starfish, and just lay there. The music slowed to a crawl in my mind and the lights seemed to flicker on and off, though it was probably just my consciousness flickering on and off. Nikki grabbed me by the foot and dragged me behind her for the entirety of the song. No matter what happened, we never missed a show.

Now, I always wonder if Roadie Boy was responsible for all the times I was dosed on the road. His behavior was getting stranger every

day. He'd use my name to get everything he could for free—club entrance, drugs, tattoos, first-class plane tickets. And if my name wasn't enough, he'd forge my autograph on an eight-by-ten to use as barter. He constantly wore the laminated passes he made for the tour around his neck along with Tool and Mötley Crüe all-access passes, even though he didn't need them to get around the clubs. The only place they provided him access to was the legs of strippers. He'd tell these eighteen-year-old girls that he was the road manager for Mötley Crüe, promise to take them backstage to meet the band next time he was in town, and then end up in the bathroom of the club taking Polaroids while he had sex with them. He had a whole scrapbook full of his conquests.

If bands wanted to meet me, they'd have to go through him first. So he'd take the opportunity to make a deal with them on the down-low. He'd promise them discounted T-shirts and merchandise, and then take off with their money. He would also have the guys in Tool leave messages for me on my phone. At first it seemed somewhat cool, but I slowly began to suspect that these guys leaving messages weren't really who they claimed to be. In fact, I don't think my roadie had ever worked for a band in his life.

When someone is on the road with you, they are in your inner circle. They become as close to you as family. And, even though his mounting bar tabs, hotel-room phone bills (which were eight hundred dollars one night), and Ecstasy-popping should have been a sign, I didn't see the truth until it was too late. I was willing to overlook a lot of his indiscretions, because he was working in exchange for nothing but his expenses. Besides, I didn't want to think I had been betrayed by one of the few people I had let into my inner circle.

The final blow came when he offered to get me a deal on custom-built road cases for two thousand dollars. My accountant sent him the money, and we never saw a thing in return. On top of that, he had promised my accountant seats at a Rolling Stones concert, and my poor accountant ended up stranded at will call with no tickets at all.

So Nikki and I sat down one day before a gig and decided to count the number of Polaroids we posed for that night, since he collected the money. By closing time, we had taken 150 pictures at twenty dollars each. But when it came time to pay us, instead of three thousand dollars, he gave us fifteen hundred dollars. No wonder the guy didn't want a salary: he was making much more under the table.

When we had a week off from the tour, I called Roadie Boy and told him we didn't need his services anymore. He went berserk. I gave him all the reasons why I didn't want him working for me, and he had an excuse for each one and flat-out denied stealing from me. When that didn't work, he threatened to ruin me. "Take a walk, mother-fucker," I finally told him. "You're lucky I'm not having your ass beat."

For weeks afterward, he called Nikki, Joy King, and everyone I knew, making all kinds of threats. Then he talked to the porn gossip sites, telling them I was a bitch and a junkie and a painkiller addict. It didn't matter whether he was wrong or right—or in this case half right—what mattered was that he was doing it out of spite, to hurt me. Months later, a certain band contacted me. He had used my name to meet and fleece them.

"We are going to do something about this situation," they said. "And we are going to do it our way. Do you care?"

I gave them my blessing.

Chapter SEVEN

M y mother was born on April 24. And every year on that day, I stay home and think about her. It was always strange to me that since her death, her side of the family had shunned my brother and me. They didn't go to her funeral; they didn't help my father pay her hospital bills; they didn't even offer to babysit us while he worked. I was able to forgive them for this, but my brother and father never could. Maybe it was because I was so young that it didn't affect me as much.

Whenever I asked about my mother's parents, my father and brother told me they were bad people and I shouldn't talk to them. So eventually I put up a wall and pretended like they weren't part of my life.

But once again, on what would have been my mom's fifty-sixth birthday, my thoughts turned to them. My father had called me just a few weeks prior. It was the first time I had spoken to him since I'd saved him from the bounty hunters. He phoned to tell me that his mother, who had nursed me to health with gobs of butter when I was withdrawing from meth, had died. After a long battle with cancer, the disease had spread to her lymph nodes and then throughout her body. She had been the closest thing I'd had to a mother, even if she did sometimes steal Tony's coke. And to also lose her to cancer was devastating.

My father was still playing boy toy in New Jersey. My brother had stayed in Florida with his wife and his son, Gage. Tony was going through a hard time. He had become a successful dry-waller, but his

Opposite: With Pam Anderson.

back started acting up and he was no longer able to work and support his family. So he decided to make a living as a tattoo artist, even though he'd never held a tattoo gun before in his life.

With my brother and father so far away and wrapped up in their own problems, my thoughts turned to my mom's relatives, especially her mother, who I remembered loving so much when I was a kid. I told Nikki all about it.

"Just call your grandmother already," she said.

"I don't know if I can. It's been awhile, and I feel bad."

"You can't be a coward about this," she said. "You have to do it, or you'll feel guilty your whole life."

My grandparents had always lived in the same little house in Las Vegas with the same telephone number. I picked up the phone and dialed the number.

"Hello," came a man's voice on the other end. It was my uncle, Dennis.

"Hi, Dennis, it's Jenna. Is Gramma there?"

There was silence on the other end.

"Hello? Dennis?"

I listened closer, and he was crying. "Jenna," he finally said. "Gramma is dead. She died two weeks ago."

"Oh no. What happened?"

"She had ovarian cancer."

When he said the word cancer, it touched a self-destruct button in me and I just started bawling. I blubbered, "Thanks, bye," and quickly hung up. I couldn't even talk to him. And I haven't talked to him since.

Months later, I tried to call and the phone was disconnected. There was no forwarding number.

I have few regrets, but one of them is not being there for my grandmother when she was sick and dying, because her pain must have been as severe as my mom's. To this day, I still beat myself up for not calling even once in all those intervening years to say I loved her

and forgave her. She probably died thinking that I hated her and abandoned her.

After that call, I had a panic attack. I was sure that I was going to die of cancer at an early age, just like my mom. And that meant I had just a few years left to make a family of my own. I couldn't keep escaping from the responsibility and commitment of adulthood by finding excuses to stay on the road, otherwise I'd end up no better than my father. Besides, Nikki and I were beginning to get on each other's nerves. I was ready to haul off and punch her if she fell on me one more time onstage. It aggravated me, and it hurt—she was practically twice my size.

So I relented and started talking to Jay more often. I had been avoiding him, because I felt that he was someone I could fall in love with. But he was there for me when I needed him, like when the bounty hunters were after my dad. We started having friendly conversations more often, and I felt a yearning to see him again. I wanted to have fun with him. I wanted to hold him. I wanted the friendship. I wanted the sex. I needed to stop hiding and settle down.

Tommy was still on the road with Mötley Crüe, and I happened to be finishing up my tour in Vancouver when he was playing there. I went to his concert, and he sat me just out of sight behind the drum set. In the middle of "Home Sweet Home," he turned around and pointed his drumstick at me. I felt nothing. And that was when I realized that I didn't love him.

He was just a fun distraction. I liked living on the edge with him, but he was in love with Pamela Anderson and always would be, no matter how much he said he hated her for putting him in jail and trying to take away the kids he loved. (Strangely, when I met Pamela a year later at the MTV Video Music Awards, she ran up to me like an old friend; when I told her that it was nice to finally meet her, she said, "Oh, we haven't met before?")

Later that night, Tommy came to see me dance. While I was doing my Polaroids, he kept kissing me and hanging all over me. I don't like

guys doing that out of the club, and I certainly don't enjoy it while I'm working. It makes me uncomfortable. To top it off, Tommy had told Howard Stern on the air that I was his new girlfriend. It was touching that, unlike most other celebrities I'd met, he wasn't just after a clandestine one night stand that he'd deny later. But I was still incensed (as was a certain listener in Phoenix).

It felt weird to have Tommy clinging to me all the time. I had been such a big fan of his as a teenager, but his neediness took all the mystique away. When all the people you used to idolize are hitting on you, having a crush on anyone becomes impossible—because no one is out of your league.

I had always found it very cool, for example, that Sylvester Stallone had never hit on me at Planet Hollywood in Bangkok. But then I saw him again when I was eating with Joy at a club called Barfly in Los Angeles. He sent a bottle of wine to our table and invited us to join him. But when we did, he was so forward that it made me uncomfortable. He couldn't seem to tear his eyes away from my breasts. The next day, Joy and I ran into him with his wife or girlfriend at a Cirque du Soleil opening in Santa Monica and he shot us a look begging us to walk past like we didn't know him.

After that, I realized that I was turning into a person I didn't want to be. I was acting just like my dad did when he drifted from partner to partner after my mom died, looking for some way to lighten the responsibility of life without investing any extra emotion into someone else. I didn't want to be another girl on Tommy's list, or the next in a long line of blond bimbos for some other star. I wanted to achieve the one thing I had always really desired, which was to have a family.

Ever since I was a teenager writing in my diary, I'd wanted to be a wife and a mother. It was never something I could explain intellectually; it was simply a gut feeling, like the urge to get pregnant when I lost my virginity. Perhaps I just wanted to know what unconditional love felt like, to look into the eyes of my own baby and make his or her life wonderful in all the ways mine never was.

When Nikki and I finally wrapped up our tour, we were just barely on speaking terms with each other. At our last show, our nerves were so frayed from exhaustion, alcohol, and drugs that we were at each other's throats. She accused me of stealing money from her at one point, and it took every ounce of self-control I had to keep from bloodying her face with my heel again. So when we returned home, I slept for the first time in the loft instead of in bed with her.

As I lay there alone that night, I realized that I had become a complete addict. I'd take so much Vicodin some nights that the next day I couldn't even remember where I'd been or how I'd gotten home. My stomach ached constantly, I had dramatic mood swings, and the drug no longer gave me any sort of euphoria. I was just an aching bundle of exposed nerves.

I recognized the path I was heading down, because I had been there before. The drug just wasn't worth all the trouble it was causing. I needed to get it—and this whole partying-to-make-up-for-my-missed-adolescence thing—out of my system. So I just said, "No more." Then I popped three pills and went out and partied. The next afternoon, I said "No more" again, as I did on the following afternoon and the afternoon after that. Finally I just grabbed my huge tub of white Vicodin footballs and dumped them down the toilet with the same conclusive certainty I had dumped most of the men in my life since Jack.

For days afterward, I had the shakes and every single part of my body ached. It felt like someone had beaten me about the back, knees, and head with a truncheon. Though withdrawal can last for months, I was done in a week. And I was done with my crash diet too. Vicodin is supposed to slow down the body's metabolism, but it seemed to have had the opposite effect on me. I was so bony I made Kate Moss look like Carnie Wilson presurgery. My lettuce-and-Power-Bar-diet was officially over.

When my head cleared, I looked at Nikki and realized that she was beyond gone. She was bloated from drinking and partying, and wasn't

going to come out the other side anytime soon. This was largely because she had started seeing another loser guy. He had moved into the apartment, and I was tired of it. She just couldn't stop the cycle, and I wasn't going to let her suck me in again.

Chapter EIGHT

I packed my bags, left Nikki's house, and stayed in West Hollywood with a friend named Holt, a movie producer who I had met in Florida. I was homeless again. And my career, my life, and my environment seemed to have gone completely stale. In the process of running away from myself, I had thrown it all away. I was too old to live like this.

I told Jay all this on the phone one day, and as soon as I mentioned that I needed to change my surroundings, he said, "I'm on my way. I'm taking you out of there."

He packed his dog Caesar into the back of his Range Rover, and drove in from Phoenix that day. It was so romantic; he was rescuing me. I packed one little Louis Vuitton suitcase, threw it into the backseat of his car, and never looked back. Two months later, we returned to L.A. and fetched the rest of my belongings from Nikki's house.

People have always told me that when you meet the person you're supposed to be with, you'll know right away. And Jay proved that he was the right guy every day. We were similar in so many ways, especially our ridiculous sense of humor. On the outside, he was an arrogant jock; but on the inside, he was a wily little prankster, kind of like a perverted Bugs Bunny. He'd do things like pay our friend Duane one hundred dollars if he'd let a girl shove an Altoid up his ass and leave it there all night. (Strangely, Duane seemed to like it.) He made me laugh and feel like Jenna Massoli, and I began to lower my guard and tell him things I had never told anyone.

I had never been with a man who was able to make me feel safe before Jay. During a short feature dancing tour, a man in his thirties started slipping me threatening letters after my shows. One night in Seattle, I woke up to the sound of him pounding on my door. I called Jay and told him that I was scared and didn't know what to do. Within half an hour, he was on a plane to Seattle.

Gradually, I began to get comfortable with Jay, to love the little things like the way he'd tiptoe around the house in the morning trying not to wake me or begrudgingly let me do emasculating things to him like plucking his eyebrows and giving him facials.

The only problem was that I wasn't comfortable being comfortable. It wasn't a feeling that had been part of my reality in the past. Since Jack, I'd been emotionally incapable of settling down with someone and letting my guard down, because it meant giving someone the opportunity to have the upper hand over me. Yet my entire hopes and dreams rested on settling down and having a family. So with everything going so well with Jay, I was determined to break my own cycle. It proved to be a lot harder than withdrawing from Vicodin, because running away was a habit that had been reinforced for so many more years.

So I began to question and doubt things, which was poison to the relationship. Jay is a dominant man. It's the only way he knows how to act. So every time he tried to control me in any way, I pulled away by instinct. One of our more unfortunate similarities is that we both have a fierce temper—he's an aggressive German and I'm a hotheaded Italian—so our happiness slowly became punctuated by fights. And after every fight, I'd leave him. It was a trait I'd inherited from my father: when in doubt, pack your bags and go.

But Jay never called and begged for me to come back like every other man. Instead, he'd change the locks on me. If I was gone for more than a few weeks, he'd have someone find me and try to talk me into coming back, because for some shady reason he knew people in every state. We loved each other, but we were completely devoid of the communication skills that could solve our problems.

Eventually, a friend of ours named Gary intervened. He checked us both into a hotel around the corner from Jay's house, and counseled us for three days straight. To make the relationship work, he told me, I needed to stop trying to make every guy I dated compensate for all the love my father and Jack had never given me. I needed to be less needy. I needed to accept his status as the alpha male of the house—or at least pretend to. Most importantly, I needed to realize that running away every time we fought over something trivial was not a constructive way of getting attention.

At the same time, he told Jay to start listening to me more, to apologize when he was wrong, to offer me some semblance of emotional stability, and to find a way to compromise on our differences of opinion—all without losing what he thought of as his power. I suppose almost every problem in a relationship, whether it be romantic, political, or creative, comes down to power—who has it and who wants it. I came away from the meeting with the realization that I needed to be with someone who was as dominant as he was, but who also had my best interests at heart. And that person was Jay. He had everything I wanted in a male, except maybe sensitivity.

We went through a small period of paradise after the intervention. In fact, we couldn't keep our hands off each other. Fooling around in public places became our favorite pastime. We had sex in the middle of the day in the crowded pool of the Delano hotel in Miami, in the changing rooms at Victoria's Secret in Beverly Hills, and in a dozen restaurants, from Bed in Miami to Balthazar in New York.

As my relationship with Jay deepened, Wicked began slipping farther away. Beyond Joy's friendship, I didn't feel like the company was in my corner anymore. Steve, who had married Joy's sister, was juggling so many contract girls that he hardly had time to return my calls or ask permission for anything he was doing that involved my name.

The tipping point came when Steve hired a guy to take care of the websites he owned, which included my site. The guy kept calling and asking for my social security number, my conversion rates, my reten-

tion, and other pieces of financial information that were none of his business. I constantly told Steve that I didn't trust this guy, but Steve didn't do a thing. I did some number-crunching with Jay, and nothing seemed to add up correctly. It was clear to us by then that the Internet was not just about promotion, but potentially a massive source of profit—when it comes to early adapters, the porn industry always gets to new technology first. So I made one last try to reach Steve.

"He's ripping me off and he's ripping you off," I told him. "I've helped build this company on my back. And maybe I could tolerate it if the money was going to you, because you worked your ass off to make me who I am. But I will not stand by and watch this chintzy-ass motherfucker get rich off me."

Steve didn't back me. He just let it go. The guy will not confront anyone. Between the website and the new girls who kept streaming into the company, things were getting uncomfortable at Wicked. They now had eight contract girls, only two less than Vivid.

And so, like most of my relationships, as soon as I saw the warning signs, I decided to leave before something worse happened. Over the years, I had noticed that women in the adult industry didn't seem to be valued. The stars were just disposable products with a shelf life of a few years. If women wanted any respect—especially in an industry built on their objectification—they needed to be more than just a pretty face on a box cover. Every big adult company was run by a man. I was talking with Jay about it, and we realized that there was absolutely no reason I had to work for anyone else once I left Wicked. I could blaze a path I had seen no other woman take and start a successful company of my own. I could run my own website, produce my own content, call my own shots. I could be not just a porn star, but a porn CEO.

However, before even attempting the potential nightmare of starting a business, I wanted to leave Wicked with dignity, because they had done so much for me and, until recently, never even came close to betraying me.

So I met with Steve. He sat at his desk as he had five years earlier, obscured behind disorderly stacks of paper. He didn't seem to have aged a day. His eyes twinkled no less brightly and blinked no less nervously.

I told Steve that I loved him and appreciated everything he had done for me. But it was time for me to leave the nest and see if I could better myself.

The last words I said to him were, "I'd like your blessing."

And he said, "Jenna, I want you to be happy. I don't want you to ever feel like you are being forced to do something against your will. So go and do your thing."

I hugged him, knocking half the papers off his desk in the process, and turned to leave the office.

"But remember," he said before I reached the door. "You still owe me one more movie."

I wasn't just leaving a company, I was losing my best friends. Joy and I managed to remain close, but Steve and I never talk anymore. It breaks my heart, and I know it breaks his heart, too.

Chapter NINE

Since it was Wicked's last chance to cash in on me, they decided to make my final film their biggest budget production ever. It was called *Dreamquest,* a special-effects-laden *Chronicles of Narnia*–style adventure tale (minus the biblical allegories) about a woman's quest to save male fantasy. It was to be helmed, of course, by my ex-husband, Rod.

People always wonder if it's hard for me to sleep with guys I don't love on screen. The truth is that it's hardest on the guys I'm dating. I can rationalize the sex if I have to because it's work and I can disconnect myself. But there are few guys who can handle imagining—and knowing that other people are seeing—another man inside the person that they love, pumping away as she screams the exact same screams they hear in the bedroom with her. Thus, the challenge for me in having sex on camera is the rare instance when I know that, because of it, someone I love may be suffering.

And so it was that my brief period of domestic tranquillity came to an abrupt end. All hell broke loose. Jay was so adamant about me not sleeping with anyone on screen that he made Jordan seem like a swinger in comparison. A side came out of him that I had never seen before. He even took my picture out of the frame on his nightstand and replaced it with a photo of Chasey Lain.

One day, as we were driving to dinner in his Range Rover, he had me so wound up that I kicked the front windshield with my shoe hard enough that the glass shattered. I've always been a kicker, and in that

period with Jay I also put my foot through a TV set and a screen door. I was constantly smashing stuff. The only problem was that it was usually my stuff.

Stomping out of the house after one of our fights over the movie, I returned to discover that Jay had changed the security code on the gates. I took off my heels, climbed over the fence, and ran half a mile up to the front door, but my key wouldn't go in the lock. He had poured liquid cement in it. I called him on my cell phone, demanding that he let me in so I could get my clothes and leave his ass for good.

He refused and threatened to kill my dogs and burn my clothes. Then he threw everything I owned into boxes, destroying most of my dresses in the process, and left them in the driveway. I gathered my things and flew to Los Angeles.

I wished so badly that I hadn't procrastinated on that last movie, and had just filmed it while I was on the road with Nikki. But I was stuck. After all these years and all these movies, it was supposed to get easier, not harder. When I was in my hotel room waiting to start shooting, Jay called.

"Jesus Christ, what?!" I snapped into the receiver.

"Listen," he said. "There is not going to be a big fight this time."

"Good."

"I'm just going to drive over there and get you. And then I'm going to make you pay for this. I'm not going to allow any of this to happen anymore."

"What the fuck is your problem?"

"It's over, sweetheart. You'd better start running, little girl."

We were on the phone for hours. The conversation was so brutal that I cried myself to sleep. He was so hurt that his voice shook. And it wasn't a crying kind of hurt, it was an angry hurt. I wasn't sure if our relationship could survive this.

The next day on the set, Joy was so sweet to me. She thought that if she could make the shoot a great experience, I'd stay at Wicked. She hadn't accepted the fact that I was leaving, and that for the first time

in years, I hadn't confided in her. She had no idea what I was going through. Rod, in the meantime, was still at the top of his game as a director but at the bottom as a human being. He was already dating the newest Wicked girl, Stephanie Swift, and the only consolation I had on set was watching her tell him to shut up just like I used to.

For Rod, like any director, making the perfect movie took precedence over everything else. And because my trauma with Jay was getting in the way of my performance, he did whatever he could to sabotage my relationship. "Give me a fucking break," he kept saying. "You're not going to last six months with that guy. This film is going to be around forever. So let's just make the best movie possible."

Even things that appeared to be unintentional on set took on extra significance, whether Rod was putting me in a lesbian scene with Asia Carrera or accidentally using lacquer paint instead of makeup glitter on my face. I was so freaked out before my one and only boy-girl sex scene that I kept throwing up into the wastebasket in my trailer. I didn't want to do it. I tried every possible excuse beforehand, even suggesting we use a stunt double, which I still think could have worked if anyone had cared to try.

Afterward, every cell inside my body was screaming, "Run." I didn't want to go home. I knew that if I returned to Phoenix, I was in for a shitstorm. But I'd spent the past year running. I wasn't going to allow myself to do that anymore. I wasn't going to fall into the pack-my-bags-and-never-look-back trap that seemed to be my biological destiny. So I summoned every reservoir of courage I had, and got on the flight back to Phoenix. Jay had told me to find my own way home, so I took a cab.

When I unlocked the door of our house, he was sitting on the couch in silence, just like my dad had been when I came home from the boat trip with Jack. I sat down in a chair across from him, and we just glared at each other in silence. With every second that passed, I could feel his anger building like a steam kettle about to boil.

After an hour, he finally looked at me and said softly, but with days of repressed venom trembling in his voice, "How . . . could . . . you . . . be . . . such . . . a . . . whore?"

Once that word comes out of a guy's mouth, all rationality goes out the window for me. Within moments, we were in a huge screaming match, both damning each other to hell.

When my volume failed to shut him up, I became violent. I started smashing things. I kicked, toppled, broke, and threw anything in the house I could reach without a ladder. I think that, subconsciously, I believed that if I lost my temper, I could distract him. If I became psycho or broke my hand hitting a wall, I could change his focus to trying to calm me down or take care of me, instead of berating me for having gone through with the movie.

When he stormed out of the house, I picked up the phone and booked a three-week dancing tour. I had at least tried to face him and make it work. But now it was time to give in to the pack-my-bags instinct. I was probably in L.A. before he even returned home.

On tour, I stayed in the most expensive hotels, rented Ferraris in every city, and racked up over $40,000 on my credit cards. But for the first time, making money didn't cheer me up. I didn't know what to do. The answer to my problems was so obvious that it eluded me. It was like trying to find a lost hat that was on my head the whole time, because the only thing that was going to make me happy and complete again was to be with Jay. He was constantly on my mind. I was so sad and broken without him. After the way he had so immaturely dealt with the movie situation, I wanted nothing to do with him logically. But love is not an intellectual decision. You can't look for it or hold on to it or run away from it. It comes and goes according to its own wild inclination, completely out of our control. All we can do is recognize it when we feel it, and try to enjoy it while it lasts—be it for a day or a lifetime. I was trying to fight it because I had taught myself, like most people, to fear love, because it makes me vulnerable.

One evening, I worked up the courage to pick up the phone and call him. "You know what, baby?" I began. "I'm tired of running. I want to come home."

And he said, "Yeah, it's time to come home."

I blew off my last gig and booked a flight that night. When I saw him, I ran into his arms and he wrapped them around me. I felt safe. His anger had resolved itself into resignation, and then acceptance, and finally love. It was like everything that had taken place between us in the past six weeks had happened to two entirely different people.

We went home and talked about everything. In my absence, he too had realized that he loved me enough to want to make the relationship work, and knowing how much I had also been hurt had helped, along with time, to heal his wounded pride. We discussed not just the movie, but also the game-playing, the running away, even the dirty dishes and his long hair, which had to go.

I'd never sat down and had such a rational, productive conversation with a boyfriend before. By the end, we came to an understanding of what each other's boundaries were. I went to bed that night not elated, but resigned to my fate. Because no matter how hard I'd tried in the months before, I just couldn't fall out of love with the guy.

Chapter TEN

In myths about everyone from Hercules to the Buddha, rewards do not come without a struggle. There are labors to be undertaken, tests to be passed, hardships to overcome. Happy endings are the product of tragic beginnings. Jay had withstood (albeit not entirely heroically) his test when I went away to film *Dreamquest*. It should not have come as a surprise to me, then, when one morning, in the midst of our newfound bliss, Jay spoke four little words that shattered my world.

"I have to go," he said.

"Where?" I asked. "And for how long? A day? A month?"

"I don't know yet."

"But everything's been so wonderful. We've been having so much fun."

"Jenna, I've lived a crazy life," he said. "And in that crazy life, I've made some mistakes and some enemies. I've fallen in love with you, and I want this to last. And the only way to do that is to take care of these ghosts from my past, because otherwise they are going to haunt both of us."

"So what does that mean?"

"I told you," he said. "I have to leave, and I can't tell you where I'm going. All I can do is promise that I'll be back."

"Is it about another woman?"

"It's about business."

"Why do you have to go?" I blubbered. "Everything's fine."

"Because if I don't take care of this now, it could come back later and really hurt us. I will never be happy with you or able to have a family if I have to worry every day about my past catching up with me. I don't want to put you through any more pain."

"Then don't go. Get out of it."

"I can't," he said. "I have to deal with it. And then everything will be okay. It's just a pothole, it's not the road."

I was flattened. The whole scenario reminded me too much of my father and his secrets, and everything I had gone through when he was on the run. I couldn't take it—not from the man I loved, not after all we'd been through, not again. But I had no choice.

Just like at Vanessa's funeral, I refused to cry. I wanted to be strong for Jay. So I stuffed all the emotion down and let him go. I booked as many photo shoots as I could to keep myself busy so that I didn't have to think about him. But, of course, I thought about him every day. I was living alone in our newly furnished house in an unfamiliar city. His ghost haunted everything. When I went to bed, his unflattened pillow lay next to mine. When I watched television, even the sports channels on the remote-control presets reminded me of him. I survived only because my mind never wavered from one simple conviction: he loved me. And I loved him.

After a week, Jay's brother stopped by the house with a note for me. He had removed it from its envelope, so I had no idea where it had been sent from. I opened it that night and cried simply from reading the first two words: "Dear Jenna."

Jay poured his heart out in the letter, in a way he never had before. "I think of you every moment," he wrote. "I think about how beautiful you are when you're sleeping, like a little angel. And I think of the blond peach fuzz along the curve of your back. I can't wait to come home and kiss every inch of your little face."

There was page after page of tenderness and affection, tinged with the hurt of being apart. It gave me chills. I'd never heard those kinds of words come out of Jay's mouth—and, to this day, I still haven't. I

couldn't get out of bed for days afterward. I was lovesick. Soon after, another letter came, followed by another two days later. After three weeks, I had a stack of six unopened letters. I couldn't bring myself to read them. I knew they would make me sick again and send me into a downward spiral. I suddenly realized the difference between genuine heartache and obsession, which was all I had really experienced with Jack. And the key difference was trust: I had never trusted Jack. I trusted Jay. For all our problems, he had always been there for me. And when he left, it had been with the intention of strengthening the relationship, not weakening it.

After a month had passed, he came home as suddenly as he had left. When I saw him, my body literally shook with emotion. It wasn't just because of the truism that absence makes the heart grow fonder, but because I knew I had done the right thing by waiting. It was so out of my character not to question the feelings and intentions of someone close to me, but, against my nurture, I had, for once, stood by my man. And Jay, in his absence, had changed too. He was still a charmingly irritating bastard, but he was much more sensitive and demonstrably in love. It was time, finally, to begin our life together.

And so Jay and I became not just lovers again, but business partners. After leaving Wicked, I had no intention of selling myself to another master—I was well known enough to try to live out my new dream of running my own company. I knew Jay had above-average business sense, because he and his brother were both retired by the time they were in their thirties. In one of their get-rich-quick schemes, they bought every phone number that was close to 1-800-CALL-ATT. This way, if anyone misdialed the number, Jay's company put the collect call through and kept the profit. The company was called Fat Fingers.

It took us a year to start Club Jenna, rent an office, hire a staff, and chase down all the assholes who had registered my domain name. Much to my surprise, one of the assholes who had registered one of

my most popular domain names was someone I knew: the uncle who had done me wrong on the strip-club deal in Anaheim.

I expected that since I hadn't made many movies recently, I'd have to start from scratch. But somehow I was still the most downloaded person online. And even though Jay and I didn't know the first thing about the Internet, Club Jenna was hugely profitable in its first month. So what began as a business created just to prove a point soon became a female-run success story as I added the websites of other girls (twenty-five and counting at present) under the Club Jenna umbrella.

When I stepped back and looked at my life, between my increasingly co-dependent relationship with Jay and the new company we were starting together, I was taken aback. It all seemed so far out of my character, because in order for everything I had put in motion to succeed, I needed to remain stable and in one place. And that scared me. It wasn't long ago that I was getting wasted on the road every day with Nikki, avoiding anything that smelled of responsibility. These newfound duties seemed so sudden, and to protect me from my worst enemy—myself—I needed extra support. I still didn't have any friends in Phoenix, so the first person I thought of was my father. I wanted him to be involved, in some way, in this new life I was building for myself.

My father and I had hardly spoken in the eight or so months since the bounty hunters, and it didn't seem right to just shut him out of my life. In childhood, you think that your parents are perfect; in adolescence, you realize that they're not; and adulthood, I realized, means finally accepting them for what they are, flawed human beings just like ourselves. So I sucked up my pride and called him at his gilded cage in New Jersey.

"We shouldn't go this long without talking," I told him.

"I dreamed about you last night," he replied. "And when I woke up, I knew you were going to call. I dream about you all the time."

There was not just love in his voice, but a hint of sadness. It was a strange emotion to hear coming from him. But the real surprise came

moments later. "And I want to thank you for the help in Miami," he continued. "I don't know if I ever actually thanked you properly. I think it's because I was embarrassed that I had to ask you for help. One of the most humiliating things for a father to do is to beg his own daughter for money."

"I miss you," I said as I choked up. "And I realize that it's partly my fault this time, because I haven't been calling you back, so I apologize."

As we talked, the sadness didn't leave his voice. He sounded defeated. I assumed he was just paying the soul tax of sponging off a wealthy woman who he didn't love, but it went deeper than that.

"I need to have surgery next week," he said when I asked him about his mental state.

He said that after he moved to New Jersey, he was constantly tired and thirsty, no matter how much he slept and drank. Soon after, his hands and feet would go numb. And then, one day, he woke up and everything was blurry. No matter how much he tried to focus, his vision wouldn't clear.

He finally relented and went to see a doctor. And that was when he discovered that he was diabetic. He ran a risk of going blind, they said, and he needed to have surgery in a few days.

Languishing up there, a kept man with no health insurance of his own, he also, it turned out, had realized the need for family. We never seem to admit these things to ourselves until it's almost too late, until all of our mistakes have already been made.

So I started calling my dad more often, like a worried mother. We talked weekly at first, and then finally every day.

Oddly, it didn't feel strange or unnatural to suddenly be talking to my father on a daily basis. It just felt right.

Chapter ELEVEN

I had decided after leaving Wicked that I was through with adult movies. My plan was to just shoot dancing and masturbation clips for the website. But with Club Jenna becoming such a success and Jay beginning to direct more porn, we decided to start a production company. And this meant that I was going to have to get in front of the camera again.

I told Jay I'd only do girl-girl scenes, but we quickly realized that the only way these films were going to be bestsellers was if I did boy-girl scenes as well. Since there was no way I was going to be with another man on camera again, there was only one option open to us: Jay was going to have to step up to the plate and do it himself. To my amazement, this was something he had actually thought about already and was willing to do—as long as he could wear a mask to disguise himself. I warned him that when 200,000 copies of a video of him having sex hit the stores, it could affect his life and his family anyway, but he was adamant about it.

I had met Briana Banks on the set of an all-girl movie, and instantly saw star quality. In person, she was a goofy, loud-mouthed tomboy. But she had the ability to transform into a tall leggy goddess whenever the occasion called for it, on camera or off. I wanted to take her under my wing, like Nikki had done with me after our Suze shoot, so I decided to make her my co-star.

Jay directed the movie, which we named *Briana Loves Jenna,* and not only was he nervous, but so was Briana. She was literally sick with

Above left: With Briana.
Above right: With my assistant and friend, Linda Johnson.

fear about working with me. But once we started kissing, she transformed from nervous girl to sexual predator, which reminded me of myself when I did my first scenes with Randy West (though hopefully I sweated a little less than he did). Her kisses were so soft and sensual, and I'd never explored a better mouth—it felt warm, with a scent I vaguely recognized from my childhood.

When it came time for Jay and me to do our sex scene, we gave the camera to the assistant director, Jim Enright, who happened to have directed my first movies for Wicked. It was late and Jim had helped himself to a few cocktails, so he was a little tipsy. I painted the promised black mask over Jay's face, and we prepared for our scene. I'd never seen a guy primp so much in my life. He was an even bigger prima donna than me, and was petrified that I would take it personally if he couldn't get hard.

The entire process was weird and uncomfortable, partly because Jay was still directing, so he kept adjusting camera angles and lights right up until the word "action." Unbelievably for a first-time performer, Jay had no problem getting wood. But the sex didn't feel right because we weren't used to making love in such a cold, sterile, loveless environment. And Jay was very aggressive, which was fine in the bedroom, but I had to hold him back so I could perform a little.

Afterward, when Jay and I gathered around a monitor to watch the scene, we were horrified. Not only was the picture shaking from Jim's tipsy camera hand, but Jim had forgotten to hit the record button for Jay's cum shot. He missed it entirely.

We waited for Jay to get hard again, and filmed the pop shot once more. Two months later, when we were editing, we saw the scene for the first time. Everything looked fine until suddenly, when Jay was about to come, the camera zoomed in on my face. All Jim had filmed was a close-up of my cheek and half my lips getting splattered from some invisible source. Jay was livid.

All we needed was a pop shot, so Jay and I decided to film it ourselves at home. I did my own makeup, which was extremely difficult because I had to match the artsy tribal look that my makeup artist Lee had given me. In addition, I had to somehow make my hair look like it hadn't been growing out for two months. To get the camera angle right, Jay stood on a box so that his crotch would be at the height of my face. Then he jumped off the box, ran around to the camera, hit record, ran back to the box, jumped on top, and started beating off until, just when he was about to pop, the tripod collapsed.

He ran to the tripod, boner bouncing in the air, and tried to raise it. But it wouldn't stay up. He dashed to the kitchen, grabbed some duct tape, and jerry-rigged the tripod. Then he ran back and forth between me and the tripod, trying to line up the shot, boner still raging. Finally, he leaped onto the box, started beating his meat furiously, and then, just as he was about to come, he fell forward off the crate into me. I pushed him back and, with my hand propping him up, we

finally managed to get the pop shot. If we had ruined the scene again, I think he would have given up.

In the end, the effort was worth it, because *Briana Loves Jenna* went on to become the second bestselling adult movie of all time next to Marilyn Chambers' 1972 classic *Behind the Green Door.*

Ironically enough, we made a distribution deal for our movies with Vivid, so after all my bitching about being just another girl in the pack, I ended up as a Vivid girl anyway—but one who actually owned her own movies.

The shooting of our next film, *I Dream of Jenna,* went much better. We were finally relaxed enough to enjoy the sex like we did in the bedroom. Somehow, Jay had transformed into a natural performer. He must have been practicing while I slept. He fucked me in a dozen different positions for two and a half hours—without a mask, even. You can actually see my stomach contracting from all the orgasms I had while he was eating me out. Just before he came, he pulled out, popped on my butt, and then licked it up. He pulled himself up, grabbed my face, kissed me, and spat it into my mouth. I had no idea what possessed him, because he had never done anything like that before in bed. Measured by porn standards, it was the sign of a healthy relationship.

With Jay and Emma.

Chapter
TWELVE

I thought the nightmares would stop once I was secure and in love, but they didn't. They revisited me every time I closed my eyes, always replaying the same fear: being alone. When dreams recur, it is often because your subconscious is trying to tell you something. And one morning, I woke up and realized what it was: I was worried about losing my father. He was still ill; now he was having trouble with his prostate. I was consumed by a fear that he would die far away from me, and that we'd never have the chance to make up for all those years of running away from each other.

Talking to him every day wasn't really filling the emotional void I felt. It was good hearing his voice, but it made me miss him more each time. My brother and his family had moved up to New Jersey to be with my father, but it didn't alleviate the sadness and the strain in my father's voice. I started crying myself to sleep at night because I missed him so much. It was as if I was a little girl again, staying up all night waiting for my dad to come home.

It seemed strange to feel the emotion of missing him, because he'd never been there for me, but I couldn't help feeling a hole inside where a family was supposed to go. I started talking to Tony more as well. One of the main reasons our conversations were so awkward, I realized, was my fault: I was still jealous of his close relationship with my father.

Every time I went out with Jay and his sickeningly happy relatives, I thought of my dad thousands of miles away. I turned into

such a wreck that my therapist told me I had post-traumatic stress disorder. I translated that to mean a late onset of separation anxiety from my father. It was time for him to stop running around and start acting like the old man he was. So, as usual, I made the first move. I called him and said, "How do you feel about moving?"

"Do you mean it?" my dad asked.

"I've been thinking about it for a while. I mean it more than anything. Let's be a family again—you, me, and Tony."

"I'll tell you what. I don't want you to do anything for me. But I'm going to save as much money as I can and try to get out of here so I can join you."

Tony had tucked away enough money to open his own tattoo shop. Since nearby Tempe, Arizona, was a college town, he figured it would be easy to turn a profit. So he arrived a month later with Selena and his son, Gage. Tony and I had grown so far apart that it took weeks before we were comfortable enough around each other to become friends again. And once we were, it was such a relief, because I'd never truly let him back in my life since I'd cut him out of it for stealing my meth. All along, a piece of me had been missing and I'd never been aware of it until it was back.

In general, I never worried about Tony, because he was successful wherever he went and whatever he did. I always knew, somehow, that we would eventually come full circle and become brother and sister again. But I had no sense of certainty with my father. His life was constantly up in the air. He clearly needed a way out of his dependence on this older woman he was living with. If he was going to be a kept man, he might as well be kept by me. I had the financial means to do it, and perhaps I could learn to have the mental means as well. So I sent him a check and told him to pack up and get out of there. I was through with being away from him. It wasn't time to pick up where we had left off when I was fifteen, because we had never really started anything. It was time simply to begin.

When I finally saw my father, he looked so different. He had grown gentle, and had finally resigned himself to adulthood. I had never realized it before, but all along he had been a child, with two responsibilities—me and Tony—that he was too emotionally immature to handle. So he ran as far away as he could without abandoning us—both physically, by burying himself in his work, and emotionally. And when he got to Arizona, he instantly saw the change in me: his little drug-addled teenage daughter had actually turned out okay.

Sometimes I think it's not fair that I'm giving my dad a happy ending when he never really gave me a happy beginning. But I can't help caring about him in spite of everything. He could hurt me again, and I'd still go to the ends of the earth for him. And that's simply because, as fucked up as he is, he is all I have, and it makes me more comfortable knowing that he's close by. I may never have complete resolution with him. I've forgiven, but I haven't forgotten. There will always be a permanent scar and, though it hasn't yet healed fully, at least it doesn't hurt anymore. Besides, since I'm paying his phone bill, I know that his number won't be changing this time.

JULY

Jenna's Schedule

MONDAY	TUESDAY	WEDNESDAY
	1 Travel to L.A. Hustler freedom tour begins → Signing with LARRY FLYNT AT Hustler store	**2** SAN DIEGO RADIO INTERVIEW signing at Hustler San Dieg
7 TRAVEL to L.A.	**8** BOX COVER SHOOT FOR "Bella loves Jenna"	**9** Shoot stills for CLUB JENNA
14 Radio Show Promos. Travel back to Phoenix.	**15** WORK ON BOOK	**16** Travel to Los Angeles VH1 Interview
21 OFF! CLUB Jenna shoot, pickup day	CLUB Jenna Shoot DAY 3	**23** Meetings at ENDEAVOR
28 Content shoot with girls of Club Jenna	**29** WORK ON BOOK Content shoot with girls of club Jenna	**30** Travel to Los Angeles GLOW AWARDS

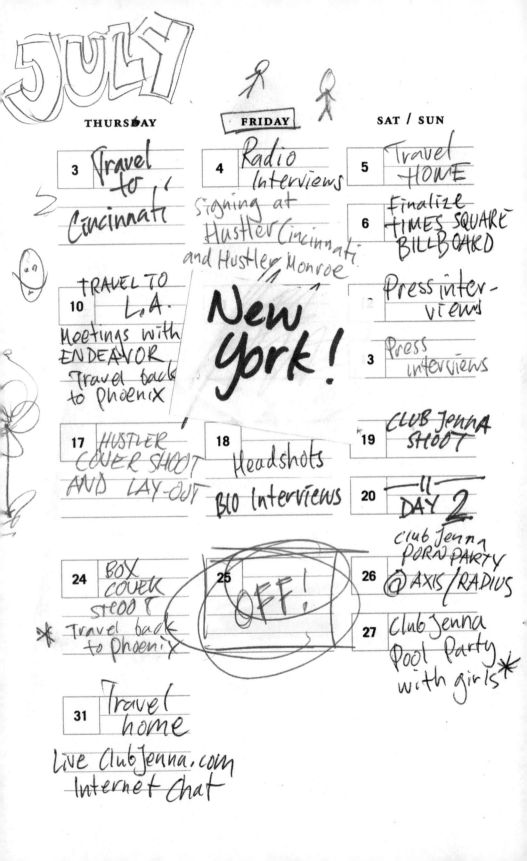

JULY

THURSDAY	FRIDAY	SAT / SUN
3 Travel to Cincinnati	**4** Radio Interviews — signing at Hustler Cincinnati and Hustler Monroe	**5** Travel HOME
		6 Finalize TIMES SQUARE BILLBOARD
10 TRAVEL TO L.A. Meetings with ENDEAVOR Travel back to Phoenix	New York!	Press interviews
		3 Press interviews
17 HUSTLER COVER SHOOT AND LAY-OUT	**18** Headshots BIO Interviews	**19** CLUB JENNA SHOOT
		20 DAY 2 Club Jenna PORN PARTY @ AXIS / RADIUS
24 BOX COVER SHOOT * Travel back to Phoenix	**25** OFF!	**26**
		27 Club Jenna Pool Party with girls *
31 Travel home Live ClubJenna.com Internet Chat		

Chapter THIRTEEN

To launch our first Club Jenna movies, we threw a party at the Consumer Electronics Show in Vegas. Despite all the times I'd returned to Vegas since my Jack days, I had never felt entirely at ease there. But now, in what came as a surprise even to me, I felt like a new person. I was not the lost teenage stripper with the abusive boyfriend, the insecure girl trying to find her footing as a porn star, or the hard-partying feature dancer living a second childhood with her girlfriend. I was, for the first time I could remember, stable in Las Vegas.

The Club Jenna party itself was a whirlwind of faces. Everyone I knew in the business was there. Even Nikki had shown up, though she had left the business and was living with her husband and daughter in a town where no one knew of her past, putting herself through nursing school. Even though she had been everything to me—lover, best friend, savior, antichrist—we talked only for an instant. This wasn't because we still had bad feelings left over for each other, but because we knew better. As soon as we interact, some spark of mischievousness ignites. We were both miraculously leading separate, normal lives, and all it would take is for one thing to happen between us—a dance, a Vicodin, a drink, a word—and we'd be running wild again. Neither of us wanted to slip up; there was too much to lose now.

I felt comfortable, however, seeing her again. But when I heard another woman screaming my name, my heart froze. I recognized the voice instantly. It was Jennifer—my Jennifer. I turned around, and

saw the same beautiful girl I had fallen in love with so long ago at the Crazy Horse. Even though Jay stood at my side, all the old feelings flowed through me as if they had never left (and perhaps they never had). I stood up, and gave her a massive hug. She told me she had left stripping and modeling altogether. She had given birth to a little boy with Lester, who had of course left her soon after, and was now working as a cocktail waitress at a casino.

Jennifer and I talked for fifteen minutes about those pivotal days, which had turned me down a path that, though it seems dark to most, ultimately became my source of light. Jack, she told me, had moved to Mexico. His hair was white from drug use, and his hands were so shaky he could no longer hold a tattoo needle. I wonder if he kicks himself in the ass now, because if he hadn't left me, he would have had all the money in the world to do drugs.

I could see in Jennifer's eyes as we talked that she was still in love. She wanted her little Jenna back. But her little Jenna was no more. And before we could even exchange a phone number, we were swept away in the torrent of people. I haven't seen her since, though I do still visit Melissa from Al's Diamond Cabaret. Her star had blazed across *Playboy* and *Penthouse,* and I was with her to celebrate when she became Pet of the Year. She went on to have four more children, and constantly promises to move with them to Scottsdale so that we can be closer. When I first sat in my hotel room bonding with her back in Pennsylvania, I had no idea I'd end up with more than a plaything for the night, but a lifelong friend.

After the party, I was feeling so wistful that I decided to go back to the Crazy Horse Too. It had been a long time since I'd last set foot in that place. Though I had changed, the club had not. It seemed to exist in some sort of topless time warp. The old lady in the merchandise booth was still there, as was Vinnie, who hadn't changed at all except for the fact that he greeted me for the first time ever with a smile.

Opal was gone, but some of the strippers remembered her. She had left town with Preacher after some bikers put a contract out on his life.

One of the girls there said she had visited their house in Maryland.
"He collects everything you do," she told me.

"What are you talking about?" I asked her. I couldn't believe what I
was hearing.

"He has a whole room full of your photos and videos and every-
thing you've ever done," she continued. "He's, like, your biggest fan."

My stomach turned. How could a creature I hated so much be my
biggest fan? It made no sense. I suppose no one ever thinks that the
actions they take are wrong or evil. They simply justify them after the
fact; the only problem was that I couldn't figure out whether his
strange trophy room was an unconscious form of penance or pride.

I thought about the random events that had led me to this point in
my life. If I had never gone to Jack's tattoo shop, and if the tattoo shop
had not led me to the Crazy Horse, and if the Crazy Horse had not led
me to Jennifer, and if Jennifer had not led me to Julia Parton, Jenna
Jameson would not exist. All the wrong choices I had made served
only to ferry me to the right place.

If my constitution weren't so thick, however, perhaps destiny
wouldn't have been so kind. I still think, sometimes, that this is all a
dream I'm having as I'm lying emaciated on the floor of my old Vegas
apartment the day Jack left me. I should have been dead. I don't know
why I was spared.

Chapter FOURTEEN

On Christmas, after eating dinner with my brother, sister-in-law, and nephew, I pulled into the driveway of the house that Jay and I share in Scottsdale, Arizona. The grass outside had been mowed that afternoon and the smell, as it always does, reminded me of meth.

I unlocked the door to discover Jay standing in the living room alongside forty oversize presents. I opened them slowly, savoring each gift: a Louis Vuitton purse, a Tiffany bracelet, a pair of Prada shoes. By the time I arrived at present number thirty-nine, I was exhausted. As usual, Jay had gone too far.

I carefully removed the wrapping, unveiling a cheap black T-shirt that had been scribbled on with puff paint. It was a somewhat anticlimactic gift, considering what I'd already received. But evidently Jay had made it himself, and I guess it was a sweet gesture.

"So am I supposed to wear this or something?" I asked him.

"Jenna, look *at* the shirt!"

On the front, he had scrawled: "Marry Xmas."

"Oh, that's cute," I said.

"Jesus Christ, do I have to spell it out for you?"

I looked at it again and realized that the word "marry" wasn't a spelling error.

When I raised my head from the shirt and saw his face, so nervous and eager, I burst into tears.

"Is that a yes?" he asked.

The shirt was crumpled in my hand like a rag. I wiped my runny nose with it, dropped it to the ground, and stammered a choked-up "yes."

Jay didn't respond. He just stared at the shirt, as if I had dropped something precious. I picked up the shirt and examined it again. I can usually sniff out a diamond, but my senses had miraculously failed me because there it was—six carats—in a pouch attached to the shirt.

Inside the last box was a bottle of Perrier Jouët with two champagne glasses. And together, that night, we celebrated our engagement.

One morning, three and a half years later, I woke up. Jay was curled around me. It was strange, because, for some reason, I wasn't seized by the impulse to push him away. In the past I'd never allowed men to cuddle with me.

He woke up, and we began our daily routine. He brought me coffee and then went to the computer to edit together a scene from my next movie, *Bella Loves Jenna*. I padded into the living room in my slippers and switched on the TV. We were like the stereotypical married couple. There was just one problem: we'd never taken the time to get married. We were so focused on building our company, and on flying constantly to L.A. to take meetings for various mainstream film and TV projects—nine-tenths of which never happened—that we'd kept procrastinating.

I wanted more than anything to finally have a child. With each passing month, I thought about it more and more. Every article I read about the mainstreaming of porn declared that I was going to be the one to make the industry legitimate (practically a pipe dream considering the conservative political climate), but business was the last thing on my mind. My only ambition was to be the mother I never had.

There were times in my life when I had thought, "I don't even care if I'm with the right guy. I just want to have a baby." But I'd thankfully come to the conclusion that it was a selfish thing to do. I didn't want my children to have to go through a divorce or have to deal with fight-

ing parents. They need to be as healthy as possible, because they're going to have to go through enough shit with a porn star for a mom.

So I padded into Jay's office and plopped down in a leather chair. He knew exactly what was on my mind.

"What day?" he asked.

So I got together with my assistant, Linda, who also happened to have become my best friend and the heart and soul of Club Jenna, and planned a wedding in two weeks. I didn't want to get too busy to become a wife again.

I don't do things half-assed, so we worked twenty-hour days planning the thing. With Rod, I had been so nervous and plagued with doubt before the marriage. This time, there were no butterflies and no worries.

We had the wedding in our backyard, surrounded by eighty of our closest friends and family. When we exchanged vows, I promised myself that I wouldn't cry. I even made it to the altar without getting misty. But the minute I started my vows, I broke down completely. I wiped my eyes and looked out at our guests—at my dad, my brother, Nikki, Melissa, Joy—and they were all sobbing with me. Then I looked into Jay's eyes, and saw such softness and love that I just knew I would be with this man forever. I saw not a husband, but the father-to-be of my children. I didn't think I'd feel—or even deserve to feel—anything like that in my lifetime. As cheesy as it sounds, I never knew what love was until that moment.

Because we were too busy at the time to travel, we decided to have our honeymoon at the Ritz-Carlton in Phoenix, so we booked the rest of the week there. That first night, we had fantastic sex—especially compared with my first wedding, when I didn't have sex at all—and fell asleep in each other's arms.

When we woke up at 10 A.M., I looked into his eyes. He looked into my eyes. And we both said the same thing: "Let's go home."

Epilogue

February 19, 2004

Dear Diary,

So we meet again. For almost fifteen years, I've been writing my last entry, thinking that I'm closing the book on my life. Yet I always find myself coming back to you. On every E! True Hollywood Story, life is always played out in three acts. But mine seems to have had at least a dozen.

I started life by choosing darkness, but now everywhere I look I see light. I've put the hardships and insecurities behind me and learned to focus on the woman and wife I've now become. My husband makes me feel as if I can conquer anything, and indeed I have. I feel like my wounds have begun to heal, and I truly believe that for the first time in my life everything will be okay.

The family that once seemed to be the epicenter of all my problems is now my support. I'm not sure if my father has told me everything yet, but all that really matters is that we've broken through the walls of silence. My father accepts me for who I am, and in turn I accept him and all his lying little quirks. Sometimes I wonder if I've made too much of my father not being around. Maybe my anger has blotted out the times when he did support me.

My company is booming now, and has brought me so much unexpected happiness. I found a new blonde named Krystal Steal and made her Club Jenna's first contract girl. I've been talking with her almost every day, telling her everything I wish someone had told me when I was starting out. I'm hoping she can take my place, because I'm done with movies. My mind is elsewhere, and soon my body will be too: I picked up an ovulation predictor kit from the doctor's office yesterday.

Oh, and on the way home from the doctor, I saw my face on the cover of Penthouse. They finally made me Pet of the Month. The photos were six years old, but I finally made it. Big whoop. Time to move on.

I feel like I've allowed myself to let go of the pain, and embrace the fact that I'm not perfect. I certainly still strive to be the best at whatever I do, but I'm not shattered if I fail. This has come from my own inner strength, not from looking to other people to fulfill me. I was always searching for someone to make it better, not realizing that someone was me. I'm comfortable just where I am. And this time I'm not going to run away because I have a future that I never thought was possible for me to look forward to. I will be a daughter, a wife, a sister, a friend, and most of all, a mother.